FILM NOIR AND THE ARTS OF LIGHTING

TMI TECHNIQUES of the MOVING IMAGE

Volumes in the Techniques of the Moving Image series explore the relationship between what we see onscreen and the technical achievements undertaken in filmmaking to make this possible. Books explore some defined aspect of cinema—work from a particular era, work in a particular genre, work by a particular filmmaker or team, work from a particular studio, or work on a particular theme—in light of some technique and/or technical achievement, such as cinematography, direction, acting, lighting, costuming, set design, legal arrangements, agenting, scripting, sound design and recording, and sound or picture editing. Historical and social background contextualize the subject of each volume.

Murray Pomerance
Series Editor

Jay Beck, *Designing Sound: Audiovisual Aesthetics in 1970s American Cinema*
Lisa Bode, *Making Believe: Screen Performance and Special Effects in Popular Cinema*
Wheeler Winston Dixon, *Death of the Moguls: The End of Classical Hollywood*
Nick Hall, *The Zoom: Drama at the Touch of a Lever*
Patrick Keating, *Film Noir and the Arts of Lighting*
Andrea J. Kelley, *Soundies Jukebox Films and the Shift to Small-Screen Culture*
Adrienne L. McLean, *All for Beauty: Makeup and Hairdressing in Hollywood's Studio Era*
R. Barton Palmer, *Shot on Location: Postwar American Cinema and the Exploration of Real Place*
Murray Pomerance, *The Eyes Have It: Cinema and the Reality Effect*
Steven Rybin, *Playful Frames: Styles of Widescreen Cinema*
Colin Williamson, *Hidden in Plain Sight: An Archaeology of Magic and the Cinema*
Joshua Yumibe, *Moving Color: Early Film, Mass Culture, Modernism*

FILM NOIR AND THE ARTS OF LIGHTING

PATRICK KEATING

RUTGERS UNIVERSITY PRESS
New Brunswick, Camden, and Newark, New Jersey
London and Oxford

Rutgers University Press is a department of Rutgers, The State University of New Jersey, one of the leading public research universities in the nation. By publishing worldwide, it furthers the University's mission of dedication to excellence in teaching, scholarship, research, and clinical care.

Library of Congress Cataloging-in-Publication Data

Names: Keating, Patrick, 1970– author.
Title: Film noir and the arts of lighting / Patrick Keating.
Description: New Brunswick : Rutgers University Press, [2024] | Series: Techniques of the moving image | Includes bibliographical references and index.
Identifiers: LCCN 2023047871 | ISBN 9781978810259 (paperback) | ISBN 9781978810266 (hardcover) | ISBN 9781978810273 (epub) | ISBN 9781978810297 (pdf)
Subjects: LCSH: Film noir—History and criticism. | Cinematography—Lighting. | BISAC: PERFORMING ARTS / Film / History & Criticism | ART / Popular Culture
Classification: LCC PN1995.9.F54 K435 2024 | DDC 791.43/655—dc23/eng/20240220
LC record available at https://lccn.loc.gov/2023047871

A British Cataloging-in-Publication record for this book is available from the British Library.

Copyright © 2024 by Patrick Keating

All rights reserved

No part of this book may be reproduced or utilized in any form or by any means, electronic or mechanical, or by any information storage and retrieval system, without written permission from the publisher. Please contact Rutgers University Press, 106 Somerset Street, New Brunswick, NJ 08901. The only exception to this prohibition is "fair use" as defined by U.S. copyright law.

References to internet websites (URLs) were accurate at the time of writing. Neither the author nor Rutgers University Press is responsible for URLs that may have expired or changed since the manuscript was prepared.

⊚ The paper used in this publication meets the requirements of the American National Standard for Information Sciences—Permanence of Paper for Printed Library Materials, ANSI Z39.48-1992.

rutgersuniversitypress.org

CONTENTS

	Note on the Text	vii
1	Introduction	1
2	The Dramatic Arc	20
3	Lighting Characters	58
4	Genre, Adaptation, and the Art of Unfolding	95
5	Lighting Milieu	131
6	Subjectivity, Symbolism, and Depiction	167
7	Conclusion	205
	Acknowledgments	207
	Notes	209
	Bibliography	231
	Index	241

NOTE ON THE TEXT

It is traditional in film studies to include the name of the director in parentheses after mentioning a film for the first time. However, this book is about lighting, and lighting is a collaborative achievement wherein the cinematographer typically plays a leading role. Rather than clutter the book with parenthetical references to multiple contributors, I have decided to keep things simple and mention the year in parentheses after the first appearance of each title. I will mention key contributors when they are directly relevant to a particular point. Should I fail to do so, I hope that readers will have no trouble finding the necessary information online.

FILM NOIR AND THE ARTS OF LIGHTING

1 · INTRODUCTION

Think of a prototypical film noir. What do you see? Perhaps the long shadow of a man walking down a city street. Perhaps a street sign blinking on and off through a window. Perhaps the glimmer in the eyes of a woman standing in the gloom. More than any other set of movies from the classical Hollywood era, film noir calls to mind a particular style of lighting: moody, expressionistic, and drenched in darkness.

This low-key style has become so familiar that it may seem there is little left to say. But look again. These, too, are a part of film noir: the brightness of the grocery store in *Double Indemnity* (1944), the glamour of Rita Hayworth's close-ups in *Gilda* (1946), the flat lighting of the police station in *Where the Sidewalk Ends* (1950), and the sunlit action scenes of *The Hitch-Hiker* (1953). The noir style is variable, shifting from scene to scene. The shadows make an impact because they are part of a larger pattern. Noir stories are grounded in conflict, and noir filmmakers were in the business of representing those conflicts *visually*. To tell these multifaceted stories, filmmakers could not afford to paint everything black. They needed to use all the tools available to them: brightness and darkness, beauty and ugliness, gleaming modernity and dull obsolescence. Such complex lighting allowed filmmakers to create bolder juxtapositions, contrasting the glamorous femme fatale with the hardened hero, the dimly lit dive bar with the brightly lit police station, the happy childhood with grim adulthood. To borrow an analogy from sound design, noir lighting showcases tremendous dynamic range, like a soundtrack that is thunderously loud in some passages and teasingly inaudible in others.

My approach may be contrasted with two common trends in noir criticism, which I call *noir symbolism* and *noir exceptionalism*. In brief, the former refers to the critical tactic of describing noir imagery in largely metaphoric terms, and the latter refers to the strategy of defining film noir in opposition to Hollywood's prevailing norm of unobtrusive brightness. I offer a modest alternative to noir symbolism by championing perceptual contributions: light helps us see particular characters inhabiting particular places. I offer a more contentious dissent from noir exceptionalism by arguing that noir builds on Hollywood's established storytelling principles, which were far more flexible than is usually supposed. Holding these arguments together is a new account of lighting in classical-era Hollywood.

Across genres, variable lighting is an essential part of pictorial storytelling. Film noir, with its bleak themes and narrative experimentation, pushes Hollywood cinematographers to do some of their best work: more varied, more densely detailed, and more socially critical.

WHO STANDS WHERE

Several seminal essays from the 1970s established symbolic readings as a staple of noir criticism. Paul Schrader proposed that lighting creates oblique lines that "splinter" the screen; shadows hide characters and "negate" their efforts. For Janey Place and Lowell Peterson, darkness "threatens" the characters from all sides; a cast shadow "suggests an alter ego, a darker self who cohabits the same frame."[1] Years later, Alain Silver and James Ursini compiled an impressive list of noir's symbolic motifs, which include the "recurring image of prison-like bars," the sharp "cut" of the venetian blinds, and the "emotional doppelgänger" of the noir mirror.[2] All these readings are plausible and often persuasive. If I avoid symbolic readings in this book, it is mostly to push other functions to the fore, including the most basic function of all: rendering figures in space.

Consider an example from one of the first noirs, John Huston's adaptation of *The Maltese Falcon* (1941). Near the end of the movie, Sam Spade calls his assistant and asks her to deliver the figurine that everyone else in the room covets so dearly. Sam flashes a grin at Casper Gutman, offscreen, the dubious leader of the pursuit. Sitting behind Sam, Casper's gunsel Wilmer hangs his head in despair. Farther back, Joel Cairo and Brigid O'Shaughnessy eye Sam intently. When Brigid takes a step forward, she casts a hard shadow onto the doorframe (figure 1.1). Given the events that have transpired so far, it seems fair to read this cast shadow as a symbol of duplicity. Brigid has been lying to Sam for the entire movie, first by pretending to be the fictitious Miss Wonderly and then by feigning innocence for the murder of Sam's partner. The shadow symbolizes Brigid's penchant for taking on fictitious roles, or perhaps it symbolizes the capacity for murder that she has kept hidden so carefully.

But what happens if we set aside its symbolism? At the most basic level, the shadow is there because of the illumination that has been added to the screen-left side of Mary Astor's face. The illumination allows us to read Astor's performance, rendering Brigid's intensity more clearly. Her expression echoes Joel Cairo's, suggesting a parallel between them. They share the same goal and the same determination to continue fighting, even against Sam if they have to. Note that this is a literal parallel, not a symbolic one: Brigid and Joel really do have this goal in common. The light is there to let us see the similarity, allowing us to read their faces at a glance.

The shadow also situates Brigid more firmly within the geography of Sam's room. Brigid is standing very close to the doorframe. If she were to take a step forward, her shadow would move noticeably farther to the right. As it is, her shadow is

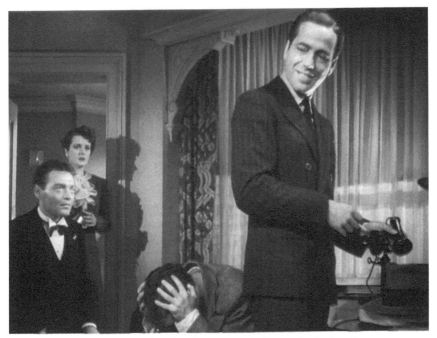

FIGURE 1.1. *The Maltese Falcon* (1941): Brigid casts a shadow on the back wall.

directly adjacent to her, letting us reckon her proximity to the frame. There may be a suggestion of entrapment here, but the abstract idea of entrapment emerges from a concrete detail: the shadow lets us measure how close she is to the wall, down to the inch. In any case, Brigid is hardly pinned down. She can step forward toward Sam, duck behind the doorway quickly, or remain unobtrusively where she is, depending on the needs of the situation at hand. With the help of the shadow, we see at a glance that Brigid has chosen to stand right here, in a position of maximum tactical flexibility.

The shadow affirms the scene's geography in another way, pointing toward offscreen space. Just before Brigid's reentrance, a close shot of Casper has established that Casper is still sitting next to a table lamp. When Brigid steps back into the room, her shadow obliquely reminds us of Casper's presence, since Casper's lamp is the shadow's most plausible source. The placement does not need to be perfect for the effect to work.[3] The shadow just needs to be salient—so obviously to Brigid's side that it calls to mind the offscreen space where Casper looms.

The high level of illumination has allowed the cinematographer Arthur Edeson to photograph the scene in deep focus, deep enough to keep Sam, Wilmer, Joel, and Brigid looking relatively sharp no matter how close they are to the camera.[4] Director John Huston takes advantage of this depth of field to design a composition with several points of interest competing for the viewer's attention. Without strain, the viewer is asked to register Sam's smile, plus the telephone, plus Wilmer's

hanging head, plus Joel's gaze, plus Brigid's posture. Because Astor is farthest from the camera, there is a serious danger that her character will get lost in the complex composition. The shadow mitigates the danger, making her seem larger in the frame and drawing the viewer's attention with movement.

Perhaps the most powerful function involves the shadow's impact on costume and set design. Take a look at the shadow's outline: that undulating curve set against the hard, straight line of the doorway. The outline renders various aspects of Brigid's appearance, such as her hair, blouse, hands, and profile. All these details are charged with cultural meaning, sharpening our awareness of Brigid's status as the only woman in a room full of men. For the bulk of the scene, Brigid has worn a fur coat. She has just removed the coat because Sam has asked her to go to the kitchen to make coffee. Her newly revealed costume would be perfectly visible without the shadow, but the shadow gives it a tiny touch of emphasis, meant to be perceived rather than pondered. The silhouette of the frilled blouse contrasts sharply with the straight vertical line of the doorway, and the contrast reinforces the salience of gender. Brigid's blouse connotes femininity in a visible way, appropriate for a character who plays a woman in distress when it suits her purposes. But femininity is not just a role she plays; it is also a role she is assigned. Sam has just delegated to Brigid the domestic chore of making coffee, excluding her from the field of battle. The shadow's extra bit of emphasis on the blouse is a tiny reminder that Sam has cast her in a feminine role and that Brigid has agreed, for the moment, to play the part.

Taken together, these functions show how a cast shadow can be quite useful whether it is symbolic or not, precisely because it lets us see the situation so clearly. Notice how a focus on basic perceptual effects has brought deeper cultural meanings to the fore. To borrow a term from the film scholar Adrian Martin, lighting shapes our understanding of the "social mise-en-scène." Cinema deals with "bodies and environments as its primary material," and those bodies and environments are already governed by rules, which govern "where and how one will sit, stand, walk, run, be active or passive, hushed or loud."[5] Whether Brigid is in the room or out of it, at the center or hovering on the edges, her positioning is the direct result of her actions and reactions as she engages in the battle of wits with Sam, Casper, Joel, and Wilmer. Because lighting helps us see her positioning, it lets us read the shifting power relationships at a glance. This spatial analysis of the lighting does not invalidate the idea that the shadow symbolizes Brigid's duality.[6] It merely reclassifies the symbolism at a second-order level. Before it can symbolize anything, the shadow must be placed in the story's world, where it works to reveal these particular characters battling it out in this particular room on this particular night.

Within noir criticism, the works of Vivian Sobchack and Edward Dimendberg provide some inspiration for my approach. In a celebrated essay, Sobchack argues that one of noir's enduring achievements is its rendering of a particular *chronotope*, capturing the look and feel of the dive bars, lounges, motels, and other transient spaces that seemed increasingly typical of life in postwar U.S. culture.[7] Similarly, Dimendberg analyzes changing conceptions of urban space in the 1940s and 1950s,

when the older notion of a downtown center was being replaced by a more scattered conception of the city.[8] My working definition of noir is somewhat looser than theirs, but their larger points about space and time remain powerful. Noir's visual style evokes a mood of alienation not just through symbolic abstractions but through the concrete rendering of characters in richly particularized settings.

From a certain perspective, my proposal may seem overly obvious. Perhaps I am saying nothing more than this: noir stories are about people in places, and the lighting lets us see *who stands where*. That is admittedly a rather straightforward way of looking at lighting, but there are benefits to adopting such a straightforward approach. In a pictorial narrative art, it really does matter who stands where: who is against the wall and who is in the open, who is on the street and who is in the gutter.

NOIR AND HOLLYWOOD

This straightforward proposal about noir lighting is, I think, true of lighting in Hollywood cinema more generally. A comedy must show us who stands where, and a romance must do the same. This brings me to a second intervention that I propose in this book, posing a challenge to what I call *noir exceptionalism*. The seminal criticism of the 1970s set another precedent that is still influential, defining noir lighting in opposition to Hollywood norms. Whereas the classical Hollywood style is high-key, self-effacing, and balanced, the noir style is low-key, expressive, and disjointed. Place and Peterson explicitly define noir lighting and camerawork as "anti-traditional."[9] Drawing on their work, Andrew Spicer contrasts the grimness of noir with the bright Hollywood norm.[10] Such arguments frame noir as a break or departure.

If I find myself disagreeing with the basic logic of noir exceptionalism, it is not because I disagree with the underlying accounts of noir per se. Noir style is often low-key, and its compositions can be unbalanced. My objection is, perhaps, more fundamental: I disagree with the premise that ordinary Hollywood movies were high-key, glossy, and unobtrusive as a general rule. Exceptionalism assumes that Hollywood cinematographers were committed to *clear* storytelling above all; they lit their movies brightly to ensure that the key story points would be visible at all times. But I prefer to think of Hollywood cinematographers as being committed to *dramatic* storytelling, where emotional engagement is the ultimate goal. To tell stories with a high level of emotional engagement, cinematographers learned to *vary* their lighting from movie to movie, from character to character, and from scene to scene. Within the industry, lighting could be high-key and glossy, or it could be dim and grim, in a wide range of genres. High tragedy called for low-key lighting; so, too, did scenes of moonlit romance. Shadows could appear in a Victorian melodrama or a Western. Noir's variable lighting was an extension of this larger industry norm, whereby cinematographers tailored each shot to the changing emotional needs of the story.

Push this alternative account to the limit, and film noir disappears altogether. I will not go quite this far, but I will define the category broadly, to include the gothic melodrama and other noir-adjacent films. Critics have long acknowledged that the category of noir is flexible and even unstable. In the first book-length study of noir, Raymond Borde and Etienne Chaumeton treat noir as a series.[11] Foster Hirsch makes a detailed case for film noir as a genre.[12] Others define the category as a tone or a style.[13] In one of the most respected volumes in the field, James Naremore offers an overview of these debates and argues that noir is always a constructed category, subject to the rhetorical, creative, and commercial needs of the critics, filmmakers, and marketers who deploy the term. There may be a cluster of recurring traits (crime, femmes fatales, flashbacks, low-key lighting, a mood of despair), but these traits fail to form a set of necessary and sufficient conditions. Naremore's point is not that the category is useless—just that the nature of its usefulness changes in different contexts. Each usage pushes us to notice similarities and differences among an ever-shifting cluster of films.[14]

What I am calling *noir exceptionalism* is a particular way of constructing two categories at once. Organizing the category of classical Hollywood cinema around brightness and unobtrusiveness allows the historian to simultaneously construct the category of film noir around darkness and expressivity. This organizational strategy encourages us to notice similarities within classical Hollywood, as well as reverse-image similarities within noir. My reconstruction brings out some very different patterns of similarity and difference: similarities across Hollywood genres, and differences within the category of noir. A glamorous noir may look very similar to a glossy period movie and very different from a noir procedural.

Rather than eliminate the category of noir altogether, I want to put the category to use, as an illustration of what lighting can do for the art of pictorial storytelling as it was practiced in classical-era Hollywood. This brings me to my biggest goal in this book: to propose a new account of Hollywood's lighting in the studio system. Put simply, noir can teach us how Hollywood lighting works.

HOW TO DO THINGS WITH LIGHT

Most of the movies I discuss in this book were produced by large studios. In some cases, the movies were produced by independent companies, but even here the cinematographers who lit the films had built their careers in the studio system. One of the striking things about studio-era cinematography is that the practitioners were so self-conscious about their craft. In their trade journal *American Cinematographer* and other venues, cinematographers explained the guiding ideals of Hollywood camerawork. I have been studying this discourse for years, with an eye toward understanding these ideals as a kind of working theory of classical-era cinematography.[15] As far as lighting is concerned, here is the most concise summary of that working theory that I can offer: *filmmakers use lighting to depict figures in a*

milieu as the dramatic arc unfolds in time. This formulation ties together five distinct but interlocking tasks.

1. Lighting gives shape to *figures*, allowing us to see the characters as three-dimensional beings acting in space. Hollywood cinematographers describe this shaping activity as an active process, a way of modeling the features of the character. With the help of the right makeup and a good performance, lighting can make a character look old or young, glamorous or ordinary, impoverished or wealthy.
2. Lighting works to locate those characters in a particular milieu, a distinctly rendered place with dim table lamps or bright fluorescents, filled with gleaming appliances or with decaying piles of junk. The concept of *milieu* is similar to *setting*, but the former word does a better job of suggesting the *social* significance of each space. With the help of appropriate set design, lighting can make a milieu look seedy, elegant, modern, or obsolete.
3. Lighting gives shape to the story's *dramatic arc*. Stories are usually about emotionally significant changes. More than just a chain of causes and effects, a dramatic arc includes high points, low points, turning points, shockers, coincidences, calamities, and conclusions. The right lighting can amplify the drama's emotional curve, as when a character steps into the light at the turning point of the scene, or when a flashback shifts from the gloomy present to the once-bright past.
4. As each movie *unfolds in time*, viewers develop and adjust their expectations about where the story is heading. Genre guides this process, both by creating expectations that are fulfilled and by creating expectations that are overturned. When a movie's lighting shifts from a romantic mode to a suspense mode or from a comedic mode to a tragic mode, it sets in motion the play of expectation and memory that is the heart of storytelling.
5. Lighting does all these things (modeling figures, rendering the milieu, shaping the arc, and manipulating expectations) by contributing to the movie's *depictions*. We do not need to be told that a character is old or glamorous. With the help of the right lighting, we look at the pictures and *see* it. We do not need to be told that a milieu is seedy or sophisticated. With the help of the right lighting, we look at the pictures and *see* it. Lighting works together with set design, costumes, makeup, acting, and other elements of cinematic style to make these traits visible at a glance.

Filmmakers use lighting to depict figures in a milieu as the dramatic arc unfolds in time. Like all one-sentence overviews, this proposal condenses some details and glosses over others, but it is meant to convey the central tasks that Hollywood filmmakers expected lighting to fulfill. With some modification, it could perhaps be turned into a general theory of lighting in narrative cinema, even beyond classical Hollywood, since most stories involve people in places and time. As it is, it

remains a historical claim about cinematography in the late years of the studio system. Cinematographers articulated these five tasks in their writings, and they accomplished them in their films. My approach fits squarely within the methodology known as historical poetics, which studies "principles of filmmaking as they inform films in particular historical circumstances."[16] If you were a cinematographer at RKO or Twentieth Century-Fox in the 1940s or 1950s, and you showed up to work on any given day, you would spend much of your time wrestling with precisely these sorts of problems: how to make characters look beautiful or ugly, how to make rooms look lived-in, how to mark turning points, how to play on viewers' expectations, and how to do it all in well-crafted pictures.

I focus on the work of *cinematographers* because the studio system assigned them the primary responsibility for lighting each film. John Huston, the director of *The Maltese Falcon*, explained, "Lighting is almost completely up to the cameraman, who of course must be in complete sympathy with the director."[17] Huston could stage bodies in space because Arthur Edeson lit and photographed that space in deep focus. That said, my focus in this book is not on the authorial styles of individual practitioners.[18] Lighting in the studio system remains a collaborative achievement. To light a scene, the cinematographer must work with the electrician who will position the lamps, with the director who will organize the staging, with the set designer who will design the walls, with the makeup artist who will sculpt the character's eyelashes, and with the actor who will hit the mark with pinpoint precision. As Sarah Kozloff writes, "Authorship in film is nearly always plural."[19] When I give credit to an individual cinematographer, I am using a convenient shorthand for this larger collaborative process. In many cases, I will go beyond this shorthand to consider additional contributors.

With its vivid imagery and its flair for drama, film noir can teach us how pictorial storytelling works in classical Hollywood more broadly. I could illustrate this broader account with other examples from the same period, such as the romantic drama *Since You Went Away* (1944) or the classic Western *My Darling Clementine* (1946), both of which benefit from the tremendous dynamic range that characterizes film noir. But noir offers several advantages to this project. The films are already well known. They tell stories about a wide variety of character types: not just detectives and grifters but glamorous femmes fatales and beautiful loners. They combine their crime stories with romance, satire, and other generic elements. They often experiment with narrative structure and point of view. They benefit from the contributions of many practitioners, from old-school Hollywood veterans to émigré auteurs. And they use pictorial storytelling for the purposes of social critique, offering a trenchant look at the world they represent.

Consider a scene from the newspaper noir *Call Northside 777* (1948), directed by Henry Hathaway and photographed by Joe MacDonald. The reporter P. J. McNeal locates the apartment of Wanda Siskovich (formerly Wanda Skutnik), whose false testimony led to an innocent man's conviction eleven years ago. McNeal approaches her doorway (figure 1.2A), enters, and finds Siskovich sitting in her

Introduction 9

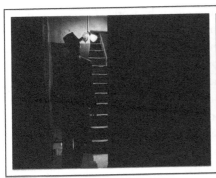 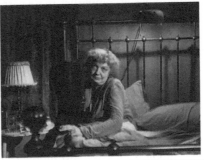

FIGURE 1.2. *Call Northside 777* (1948): P. J. McNeal enters a dimly lit apartment building and finds Wanda Siskovich in her bed. *A (left)*: McNeal. *B (right)*: Siskovich.

bed (figure 1.2B). The figure lighting heightens the contrast between the upstanding hero and the disheveled woman he has come to interview. In the hallway, McNeal looks strikingly tall. Of course, actor James Stewart was tall, but MacDonald has enhanced the impression by creating a composition with a strong vertical line and a series of horizontal lines. By contrast, the lighting in the second image makes Wanda Siskovich look aged and worn down. Her key light is placed above her and to the side, mimicking the effect of the small lamp pinned to her bed frame. The resulting light brings out the circles under her eyes, the wrinkles around her mouth and chin, and the uncombed disorder of her hair.

Similarly, MacDonald's lighting amplifies visible features of the milieu. In the hallway, there is no general illumination, making it seem like a tiny electric bulb is the only source of light around. The result is an overwhelming impression of decay. Here is a remarkable fact: we know that the building's landlord is cheap. No, the landlord is not a character in *Call Northside 777*, but the film's world is sufficiently detailed that we can understand the characteristics of a person whose existence is merely implied. The landlord is saving money on electricity. The light bulb is sitting in a fixture that is obviously decades old, since it contains an unused globe for gas. This little detail gives the milieu a history stretching back for decades. It is a history informed by the movie's larger representation of Chicago. Siskovich's neighborhood is depicted as a space of unassimilated Polish ethnicity, and McNeal feels distinctly out of place.

The scene is the darkest in the movie so far: darker than the murder in the opening sequence, darker than the prison scenes, and much darker than the scenes set in McNeal's brightly illuminated office. The contrast reminds us how far McNeal has come as a character, giving shape to his dramatic arc. Earlier in the story, he did not want to waste his time on a dead-end investigation. Now, he is willing to put himself at risk in his pursuit of justice. In a sense, this dark scene is a high point for McNeal: his most courageous moment. By contrast, the same darkness represents a low point for Siskovich, who has clearly been declining for years.

The movie accomplishes these narrative effects by working *through* its depictions. I think of it as an achievement in *depicting-as*. The apartment building is depicted *as* cut-rate and obsolete, Siskovich is depicted *as* faded and weary, and McNeal is depicted *as* respectable but out of place. Lighting qualifies the story's world, helping us see the characters and their environment in a particular way. Casting, set design, and makeup also contribute to this process. Lighting may be just one tool among many—but it is a powerful tool indeed. Lighting can allow a filmmaker to represent a character as glamorous, menacing, tired, impoverished, wealthy, or grim, and lighting can allow a filmmaker to represent a milieu as urban, rural, modern, obsolete, institutional, or marginalized. Here is where noir lighting can truly excel. Noir's stories push cinematographers to exercise the power of depicting-as to the fullest extent, along all five of the axes I have discussed. In the realm of figure lighting, cinematographers confronted a fascinating array of recurring character types, from the impossibly beautiful to the over-the-hill, from the fabulously wealthy to the unjustly excluded. Noir's milieus could be just as variable: there are dive bars and hideouts, of course, but also office buildings, mansions, nightclubs, and police stations. Noir's dramatic arcs can be quite dynamic: happiness turns to misery; grimness opens up to a hint of hope; a slow rise turns into a quick descent. Noir's patterns of expectation range from wide-open suspense (where hope is balanced by fear) to dread (where the worst possible outcome seems assured). And noir's pictorial strategies are equally varied: the slashing diagonals, the harsh bright glares, and the deepest of blacks. More than the sum of its shadows, noir lighting tells stories about people in specific places and times. These are stories of conflict, tension, and failure, requiring a palette that shifts from film to film, from scene to scene, and even from moment to moment.

CHAPTER OVERVIEW

My argument that noir lighting can teach us about Hollywood lighting more broadly calls for an approach that is both wide-ranging and particular: wide-ranging enough to show that noir lighting draws on shared practices, but particular enough to show that filmmakers make each story more meaningful by modulating their lighting from scene to scene. To capture both sides of this argument, each of the five main chapters offers one broad overview followed by two close analyses. The overviews focus on core concepts, such as figure lighting or the idea of the dramatic arc. The examples cover an eclectic mix of noirs and near noirs: mostly modern movies, but with one period example; mostly dour thrillers, but with one upbeat example; mostly no-doubt-about-it noirs, but with at least one borderline case; mostly movies from the peak noir years of 1941 to 1951, but with one earlier example and three later examples. Each in-depth analysis has a different director, a different lead writer, and a different cinematographer. Let me confess up front: my list of in-depth examples has some obvious gaps. There are no films directed by Billy Wilder or Otto Preminger and no films photographed by John Alton or Nick

Musuraca. Rest assured that the book's many shorter examples will refer to all these major figures and more.

The focus of chapter 2 is the idea of the *dramatic arc*. Whereas many Hollywood films build their stories around likable, goal-oriented protagonists, noirs build their stories around flawed protagonists, people who pursue goals that are unworthy or even impossible. My examples are the suspense film *Sorry, Wrong Number* (1948) and the heist movie *Odds against Tomorrow* (1959). Chapter 3 offers an overview of Hollywood's *figure-lighting* conventions, which expressed historically specific assumptions about gender and race. Building on the previous chapter, I argue that figure lighting also unfolds in dramatic time, shifting in brightness and quality to mark turning points and bleak moments. My examples are the noir-tinged melodrama *The Letter* (1940) and the investigative thriller *Phantom Lady* (1944). Chapter 4 expands on the concept of *unfolding* with a discussion of genre and adaptation, explaining how noir lighting reworks the preexisting lighting conventions of the suspenseful melodrama. Stories unfold in time, and lighting creates expectations about how each story might unfold—expectations that the movie may go on to adjust or overturn. My examples are the romantic mystery *I Wake Up Screaming* (1941) and the crisscross classic *Strangers on a Train* (1951). Chapter 5 shows how the lighting of *milieu* becomes a vehicle for noir's social critique. With its dimly lit apartment buildings and overly lit corporate spaces, film noir takes the electricity industry's optimistic vision of technological progress and turns it into a pessimistic vision of alienation and inevitable obsolescence. My examples are the bitter satire *Sweet Smell of Success* (1957) and the border baroque *Touch of Evil* (1958). Chapter 6 returns to the matter of noir storytelling by addressing a range of thorny narratological problems, such as the representation of subjectivity and the role of symbolism. At the end of this chapter, I return to one of the book's core ideas: cinematographers tell the story by working through *depiction*. My examples are the nineteenth-century thriller *Gaslight* (1944) and the modern gothic *Secret beyond the Door* (1947). Together, these ten examples show that noir lighting can be many arts at once: an art of portraiture, an art of atmosphere, an art of metaphor, and above all an art of pictorial dramatic storytelling.

THE ASPHALT JUNGLE (1950)

To bring this introduction to a close, I take a close look at one standalone example: *The Asphalt Jungle*, which John Huston directed nine years after *The Maltese Falcon*. The movie tells the story of a jewelry heist that goes wrong, leading to the death or capture of all the participants. It is an ensemble story with over half a dozen major parts, including the criminal mastermind Doc (Sam Jaffe), the honorable tough guy Dix (Sterling Hayden), the troubled singer Doll (Jean Hagen), and the dishonest lawyer Emmerich (Louis Calhern). On the one hand, the story is eminently classical, as all the major characters have clearly articulated goals. Doc's goal is to execute the heist so he can retire to Mexico and spend his time

ogling pretty young women. His antagonist Emmerich has a strikingly similar goal: to execute the double cross so he can leave the country with Angela (Marilyn Monroe). Dix wants to return to Kentucky, Doll wants to be with Dix, the police commissioner wants to arrest the criminals, and the corrupt detective wants to get the commissioner off his back. The goal of stealing the jewels brings Doc and Dix together, along with two other accomplices, Anthony and Gus. To accomplish that goal, the group needs to overcome a series of obstacles, such as an electric eye outside the vault. It is all very tightly constructed.

The film's noir sensibility comes to the fore when the protagonists encounter a series of random accidents, as when a watchman's gun falls on the ground and fires, wounding Anthony. The contrast between the best-laid plans and the worst-timed luck is so stark that Doc utters a monologue on that very theme: "Put in hours and hours of planning. Figure everything down to the last detail. Then what? Burglar alarms start going off all over the place for no good reason. A gun fires of its own accord, and a man is shot. And a broken-down old harness-bull, no good for anything but chasing kids, has to trip over us. Blind accident! What can you do against blind accident!" Later, Doc is caught by the police because he spends too much time in a diner watching a young woman dance. Again, Doc takes the opportunity to muse on the theme of chance. If only he had left a couple minutes sooner, he could have escaped.

In other noirs, such as Fritz Lang's *Scarlet Street* (1945), chance is so persistently malevolent that it feels more like fate or destiny, as if evil forces were pulling the strings to ensure that the protagonist would fail.[20] By contrast, Doc understands that his adversary is not fate in a quasi-religious sense of the word, but a more modern conception of randomness. And Doc acknowledges that chance deserves only some of the blame. After his monologue on the power of "blind accident," Doc admits that he made a mistake in trusting Emmerich. After his arrest, Doc recognizes that he has acted like a fool by lingering in the diner too long, letting a momentary pleasure get in the way of his long-term goal of escaping with the jewels.

The Asphalt Jungle follows the letter of the Production Code by having all its criminals be punished by the end of the story, but it violates the spirit of the Code by making its criminals so sympathetic. Each member of the gang is given at least one admirable trait: Anthony is a family man, Gus is loyal to his friends, and Doc is calmly observant. Dix emerges as a particularly complex character. Initially described as a hooligan, Dix shows flashes of kindness when he helps Doll after she loses her job, moments of depth when he nostalgically recalls his past, and a powerful streak of honor when he refuses to take insults from Cobby, the cowardly underworld fixer who helps Doc put the team together. Near the end of the film, the police commissioner delivers a self-righteous speech about the need for law and order, denouncing Dix as a "hooligan, a man without human feeling or human mercy." It is the sort of moralizing speech a Production Code official would love, but the effect is ironic: we have already seen how deeply human Dix can be.

The film's cinematographer was Hal Rosson, a longtime employee of MGM who was best known for his color work on *The Wizard of Oz* (1939), and before that for his failed marriage to Jean Harlow. There are several ways Rosson could have approached *The Asphalt Jungle*. He might have decided to light the criminals heroically, generating further sympathy for them by making them look as attractive as possible. Or he might have crafted a rise-and-fall pattern moving from brightness to darkness, echoing the rise-and-fall shape of the dramatic arc. Instead, he decided to start with the problem of depicting the milieu first. An article in *American Cinematographer* explained that Rosson would "let the players play in and out of the light as they would in the action situation."[21] For every set, Rosson asked how would it be lit in real life: Fluorescents? Windows? Dangling bulbs? Once he had settled on the logical source, Rosson would arrange his lamps to mimic that appearance, even if it meant creating zones where the actors might disappear into shadow.

A scene in Cobby's hallway shows Rosson locating his characters in that specific milieu. The space offers three plausible sources: a lamp dangling from the ceiling, a transom window above the doorway at the end of the hall, and an open doorway near the end of the hall to the left. Rosson takes advantage of all three sources to create a layered space:

1. There is a bright bulb in the hanging lamp, providing top light for the zone directly in front of the camera.[22]
2. Light from a room at the end of the hall spills through the transom window, providing backlight for characters standing in front of that far door.
3. Light from the unseen side room spills through an open doorway and creates a rectangle of illumination on the far right wall.

After establishing these three sources, Rosson's next decision is crucial. He adds very little fill light to the scene—just some dull illumination from the front, which falls off so rapidly that the distant zones are effectively unfilled. The result is a space with distinct zones of illumination separated by pools of shadow (figure 1.3).

To appreciate how bold this is, remember that Doc is the primary protagonist of this ensemble film, and that this is his first scene. The conventional thing to do would be to let us see Doc as clearly as possible. Instead, Doc paces back and forth along the hallway, creating a little game of revelation and concealment. Now he is in the light, and now he is gone. Eventually, Doc settles in the left foreground, and the focus shifts toward Cobby. The character actor Marc Lawrence had a pockmarked complexion, and the top light etches every flaw in Cobby's face.

Rosson does a particularly good job rendering the effect of spill, whereby a lamp creates a hot spot surrounded by a zone of dimmer illumination. Look at how Cobby is standing in the hot spot; just a couple feet away, the thug behind him is standing in the spill. Rosson championed this approach as a kind of realism, and it is easy to see why: in everyday life, the world does not organize itself so that

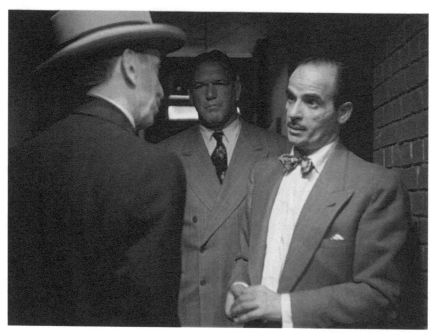

FIGURE 1.3. *The Asphalt Jungle* (1950): Doc enters a hallway with pools of light and shadow.

we look good at all times. Doc lives in an indifferent world, where blind accident can ruin all his plans. The lighting shows us what an indifferent world looks like, with illumination falling here and there, whether the characters are standing next to the lamps or not.

When Doc enters Cobby's office, he steps into one of the ugliest rooms ever constructed for an MGM film. The set decorator has crafted the decor to make it look like Cobby has selected a range of lamps over the years with no thought to how they might look together. Three fluorescent lamps hang from the ceiling near a theatrical spotlight with a makeshift shade. Another lamp casts a triangle of light on the wall, and there is an unshaded bulb that dangles in the back room (figure 1.4). Moments later, we see another lamp with a piece of paper taped over it, but again the lamp and the shade differ from the lamps and shades we have already seen. The visible wires make the arrangement seem even more haphazard. The result is hideous. The practical sources provide some of the illumination, and Rosson completes the picture with modest general lighting on the back walls and an unflattering top light on Doc. Note that the shadow areas on the back walls do not go black, as they do in the hallway. Deep black would be inconsistent with the fluorescent lamps hanging from the ceiling, as fluorescents cast a dull flat light over an entire space. The effect is distinctly unglamorous. When Doc leans back, the lighting is too flat, providing little modeling for his features. When Doc tilts forward, a shadow covers his eyes and sculpts the bumps and wrinkles under his

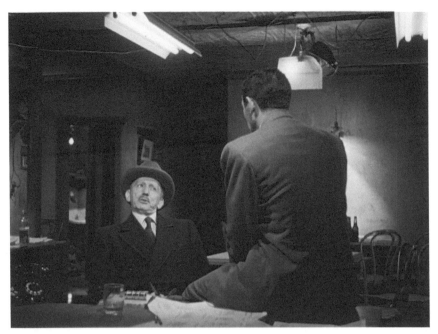

FIGURE 1.4. *The Asphalt Jungle* (1950): Ugly fluorescents adorn Cobby's office.

mouth. It is not that Rosson has abandoned figure lighting altogether; rather, he uses his figure lighting to teach us about the milieu. Even in close-up, the lighting reminds us that Doc is sitting under a ceiling full of ill-placed lamps.

In the *American Cinematographer* article, Rosson claimed that he broke from realism for one actor in particular: Marilyn Monroe, who received the glamour treatment.[23] I think that Rosson exaggerated the point. Although Monroe certainly looks beautiful, the lighting remains plausible within her character's milieu. Angela's scenes all take place in one location: an expensive cottage that Emmerich has acquired to facilitate his affairs and criminal activities. The decor marks this space as the exact opposite of Cobby's hideout. In place of the office's fluorescents and dangling lamps, there are table lamps with delicate shades (figure 1.5). In place of the hallway's pools of shadow, there is moderate illumination across the entire space. When Monroe appears in medium close-up, she receives smooth frontal lighting on her face, with no glowing backlight apart from a touch of light on her shoulder.

Again, the figure lighting teaches us about the milieu: this is the home of a man who has good taste. Taste is at issue here because the film explicitly associates class with artifice. Over the course of the story, we learn that the rough-edged Cobby is rich, and that the sophisticated Emmerich is broke, complicating our understanding of Emmerich's upper-class identity. Emmerich's associate Brannom comments resentfully on Emmerich's ability to command respect: "All these years, I've been

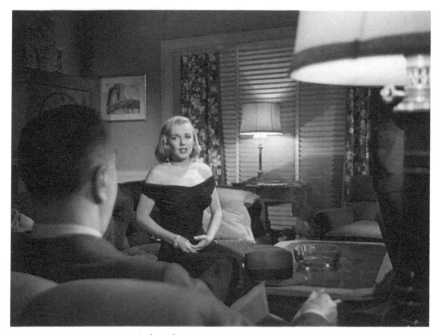

FIGURE 1.5. *The Asphalt Jungle* (1950): In Emmerich's cottage, table lamps add to the decor.

suffering from an inferiority complex. I should have been in the money years ago. You big boys—what have you got? Front—nothing but front. And when that slips . . ." It is not that Emmerich has fancy decor because he is rich; it is that everyone, including Angela, assumes that Emmerich must be rich because he has such fancy decor. If the lighting in Cobby's office suggests that Cobby barely thinks about lighting, then the lighting in Emmerich's cottage suggests that Emmerich thinks about lighting all the time, as a way of projecting his upper-class identity and claiming all the privileges that go with it.

When Doc and Dix visit Emmerich and Brannom in this same cottage, Rosson faces a difficult decision. He could respect the logic of the milieu and light the four men with the simple but flattering light he uses in Angela's scenes, or he could respect the logic of characterization and light these criminals with distinctly unglamorous arrangements. Rosson's solution is ingenious: he lights all four men differently, but he does it in a way that makes sense within the space—not perfect sense, since there are some cheats, but enough sense to heighten the drama without being distracting. Here are the lighting schemes for all four characters:

1. Doc is lit from below, producing a visible nose shadow and a bright glimmer in his eyes (figure 1.6A). The suggestion is that he is standing next to the fireplace, which also produces the looming shadow over the cabinet.

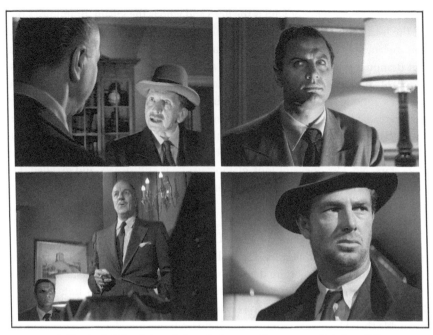

FIGURE 1.6. *The Asphalt Jungle* (1950): In a single room, four men are lit in four different ways. A *(top left)*: Doc. B *(top right)*: Brannom. C *(bottom left)*: Emmerich. D *(bottom right)*: Dix.

2. Brannom is also sitting next to the fireplace, so he also receives light from below (figure 1.6B). Rosson makes several adjustments to make Brannom look more menacing than Doc. Because Brannom's fill light is dimmer, certain highlights are more prominent; notice the creases in his forehead and the tension around his mouth. We can see both eyes clearly because there is an extra little spotlight on the shadow side of his face.[24]
3. Emmerich's lighting is probably the most illogical. He, too, is standing next to the fireplace, but he is not lit from below; instead, he receives more traditional three-point lighting (figure 1.6C). I suppose you could say that the missing firelight is motivated by the fact that Emmerich's back is toward the fireplace, but Rosson is simply cheating here, favoring figure over milieu.
4. Dix is not standing near the fireplace, so there is no expectation that he would receive a light from below. The high placement of the key makes his brow seem heavy, casting partial shadows over his eyes. The fill light brings out the texture of his grizzled chin and the beads of sweat on his cheek (figure 1.6D).

The lighting renders four different figures in the same milieu, with adaptations that suit each character while heightening the drama considerably. The scene is about two older men who try to outnegotiate each other and about two younger men who try to outduel each other. The lighting shapes the scene's dramatic emotion

by playing on our sense of who is the hero and who is the villain. Brannom is one of the least sympathetic characters in the entire movie. Almost everyone else in this melancholy tale is motivated by a mixture of pride, loyalty, and desperation, but Brannom seems to be driven above all by the urge to dominate others. Rosson lights him like a villain: the illumination from below downplays actor Brad Dexter's good looks, and a little spotlight makes his calculating eye movements easy to read. Dix is also a killer, but the emotional architecture of the film rests on the decision to treat him like a sympathetic hero. Rosson lights him like one in this scene, employing the rounded lighting pattern that Hollywood favored for male stars. No, Dix does not look glamorous: he is still sweaty and grizzled. He just looks three-dimensional, straightforward, and handsome in a regular-guy sort of way.

These choices establish a readable binary. Dix = good. Brannom = bad. What, then, are we to make of the lighting on Doc and Emmerich? Doc is arguably the leading protagonist of this story, and he has been given several sympathetic character traits: intelligence, a calm demeanor, and the insight to understand that the hooligan Dix is trustworthy and that the polished Emmerich is not. The self-deluding Emmerich may not be the sociopath that Brannom is, but he is far less honorable than Doc. Given these contrasting traits, we might expect Doc to be lit well and Emmerich to be lit unflatteringly. Instead, it is Doc who is lit from below for most of the scene, and it is Emmerich who receives conventional three-point lighting even when it requires visible cheats. The resulting polarity differs from the one drawn between Dix and Brannom. Emmerich is a vain man who uses his patrician appearance to deceive others. The mildly implausible lighting underscores the point that he is playing a role, trying to win trust by appearing as elegant as possible. Doc may have his own affectations (such as the quasi-military way he has of bowing his head in greeting), but he does not have Emmerich's pretense of being above it all. Lighting Doc from below paradoxically reinforces our sense of his innate honesty. Doc does not care if he looks like a criminal; he is a criminal, and he does not pretend to be anything else.

The film's final scene is justly famous—perhaps the clearest example of counterpoint in noir cinema. In crime movies, characters typically die in the shadows. Dix dies in the brightest sunlight. The screenplay, written by Ben Maddow and John Huston, actually recommended that a shadow effect be added to this scene: "There's a second of perfect silence, then a peculiar shadow moves over the grass and over Dix's body and across his face. It's the shadow of a horse, and now a big bay gelding walks slowly toward him, lowering his head to look at Dix. Another horse, full of their peculiar slow curiosity, comes up, too. And then, still other horses move toward the group, and they stand there, looking down at the dead human face, watching with infinite patience."[25] In the finished film, the wide shots show the shadows of the horses, but the closer images avoid any suggestion that the shadow of death is passing over Dix's body. Dix is in the sun, all lit up—and he is

dead. In this way, the film closes on the theme of indifference. The sunlight is like the horses—utterly indifferent to Dix's death.

Yes, sunlight. *The Asphalt Jungle* is one of several noirs that ends in sunlight. So, too, do *Mildred Pierce* (1945), *The Lady from Shanghai* (1947), *Force of Evil* (1948), and *Sweet Smell of Success*. The fact that most of these movies are as bleak as they come should remind us that there is not always a straight line that connects noir's shadows with anxiety, critique, or despair. Lighting gets at these emotions and more by working through the particularities of each story's world, with its distinctive figures, milieus, and unfolding drama.

2 · THE DRAMATIC ARC

Dramatic time is time infused with a sense of possibility, where it matters if things change or stay the same.[1] One of the biggest contributions that lighting can make is to give the movie a sense of dramatic time: a sense that characters are living in world where things might or might not happen, maybe for the better, or maybe for the worse. In the previous chapter, I introduced a number of terms, such as *figure*, *milieu*, and *dramatic arc*. My immediate goal in this chapter is to explain one of these terms, the *dramatic arc*. But my larger point will be that the task of building an effective dramatic arc informs everything else that a cinematographer must do, from casting a shadow over the villain's face to streaming sunlight through a window.

Time holds these choices together. To light even the simplest shot, a cinematographer must represent a particular moment: what this person in this space might look like at this particular time. But then the cinematographer must look beyond the moment, considering what this shot means in the context of the ongoing scene and the film as a whole. When a star actor looks handsome in one shot, it produces a different effect if the same actor looked bedraggled a few scenes earlier. When an office building looks expensive and modern in one shot, it produces a different effect if a character has been longing to work there or longing to escape it. Whether bright or glum, each dramatic image comes to us situated within a timeline—or, better yet, within a field of *virtual* timelines, where what happens seems meaningful in relation to what has happened, what will happen, and what might have happened instead.

I begin by outlining the basic features of Hollywood's dramatic narratives: protagonists, goals, and obstacles. I then show how noir filmmakers took these basic features and turned them in a more pessimistic direction, creating protagonists who are often unlikable, with goals that can be self-defeating, faced with obstacles that seem insurmountable. The remaining sections bring lighting back into the account. Far from making everything dark, noir cinematographers thought carefully about when the lighting should go dark, and when it should not. The best ones tackled this problem on three levels at once: the level of the shot, the level of the scene, and the level of the overall film.

NOIR AND HOLLYWOOD NARRATIVE

A quick overview of Hollywood's basic storytelling conventions will clarify noir's unusual place within this tradition. Most studio-era Hollywood screenwriters favored a dramatic structure grounded in conflict: a *character* pursues a *goal* and encounters *obstacles* along the way. As David Bordwell writes: "The plot is based, the screenplay manuals usually say, on conflict, but what arouses conflict? Typically, a protagonist with a goal. The film's forward movement is created by efforts to achieve the goal and by obstacles that block its attainment. Yet the goal doesn't remain the same throughout the plot; typically, the protagonist adjusts the goal in response to changing circumstances."[2] In many classical films, this structure generates a tightly constructed causal chain, whereby causes in earlier scenes produce effects in later ones.[3] What I am calling the *dramatic arc* is related to this idea of the causal chain, but it is not identical. Whereas the word *causal* implies logical connectedness, the word *dramatic* brings a sense of possibility to the fore. Goals are particular kinds of causes, with a built-in bias toward uncertainty. Indeed, the most salient trait of a goal is that it might *not* succeed. Narrative engagement springs from a sense of risk, playing on our awareness that the protagonist might fail, or succeed, or fail and then succeed in some surprising way, or succeed in a bitterly ironic way that feels like failure. I stress the importance of uncertainty because it offers a fresh way of thinking about Hollywood narrative, even in its most classical forms. Scholars sometimes contrast the tight construction of classical stories with emotion-driven melodramas. By contrast, I see no contradiction between the goal-driven plot and a story with powerful emotional appeal. Goal-driven Hollywood narratives play relentlessly on our hopes and fears—precisely by creating likable characters and throwing obstacles in their way. As Janet Staiger argues, Hollywood movies can be classical and melodramatic at once.[4]

My understanding of Hollywood narrative is broadly functionalist, assuming that dramatic arcs are constructions, designed to produce emotional effects.[5] To see these constructions at work, consider two non-noir classics from the 1940s. In Alfred Hitchcock's thriller *Foreign Correspondent* (1940), John (aka Huntley Haverstock) sets out to uncover the nest of spies who have kidnapped a diplomat, and the ensuing plot generates the hope that John will save the diplomat and the fear that John will be humiliated or killed. In the romantic drama *Random Harvest* (1942), Paula sets out to cure the mental blocks in the mind of the amnesiac Charles so he will remember that he is in love with her, and the plot generates the hope that Paula achieves her reunion with Charles and the fear that they will lose their love forever.[6] Both films are in a sense melodramatic, using implausible scenarios to cultivate strong emotions, but the melodrama succeeds because of the goal-and-obstacle plot structure, not in spite of it. These are stories of possibility—of risk. When these stories end happily, the joy is all the greater because the protagonists might have failed.

Goal-oriented stories such as these work on our *temporal* emotions. Hope and fear are grounded in uncertainty about what will happen next to a character who has become the target of our concern. Other emotions point toward the past, ranging from curiosity about a mystery to nostalgia for a character's lost love. Even emotions that appear immediate, totally grounded in the present, benefit from the flow of time. When John gets his coat stuck in the gears of a windmill in *Foreign Correspondent*, I feel instant tension; when Charles recognizes Paula at the end of *Random Harvest*, I feel immediate delight. My emotions arise in the moment, as the movie plays onscreen. But my emotions feel all the more intense because these moments belong to a timeline. Each film has built sympathy for these characters, and that investment enhances the emotional impact whenever they struggle or succeed.[7]

As in any narrative, the timeline within the story's world differs in principle from the timeline that the movie presents to us. Filmmakers must select which scenes to present, and which to skip, and they must decide whether to present those scenes chronologically or out of order. Each selection is functional, reshaping our understanding and emotions. *Foreign Correspondent* reveals a key character's villainy before the protagonist discovers it for himself. This bit of privileged knowledge increases the suspense, heightening our awareness of Johnny's potentially fatal ignorance. *Random Harvest* skips over Paula's decision to take a position as Charles's executive assistant after he has forgotten all about her. This bit of suppressed knowledge generates one of the best surprises I have ever seen: Paula matter-of-factly steps into Charles's office and acts like she is his employee, not the great love of his life.

Where does film noir fit into this tradition of storytelling? Many scholars draw a sharp distinction between the narrative conventions of noir and the narrative conventions of Hollywood at large.[8] Whereas classical movies are orderly and optimistic, noirs are confusing, fragmented, and bleak. I prefer to make the distinction more loosely, for two reasons. First, a too-sharp line tends to overstate the strangeness of noir narrative. We should remember that plenty of noirs tell chronological stories, and a fair number of them have happy endings. Second, a too-sharp line underestimates the strangeness of Hollywood narrative beyond noir. Two books by David Bordwell bring that strangeness to the fore, greatly enriching his landmark account of how classical movies work. *Reinventing Hollywood* shows that filmmakers experimented with narrative construction in a range of genres throughout the 1940s, not just in film noir but also in comedies, musicals, and dramas. *Perplexing Plots* argues that these experiments amplified ongoing developments in the mystery genre across media, where authors had a long history of tinkering with timeline, segmentation, and point of view.[9] Noir emerged at an unusually creative time—and in a genre with a long history of exploring bold storytelling strategies.

If I hold onto the idea that noir narratives feel different, it is because so many noirs used their storytelling strategies to tell such downbeat stories. Robert Porfirio

writes, "It is the underlying mood of pessimism which undercuts any attempted happy endings and prevents the films from being the typical Hollywood escapist fare many were originally intended to be."[10] This perspective is open-ended enough to recognize that noir filmmakers continued to rely on the basic tools of Hollywood dramaturgy (protagonists, goals, and obstacles), while leaving those filmmakers ample room to deploy those tools in creative and sometimes critical ways.

Certain noir experiments still seem quite radical, even to this day. At the most unclassical end of the spectrum, a noir might examine a character who lacks a goal altogether. The canonical example is the Swede, the protagonist of the Ernest Hemingway adaptation *The Killers* (1946). Burt Lancaster's character learns that two hit men are coming to kill him, and he does nothing. His inaction—his absolute passivity—is a disquieting break from Hollywood norms. We expect the protagonist of the film to tackle a goal at the beginning of the film. Here we are at the beginning of the film, and here is the Swede, who certainly looks like a Hollywood hero. The goal of defeating the killers is staring him in the face, but he does not grab it. And so, he dies.

This situation is powerful in part because it is so exceptional—unusual by Hollywood standards, by noir standards, and even by the standards of this movie. The rest of the film is stuffed with goal-oriented characters, including Reardon, the insurance investigator who wants to solve the mystery of the Swede's death, and the Swede himself, whose doomed pursuit of love and money unfolds in flashbacks. Indeed, most noirs start out with a surprisingly conventional Hollywood template. They are about goals and obstacles. In *Murder, My Sweet* (1944), Philip Marlowe wants to solve the crime; then he encounters a series of suspects and villains. In *Undercurrent* (1946), Ann wants to figure out why her husband is acting so oddly; then she learns that he is much more dangerous than he seems. In *T-Men* (1947), Dennis wants to infiltrate a counterfeiting ring; then his partner's identity is exposed. All three deploy the basic components of Hollywood dramaturgy: the protagonist, the want, and a set of mounting obstacles.

But a more conventionally optimistic Hollywood movie would put these components together in a very particular way: with an upbeat protagonist pursuing a worthy goal. As the screenwriter Frances Marion explained, "Suspense on the part of the audience is a compound of curiosity and sympathy.... [The audience] will not experience suspense if it has no real liking for [the hero]."[11] This is where noir narrative can be truly innovative. Noir stories are often about flawed or even evil characters, adopting dubious goals. These stories dwell on a different kind of possibility—the gnawing sense that things are likely to get worse, even if the character does, in some sense, succeed. Some of the noir protagonists' goals are dubious because they are criminal, as in *Gun Crazy* (1950), about a pair of gun enthusiasts who become bank robbers. Others are dubious because they are so plainly selfish, as in *Sweet Smell of Success*, about a press agent who lies and cheats to break apart two young lovers. Still others are dubious because they are irrational, as in *Possessed* (1947), about a psychologically troubled nurse who tries to win the love of a

man who is obviously unworthy. In contrast to more conventional thrillers and romances, which make it easy to root for the protagonist's success, these movies cultivate an experience of queasy uncertainty. Should we hope that these criminals, con artists, and self-deluding souls accomplish their goals or not? Even when the characters do have worthy goals, details of dialogue and performance may make the protagonists unsympathetic, rendering it difficult to root for them wholeheartedly. In *The Maltese Falcon*, Sam Spade wants to solve the murder of his partner. That seems like a worthy goal in a mystery film, but Spade accomplishes this goal by lying, bullying, scheming, and double-crossing; he eventually resolves the mystery plot by betraying the woman he loves.

Gender shapes these patterns in complicated ways. In a classic essay, Elizabeth Cowie has warned against "the tendency to characterize film noir as always a masculine film form."[12] She points out that women wrote the source material and/or the screenplays for many classic noirs, and she argues that some films that might initially be classified as women's films or melodramas employ the familiar tropes of noir, such as investigation, obsession, duplicity, and chance. For instance, Cowie notes that *High Wall* (1947) features a female psychiatrist who investigates a man's mental illness, that *Nora Prentiss* (1947) has an honorable title character who tries to help a very flawed man, and that *Born to Kill* (1947) is about a woman who is "uncontrollably drawn to a psychopathic man."[13] Extending Cowie's line of research, the noir scholar Philippa Gates has found "at least twenty noir films with women in various roles as detectives."[14] Unlike the stock characters of the loyal girlfriend and the femme fatale, these women investigators can enjoy moments of independence without suffering punishment. Other noirs combine action plots with the emotional appeal of the traditional women's film melodrama, as in *Woman on the Run* (1950). For much of the film, Ann Sheridan's Eleanor is the protagonist of an action-driven story, tracking down her estranged husband so she can warn him that a killer and the police are both searching for him. But the more she remembers her lost love for her husband, the more passive she gets. In the climactic scene, she is completely powerless, stuck in a roller coaster while the killer confronts her husband below. Her action plot has become a pathos plot.[15]

Early noir scholarship emphasized how the figure of the femme fatale deprives the male protagonist of agency, as in *Double Indemnity* or *The Lady from Shanghai*.[16] But revisionist scholars have argued that the role of the femme fatale is sometimes overstated and often misunderstood.[17] Angela Martin has studied eighty noirs with central female characters and found that only eight of them feature femmes fatales in the canonical sense.[18] And Julie Grossman has argued, quite convincingly, that the very idea of the femme fatale can cause viewers and scholars to misread several key films. Too often, critics rhapsodize about dangerous femmes fatales even when the movies present the women in question as complex, ambivalent, or wholly sympathetic figures. *The Postman Always Rings Twice* (1946) is a case in point. Lana Turner's character, Cora, does indeed join the plot to murder her husband, but that does not make her a femme fatale in the conventional sense. As Grossman

explains, "Cora is shown by the film to be desperately confined and victimized by the limitations imposed on her desires and her ambition by the enforcement of conventional domesticity."[19] Rather than see Cora as a character who becomes an obstacle to Frank's goals, we might see her as a protagonist in her own right, struggling within socially defined limits.

Whether male or female, noir protagonists differ from more conventional characters in another way: they seem doomed to fail. Think of Doc facing a string of bad luck in *The Asphalt Jungle*. In place of tight causality there is often outrageous coincidence. In *Detour* (1945), Al picks up a woman who is hitchhiking, and she just happens to be the one person who can recognize he has taken a dead man's car; in *Dark Passage* (1947), a man who has changed his identity keeps bumping into people who might know him, to the point that the world seems like a manifestation of his paranoia.[20] Such doom-laden scenarios disrupt Hollywood's mechanism of hope and fear, producing something more like dread.

In some cases, noir's sense of doom is simply evidence of the Production Code Administration doing its work. Studio-era filmmakers understood that they could represent crimes only if the criminals were punished before the end of the film, so they often punished them in the final reel to please the censors.[21] But the noir idea that failure is inevitable may run more deeply than the Code would require, expressing a worldview that can be described as fatalistic. Such fatalism problematizes the structure of goal orientation—but only partly. The philosopher Robert Pippin explains the tension well. On the one hand, film noir offers a fatalistic vision of a world that is "not wedded to the notions of reflective individuals formulating plans for avowed purposes and then enacting causal powers to effect them." On the other hand, the characters who live in this world "still have to continue to live or lead a life, in some sense to plan and decide."[22] Rather than represent characters who have no goals at all, noirs tell stories about characters who pursue goals even if they believe that doing so is in some ways pointless. In *Out of the Past* (1947), Jeff makes dozens of strategic decisions along the way as he tries to evade the traps that Kathie and Whit have set for him, but he often seems disinterested, and he eventually makes the choice to go away with Kathie even though he must know that this choice will kill them both. In other noirs, the danger is not fate at all. It is a social cause, a cultural shift, or a diagnosable mental illness. Gaylyn Studlar situates several noirs within a wartime/postwar culture that was bracing for the impact of traumatized men returning from the war.[23] These worries inspired stories about men who cannot control their violent impulses, as in the police thriller *On Dangerous Ground* (1952).

Most Hollywood movies combine an action plot with a heterosexual romance plot. Several noirs can be quite conventional in this respect: *Phantom Lady* ends with a quirky marriage proposal; *Murder, My Sweet* ends with a comedic kiss; *Ministry of Fear* (1944) ends with a joke about a wedding cake. But many noirs undercut their romance plots in various ways, to the point that the happy endings can seem ludicrous. The classic example is *Gilda*. As Andrew Britton explains, the film

at its best criticizes its protagonist Johnny, who is shown to be disturbingly similar to the villain Ballin in his desire to control and degrade Gilda. Alas, the movie reneges "in the last ten minutes on everything it has done in the first hundred," suggesting absurdly that Gilda can be happy with Johnny after all.[24] Other movies are more consistent, delivering the unhappy endings that they have promised all along. *The Strange Love of Martha Ivers* (1946) ends in death, as the title character carefully helps her husband fire the gun that he is pointing at her. *Kiss Me Deadly* (1955) ends in catastrophe, as a box full of nuclear material explodes.

So far, I have described storytelling tactics that operate at the level of the *story*. Many noirs also experiment at the level of the *telling*: how the story gets revealed to spectators. In a respected study, J. P. Telotte has analyzed several narrative techniques associated with noir, such as flashbacks, voice-overs, and the representation of character subjectivity.[25] Classic examples include *Brute Force* (1947), which provides a separate flashback for several major characters; *Sunset Blvd.* (1950), with cynical narration from a floating corpse; and *Lady in the Lake* (1947), which uses point-of-view shots to mimic the first-person perspective of Raymond Chandler's novel. None of these techniques was exclusive to noir. As Bordwell reminds us, similar experiments appeared in *Kitty Foyle* (1940, a Ginger Rogers vehicle), *The Human Comedy* (1943, a sentimental home-front picture), *Unfaithfully Yours* (1948, an abrasive comedy), and *A Letter to Three Wives* (1949, an Oscar-winning satirical drama).[26] Noir took existing techniques and infused them with bitterness and dread.

The very idea of doom raises a narratological problem for my account. I have argued that Hollywood movies benefit from a sense of openness, and that suspense arises from the sense that the protagonist might succeed or fail. It could be argued that noir stories, with their flashbacks and fatalism, demolish the more open-ended model of narrative that I have been advocating, where a sense of possibility drives engagement. Is it not the case that noir's overriding mood of doom closes down all sense of possibility? I say no, for several reasons. First, we should remember that plenty of noirs are not achronological. The cycle includes several conventionally structured action movies, mysteries, and romances. Second, a movie may introduce the theme of fatalism only to criticize it. Characters blame fate to avoid blaming themselves. For Elisabeth Bronfen, some of the most famous noirs draw a contrast between a self-deluding man who abdicates personal responsibility and a woman who enjoys greater self-determination (even if it is only the determination to allow the man to fall prey to his delusions).[27] Third, noir balances its gloomy mood with a kind of playfulness. As Deborah Thomas explains, "Noir's play with language and narration is a major source of its pleasure."[28] A viewer might experience a complex flashback structure not as the march of doom but as a series of delightful storytelling surprises.

Fourth, and most important, it is simply a narratological mistake to assume that knowing the ending in advance makes it impossible to imagine or understand that the chain of events *could* have ended differently. (I can tell you a story about

how I burned my dinner yesterday, and the point of the story may be that I made several avoidable mistakes along the way, not that I was eternally fated to ruin the meal. The point remains the same whether I begin the story with the burning or not.) The narrative theorist Marie-Laure Ryan argues that a tellable story is one that situates its actual events within a wide range of *virtual* events, a field opened up by the characters' goals, beliefs, and misperceptions.[29] I have long found Ryan's idea to be a game-changing insight about narrative structure, one that pushes us to locate a movie's linear chain of events within a nonlinear array of possibilities, some realized, some not. On this account, a story may reveal its ending in advance and still juxtapose the actual ending with the virtual outcomes that characters wanted, expected, doubted, or feared along the way. Indeed, some of noir's bleakest stories increase their emotional power by appealing to the logic of the counterfactual: if only Tom had not picked up Vera in *Detour*, or if only Joe had not suffered a blown-out tire outside Norma Desmond's house in *Sunset Blvd*.[30] If these movies are bitter or depressing, it is because they implicitly contrast the dismal ending that does happen with some hypothetical alternative that could have happened but did not.

Indeed, an overemphasis on fatalism can lead us to overlook an important fact: most noirs remain taut with suspense, even when they unfold in flashback. An artfully constructed flashback can still generate suspenseful uncertainty if it reveals its details carefully enough. *Double Indemnity* was based on a novel by the hardboiled author James M. Cain; director Billy Wilder cowrote the screenplay with Raymond Chandler. The protagonist Walter is, in some sense, a classical protagonist: a man with goals that are clearly defined (albeit dubious). He wants to commit the murder and defraud the insurance company so he can be together with Phyllis. These goals neatly tie together the film's action plot and its romance plot. The flashback structure actually sharpens the goal-oriented framework that organizes the drama. There are exactly five flashbacks in the film, and each one corresponds to a distinct stage in Walter's progression:

1. Routine and disruption. Walter is having a normal working day when Phyllis obliquely pitches a murder plot to him.
2. Locking the conflict. Walter agrees to commit the murder.
3. Overcoming obstacles and approaching success. With Phyllis's help, Walter commits the murder without any obvious slip-ups.
4. Inversion: the plan fails. Walter tells Phyllis that they must withdraw their claim because Keyes is getting too close.
5. Reformulation of the goal leading to a final conclusion. Walter tries to pin the murders on Phyllis and Nino, but fails.

With five flashbacks for five stages in a narrative progression, *Double Indemnity* lets Walter's goal orientation stand out in relief, with all its ups, downs, twists, and turns. The movie is so well structured that contemporary screenwriting

instructors point to this film and others by Billy Wilder as models of well-crafted stories.[31]

But *Double Indemnity* also takes this tightly structured plot and darkens the tone, producing an unusual set of emotional effects. Walter may be played by the likable Fred MacMurray, but he is still a cold-blooded killer, and he generates an ambivalent sort of suspense, asking us to hope for outcomes we would probably reject in everyday life.[32] Walter starts out rather goalless (as it is Phyllis who wants him to commit the murder), but then he gets overly obsessed with his goal (as he is so determined to outwit Keyes that he loses interest in Phyllis), and then he ends up acting against his own self-interest (as he wastes valuable time confessing to Keyes before attempting a half-hearted escape). Several times, characters utter the words "straight down the line," and the motif rebukes the very ideal of goal orientation. Committing to a goal is exactly what leads Walter and Phyllis to the cemetery. All along, we know that Walter is going to fail at both his goals: "I killed him for money and for a woman. I didn't get the money, and I didn't get the woman." Far from making the conclusion seem like it was the only thing that *could* have happened, Walter's admission makes the tale's counterfactual appeals more salient. Because we know that Walter will fail, we are encouraged to scrutinize his behavior, spotting the moments when he could have done something differently. Walter emerges as a man who likes to blame outside forces—fate, luck, and Phyllis—when in fact the responsibility for his crime rests with him, no more so than when he shoots Phyllis in cold blood seconds after she has spared his life.

LIGHTING AND TIME

Let us bring lighting back to the account. How might a film's lighting support a dramatic story—particularly, a story that unfolds according to the temporal logic I have sketched here? In an earlier book about Hollywood lighting, I explained that studio-era cinematographers justified their craft in functional terms—that is, in terms of glamour, realism, or storytelling.[33] And I argued that the *storytelling* function involved four distinct subfunctions: characterization, mood, the denotation of time and place, and the control of the spectator's attention. While I still find this list useful, I have revised my thinking. None of these four subfunctions is necessarily a storytelling function.[34] Why not? Because none of these subfunctions is necessarily temporal, and storytelling must involve some sort of temporal effect, such as wondering what happens next or developing sympathy for a character over time. The fact is that lighting may perform any one of these tasks (denotation, attention, characterization, and mood) in a painting, even when the painting in question is nonnarrative, with no story to tell. (Of course, paintings can tell stories, too, but at least some of them are nonnarrative.) In a painting of an empty room, lighting may *denote* that the room has a candle in it. The skillful rendering of candlelight's appearance may be the point of the painting. In a still-life painting of

a bowl of vegetables, lighting may draw *attention* to a perfectly goalless onion resting on the edge of the bowl. In a portrait of an old woman, lighting may enhance *characterization* by modeling the subject's eyes and wrinkles, emphasizing her disposition without telling a story. In a landscape painting of a mountain, lighting may convey a somber *mood*—not to set the stage for an unfolding story but to capture its general atmosphere or feeling. Storytelling, in a painting or a movie, comes into play when the images produce temporal effects: the sense that something is happening or will happen or has happened or might happen, with attendant feelings of surprise, suspense, hope, uncertainty, delight, or dread.

On my new account, a narrative image solicits a particular kind of temporal experience, one that is simultaneously focused on the represented moment *and* some other time. As we look at a narrative image (whether a painting, photograph, or movie), we may start by appreciating its nuanced rendering of detail, but we must also do something more, viewing *this* moment in relation to some other moment. This other moment could be from the past or the future, or it could be entirely virtual: something that might happen or something that a character wants to happen. The philosopher Paul Ricoeur has argued that narrative produces the experience of a *threefold present*, whereby our attention to the present moment is infused with a sense of memory and expectation.[35] I count an image as narrative whenever it produces such a multifold present. And I count lighting as a narrative technique whenever it does the same, soliciting our attention to the present moment while also pointing outward to some other time, including the virtual timelines of what might happen next or might have happened instead. To take an example from the history of art, Artemisia Gentileschi's *Judith and Her Maidservant with the Head of Holofernes* (1623–1625) depicts a moment just after the heroic Judith has severed the head of the enemy general Holofernes.[36] Even though the image depicts a single moment in time, it counts as a richly narrative painting on my account because it produces that experience of the threefold present. Our understanding of the unseen past (Judith's courageous action) and our expectation about the possible future (her impending escape) infuse this image before us with significance and emotion. Building on the tradition of Caravaggio, Gentileschi's lighting combines pictorial and narrative appeal. On the one hand, the lighting has a sensory appeal all on its own. Judith holds a hand over the candle, which casts a shadow over her face. The light from the left models the folds in Judith's dress and the clenched muscles in her hand. These textural effects would be fascinating to look at even if we set the story aside. But there is no need to set the story aside. As art historian Elena Ciletti explains, the candlelight creates a "powerful sense of suspense," reminding us that Judith and her maid are trying to remain in the dark so they can make their escape.[37] Because the shadow does not cover Judith's entire face, we can still appreciate her calm demeanor, which seems all the more heroic given what she has just done and the situation she is in. It is by rendering the details of *this* moment that Gentileschi appeals to our understanding of other times and events: an unseen past and a possible future.

If lighting can produce such powerful narrative effects in a painting, then it certainly can do the same in a movie, which has the additional storytelling advantage of unfolding over time. Imagine a cinematographer who has been given a simple depictive task: a shot of a character standing next to a door. The cinematographer might use figure lighting to model the character's features, while rendering the doorway with terrific precision. The result might be beautiful and well-observed. Now imagine a cinematographer who has been given the additional task of telling a story. The script again calls for a shot of a character standing next to a door—but then the script adds that this is a character who plans to escape, for this building is a prison. Technically, the cinematographer might do exactly the same thing, modeling the character's features and rendering the doorway with shadow. But the effect in the finished film will be different, for now the shot has been charged with emotion, a feeling of suspense as the character's fate hangs in the balance. The shot may still be beautiful, well-observed, even painterly. The story has not taken any of that away. It has added something new: a sense of drama. I think of these temporal effects as a kind of charge or infusion. The timeline charges the image before us with memories and expectations, enriching its emotional appeal.

We can see this complex process of infusion at work in a crucial scene from Sam Fuller's *Pickup on South Street* (1953). The communist agent Joey is preparing to kill Moe, an old woman who supplements her meager income from selling ties by working as a stool pigeon for the police. Played by the incomparable Thelma Ritter, Moe lives in a cramped apartment, which is illuminated by a cheap little lamp attached to her bed's metal headboard. The cinematographer Joe MacDonald organizes light and shadow to create a picture of Moe in her room. The set's decor features a practical lamp attached to the bed frame. An overhead key light mimics the appearance of that practical lamp, and some weak fill light preserves the impression of darkness while adding detail to the shadows (figure 2.1).[38]

As in a good painting, the picture gives us the world at a glance: Moe with wrinkles on her forehead and circles under her eyes, the nightstand with a record player sitting on a small lace tablecloth, the lamp hanging above Moe's head and illuminating the ties hanging behind her. The narrative charges the image with additional emotion by situating this moment—what we see right now—within a timeline. By this point in the story, we know a lot about Moe. She is a stool pigeon who has earned the grudging respect of the pickpockets she betrays. She works hard, but she is still desperately poor—so poor that she fears she will be buried in a potter's field without the benefit of a funeral. When we see Moe sitting in semi-darkness under that cheap little pinup lamp, we can see that she is still too poor to pay for her funeral, which makes her death at the hands of the cowardly Joey even more of an outrage. The depiction carries this extra emotional impact because it fits into an arc: a pattern that has unfolded in time. This is not just an image of Moe but an image of the *end* of Moe, and not the end she was hoping for.

Compare the mood of this scene with the moment in *Call Northside 777* when McNeal finds Wanda Siskovich in her apartment, as discussed in chapter 1. The

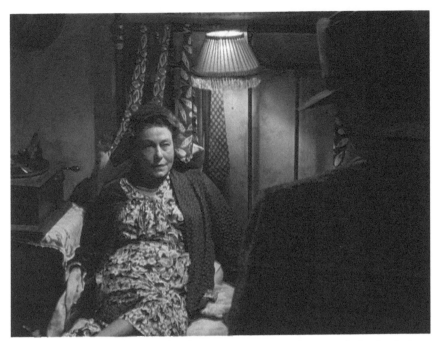

FIGURE 2.1. *Pickup on South Street* (1953): Moe lies under a tiny lamp attached to her bed frame.

cinematographer Joe MacDonald photographed both films, and he lights both women by mimicking the appearance of a tiny lamp pinned to the bedpost. The images look alike, but they feel very different because they appear at different points in the films' dramatic arcs. *Call Northside 777* presents Siskovich unsympathetically; her intransigence has kept an innocent man in jail. The squalor of her apartment is made to seem like a cruel but deserved punishment. By contrast, *Pickup on South Street* has treated Moe much more warmly, and it uses the image of her dimly lit apartment to generate tremendous sympathy for her character as her life ends.

Moe's killer, Joey, is standing in the same room, but he looks subtly different. MacDonald keys actor Richard Kiley from below; the weak fill light adds a tiny glimmer to each eye (figure 2.2). We may find symbolism in the details, perhaps letting the light from below hint that he is some kind of devil. But the lighting need not evoke this symbol—or any symbol—to be effective. With painterly care, the image shows us who stands where, and that is enough. We see at a glance that Joey is positioned *higher* than Moe because she is lit from above and he is lit from below. We see at a glance that Joey is positioned *close* to Moe because the illuminated side of his face is bright, putting him close to Moe's lamp. We see at a glance that Joey is *staring* at Moe because the glimmer in his eyes rivets our attention on his unblinking stare. And we see at a glance that Joey is *nervous* because the key

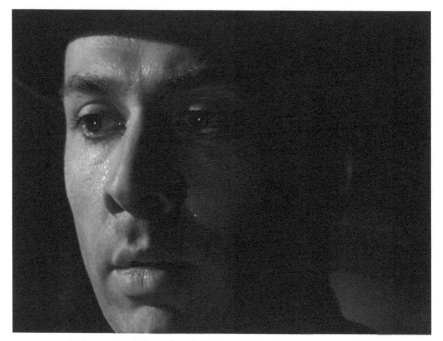

FIGURE 2.2. *Pickup on South Street* (1953): Lit from below, Joey prepares to kill Moe.

light and the fill light create additional glimmers of light in the beads of sweat covering his face. All symbolism aside, the literal meaning is chilling enough: Joey is just a few feet away from Moe, and he is getting up the nerve to kill her. The temporal configuration charges the image with meaning: the sense that Joey is on the verge of doing the worst thing he could do.

Throughout this discussion, I have been tempted to use the word *description* as a synonym for painterly depiction. In a meaningful sense of the word, light helps the cinematographer describe the space, the way a novelist describes a room.[39] But the word requires clarification. Narrative theorists often contrast *description* and *narration* to account for those passages where the narrator *halts* story time to describe a particular place.[40] In an early article on narrative theory, Seymour Chatman argued that the cinematic image is inevitably narrative, on the grounds that the moving image depicts change, and change is a quintessentially narrative subject.[41] In a later book, Chatman argued on the contrary that the cinematic image is inevitably descriptive, on the grounds that it renders the sensory details of its subjects with exceptional precision, even when those details are of little consequence to the primary chain of events.[42] Oddly, I think Chatman got it right both times: a moving image can do both sorts of tasks, narration and description, at once. Cinematographers tell the story by working *through* depiction.

When a Hollywood cinematographer shows up to the studio on any given day, the most immediate problems are often depictive, similar to the problems faced by

painters and portrait photographers. How do I render the character's cheekbones? How do I make the table look solid and three-dimensional? How do I mimic the appearance of sunlight streaming through the window? These are all depictive tasks, more concerned with getting the look of things just right than with spinning a story. But it is precisely by accomplishing these depictive tasks that the cinematographer renders the world of the film, a world that becomes enmeshed in the play of attention, memory, and expectation that is the heart of storytelling. As I watch *Pickup on South Street*, I see depictions of its storyworld, which carry considerable pictorial appeal. Now I see Moe lying sadly on her bed, and now I see Joey looking down toward her. (More precisely, I see pictures of Moe and Joey; I see Moe and Joey *in* the pictures.)[43] However appealing individually, the images do not halt time. They become part of the unfolding film, accumulating layers of memory and expectation: memories of Moe's past because I recognize that she is coming to the *end* of her story, and expectations for the immediate future because I recognize that Joey's villainy is about to reach a new *low*.

These temporal emotions do not cancel out the depiction's more immediate appeals. We may enjoy a film's milieu—its evocation of a historically specific time and place—even if we are bored by a film's story. But if the story does work, then we can get involved in the narrative and appreciate the evocation of the character's milieu simultaneously. Even better: we can get more deeply involved in the narrative *by* appreciating the evocation of the character's milieu. As *Pickup*'s director, Sam Fuller, remarked, "How could you tell a story about petty thieves, informers, and spy rings without a realistic portrayal of their dilapidated, predatory world?"[44] The better the lighting, the more the image evokes an atmosphere of poverty and despair. The more the image creates an atmosphere of poverty and despair, the stronger the impression of tragedy as Moe dies without the money to pay for the funeral she has wanted for so long.

My account defends the narrative significance of lighting, but it does so in a rather peculiar way. There is a long tradition of defining narrative as the representation of an action.[45] With that tradition in mind, we might expect lighting to carry its greatest narrative force whenever it enters the chain of actions, as when a character hides in the shadows. However, I want to keep the idea of light-as-action at a distance for two reasons, one related to the theory of narrative in general, another related to the practice of lighting in particular. First, I follow Meir Sternberg in preferring a functionalist model of narrative to an objectivist model. An objectivist model typically defines a narrative in terms of the underlying structure of stories, for instance, by saying that a story must have an event or an action or two events connected by causality. By contrast, Sternberg defines a narrative in terms of its designed effects—specifically, in terms of its temporal effects of prospection (looking ahead), retrospection (looking back), and the related emotions of suspense, curiosity, and surprise.[46] It is not necessary for a particular device, such as lighting, to *be* an action, or even to illuminate an action, to qualify as a narrative technique. What counts is its means-end functioning. If the lighting

is designed to shape our temporal experience, then it qualifies as a narrative technique.

The second reason I am putting qualifications around the idea of light-as-action is more specific to cinematic lighting in studio-era Hollywood. An insistence on action might lead to an overemphasis on certain kinds of examples: scenes where the characters *use* the light to further their goals. These scenes exist, and they can be marvelous, but they are comparatively rare. For instance, in *The Night of the Hunter* (1955), Lillian Gish's character is staying up late on the porch one night to keep an eye on the film's villain, an evil preacher. A child steps onto the porch carrying a lamp, and suddenly the porch screen looks opaque, not transparent. The preacher sees an opportunity to make his move, and the climactic showdown begins. If someone asked you to summarize the story, you would need to mention the lighting; it is undeniably a part of the chain of actions when the illumination lets the preacher slip out of view. And yet my intuition is that scenes like this are the exception, not the rule. The scene in *Pickup on South Street* seems more typical. Joey does not kill Moe with a light bulb, and Moe does not try to hide in the shadows. If someone asked you to summarize the action, you could do a perfectly good job without mentioning the lighting at all. The lighting still does narrative work—because it deepens the emotional impact of this turning-point scene.

Instead of asking, "How does the lighting advance the action?," I prefer to phrase the question in functional terms: "How does the lighting contribute to (or benefit from) the play of attention, expectation, and memory that is the heart of narrative engagement?" In *Pickup on South Street*, the dimness and grimness teach us about Moe's life, letting us understand that life more deeply just before her death. Pushing the idea farther, I would count an atmospheric scene as a bit of successful storytelling even when it depicts *no* action at all. Suppose we are watching a scene of a man sitting alone in a room. If we have reason to believe that the man is a murderer (perhaps because the character is lit ominously), then this scene may generate feelings of dread as we fear what the character is about to do. My theory of narrative as an unfolding arc with dramatic effects is expansive enough to include seemingly uneventful scenes such as this, as long as they are charged with temporal emotions such as suspense, hope, and fear. Indeed, we could reduce the scene's causal consequences to zero. Perhaps we later learn that we have been misled; this character is not a murderer at all. The scene will have engaged our expectations and memories nonetheless. We follow a story even when its emplotment leads us down false paths.[47]

If this example seems overly hypothetical, here is a more concrete example from an undisputed master of film noir. In his textbook *Painting with Light* (originally published in 1949), John Alton explains how lighting can work on our emotions, and he sketches this scenario: "To realize the power of light and what it can do to the mind of the audience, visualize the following little scene. The room is dark. A strong streak of light sneaks in from the hall under the door. The sound of steps is heard. The shadows of two feet divide the light streak. A brief silence follows.

There is suspense in the air. Who is it? What is going to happen? Is he going to ring the bell? Or just insert a key and try to come in?"[48] Alton stretches his tale for several more sentences, only to give his story a flagrantly anticlimactic ending: the mysterious figure is a hotel manager asking someone to turn down the radio. This anticlimactic ending actually clinches Alton's argument. Lighting can make something dramatic out of purely virtual events: what might happen. In no way is Alton saying that the cinematographer should ignore the story and paint abstract pictures. Quite the contrary; he is championing the narrative power of lighting by showing how lighting can manipulate temporal experience even when the story has very little action at all.

Alton's hypothetical example seems canonically noir, with those streaks of light piercing the darkness. But lighting can contribute to the suspense even when it is glaringly bright. Consider a suspenseful scene from Ida Lupino's *The Hitch-Hiker*. Lupino and her producer Collier Young associated their movie with the semidocumentary trend that came to prominence in the late 1940s, and the movie combines shadowy noir with sunlit location work.[49] In one scene, the sadistic hitchhiker Emmett tells Roy (Edmond O'Brien) to place a can on some nearby rocks, and then he hands Gil (Frank Lovejoy) a rifle and forces him at gunpoint to take a shot at the can. Emmett is acting like a black-hatted villain in a Western, and the movie looks, for the moment, very much like a Western.

Rather than enshroud the space in artificial darkness, Lupino has opted for the heightened clarity of deep focus. The bright sunlight makes it relatively easy for the cinematographer Nick Musuraca to achieve razor-sharp depth of field. One lamp is illuminating both men from offscreen right. Another lamp (or possibly a reflector) provides the fill on both their faces. And a third light source (most likely the sun itself) provides the kicker, a bright light coming in from the back-left (figure 2.3). That kicker is doing amazing work. Look at how it highlights the barrel of the rifle, the wedding band on Gil's near hand, the tense muscles in Gil's far hand, the beads of sweat on Gil's forehead, the gun in Emmett's hand, and the shine of Emmett's leather jacket. All these objects are charged with emotional significance, grounded in memory and expectation. The two guns generate short-term suspense. The beads of sweat amplify that suspense by making it more likely that Gil will fail. The ring reminds us that the sympathetic Gil has a family, and that he was once a bit too grateful to have a break from them. The ring also sets up a future plot point: Gil will leave it behind as a clue. The leather jacket serves the immediate purpose of distinguishing Emmett from the other two men; it also sets up the moment, nearly an hour later, when Emmett forces Roy to wear the same jacket in the climactic scene. Best of all, the clarity of the lighting lets us appreciate the characters' facial expressions right now, at this very moment. Look at how the kicker highlights a wrinkle on Gil's forehead. And look at how it outlines Emmett's arched eyebrow, so expressive of this man's contempt for everyone around him. Lauren Rabinovitz has argued that the film's underlying theme is the "cultural crisis in masculinity."[50] This shot makes that crisis visible, in the contrast between

FIGURE 2.3. *The Hitch-Hiker* (1953): In broad daylight, Emmett forces Gil to aim at Roy, offscreen.

one man's worried forehead and another man's contemptuous eyebrow. By letting us see all these emotionally charged details, the blindingly bright lighting ends up being deeply suspenseful.

WHAT TIME IS IT?

The rest of this chapter focuses more squarely on a set of tasks that are common to all Hollywood films: the representation of time. We can divide this set of tasks into three distinct clusters. At the most immediate level, a cinematographer must represent the time of the *shot*—whether it is day or night, and whether it is the 1940s or some other historical period. At a somewhat broader level, a cinematographer may use lighting to shape the progression of a *scene*. A shift in lighting can mark a turning point or prepare us for the end of an event. More broadly still, a cinematographer may design the lighting to chart the dramatic progression of the *movie* as a whole, as when a movie's imagery gradually grows darker over time.

To represent time of day, studio cinematographers could draw on a familiar repertoire of shared conventions. As a 1949 article in *American Cinematographer* explained: "The establishment of the basic source is usually quite simple. For a daylight exterior sequence, the source would naturally be the sun. For a similar situation staged at night, the source would be the moon. For a daylight interior, the source would be the sun's rays reflected through windows and doors. For a

 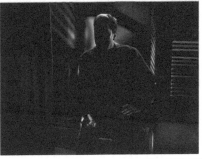

FIGURE 2.4. *Cornered* (1945): The lighting establishes the time of day, but not down to the minute. *A (left)*: Generic daytime. *B (right)*: Generic nighttime.

night interior, the basic source could be a lamp, chandelier, open fireplace, etc."[51] On this logic, most scenes can be sorted into four categories: daylight interior, daylight exterior, nighttime interior, nighttime exterior. Hollywood screenwriters typically provided this information in bold type in their screenplays, and a cinematographer could look for the bold type and know what sort of lighting to deploy. Figure 2.4 shows the basic convention at work in the Buenos Aires–set thriller *Cornered* (1945): day versus night, both visible at a glance based on the light coming through the blinds.

The cinematographer Harry Wild was a noir specialist at RKO. He was probably not as talented as his colleague Nick Musuraca, but he had command of all the basic tools. Here, he makes each shot instantly readable via the control of *angle* and *tonality*. In figure 2.4A, the light is angled downward, suggesting sunlight. The general illumination is bright, producing a high overall tonality or key: there are a few whites, a lot of grays, and no true blacks. In figure 2.4B, the light is angled upward, suggesting a streetlamp. The overall tonality or key is much darker: there are a lot of blacks and near blacks, a few midtones, and just two highlights, including the little glint on the gun.

One of the striking things about the conventions of lighting for day or night is that they could be quite generalized in their effect. In daytime shots, there is usually no attempt to render the look of noon or 8:16 in the morning or seven minutes before sunset. The lighting tells us it is daytime, and that is all. In nighttime shots, there may be no attempt to render the look of late evening, midnight, or 4:42 in the morning. The lighting tells us it is nighttime, and that is all. We can imagine some alternative practice whereby cinematographers took all the relevant details into account (time of day, season, weather, geographic latitude) and calculated the exact angle of the sunlight streaming through the window. And we can imagine some alternative viewing practice whereby spectators learned to notice the precise angle of the sunlight and conclude, "It looks like this scene takes place at 3:30 in the afternoon." Instead, studio-era conventions were much more schematic.

Whether morning, noon, or evening, summer, spring, winter, or fall, Northern Hemisphere or Southern Hemisphere, the solution was often thé same. Want daylight? Cast a light through the window and make the angle look slightly downward. Want nighttime? Cast a light through the window and reduce the general illumination. The conventions were so routinized that they allowed blatant inconsistencies to pass by unquestioned. A character might enter a room with sunlight streaming in from left to right. Then the film might cut to the reverse angle, and suddenly sunlight will be streaming in from an entirely different direction.

This generality suggests a tension at the heart of the pictorial storytelling ideal. As picture makers, ambitious cinematographers may have wanted to render the nuances of time and space with the attention to detail of a great painter. As storytellers working in a studio system, they needed to get information across quickly. Since the exact time of day was rarely important to the narrative, the most efficient solution was usually to set the lamp at a standard height and blast it through the window. As long as the shot tells us it is day or night, it works, even if the image lacks pictorial nuance.

These generalized conventions could still be refined when the scene demanded it. In the supernatural thriller *The Uninvited* (1944), the characters visit an upstairs room just after the sun has gone down, and the cinematographer Charles Lang uses a silhouette effect to suggest the dying light of the magic hour. In so doing, he renders light's appearance with painterly care while situating the moment within an ongoing timeline. I have chided Wild for the conventionality of his daytime lighting in *Cornered*, but his nighttime shot from the same film (figure 2.4B) is nuanced and effective. The scene takes place very late at night—not just at any time, but late, in a bar that closed hours ago, in a neighborhood that is now nearly devoid of people. Wild's extraordinarily dim lighting renders the moment perfectly. No, we cannot specify the time down to the minute, but we can see at a glance that it is the dead of night. The best noir cinematographers excel at these sorts of nuances, using the windows to suggest an entire world outside: a world of blinking lights or a world of moonlight, a world that is abustle at rush hour or a world that is asleep before sunrise.

Both of these images from *Cornered* represent time in another way, revealing the historical period of the story. Take another look at the daytime shot from *Cornered*. At a glance, we can tell that the scene is set in the twentieth century. There are many clues that give it away: the lamp, the chair, Dick Powell's suit, maybe his haircut. The venetian blinds provide another clue. The shadow they cast is so sharp and straight that the blinds must be modern, machine-made. By contrast, the blinds in the nighttime scene seem rougher and more old-fashioned, suitable for an older neighborhood in Buenos Aires, or at least an older neighborhood in Buenos Aires as Hollywood might conceive it. Hollywood cinematographers had many tools for representing historical time, and they were just as routinized as the tools for representing day and night. Working in close collaboration with the set decorator, a

cinematographer might set the scene under an electric light bulb, or by gaslight, or by a flickering candle. The first option would set the scene in the twentieth century; the second, in the nineteenth; the third, in a much wider range of times and places.

BEAT BY BEAT

Let us add another layer of temporality, moving from the charged moment to the unfolding scene. In the night scene from *Cornered*, the villain Jarnac delivers a speech while standing in the shadows for nearly four minutes. The darkness builds up tremendous suspense: we must wait and wait and wait for the evil man's face to be revealed at last. (At one point, Jarnac lights a cigarette, and we are given a brief glimpse of his face, but then the match goes out, and the suspense returns, even stronger than before.) The darkness is so insistent that it becomes a symbol, an expression of the film's themes. *Cornered* was directed by Edward Dmytryk and produced by Adrian Scott, with a story by John Wexley. All three were Hollywood leftists who would suffer the blacklist a few years later, and the movie was a timely warning about the ongoing need to confront fascism even after the war had ended.[52] Jarnac's monologue is about the future of fascism: he and his fellow fascists plan to remain obscure for five years or more, but then they will come back out into the open. The image of Jarnac, standing calmly in the shadows, comes to stand in for the evil of fascism, hiding, but ever present. When Jarnac finally steps into the light, the moment is all the more chilling because its significance has been growing for so long.

In a dramatic art, smart staging can create a before-and-after logic that sharpens the structure of the scene. These shifts may be symbolic, but they often emerge from characters' choices. A character may move from point A to point B for many reasons: to hide, to discover, to avoid, to attack, to retreat, to seduce. Lighting may support the scene simply by letting us see the space more easily, giving us a more vivid sense of who stands where—and of who moves when.

Consider a three-minute scene from *Human Desire* (1954). This film by Fritz Lang was an adaptation of Émile Zola's naturalist novel *La bête humaine*, previously filmed by Jean Renoir in 1938. Gloria Grahame plays Vicki, who is trapped in a marriage with her menacing husband, Carl. In one key scene, Vicki tells her lover Jeff about the increasing threat of Carl. The scene offers a classic noir scenario—a woman induces a flawed man to murder her husband. Some filmmakers might have staged the scene as a dangerous seduction, using the lighting to heighten Vicki's glamorous appeal. But Lang's staging of the scene strikes a different tone; there is no sense that Vicki is unspeakably malevolent. Instead, the scene as filmed evokes the idea of an ordinary woman struggling to get out of an impossible situation. Grahame's nuanced performance skillfully conveys multiple aspects of Vicki's character.[53] Vicki is playing a role to win Jeff's sympathy, but her role is grounded in reality, as Vicki has every reason to fear the abusive Carl. (Indeed,

Carl will kill her in the end.) The lighting enhances Grahame's interpretation, favoring plausibility over ostentatious glamour.

Working with the cinematographer Burnett Guffey, Lang has made the crucial decision to stage the scene across adjacent rooms. The characters stand in the unlit foreground room, where they are illuminated by some small lamps in the room beyond. For much of his career at Columbia, Guffey favored midrange tonalities in lighting; his chiaroscuro is usually less extreme than, say, John Alton's.[54] Here his lighting divides the foreground room into three distinct zones: a zone by the doorway, where the characters receive bright light from the back room; a zone farther from the doorway, where a narrower beam of light barely hits their faces; and a zone in the vestibule, where the characters appear in near-total darkness. These three zones create a number of different pictorial possibilities, each one a variation on the theme of two people standing in a half-lit space.

Put Vicki in the large doorway and Jeff in the vestibule, and you get *partial* lighting on Vicki and dim *gray* lighting on Jeff (figure 2.5A). Move Jeff to the doorway, and you get *backlighting* on both characters (figure 2.5B). Move Vicki to the center

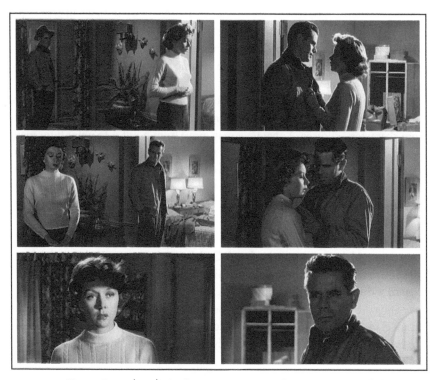

FIGURE 2.5. *Human Desire* (1954): As the scene progresses, the actors move to different marks. *A (top left)*: Only Vicki is in the light. *B (top right)*: Both are backlit. *C (center left)*: Jeff is closer to the light. *D (center right)*: Vicki's face is lit. *E (bottom left)*: Vicki turns toward the light. *F (bottom right)*: Jeff's face is in shadow.

of the foreground room, and you get Vicki standing in a narrow *sliver* of light from the background, with dim light on her face from the foreground (figure 2.5C). Move the characters closer together, and that same sliver now outlines Vicki's *profile* and supplies a *kicker* on Jeff's cheek (figure 2.5D). Cut to a new angle of Vicki turning to face Jeff in the doorway, and you get Vicki *brightly* lit, with a glowing eyelight, a flagged shadow on her forehead, and a touch of hair light separating her from the background (figure 2.5E). Then close the scene with a cut to Jeff, nearly a *silhouette* with two bright backlights on his slicked-back hair (figure 2.5F).

And now we come to the crucial point. The sequencing is not just true to the space; it is also dramatic. Each new arrangement marks a separate stage in the unfolding arc. To grasp this pattern, we can think of the scene as unfolding by *beats*.[55] The characters have goals, and they pursue different tactics to achieve their goals. A scene shifts to a new beat whenever a character changes a tactic. Lang has organized the actor's movements to reinforce each shift in tactic. These movements break the action into six dramatic beats. Let us look at the illustrations again and consider how light lets us see, beat by beat, who stands where.

1. Vicki walks away from Jeff. Her goal (we later learn) is to encourage him to murder Carl, but her tactic for now is simply to appear preoccupied and nervous, appealing to Jeff's sympathy. The lighting emphasizes the physical *distance* between them by putting Vicki in the light and Jeff in the shadow.
2. Jeff approaches, and she puts her hands on his chest. Jeff is trying to take control of the situation (as Vicki intended), and Vicki is trying to play on his sexual desire. Now the lighting is similar for both characters, reinforcing how *close* they are, while the backlight carries connotations of romance.
3. Vicki walks away from Jeff again. Again, she appeals to his sympathy or pity, but the appeal is even stronger now, with the suggestion that she is considering suicide. Standing in the shadows makes her *apartness* directly visible—to us and perhaps to him.
4. Jeff approaches Vicki again; she puts her hands on his face, and he grabs her hands. Now her tactic is to put the idea of murder into Jeff's mind. She does not want to say it out loud; she wants him to draw the conclusion himself. Both are in the shadows now, but Vicki's face picks up the light when she *turns away* and speaks into the void.
5. Taken aback by Vicki's proposal, Jeff walks away. Now Vicki faces him directly, unblinkingly. No longer evasive, she stands firmly in the light with a purpose—to *let him see* the look of determination on her face.
6. Jeff turns to face Vicki. He does not speak, but his *glance* conveys that he understands Vicki perfectly. This moment brings the scene to an end. Through a range of tactics, Vicki has accomplished her goal of getting Jeff to consider the murder.

The light's undeniable symbolism builds on this primary layer of depiction. To tell the story of Vicki and Jeff standing on the edge of a momentous decision, Lang

has placed them right on the border between light and shadow. The liminality of the lighting evokes the idea that they are about to cross a threshold from good to evil. Vicki pulls Jeff into the shadows when she makes the (implied) request, and then Jeff turns away from the light and becomes a near silhouette when he appears ready to agree. Rather than deny the existence of symbolism, I want to stress how it emerges from the blocking, which remains grounded in the characters' goals and choices. In figure 2.5A, we can look and see, right away, that Vicki and Jeff are standing far apart. The apartness is not symbolic; it is a visible fact, and the lighting makes it easy to see at a glance. Symbolic or not, lighting tells the story by working through depiction—by making the changing storyworld visible in the pictures.

A WORD OF CAUTION

The example from *Human Desire* shows a fairly tight correlation between the shifts in lighting and the beat-by-beat progression of the scene. However, I think it is important to add a word of caution. It would be a mistake to expect the light to change every time there is a dramatic shift. Lighting must perform many functions at once, and some of those functions require stability, not modulation. A daytime interior might require the effect of sunlight shining through the window from the beginning of a scene to the end. We can imagine a cinematographer dimming the sunlight every single time the character experienced a negative emotion and brightening the sunlight every single time the character enjoyed a victory. But then it wouldn't really look like sunlight anymore, would it? V. F. Perkins argues that a coherent movie balances significance and credibility, and he draws a useful distinction between meanings that are imposed onto the action and meanings that are fully absorbed into the action.[56] The pull toward significance might call for moment-by-moment adjustments, but the pull toward credibility might call for a setting that remains more or less the same, adhering to the logic of the fictional world.[57]

Sometimes I wish I could discover some kind of code: a cheat sheet that would allow me to interpret any image at a glance. Such a code might consist of an easily learned binary opposition: heroes are lit brightly, for instance, and villains are lit darkly. The problem is that such a code, if applied consistently, would lead very quickly to absurdities. A heroic character may walk through a mild shadow for two seconds and then walk back into the light. It would be ridiculous to conclude, on the basis of the lighting alone, that the character had become a villain for two seconds. Another character might be lit from the side for the bulk of the movie. It would be equally ridiculous to conclude, on the basis of the lighting alone, that the character was actually half villain, or that the character's virtue changed with every turn of the head. Shadows create a sense of roundness in space, allowing us to see the shape of the subject's face at a glance. The primary effect is perceptual. Of course, the effect *may* be symbolic, too, but we need not look for symbolism in every shadow. The perceptual contribution is often enough.

THE LARGE-SCALE PATTERN

We have moved from the pregnant moment to the unfolding scene. The final step is to add one more layer of temporality: the movie itself. Imagine two narrative movies. One movie begins in darkness, but then it gets brighter and brighter over the course of the next ninety minutes. Another movie begins in brightness, but then it gets darker and darker as its story proceeds. The two films will be equally bright overall, but they can produce radically different effects, simply because the sequencing produces the expectation of ever-increasing brightness in the first case and an expectation of ever-increasing darkness in the second case. This hypothetical example may sound unduly abstract, but the cinematographers of the 1940s considered such possibilities in depth, both in theory and in practice. For instance, the trade journal *American Cinematographer* ran a series of articles by Herb Lightman outlining a theory of mood lighting, whereby lighting shifts to match the mood of the story. In one article, titled "Psychology and the Screen," Lightman explicitly states that emotional storytelling should be the cinematographer's guiding ideal: "Film audiences, especially in America, do not go to motion pictures to think. Rather, they go with the expectation of taking part in a vicarious emotional experience."[58] To achieve that emotional engagement, filmmakers must tell stories that are grounded in "struggle and conflict"; audiences get bored by stories that unfold "too smoothly."[59] Lightman's other articles from the 1940s analyze a range of techniques that a cinematographer might use to make a film more engaging, including camera movement, composition, and lighting. Of these three, Lightman argues that lighting is the "most fundamental," for it is lighting that gives each scene its mood, as when high-key lighting creates a "light airy mood," or when low-key lighting produces a mood that is "richly dramatic."[60]

A mood works on our immediate emotions, but its real function for Lightman is temporal, shaping our expectations about where the arc is heading. When Lightman praises James Wong Howe's famously bleak photography on *Kings Row* (1942), he notes that it creates "a mood of impending tragedy, even in the relatively gay sequences which preceded the dramatic climax."[61] The word *impending* is temporal, suggesting that lighting charges each scene with a sense of foreboding—a fear that things are about to get worse. When Lightman celebrates Joseph Valentine's lighting on the psychological thriller *Sleep, My Love* (1948), he observes that the lighting shifts from brightness toward darkness in the second half of the film. Again, the design works because it suits the narrative's temporal effects, generating suspense as the danger increases.[62] Both of these movies may plausibly be classified as noir, and indeed Lightman's writings throughout the late 1940s draw on the cycle extensively.[63] His examples include *Mildred Pierce*, *The Killers*, *The Lady from Shanghai*, and *The Naked City* (1948).[64] Eventually, Lightman's writing and taste would settle into a more predictable pattern, but these articles from the 1940s are surprisingly bold, championing films with a highly expressive aesthetic. As such, they offer an early, in-house theory of noir lighting.

Since noirs tend to have downbeat storylines, we might expect the resulting large-scale patterns to be unchanging: darkness, darkness, and more darkness. The films are actually more variable, sometimes bright and sometimes dark. Here are two common large-scale patterns. (There are many more.) In the woman-in-peril thriller, a woman confronts a man who threatens her. Examples include *Lured* (1947), *The Spiral Staircase* (1945), and the aforementioned *Sleep, My Love*.[65] For such a story, a cinematographer might devise a rule: use light for scenes of relative calm, but use darkness for scenes of suspense. As the story progresses, the dark scenes will increase in number and intensity. Far from being relentlessly dark; these films are *increasingly* dark. All three of these films contain long passages of relatively bright illumination; all three of them shift toward darkness when their protagonists face the threat of physical or psychological violence. In *Sleep, My Love*, Claudette Colbert plays Alison, whose husband tries to destroy her by driving her insane, or by killing her, or by pinning a murder on her. The first half of the movie is relatively bright. The suspense remains low because we are not sure how much we should distrust Alison's husband, Richard, played by the usually likable Don Ameche. But the style shifts around the midpoint, when Richard coldly commits to eliminating his wife quickly. From then on, scenes of danger or violence get increasingly tenebrous treatment. The climactic scene is quite literally a battle of light versus dark: one of the villains is smashing lamps on the floor to make the room darker, while Alison's love interest, Bruce, is frantically turning on the wall lamps to keep it bright.

Here is another recurring pattern of modulation, one that is well suited for stories told in flashback. A *dark present* introduces a *brighter past* and then opens up to an *uncertain future*. A movie with this pattern begins with the protagonist in despair, then it flashes back to happier times to show how the protagonist got there, and then it concludes decisively one way or the other, happily or unhappily. The pattern appears in *Murder, My Sweet*, *Mildred Pierce*, *The Big Clock* (1948), and *Dead Reckoning* (1947). In the last-named example, the beleaguered veteran Rip (Humphrey Bogart) tells an army chaplain why he is on the run from the police. The lighting is as dark as it could be: Rip is a faceless silhouette sitting in the shadows. Then the flashback begins, and the style swerves abruptly toward brightness, as Rip recalls sitting in a sunlit train compartment with his army buddy. The style varies for the remainder of the flashback—sometimes bright, sometimes dark, but never quite so dark as that opening sequence. When the flashback ends, we are back to the beginning: Rip, a silhouette sitting in the shadows. The pattern has prepared us to expect Rip to fail—and he has. But the movie is not over. Now that we are back to the present, Rip has the opportunity to escape his dire situation, which indeed he does. Notice how the flashback structure has produced multiple narrative effects: some closed, some open. The timeline seems closed because we know that Rip's flashback, for all its highs and lows, will end up with Rip in the shadows and on the run from the police. But the timeline also seems open, since we know that Rip will still be alive at the end of his flashback, with one more chance to

make things right. We have seen darkness, and we have seen light, and we cannot know for sure whether the finale will shift toward one or the other. In the end, we get both: a dark car crash scene, followed by a bright hospital scene. *The Big Clock* duplicates this overall pattern very closely, introducing its protagonist in near-total darkness, shifting toward bright daylight as the flashback begins, moving through a series of ups and downs as the flashback unfolds, then returning to the original moment of darkness, and finally concluding on an unexpectedly bright note.

These large-scale patterns admittedly draw on some rather broad analogies. Darkness is used for seriousness and suspense, while lightness is for happy endings and other moments of hope. However, the patterns remain flexible, capable of many narrative effects. A film might create expectations of doom—and then surprise us with a happy turn. Or a film might create expectations of doom—and then fulfill them, all too grimly. Or a film might seem bright and cheerful—and then shock us with a sudden turn toward violence. The noir canon includes all three of these dramatic arcs and more.

It also includes films that combine these patterns in interesting ways. A case in point is my first detailed example, *Sorry, Wrong Number*. Like *Sleep, My Love*, this Barbara Stanwyck vehicle is a woman-in-peril thriller set in a wealthy Manhattan home. Like *Dead Reckoning*, it is a flashback story with a dark present, a bright past, and an uncertain future. But *Sorry, Wrong Number* lacks the (moderately) happy ending that concludes both of these films. The lighting cues us to expect the worst. And the worst is exactly what happens.

SORRY, WRONG NUMBER (1948)

The writer Lucille Fletcher adapted *Sorry, Wrong Number* from her own radio play, which had premiered on the popular program *Suspense* in 1943, featuring Agnes Moorehead in the starring role. Episodes of *Suspense* would begin with what amounts to a narratological definition of the subject: "In this series are tales calculated to intrigue you, to stir your nerves, to offer you a precarious situation, and then withhold the solution until the last possible moment."[66] To suspend is to leave something dangling; a suspenseful tale hints at what might happen while delaying the outcome. Fletcher's play fulfills this call brilliantly. Running for just under thirty minutes, it tells the story of a bedridden woman who calls her husband's office and overhears two men talking about a murder they plan to commit at 11:15 that night. It seems likely (to us) that the woman herself is the target of the murder plot, but she fails to realize the danger until the end of the episode.

To fill a longer running time, the movie adopts a frame-and-flashback structure. The frame tale follows the original play closely. The flashbacks introduce a new backstory, filtered through the experience of various secondary characters in the manner of *Citizen Kane*.[67] Barbara Stanwyck plays the protagonist (now named Leona), and Burt Lancaster plays her husband (now named Henry). Years

ago, Leona stole Henry away from a woman named Sally Hunt, and now Henry works for Leona's father. Resentful of Leona's control over his life, Henry starts a side business with a scientist named Evans, but they soon find themselves in trouble with gangsters who order Henry to have Leona killed for the insurance money. In the final moments, Henry pleads with Leona to escape, but his turnabout comes too late to save her from murder or him from jail.

This complicated narrative structure remains grounded in the logic of goal orientation, even as it questions whether the characters have any true agency at all. In the frame story, Leona quickly adopts a goal: to solve the mystery of the phone call. Later, she revises that original goal into something more personal: to save her own life. Leona seems totally unlike the Swede in *The Killers*. She learns of a danger, and she does something about it. In the flashbacks, Leona tells Sally, "When I want something, I fight for it. And I usually manage to get it." But the film also undercuts Leona's agency in several ways. In scene after scene, the movie suggests that Leona's determination is a negative trait (that is, negative for a woman), leading her to mistreat Sally, Henry, and the telephone operators who try to help her. Also troubling is the revelation that Leona's inability to walk is psychological: she loses her mobility when Henry tries to break free from her. It is not that Leona is actively trying to manipulate Henry by feigning her illness; that would suggest that she is still in control of her actions. It is that Leona has lost the ability to move her own body. At the end of the film, she has finally settled on an appropriate goal—to escape from the killer—but she can do nothing about it. So, she has become like the Swede, after all: sitting in bed and waiting for death. Meanwhile, Henry is characterized as a man whose working-class origin prevents him from accomplishing his goals in a hierarchical society. He tells Leona, "I want to be my own boss," but he ends up working for gangsters who operate with the ruthless efficiency of a modern-day corporation. The film's critique of goal orientation unfolds along strictly gendered lines. Leona is criticized for being too controlling; Henry is pitied for being too weak.

The Ukrainian-born director Anatole Litvak was a Jewish émigré filmmaker who left Germany in 1933 and honed his dynamic visual style in Paris before directing his first Hollywood movie in 1937.[68] The opening credits appear over an illustration of a telephone casting a large shadow on a wall. It is a classic noir image, warning us to expect a tale of danger and death. Even so, the movie never creates an impression of inevitability, whereby Leona's death seems assured from the beginning. It helps to compare the movie's frame-and-flashback structure to that of *Double Indemnity*. In Wilder's film, Walter has already been shot when the frame story begins. There is little left for him to do but confess. By contrast, Leona begins her frame story with a real chance to survive. If anything, overhearing the phone call is actually a stroke of *good* luck, giving her an opportunity to escape that she would not have had otherwise. This shift in agency gives Leona's frame story a different emotional key, producing much more present-tense suspense. In *Double Indemnity*, there is no need to suggest that Walter experiences twists and turns while he narrates his story. All the

highs and lows appear in his flashbacks. In *Sorry, Wrong Number,* Leona experiences a fully developed arc over the course of the frame story, swerving from one emotion to another: curiosity, anger, hope, and terror. The lighting swerves to match, shifting from scene to scene to amplify Leona's emotional arc.

Take a look at these six close-ups. In each shot, Leona is in the same location, lying on her bed next to a table lamp on her nightstand. And yet cinematographer Sol Polito has figured out how to light Stanwyck differently each time.

1. Leona leans against the bed's headboard as she overhears the menacing phone call (figure 2.6A). Frontal lighting provides a *clear view* of Leona's facial expressions, heightened by the glimmer in each eye. A flag paints a slight shadow over the top of her head, as if cast by the table lamp's shade.
2. Later, Leona appears in a classic three-point arrangement: symmetrical lighting on her face, modest fill, and a little backlight to touch up the curls in her hair (figure 2.6B). Leona is in a good mood, intrigued rather than frightened, and the lighting encourages us to notice the signs of her *wealth*—the enormous wedding ring, the elongated eyelashes, the fabric on the headboard.
3. As the suspense rises, the pattern shifts, casting *more shadow* on Leona's face and emphasizing the texture of her features (figure 2.6C). The increased shadow may be a metaphor for encroaching doom, but it also does depictive work, rendering the worry lines in Leona's forehead and the tension around her mouth.
4. Around the film's midpoint, Leona finally realizes that she is the intended victim of the murder plot (figure 2.6D). The lighting still fits within the three-point paradigm, but the effect is now devoid of glamour, leaving half of Leona's face in dark shadow. The wide-angle lens further *deglamorizes* the image by allowing the camera to get extremely close.
5. Things get worse from here. As Leona pleads for help near the end of the movie, she lies directly under the table lamp, enabling a *top-light* effect that produces harsh glare on her nose and forehead, while putting the rest of Leona's face, including her eyes, in shadow (figure 2.6E). A marvelous eyelight lets us see Leona's desperate stare.
6. In the final scene, the murderer approaches, and the lighting shifts radically to an entirely new arrangement (figure 2.6F). At some unspecified point, the table lamp has been turned off. Now the primary source is the light from the hallway, which produces a *cast shadow* directly across Leona's face as the killer approaches. The symbolic reading is unavoidable: Leona lies in the shadow of death. But the lighting does other tasks, too. The flat, frontal lighting is distinctly unflattering, especially in comparison to the three-point schemes that have graced Leona's face for much of the film. And the lighting is still bright enough to produce highlights on that brooch, which exemplifies (rather than symbolizes) Leona's wealth.

Polito is doing terrific work here—some of the best of his career. His achievement is all the more impressive because he is operating within such severe

FIGURE 2.6. *Sorry, Wrong Number* (1948): Leona barely moves, but her lighting changes over time. A *(top left)*: Hearing the threat. B *(top right)*: In a good mood. C *(center left)*: Getting worried. D *(center right)*: Realizing she is the target. E *(bottom left)*: Desperate. F *(bottom right)*: The murder.

constraints: one character, one room, and one night. A lesser cinematographer would have delivered a much more monotonous result. Polito finds enough variety to create a fully developed pattern.

Lucille Fletcher made things easier for Polito by writing a script in exceptionally vivid detail, endowing each location with a characteristic feeling expressed through lighting. In flashbacks, Leona and Henry share a penthouse apartment, and Fletcher's script remarks that its corridor is "flooded with light from a huge plate glass window overlooking the city." As Henry is drawn further into his criminal scheme, several scenes take place in the parlor of an old Staten Island mansion.

The script informs us that "there are signs of better days in the elaborately carved fireplace," but now the grim room is illuminated by "one dim electric bulb, hanging down from the ceiling."[69] Polito changes a few of these details, but he follows the spirit of Fletcher's script closely, contrasting the bright modernity of the penthouse that traps Leona and Henry in a life of wealth with the dim obsolescence of the mansion that traps Henry in a life of failure.

In contrast to Leona, the character Sally moves from one milieu to another, enabling Polito to alter her lighting more radically from scene to scene. Sally appears in the frame story, the assistant's flashback, Leona's flashback, and Sally's own flashbacks. These scenes depict Sally in numerous settings: a fancy office, a cramped apartment, a small-town dance hall, a drugstore phone booth, a nighttime beach, and a subway station. Together, these scenes develop a series of contrasts between Leona and Sally: wealthy versus working-class, selfish versus selfless, static versus mobile, isolated versus crowded. And yet the contrasts also hint at a deeper affinity. Both women are trapped. All Sally wants is a moment of privacy to tell Leona her story. When she tries to hide in her son's room, a thin beam of light reminds us that the flimsy curtain has been left slightly open, offering no protection. When she makes a phone call at the subway station, the lights of the passing train threaten to expose her again. The lighting tells Sally's story, showing a woman who tries to hide in the shadows and fails to do so.

Another character whom Fletcher added to the original story for the film version is Evans, the placid chemist who gets drawn into Henry's drug trafficking scheme. Evans first appears when he calls Leona and asks her to take a message for Henry. He is in a hotel, and Fletcher's script contains these instructions: "CHEAP DRAB HOTEL ROOM. . . . A shadowy room, lit only by the dim light coming through a transom. For a moment we see nothing but the dim room with a beam of light."[70] Again, Polito's lighting alters the details while rendering the core idea. We see a dim bulb and street sign. In the noir lexicon, this means *cheap drab hotel room*. On the metaphoric level, the darkness evokes the idea of death—the death that Evans alludes to when he gives Leona the telephone number for the city morgue. On the literal level, the darkness teaches us about Evans's state of mind. Here is a man who is so ready to give up that he has not bothered to turn on another lamp. Arguably, this sequence teaches us about Leona's state of mind, too. As Amy Lawrence contends, it is possible to read much of the film's imagery as subjective, imagined by Leona as she listens to the real voices she hears on the other end of the line. Leona is like a radio listener, conjuring a world on the basis of sounds.[71] Maybe the movie gets darker because Leona's thoughts grow bleaker.

As the climax approaches, Leona's death looks increasingly like a certainty. And yet *Sorry, Wrong Number* remains a suspense film right up to the end. Fletcher's screenplay insists on this point: "CLOSE SHOT—LEONA. We see suddenly at this darkest, most hideous moment of her life—when she is hounded, bewildered and adrift on a sea of emotions—how the fleeting hope that it may all be a lie—a dream . . . flits into her eyes."[72] The bleakness of this "hideous moment"

contrasts with the hope that Leona cannot help but feel. The ensuing finale opens up three new areas of possibility. First, there is the possibility that Leona will accept the obvious fact that Henry is the one who hired her killer. Second, there is the possibility that Henry will get arrested or escape. Third, and most interesting of all, there is the possibility that Leona and Henry will reconcile before her death. Leona apologizes to Henry and tells him that she would have given him the money he needed. Henry then pleads with Leona to save herself. It is almost touching, except that Henry's motivation remains ambiguous. Henry might be trying to help Leona, or he might be trying to save himself from a murder rap.

As stories unfold, they accumulate memories and emotions, and those memories and emotions come together in each story's finale. When the murderer's shadow crosses over Leona's face in *Sorry, Wrong Number*, the moment carries a powerful emotional charge because it has figured as a possibility for so long—a once-virtual event with different meanings for different characters at different stages of the story. Leona thought the murder would happen to someone else and that she could prevent it. Then she realized that the murder would happen to her—but she still thought that she could prevent it. Now she realizes, too late, that the murder will happen to her, and that she cannot prevent it. Henry initially did not want to have his wife killed, and then he did, and now he has decided that he wants her to survive, at the precise moment when he can do nothing to stop the murder. Only the murderer has formulated a plan and executed it without revision. The image of the killer's encroaching shadow works as a triple culmination—the culmination of the murderer's task, of Henry's unwanted goal, and of Leona's belated fears.

ODDS AGAINST TOMORROW (1959)

Released in 1959, *Odds against Tomorrow* is often seen as one of the last works in the original noir cycle.[73] The movie builds on various precursors, including *The Asphalt Jungle* (with its tale of a heist gone wrong), *T-Men* (with a gun battle staged against a crisscross pattern of metal lines), and *Kiss Me Deadly* (with its climactic image of an all-consuming explosion). The movie also breaks new ground, using the narrative template of the failed heist to mount a stinging attack on racism in the United States. It is racism that causes the heist to go wrong, and it is racism that leads to the conflagration at the end.

Building on his successful music career, Harry Belafonte had recently founded HarBel as an independent film production company. He aimed, in his own words, "to scout for good scripts and to pitch them to the studios, not just as some supplicant on bended knee, but as a business—a black business—coming at them on their own level."[74] Looking for a story that combined social significance with genre appeal, HarBel acquired the rights to the source novel by William P. McGivern. Belafonte then took the bold step of asking the blacklisted screenwriter Abraham Polonsky to write the script. Belafonte's friend, the novelist John O. Killens, served

as Polonsky's front.[75] Robert Wise produced and directed the film, and Wise's longtime collaborator Nelson Gidding shared a credit on the script. Belafonte played one of the three leading roles, along with Robert Ryan and Ed Begley. It would be his last role in a Hollywood film for over a decade. Weary of Hollywood's compromises, Belafonte focused on providing financial and strategic support to the civil rights movement.[76]

The three main characters are Johnny Ingram (Belafonte), a Black musician with gambling debts; Earle Slater (Ryan), a bitter white southerner recently released from prison; and David Burke (Begley), a genial but disgraced white police veteran. The story unfolds in four parts. In the first part, Burke asks Ingram and Slater to join his team for a bank robbery, and they are both reluctant to do so. In the second part, Ingram and Slater decide that they are desperate enough to commit to the heist in spite of their reservations. The third part of the film shows the men arriving in the small town and waiting for night to come.[77] The fourth part shows the heist and its deadly consequences. The climactic confrontation between Slater and Ingram is one of the most famous finales in the noir canon. Ingram aims at Slater, and Slater aims at Ingram. They fire simultaneously—and all the tanks in the yard explode. The final scene offers a bitter coda. A rescue worker uncovers the charred bodies of Ingram and Slater and asks, "Which is which?" The answer: "Take your pick."

When Hollywood films of the 1950s address racism, they often do so within a "liberalism-of-conscience" framework, presenting racism as a matter of personal bias that may be solved by greater tolerance rather than as a systemic problem requiring more far-reaching political and economic changes.[78] *Odds against Tomorrow* pushes the limits of this framework, showing that Ingram faces both kinds of racism, the personal and the systemic. At the personal level, he must confront Slater, a dangerous man who is fueled by resentment. The movie contrasts Slater with Burke, who dismisses Slater's racism as Civil War nonsense. If Slater's personal animus were the only form of racism on display, then the movie could be read as an earnest and ultimately modest call for greater tolerance. But the movie also offers a more systemic critique, arguing that capitalism's culture of inequality and debt facilitates or even mandates racist exploitation, whether or not individual characters are personally hateful. On a personal level, Burke and Ingram like each other, and Burke explicitly mocks Slater's views. Still, Burke is the one who asks a gangster to pressure Ingram with threats, thereby forcing Ingram's hand. As we learn more about the heist plot, it becomes clear that race is the primary reason that Burke needs Ingram: the plan rests on the assumption that a bank guard will mistake Ingram for another Black man. All these factors show that racial oppression extends beyond personal animus. Burke is tightly implicated in the exploitation of Ingram, even though Burke and Ingram are friends.

Belafonte was particularly proud of Ingram as a character. Unlike the restrained heroes associated with Sidney Poitier, Ingram is always ready to confront racism head-on. As Belafonte explained, "He walked in and demanded his dignity by just

his presence.... No black guy ever talked to white guys that way in films."[79] Ingram also differs from the typical noir protagonist. Whereas the protagonists of *The Asphalt Jungle* are doomed by bad luck, Ingram is doomed by social causes: the long-standing hatreds of people like Slater, and the equally long-standing system of racial and economic exploitation. As an actor, Belafonte invests the character with confidence and charm, and for most of the film his moments of anger are presented as bold and justified. Indeed, the structure of sympathy is so thoroughly aligned with Ingram that the moralizing coda seems oddly out of place. As Kelly Oliver and Benigno Trigo have argued, the "Take your pick" line suggests a false equivalence, assigning equal blame for the explosion to Slater's racism and to Ingram's anger, even though the preceding film has shown Ingram's anger to be far more justifiable than Slater's irrational hate.[80] (Polonsky reportedly disliked the ending, too.)[81]

Like *The Asphalt Jungle*, *Odds against Tomorrow* unfolds chronologically, avoiding the complex flashback structure that characterizes *Double Indemnity* and *Sorry, Wrong Number*. Unlike *The Asphalt Jungle*, the pacing of *Odds against Tomorrow* is very deliberate. Delaying the heist until the final quarter, *Odds* spends much of its running time exploring the characters' lives. The opening sequence juxtaposes Slater with Ingram: Slater refuses to banter with the elevator operator, but Ingram shares a grim joke with him. The imagery contributes to this comparative logic, representing Slater and Ingram as two men who inhabit the same space differently. The cinematographer was Joseph Brun, a French-born cameraman who had photographed Poitier's noir drama *Edge of the City* (1957) two years earlier. When Slater knocks on Burke's door, Brun's lighting and camerawork make the hallway seem dim and narrow. We see two overhead bulbs, one with a globe and one without. The resulting illumination is visibly uneven, as Slater walks through three pools of shadow on his way to the door (figure 2.7A). The low-angled camera, equipped with a wide-angle lens, produces an image with a powerful sense of perspective. The impression of depth enhances the feeling of narrowness as the hallway stretches far into the background.[82] The dimness of the setting makes two related points, one sociological, the other psychological. The sociological point is that this space has been shaped by the intersecting logics of class and race; we see at a glance that this is not an upscale white neighborhood. The psychological

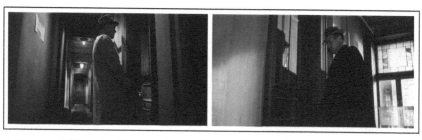

FIGURE 2.7. *Odds against Tomorrow* (1959): Slater and Ingram at the same door, in a different composition. *A (left)*: Slater. *B (right)*: Ingram.

point is that Slater experiences the space as confining. He knows that he is in a part of town where many Black people live and work, and he is visibly uneasy.

When Ingram knocks on the same door, we see the hallway from a different angle. Instead of showing two walls converging toward a distant vanishing point, the new composition shows a single wall angling toward a brightly patterned window (figure 2.7B). The relatively open space of this composition contrasts with the narrow, closed space of Slater's composition, and the resulting suggestion is that the two men experience this space differently. That bright window casts Ingram's shadow on the doorway. Maybe there is the noir symbol of the doppelgänger here, but we should not overlook the shadow's depictive contributions, too. Because the shadow is roughly the same height as Ingram, it makes him look tall in the frame. Because the shadow outlines his hat so clearly, it reminds us that Ingram is stylishly dressed. These are literal facts about Ingram, sketching his character at a glance.

The movie develops the comparison between Slater and Ingram further through the use of a recurring shadow motif. At various points, both men are shown with shadows over a portion of their faces. The motif first appears in Burke's apartment. Burke comments on Slater's difficult circumstances, and the easily offended Slater steps toward the door. Then Burke asks, "How would you like to pick up $50,000?" Slater turns toward Burke, and a hard shadow obscures the top half of Slater's face (figure 2.8). He is tempted by the offer.

I want to propose some different claims about this shot, and I will group those claims into three categories: symbolic, spatial, and motivic. My goal is to show how a single shot might be meaningful in various ways, including some ways that contradict one another. First, the fact that Slater's face is split in half may be read as a symbolic comment on his character, who is simultaneously a troubled noir

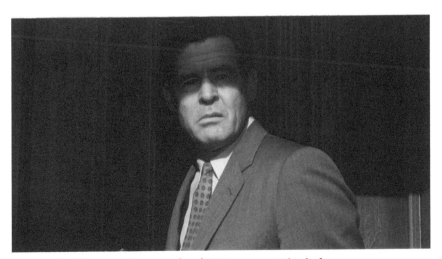

FIGURE 2.8. *Odds against Tomorrow* (1959): Slater wavers in the shadow.

protagonist and the villain of the story. Robert Ryan had played both sorts of roles in his long career as a noir lead. He generated enormous sympathy as the over-the-hill boxer in *The Set-Up* (1949, also directed by Robert Wise), but he generated an equal amount of terror as the anti-Semitic murderer in *Crossfire* (1947) and as the anti-Japanese murderer in *Bad Day at Black Rock* (1955). *Odds against Tomorrow* plays on this duality, sometimes suggesting that Slater is a flawed man who is victimized by his own resentments and sometimes suggesting that he is simply cruel to the core. Here he is both, visually represented as a man cut in two.

Alternatively, the shadow may be read as a symbol of Blackness—that is, Blackness as Slater perceives it, as a threat. Slater feels his racial identity is under attack simply because he has been asked to visit this neighborhood that is not uniformly white. As Eric Lott has explained, the visual vocabulary of film noir often rests on the familiar and implicitly racist association of darkness with danger.[83] *Odds against Tomorrow* draws on that same symbolic vocabulary quite self-consciously, asking us to question its racist presuppositions.

Without invalidating this symbolism, a spatial reading of the shadow explains how it helps us see who stands where. Burke's tiny apartment is brightly lit: there are two large windows on one side and a sunlit kitchen on the other. The only zone of shadow in the entire space is the area directly next to the door. When Slater steps into the shadow, we can see, at a glance, that he is *this* close to the exit. When Slater leans forward into the light, we can see, at a glance, that he has moved *this* far into the room: one inch closer. This spatial information gives us direct insight into Slater's character not via symbolism but via the representation of behavior. When he is close to the door, Slater is acting on his resentments. He feels that Burke has insulted him, and he is making a demonstrative exit. When he leans away from the door just a little bit, Slater shows some deeply buried capacity to overcome his resentments. There is nothing metaphoric about this reading. The shadowed exit is quite literally where Slater is standing when he rejects Burke's plan, and the illuminated room is quite literally where Slater must step if he would like to learn more about the plan. At this depictive level, we can think of lighting as an aid to performance. Robert Ryan communicates information about his character by moving very, very slowly, and the lighting lets us see his movements, with all their nuance and hesitation. It is clear that Ryan, a consummate noir actor, knows exactly where the light is.

The cut-in-half lighting effect is memorable, so much so that it becomes a motif: a repeated element that is meant to be experienced *as* a repetition. Motifs are often symbolic, but their primary function is temporal. Each appearance of a motif is an invitation to compare the latest iteration with all the preceding ones, and to speculate about how the storyworld has or has not changed in the meantime. In a later scene in Burke's apartment, Slater and Ingram meet for the first time. Slater deliberately insults Ingram with demeaning language and attacks his intelligence. The film cuts to a closer view of Ingram, who is staring directly back at Slater with anger and intensity. A top-lighting effect casts a shadow over Belafonte's eyes, and an eyelight ensures that his fixed gaze remains visible. The effect is not identical to the earlier

image of half-lit Slater, but it is close enough to bring the previous scene to mind, especially with the help of an aural motif: wind blows ominously in both scenes. The first scene creates an association between Slater's eyes and Slater's anger. The second scene reworks that association, suggesting on the one hand that Slater and Ingram are similar (as Slater is angry at being insulted, and so is Ingram) and on the other hand that Ingram and Slater are quite different (as Slater seems incapable of controlling his anger, but Ingram has spent years controlling his).

The shadow motif continues to develop and mutate across the rest of the film, reaching a culmination as Ingram watches Burke commit suicide during the botched heist. A shadow over the lower half of Ingram's face emphasizes the expression of wounded sympathy in Belafonte's eyes. The motif is recognizably the same, and yet it is now visibly inverted. What was once a shadow over the top half of Slater's face has become a shadow over the lower half of Ingram's; what was once an image of anger has become an image of care and concern.

So far, I have focused on the lighting effects that seem most characteristically noir: the dimly lit hallways and the cut-in-half faces. The movie features several more noir staples: backlit smoke in the jazz club where Ingram works, lighting from below when Slater utters his most vicious epithet, venetian blinds in Ruth's tastefully decorated apartment, deep shadows in Lorry's more old-fashioned apartment, and crisscrossed lines of metal in the gas-tank shootout. But the film also includes several scenes that unfold during the daytime. Indeed, the film as a whole is actually quite bright.

One scene shows Ingram in a telephone booth, photographed in Central Park against a background of real skyscrapers. Brun's lighting is a three-point scheme, with a key light from the side, fill light from the front, and a kicker highlighting Ingram's hat from behind. At first glance, the shot seems fairly conventional: three-point lighting, as in countless Hollywood movies. But the shot neatly balances its depictive and narrative appeals. Throughout the scene, a balloon billows in the wind, and its shadow flutters back and forth across Ingram's shoulder. The filmmakers went to the trouble of bringing a wind machine to the location to ensure that the fluttering would be visible.[84] The resulting image activates memory and expectation. Ingram had asked his daughter what she wanted to see that day, and she had recited a list of possibilities, including a red balloon. Every time the shadow of the balloon draws our attention, it reminds us of Ingram's desire to be a good father. This reminder, in turn, leads directly to an unexpected payoff when three teenagers walk by, and one of them casually pops the balloon. Ingram's promise has now been broken. The moment is another illustration of how racism takes many forms, including the form of casual indifference. The white teenager who pops the balloon is not targeting Ingram specifically, but Ingram and his daughter suffer the consequences.

With its sharply focused background, the phone booth scene plants the idea of the city vividly in our minds, vividly enough that the city's absence will be felt all the more deeply in the movie's later scenes. After the characters arrive at the small

town, we get the film's most daring sequence. No, I am not referring to the heist scene or to the explosion. I am referring to the brightly lit montage that precedes the heist sequence—a montage so bright that it challenges our very idea of what a film noir should look like. Ingram, Slater, and Burke all arrive in the small town, and they must wait for several hours for night to fall. So, they wait. They do not talk to each other; they do not interact with anyone else. They just wait. Eventually, the street lamps turn on, and a clock announces the time as six o'clock. The waiting sequence benefits from the contributions of three distinct collaborators: the cinematographer Brun, the director Wise, and the editor Dede Allen, then beginning her career as one of the most innovative editors in Hollywood history. During filming, Wise and Brun would abandon whatever scene they were working on whenever they noticed that the weather outside was right for the sequence. Allen then took the shots and organized them into a meaningful sequence. Rejecting the convention of using dissolves to signify the passage of time, she relied exclusively on cuts to create the progression.[85] The end result, Brun explained, allowed audiences to "witness the end of a day and the birth of a night in its full progression."[86]

It is remarkable that the crew went to all this trouble for a sequence where nothing seems to happen. The characters wait, and night falls. That is all. Does this scene even qualify as a narrative? Yes, but in a very peculiar way. The scene is about the failure to act—and a failure to act may be just as consequential for these three characters as the decision to act is for characters in a more conventional Hollywood movie. The characters have every opportunity to realize that they are walking into a mistake, but they fail to change course. Time ticks by, moment by moment, and every moment seems charged with a sense of missed possibility.

In closing, I submit figure 2.9 as an iconic example of the noir style—even though it flips many of our preconceptions about that style. The dark city at night

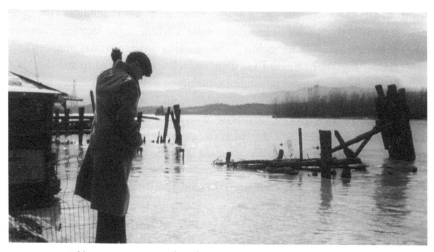

FIGURE 2.9. *Odds against Tomorrow* (1959): Ingram waits, and nothing happens.

has become a bright, semirural area on a cloudy day. The pools of shadow have become patches of gray, rendering the texture of the water, the sky, and the mountains in the distance. For all its beauty, the image is as bleak as anything in the noir canon. We see the bleakness in the setting, with its decaying wooden structure, and we see the bleakness in Belafonte's performance, with his tightly wrapped clothing and his downward gaze. The image makes its narrative point by working through depiction, by showing us who stands where. Ingram is here, now, exactly where and when he does not want to be.

3 · LIGHTING CHARACTERS

Great close-ups are made, not captured. To craft an effective portrait, it is not enough to seat someone in front of the camera and flip the switch. The figure must be rendered, allowing viewers to see a three-dimensional shape in a two-dimensional picture. Lighting is the key to effective rendering. Just as a well-placed shadow can make a circle look like a sphere or vice versa, a well-lit image can reveal or conceal the shape of a person's face.[1] As early as the 1920s, articles in *American Cinematographer* used the term *modeling* to refer to this vital task—a task of representing each subject's shape in pictorial form through the judicious use of light and shadow.[2]

Sets and props need to be modeled, too, but this chapter focuses on the modeling of people—especially their faces. The first half of the chapter takes the form of a step-by-step guide, working through a variety of examples to show what different sorts of lights can do, from the key light and fill light to the eyelight and backlight. The techniques were not rigid rules but creative options, which could be darkened, softened, combined, or eliminated. This flexibility turns the craft of lighting into an art of depicting-as, rendering characters as aging, as young, as glamorous, as square-jawed, and perhaps even as fatale.

After working through the basics, this chapter addresses three general questions. One concerns the ideology of figure lighting. How were Hollywood's figure-lighting conventions shaped by the studio system's larger assumptions about gender and race? Another question concerns glamour. How did noir transform existing standards of glamorous lighting? A third question concerns modulation. How does lighting vary over the course of a film to enhance the dramatic arc? My closing examples are both early noirs with female protagonists: *The Letter*, a tale of murder and revenge set outside of Singapore, and *Phantom Lady*, a contemporary thriller with a female investigator plot. Both show how an artfully crafted noir might tie all three of these questions—questions of ideology, glamour, and modulation—together.

THE KEY LIGHT: MODELING THE FACE

Suppose that you are a filmmaker working in the Hollywood studio system during the 1940s or early 1950s. Your assignment is to shoot an ordinary shot: a person

Lighting Characters 59

standing in a room. You have a set of familiar tools: lamps to cast the illumination and grip equipment to create the shadows. You also have a set of familiar techniques: established ways of arranging these tools to produce the look you want. One thing you do not have is the concept *film noir lighting* to guide you. You are not trying to light the movie so it looks like a film noir. You are just trying to light the scene so it will work—so it reveals the characters, sets the scene, and tells the story.

First, you need a lamp, such as an arc or an incandescent. The arc is more powerful; it casts a hard shadow with crisp lines. The incandescent is well-suited to your film stock, and it casts a shadow that looks slightly more diffuse. You may put either lamp on a stand, or you may hang it from the grid above the studio floor. Once you have selected your lamp, you might use it to establish the key light. This light will begin the modeling process by establishing a pattern of shading on the actor's face. Selecting the placement of the key light is a creative choice—one of the most consequential choices a cinematographer can make.

To give a better sense of the options available to studio-era cinematographers, I will borrow four terms from present-day portrait photography: *butterfly lighting*, *loop lighting*, *Rembrandt lighting*, and *split lighting*. These terms were not in common usage during the studio period, but they identify principles that were clearly in effect. Some of these lighting arrangements may lend themselves to symbolic readings, like the idea that a character lit from the side is half angel, half devil. I ask you to kindly put these symbolic readings aside for a few pages more. My focus for now is on something more prosaic. How does the lighting shape the subject's face? Or, to put it even more prosaically: What does the lighting do to the person's chin? Eyes? Nose?

Figure 3.1A, from Alfred Hitchcock's *The Paradine Case* (1947), illustrates a pattern now known as butterfly lighting.[3] Alida Valli stands under the lamp, which creates a pointed shadow under her chin, a curved shadow under her cheekbones, and a butterfly-shaped shadow under her nose (hence the name of the technique). The light makes Valli's face seem symmetrical: look at the matching shadows under her eyebrows, the perfectly centered dab of shadow under her lower lip, and the clean arcing line separating her chin from her neck. The light also wipes out whatever wrinkles Valli might have on her cheeks and forehead.

Precision is essential to the effect. Move the lamp down to camera level, and you get flat lighting, which tends to reduce modeling. True flat lighting is unpopular because it weakens the chin. Somewhere between butterfly lighting and flat lighting is an intermediate position (I will call it *flat-butterfly lighting* for lack of a better term), where the light still creates a decisive line under the chin, but it makes the nose look entirely unobtrusive, diverting attention toward the eyes and lips.

Of all Hollywood lighting techniques, butterfly lighting is perhaps most firmly associated with old-fashioned Hollywood glamour. Indeed, some contemporary photographers call the butterfly technique *glamour lighting* or *Paramount lighting*, in reference to the outrageously glamorous films starring Marlene Dietrich and directed by Josef von Sternberg, all produced at Paramount. One of von Sternberg's cinematographers was Lee Garmes, who went on to photograph *The Paradine*

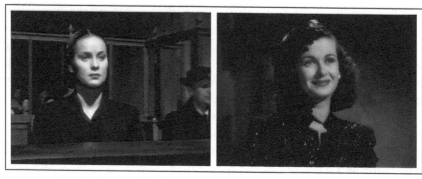

FIGURE 3.1. *The Paradine Case* (1947) and *The Woman in the Window* (1944): Butterfly lighting and short loop lighting model the nose and chin differently. *A (left)*: Butterfly. *B (right)*: Loop.

Case for Hitchcock. I will discuss the influence of von Sternberg's glamour lighting in more detail later in this chapter. For now, it is important to note that butterfly lighting, for all its beauty, brings challenges. The effect can look flagrantly artificial, featuring illumination that comes from no visible source in the story's world. The technique also sets severe limitations on the actors, who have to hit precise marks to produce the butterfly effect. For these reasons, many cinematographers preferred a more adaptable alternative: loop lighting.[4]

Compare figure 3.1B, from *The Woman in the Window* (1944), with the previous image from *The Paradine Case*. The key light is a touch lower (but still above Joan Bennett's eyes), and the lamp is now ever so slightly to the star's left (that is, the camera's right). These are tiny adjustments, achieved by moving the lamp a few inches, but look at what they do to the shadows. Instead of creating a butterfly pattern under Bennett's nose, the lighting creates a loop—a little curve that arcs toward one side of her mouth. Instead of casting a symmetrical shadow underneath the star's chin, loop lighting casts a diagonal line across her neck. This revised scheme preserves some of the key advantages of the butterfly technique: it models Bennett's nose without drawing too much attention to it, it creates a crisp line separating her chin from her neck, and it makes her skin look smooth. At the same time, loop lighting does not require the finicky precision of butterfly lighting, where everything is subordinated to symmetry. When Bennett moves her head, the shadow changes its shape without breaking the basic loop pattern. The lighting is simple enough that it can fit into a number of contexts (daytime, nighttime, indoor, outdoor), and artful enough that it can evoke the idea of the painterly portrait when necessary.

Loop lighting comes in two forms, known as *short* and *broad*. Compare figure 3.1B with figure 3.2A, showing Cathy O'Donnell in *Side Street* (1949). In both images, the subject is looking left to right. This means that the subject's face has a near side and a far side: her screen-left cheek is on the near side, and her screen-right cheek is on the far side. Both women receive loop lighting, but the resulting shadows appear on a different side: on the near side in Bennett's case and on the

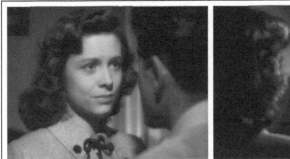

FIGURE 3.2. *Side Street* (1949): Broad loop lighting illuminates the face; short Rembrandt lighting produces more shadows. A *(left)*: Loop. B *(right)*: Rembrandt.

far side in O'Donnell's. The lighting on Bennett is *short*; it narrows her face by illuminating the far side, putting the more visible side of her face in shadow. The lighting on O'Donnell is *broad*; it widens her face by illuminating the near side, hiding the shadows on the less visible half. Contemporary photographers believe that short lighting is more flattering because it makes the subject appear thin.[5] During the 1940s and 1950s, short and broad lighting were routine options for men and women alike. The short-lit image from *The Woman in the Window* is more elegantly modeled and more self-consciously artful—appropriate for a woman who manages to seduce the hero even though she does not exist.[6] The broad-lit image from *Side Street* is somewhat flatter and simpler, and the results seem well-suited for O'Donnell, who specialized in girl-next-door roles.

Now take the key light and move it farther to the actor's side. Watch the nose shadow as it stretches across the actor's cheek. When the nose shadow has lengthened enough that it touches the cheek shadow, you will have arrived at a new setup: Rembrandt lighting, named after the seventeenth-century Dutch painter Rembrandt van Rijn.[7] During the silent period, the term *Rembrandt lighting* had referred to a form of backlighting.[8] In the present context, it refers to an arrangement of the key light that produces a characteristic triangle of light under the subject's eye, as in figure 3.2B, also from *Side Street*. Like loop lighting, Rembrandt lighting can be short or broad. The example here is short: the far side of the face is illuminated, and the triangle appears on the near side. The cinematographer Joseph Ruttenberg has used completely different modeling for Farley Granger, even though his character is just a foot away from O'Donnell's.

Now pick up the key light and move it farther to the side. The triangle of light will disappear, and you will be left with split lighting, where the shadow cuts the character's face in half. In figure 3.3A, from *The Glass Key* (1942), the light cleanly bisects Alan Ladd's head into a bright side and a shadow side. The crease in Ladd's brow is unmistakable, as is the dimple in his chin. Again, the scheme may be short or broad. (Ladd's lighting is short. Broad split lighting appears in figure 2.5D from *Sorry, Wrong Number*, an unglamorous moment illustrated in the previous chapter.)

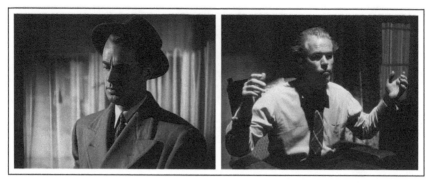

FIGURE 3.3. *The Glass Key* (1942) and *The Killers* (1946): Split lighting illuminates half of the actor's face; top lighting produces shadows over the eyes. *A (left)*: Split. *B (right)*: Top.

These four schemes—butterfly, loop, Rembrandt, and split—cover the vast majority of Hollywood close-ups, in and out of film noir. Noir cinematographers also experimented with some bizarre alternatives, such as lighting from above and lighting from below. Top lighting is now known as *godfather* lighting, due to its association with Gordon Willis's work, several decades later, on *The Godfather* (1972).[9] In figure 3.3B, from *The Killers*, the key light hangs directly over the actor's head. The placement is surprisingly close to that of butterfly lighting, but top lighting is much less kind to the actor's features. The high placement creates a shadow under the nose (but now it is so long that it touches the mouth), shadows under the eyebrows (but now they are so deep that they obscure the eyes), and a shadow under the chin (but now it blends with the shadows of the cheekbones, destroying the impression of a cleanly sculpted face). If butterfly lighting makes Alida Valli look like a classical sculpture, top lighting makes the character actor Jack Lambert look more like a gothic grotesque.

When you lower the lamp so it is under the actor's eye level, the results look slightly misshapen, as in the images of Doc and Brannom illuminated by the fireplace in *The Asphalt Jungle* (see the illustrations in chapter 1). In lieu of a consensus term, I will adopt the term *lighting from below* for this effect; others might prefer the theatrical term *uplighting* or the evocative phrase *horror lighting*. This positioning illuminates the bottom of the chin, nose, and eyebrows, while casting the nose's shadow up toward the eyes. The effect can look distinctly abnormal, as the most natural source of light is the sun, and sunlight necessarily comes from above the horizon line.

EXPOSING THE FACE

Once you have settled on the placement of your key light, you need to decide how bright the face will appear on the screen. The image's onscreen brightness will be a function of various factors: the intensity of the lamp itself, of course, but also the aperture of the lens, the presence or absence of lens filters, and the laboratory's developing and printing procedures. Compare a close-up from the noir drama

Lighting Characters 63

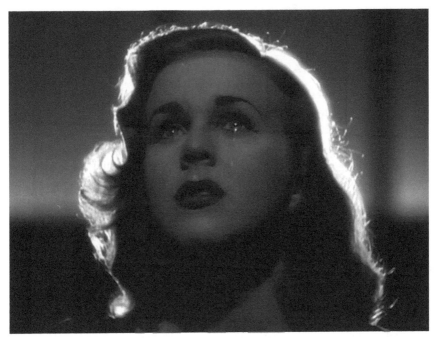

FIGURE 3.4. *Christmas Holiday* (1944): The lighting on the face is strikingly dim, especially compared to the bright backlight.

Christmas Holiday (1944) with the butterfly-pattern close-up from *The Paradine Case* (seen previously in figure 3.1A).

In spite of its title, *Christmas Holiday* is actually a film noir. Deanna Durbin plays a surprisingly adult role (a singer in a sleazy clip joint, with suggestions of sex work), and the overtly glamorous lighting works to convey seriousness and sexuality—but with a lingering hint of the transcendent. In this image from the end of the movie, the cinematographer Woody Bredell points a lamp at Durbin's face and produces a small shadow under her nose and a strong shadow under her chin. He also adjusts the intensity of that lamp to produce a noticeably darker effect (figure 3.4). In a sense, the modeling on the star's face is the same as in butterfly lighting: we see the same thin line underneath Durbin's chin, and we see the same smooth illumination on her cheeks and forehead. What has changed is the light's brightness relative to the exposure. The face of Valli registers onscreen as near white, but the face of Durbin registers onscreen as dark gray. Dimming the light on Durbin's face makes the other lights pop. Indeed, the backlight looks so intense that some might describe the illumination on Durbin's face as the fill light. However, I think it makes more sense to say that the lamp pointing toward Durbin's face is the key—just an unusually dim one. As one contemporary photography manual notes, the key light is "the light that determines the shadows, at least on the face."[10] The dim light on Durbin's face is responsible for the close-up's modeling; it illuminates the

star's eyes, nose, and mouth, and it puts that crisp shadow under her chin. As such, it does the work of the key—darkly.

FILLING IN THE SHADOWS

Figure 3.5 gives a better illustration of what a true fill light can do. Hurd Hatfield plays the title character in the noir-inflected period film *The Picture of Dorian Gray* (1945). The pattern is a short split-lighting scheme, as in the previous illustration from *The Glass Key* (see figure 3.3A), but the overall tonality seems quite vivid because there is additional illumination brightening the resulting shadows. This additional illumination comes from the *fill light*—so called because it fills in the shadows created by the key. The most common placement for a fill is directly above the camera or immediately adjacent to it, like a flat key. Here, flatness is an asset: the purpose of a fill is to attenuate the shadows, not to produce new ones. The best way to do that is to make the fill as even as possible by putting it very close to the camera. In *The Picture of Dorian Gray*, Hatfield's face looks impossibly smooth—the perfect look for a character with the supernatural ability to remain forever young. In comparison, the image from *The Glass Key* features less fill, creating a more abrupt distinction between light and shadow. Ladd still looks handsome, but his features seem more etched, with extra modeling on his mouth and brow.

A familiar way to describe the difference between the image from *The Glass Key* and the image from *Dorian Gray* would be to say that the former is *low-key* and

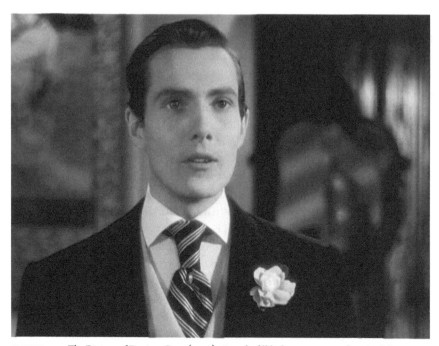

FIGURE 3.5. *The Picture of Dorian Gray* (1945): Ample fill light creates gentler modeling.

that the latter is *high-key*. This terminology refers to each image's contrast ratio. In *The Glass Key*, there is a large difference between the (bright) key light and the (dim) fill light, producing a low-key image, so called because the overall tonality or key of the image is dark. In *Dorian Gray*, there is a much smaller ratio difference between the (bright) key light and the (almost equally bright) fill light, producing a high-key image, so called because the overall tonality or key of the image is bright.

But wait—the distinction between high-key and low-key is not so simple. The image from *Christmas Holiday* is also low-key but in a different way. Why does the image from *Christmas Holiday* look so dark? Because the *primary* light—the one illuminating Durbin's face—looks so dim. Why does the image from *The Glass Key* look so dark? Because the *secondary* light—the one illuminating the shadow side of Ladd's face—looks so dim. Both could be described as low-key on the grounds that both feature dark overall tonalities, but they have arrived at that overall effect via alternate routes. I stress this point because *low-key lighting* is the term most associated with the noir style, and it is important to recognize that the term can apply to multiple techniques with multiple effects—as long as the overall tonality seems dark. Woody Bredell, who photographed both *Christmas Holiday* and *The Killers*, described his high-contrast, low-key work on the latter film as "out of balance" lighting.[11] In *Christmas Holiday*, the lighting is smoother and more glamorous: low-key but not disturbingly strange.

FILL LIGHT AND GENERAL ILLUMINATION

Hollywood cinematographers drew a distinction between modeling lights and general illumination—that is, between the lamps focused on the actors and the lamps that provide the base-level illumination on the set.[12] General illumination typically comes from an array of lamps positioned above the set; modeling light is more likely to come from lamps on movable stands. Take another look at the still from *The Picture of Dorian Gray* (see figure 3.5). Notice that there are two shadows underneath Hatfield's chin. There is one shadow on the screen-left side of his neck; this shadow comes from the key light. There is also a second shadow, more symmetrical. Look for the thin line that curves around to echo the shape of Hatfield's chin. This second shadow comes from the fill light, which is hitting Hatfield directly in the face. So, we have a shadow within a shadow—but even this shadow does not go completely black. That is because the entire set has a high level of general illumination, providing that base-level brightness that prevents all the shadows from losing detail. This distinction between general illumination and modeling light was built into the studio system's division of labor. A gaffer's crew might arrange the general lighting above the set ahead of time, freeing the cinematographer to focus on modeling light on the day of shooting.[13]

By the mid-1930s, articles in *American Cinematographer* began to remark that general lighting was on the wane.[14] Cinematographers were using spotlights to

model each character or object individually. In the next decade, John Alton would pride himself on his rejection of general lighting, allowing the modeling lights to do all the work.[15] Given noir's obvious association with darkness, we might suppose that the cinematographers of the 1940s were reducing their levels of general illumination so they could produce images with pitch-black shadows. This is sometimes true, but it would be more accurate to say that practitioners reduced their levels of general illumination precisely because they knew they could do so *without* producing pitch-black shadows. I know this sounds paradoxical; let me explain. Kodak had introduced Plus-X film stock and Super-XX film stock in 1938, and several cinematographers thought these faster stocks facilitated low-key lighting by preserving more detail in the shadows. One *American Cinematographer* article from 1939 quoted the cinematographer William C. Mellor: "Today we must watch our highlights—and the shadows can pretty well take care of themselves."[16] A good shadow was one that looked dark but not empty. This preference helps explain why stocks that were *more* sensitive to light facilitated the emergence of a *darker* style. (You would expect it to be the reverse, right?) Think about it this way. If you were worried about losing detail in the shadows, you might avoid shadows altogether, just to play it safe. In the 1930s, many cinematographers did just that, designing shadow effects with caution. But if you were confident that the sensitivity and latitude of the stock enabled you to photograph a shadow without losing detail, then you might design shadow effects more often. This was as true for polished studio professionals like Mellor as it was for iconoclasts like Alton. Both knew how to cast a shadow over an actor's face without plunging the actor's eyes into an absolute void.[17]

BACKLIGHTS AND KICKERS

Set a lamp behind the actor's head, and you get the traditional backlight, sometimes known as a *rim light* (because it creates an outline of light around the subject) or a *hair light* (for obvious reasons). Along with the key light and the fill light, the backlight serves as one of the three points in what is now known as the *three-point lighting* system. The backlighting on Deanna Durbin (see figure 3.4) is ablaze with glamour. The backlighting on Alida Valli (see figure 3.1A) is subtler, giving shape to her hairstyle without creating a glaring halo. Cathy O'Donnell's close-up in *Side Street* (see figure 3.2A) goes farther, eliminating the backlight entirely to suggest the actor's everyday appeal. A variation on the backlight is the kicker. In its broadest sense, the term *kicker* can apply to any sort of effect that highlights an additional feature in a shot. In its narrower sense, which I am using here, *kicker* refers to a lamp that is positioned approximately forty-five degrees behind the actor, "kicking" off the actor's cheek, as in the close-up of Farley Granger from *Side Street* (see figure 3.2B). Kickers are more common with men than they are with women, partly because longer hairstyles prevent kickers from hitting the cheeks of women, and partly because the kicker's emphasis on the jawline was deemed more suitable for masculine portraiture.

A GLIMMER IN THE EYE

One of the subtlest effects in the cinematographer's tool kit is the *eyelight*, also known as *catch light*.[18] The term refers to the little point of light reflected in an actor's eyes, as in several of the illustrations seen so far: Bennett, O'Donnell, Granger, Hatfield. The glimmer in Durbin's eyes is particularly effective, bringing her eyes out of the gloom. In some cases, the eyelight is simply a reflection of the key light or fill light; in other cases, the eyelight is an added effect, produced by a tiny lamp that is there to generate that special sparkle. For examples of the latter, see the carefully crafted portraits of Merle Oberon in mid-1940s movies such as *The Lodger* (1944). The cinematographer Lucien Ballard allegedly invented this type of lamp to photograph Oberon, whom he married the following year. Some sources say that Ballard's goal was to hide Oberon's facial scars, which were the result of a car accident.[19] Other sources say that the goal was to whiten Oberon's skin onscreen, hiding the fact that the Indian-born British star was of mixed-race ethnicity.[20] Ballard continued to use this type of lamp long after he and Oberon divorced, and the term *Obie* became a synonym for an eyelight—any lamp placed on or next to the camera to produce that glint.[21]

CASTING SHADOWS

Now that you have placed your lamps, you can fine-tune the lighting with the help of grip equipment, such as flags, scrims, silks, and cookies. A *flag* is a piece of cloth attached to a frame, which can be positioned in front of a lamp to create a shadow. A *scrim* or *net* is a lighter piece of fabric that reduces the intensity of the illumination without blocking it completely. A *silk* is a piece of fabric that softens the light by diffusing it, producing a shadow with a gentler penumbra, the way a cloud passing in front of the sun diffuses the shadows on the ground. A *cucoloris* or cookie is a piece of wood or fabric with holes cut into it to produce a dappled effect.[22]

In figure 3.6, from *Mildred Pierce*, the key light produces the butterfly lighting on Joan Crawford's face, but a piece of grip equipment (namely, a flag angled in front of the key light) produces the diagonal shadow across the star's forehead. The background shows additional grip work, as a network of flags and scrims produces a crisscross pattern. Note how the angled rectangle behind Crawford's head is slightly darker than the adjacent triangle. The rectangle shows the work of a scrim, darkening the wall slightly without going black. The effect of all this trickery is deeply symbolic: Mildred's movement from the shadow into the light coincides with her passage from ignorance to knowledge. But the modeling function is just as important. By rendering the nuances of Mildred's movement, the lighting positions her more firmly in this particular space. One moment, we see that she is standing *back there*. The next moment, we can see that she is standing *up here*.

These are the basics—the tools in your tool kit. You have key lights, fill lights, backlights, eyelights, grip equipment, and all the various ways they can be

FIGURE 3.6. *Mildred Pierce* (1945): A network of flags and scrims creates shadows.

combined. With these tools, you can make almost anyone look beautiful, sinister, or utterly ordinary.

ON GENDER AND RACE

In *Hollywood Lighting from the Silent Era to Film Noir*, I argued that Hollywood cinematographers preferred side lighting for men and frontal lighting for women—not in every shot, but as a default norm that could be adjusted to suit varying situations.[23] Frontal light favors smoothness; side light favors ruggedness. Cinematographers frequently described their practice in these terms, and the films consistently support their accounts. However, these terms (*front* and *side*) now seem overly ambiguous. Does *side* mean to the side of the actor or from the side of the camera? The new terminology (*butterfly*, *loop*, *Rembrandt*, and *split*) allows me to expand on this point with greater precision. Front and side are defined in relation to the camera; butterfly, loop, Rembrandt, and split lighting are all defined in relation to the actor's face. Butterfly lighting and loop lighting were preferred options for women; Rembrandt lighting and split lighting were preferred options for men. Here is the longtime 20th Century-Fox cinematographer Arthur C. Miller on his strategy for lighting women: "I usually try to put the nose shadow down and just above the corner of the mouth, so the tip of the nose falls above the corner of the mouth. That is portraiture technique."[24] Translation: loop lighting. Other

commenters recommended using less fill light and more extreme placements for men, on the grounds that the actors should "appear as masculine as possible."[25] The stated goal was to make the hardened structure of men's faces more visible.

Noir lighting conventions grew out of these gendered codes, while exploiting their variability. Some noirs intensify the codes, making the men seem lined and weary (think of Sterling Hayden in *The Asphalt Jungle*) and the women seem exceptionally glamorous (think of Rita Hayworth in *Gilda*); other noirs reduce or invert the gendered codes, making the men seem strikingly beautiful (think of Burt Lancaster in *The Killers*), and making the women seem realistically ordinary (think of Shelley Winters, photographed in wide angle, sans backlight and sans diffusion, in *He Ran All the Way*, 1951).

The guidelines for gender were quite explicit. Articles in *American Cinematographer* routinely explained how to light men differently from women. Assumptions about race were spelled out less explicitly, but it is clear that filmmakers adopted a standard of white feminine beauty as the highest ideal, to the exclusion of other kinds of beauty. Here are three pieces of evidence that bring some of those assumptions to the fore—even as they open up some lingering contradictions.

Hollywood's baseline assumptions about race were established well before the noir period. Lewis Physioc was a former lab technician who worked as a cinematographer during the 1910s and 1920s and then as an editor at the trade journal *International Photographer* during the 1930s. In 1921, he published an article in the fan magazine *Picture Play* that featured several photographs of the Venus de Milo, lit in various ways to demonstrate what modeling could do. Physioc was so pleased with these photographs that he wrote an entirely new article using the same illustrations for *American Cinematographer* in 1928. The same journal reprinted this second article the following year. In 1933, the 1928 article appeared a third time, featuring those same old Venus de Milo photos, in *International Photographer*.[26] All these articles bear different titles, most of which are variations on the theme of depiction-as-deception: "The Witchery of Lights," "Does the Camera Lie?," and "Lighting: The Magic of Cinematography." For Physioc, deception is a good thing. It proves how powerful the cinematographer can be. According to Physioc, good lighting reproduces the Venus "in all its feminine delicacy and charm," while bad lighting turns her into a "stupid, gross featured, flat nosed, blear-eyed individual."[27] In the hands of an artist, lighting can reshape each subject entirely.

The choice of the Venus de Milo as a subject established a classical and specifically European ideal of femininity as the default norm for beauty.[28] Physioc also denounced the supposed defects of a broad nose or thick lips. Making the racist logic behind his thinking even more explicit, Physioc's first article included one additional photograph: an image using "strong contrast of light and shadow on the face" to emphasize a character's "sinister" expression.[29] The image is a publicity photograph for a Chinatown-set thriller, and the character in question is a white actor dressed in yellowface makeup. The juxtaposition proposes a strict binary logic: lighting should make white women like the Venus look soft and rounded,

but it should make Asian villains appear dark and dangerous. Well before the emergence of noir, many Asian-themed Hollywood thrillers were putting this logic to work in bluntly racist ways. See, for instance, the dreadful thriller *The Mask of Fu Manchu* (1932), wherein Sheila (Karen Morley), an innocent white woman with blonde hair, is often illuminated with well-filled Rembrandt lighting, whereas Dr. Fu Manchu's evil daughter (played by Myrna Loy in yellowface) routinely receives unflattering low-key lighting from below. Similarly, in *Shadow of Chinatown* (1936), a biracial villain played by the horror star Bela Lugosi receives lighting from below in a big-close up, even though the lighting in the wide shot is completely different.

My second piece of evidence illustrating Hollywood cinematographers' shared assumptions about lighting and race is a 1942 article by Karl Freund, the celebrated German cinematographer who was by then an Oscar-winning cameraman at MGM. Freund ponders a narrow technical question: Should the figure lighting change depending on the brightness of the background? Freund's article spends several paragraphs explaining why the answer is a simple no. The cinematographer may adjust the general illumination to make the background bright or dark, but the figure's modeling should look the same regardless. The article features four illustrations, each showing the same mannequin against a background that ranges from black to light gray. The mannequin represents an unsmiling bald woman with light skin, illuminated with a broad Rembrandt pattern. Even though Freund had won his Oscar for a film set in China (*The Good Earth*, 1937), he unambiguously takes this apparently white mannequin as a norm: "Assuming, of course, that the player's complexion and make-up are such as will give us a normal face to photograph, it is clear that to obtain a normal photographic rendition with a given emulsion and a given normal negative development, there can be but one correct exposure-value for that face, and but one correct printer-light setting, regardless of whether the background is photographically black or photographically white."[30] Freund offers no recommendations for photographing anyone without this particular complexion, and he offers only a single strict rule for photographing anyone with this complexion: make the skin tones look bright. These prescriptions implicitly define all other faces as abnormal. Indeed, Freund's norms are even narrower than Physioc's. Physioc at least manages to show that the same face can be lit ten different ways. Freund offers his readers exactly one option for lighting the face itself, based on the model of a seemingly white female mannequin, and he restricts all variation to the background.

The third piece of evidence is not a specific article so much as it is a recurring feature of cinematographic discourse. In interviews, Hollywood cinematographers often boasted that they took Old Masters painting as an ideal. The term *Rembrandt* lighting owes an obvious debt to this tradition, as does the term *north light*, which was Lee Garmes's phrase for his favorite lighting technique (and which I am calling *butterfly* lighting).[31] The phrase *north light* has a geographic basis, referring to the indirect light admitted by a north-facing window in the Northern Hemisphere.[32]

Of course, indirect light can be obtained in either hemisphere, and I see no reason to believe that seventeenth-century Dutch people are the only ones who can look attractive underneath it.[33] The problem involves the rhetoric: all those repeated invocations of north light as a guiding ideal encouraged cinematographers to take a certain kind of northern European painting as a model to be emulated, reinforcing European norms of representation and white standards of beauty. For Richard Dyer, the effect of all this Old Masters rhetoric has been particularly pernicious, leading Hollywood cinematographers to turn white female stars into ethereal creatures with smooth, bright skin.[34] If figure lighting is an art of modeling, then cinematographers had considerable power to construct their subjects' race and gender onscreen, using light and shadow to emphasize certain facial features and de-emphasize others.

John Alton's book, *Painting with Light*, extends this discourse of (European) artistry. Rembrandt makes another appearance, as does the Italian-inspired idea of chiaroscuro.[35] Although Alton does offer a few remarks about lighting women with different skin tones, his examples of glamour photography and portraiture overwhelmingly emphasize white women.[36] His primary example of lighting a woman with a different skin tone is Hattie McDaniel, who is lit unglamorously. The example illustrates how Hollywood's lighting practices amplified its openly racist casting practices. The Production Code specifically forbade representations of miscegenation, which effectively excluded actors of color from romance plots with white leads. Cinematographers rarely lit women of color for beauty because women of color were so often consigned to supporting roles. When the nonwhite characters were supposed to be glamorous, they were likely played by white actors in makeup, as when Gene Tierney performed in yellowface in Josef von Sternberg's early noir *The Shanghai Gesture* (1941).

These three pieces of evidence point to a shared conclusion. By looking to a specifically white and European tradition of art-making as a guide, cinematographers set severe constraints on how race might be represented. That said, all three of these pieces of evidence expose areas of tension and contradiction. Cinematographers may have agreed that close-ups should look like painterly portraits, but they did not agree on how to accomplish that goal. Even in the articles I have quoted, Physioc, Freund, Garmes, and Alton make strikingly different recommendations. What is more, Hollywood cinematographers often ignored their proposals. Physioc's preferred method of illuminating the Venus de Milo involves split lighting with a kicker. Hollywood cinematographers did use this technique over the next few decades—but the technique became a preferred option for men, not women. Karl Freund proposes lighting women so their skin tones will register at the exact same tonality onscreen every time, but the filmmakers of the 1940s simply did not follow Freund's reductive advice. Excited about the possibilities of film stocks that registered more detail in the shadows, cinematographers lit the faces of women and men from a variety of angles (loop and Rembrandt, mostly, but also butterfly, split, and occasionally from above or below), or they cast shadows across

their faces (as in *Mildred Pierce*), or they simply underexposed their faces outright (as in *Christmas Holiday*). The decade's variability extends well beyond film noir, as heavily modulated lighting appears in the family melodrama (*Since You Went Away*) and the Western (*My Darling Clementine*), too. As for Garmes and Alton, each produced a signature style, not one that was easily replicated.

We need to keep these contradictions in mind when we turn to the analysis of specific films. Hollywood cinematographers certainly idealized white feminine beauty, but they did so by using a range of shifting techniques, which often conflicted with the recommendations that appeared in the pages of the trade journals. Hollywood films tell stories grounded in conflict—conflict involving gender, race, class, age, urbanity, sexuality, national identity, modernity, and more. With the help of lighting, Hollywood cinematographers take these conflicts and turn them into *visual* distinctions, such as the distinction between the rich lawyer and his too-young companion in *The Asphalt Jungle* or the distinction between an embittered white criminal and a struggling Black musician in *Odds against Tomorrow*. As an art of depicting-as, lighting can heighten these differences or mitigate them; it can present them all too predictably, or it can upend our expectations. From this perspective, it is precisely the variability of lighting that gives the craft its representational power, for good or ill. Rather than reduce noir lighting to a single framework like low-key lighting or reduce Hollywood to a single framework like high-key, we should ask how the style of lighting changes over the course of the film to intensify, hint at, or destabilize the story's driving differences.

THE MODERNITY OF GLAMOUR

A framework of *depicting-as* can help us understand one of the defining traits of Hollywood figure lighting: glamour. Hollywood cinematographers use lighting to depict the stars and the characters they play *as* glamorous. Glamour, too, is made, not captured. Articles in *American Cinematographer* explained quite plainly that lighting was like makeup; both worked to modify stars' features.[37] Leonard Maltin once asked the MGM cinematographer Hal Rosson if he could make someone plain look glamorous. Rosson replied dryly, "It's been proven a thousand and one times."[38] Rosson, of course, worked for Louis B. Mayer, whose philosophy was "If you're selling beautiful women, *make* them beautiful."[39]

Like figure lighting in general, glamour lighting is shaped by cultural assumptions. To better understand these assumptions, I want to rewind the story to the 1930s, when many of noir's glamour conventions emerged. As the historian Stephen Gundle has shown, the word *glamour* entered widespread use only in the twentieth century.[40] He explains that the concept is "quintessentially modern," holding "the promise of a mobile and commercial society [in which] anyone could be transformed into a better, more attractive, and wealthier version of themselves."[41] In my previous book about Hollywood lighting, I regularly described the softly lit and softly focused close-ups of the 1920s as glamorous, but I now think

that my usage of the term was out of place.[42] *Glamour* was not a synonym for beauty. It referred to a particular kind of beauty: clean, hard, and modern. This conception of glamour only began to dominate Hollywood discourse in the 1930s. A 1931 article in the fan magazine *Photoplay* comments on the suddenness of the shift: "The movies have done it again! They've introduced a new word into ordinary conversation, started a new fad, begun a new cycle, created a new standard.... The new word is 'glamour,' the new fad is glamorousness, the new cycle is more glamour, and the new standard is more of the same thing."[43] The article's author, Katherine Albert, credits Greta Garbo with starting the trend, while pointing to Marlene Dietrich, Tallulah Bankhead, and Joan Crawford as representative examples. Albert specifically distinguishes the glamorous star from an older type, the ingenue, best embodied by stars such as Mary Pickford and Janet Gaynor. (Albert on Gaynor: "Sweetness and sunshine in its most advanced stages.")[44] The new glamorous stars play entirely different roles: sophisticated, dramatic, urban, and mysterious. Albert singles out Norma Shearer as a star who had successfully made the switch, and the article features two photographs of Shearer, one soft and demure, the other provocative and glamorous.

More than just a role, glamour is a style, featuring expensive clothing, sleek hairstyles, carefully worked makeup, and a bolder approach to lighting. Earlier, Shearer had tried to convince her husband, Irving Thalberg, to cast her in the title role of *The Divorcee* (1930). Thalberg doubted her ability to play the role convincingly, and Shearer approached a young photographer to ask him if he could make her look sexy.[45] The young photographer was George Hurrell, who crafted a fresh image for Shearer: older, modern, and a bit risqué. Shearer got the part (and won an Oscar), and Hurrell soon signed a contract with MGM. Over the course of the next decade, Hurrell would prove to be the most audacious practitioner of an emerging art form: the Hollywood glamour portrait. The glamour photography of the 1930s directly inverted the earlier norms of feminine portraiture. As the photography expert Mark Vieira explains, "When [Hurrell] came to Hollywood in 1930, a movie star photograph was soft and undistinguished, like a portrait from a Main Street salon. Hurrell introduced a bold new look: sharp focus, high contrast, and seductive poses."[46] In addition to mocking the soft-focus techniques that were still in vogue, Hurrell abandoned three-point lighting as a norm. Always experimenting, he would place a lamp at the end of a boom and maneuver it into unexpected positions.[47] He might position the lamp above and behind the subject's head to create a blazing halo and then bounce the light back into the subject's face to generate soft shadows from below. Or he might illuminate a star with a single source, allowing the background to go completely dark.[48]

The results could be unabashedly sexual, as in a famous portrait of Joan Crawford from 1932.[49] The single-source lighting models Crawford's figure, which gleams in white against a black background. Hurrell's technique was featured prominently in the trade journal *International Photographer*, and other photographers copied it.[50] When Loretta Young began a portrait session with the photographer Frank

Powolny, she told him, "Just take a look at those Hurrell things. That's what I want to look like."[51] RKO's Ernest Bachrach, Paramount's Eugene Robert Richee, and Universal's Ray Jones proved to be adept practitioners of the new style.[52] Their approaches varied, but they all produced images with harder shadows and deeper blacks—exactly the traits that would come to define noir in later years.

Meanwhile, Josef von Sternberg was bringing his distinctive brand of glamour photography to the screen in the series of films he directed starring Marlene Dietrich. Von Sternberg later took sole credit for inventing the Dietrich look.[53] His cinematographer Lee Garmes disagreed, sometimes asserting that he created the look himself, and sometimes acknowledging that John F. Seitz had done something similar a few years earlier.[54] Seitz, in turn, gave the credit to Rembrandt.[55] While I cannot settle this dispute, I offer a few clarifying points. First, the canonical form of Dietrich lighting corresponds to what I have been calling *butterfly* lighting, where the lamp is positioned above the star and creates symmetrical shadows on her face, particularly under the nose, cheekbones, and chin. Second, it took von Sternberg and his collaborators a few years to settle on this lighting pattern as Dietrich's signature look. Prior to his collaboration with Dietrich, von Sternberg had directed *Underworld* (1927) and *The Docks of New York* (1928). Both can be considered proto-noir, but neither relies extensively on Dietrich lighting. Nor does *The Blue Angel* (1930), where Dietrich more often appears in split lighting, reminiscent of the illumination used on Betty Compson in *The Docks of New York*. The butterfly pattern appears in *Morocco* (1930) and *Dishonored* (1931), but *Shanghai Express* (1932) seems to me to be the decisive film. After this movie, butterfly lighting would be the dominant pattern used on Dietrich for the rest of her career, with and without von Sternberg. Dietrich insisted on it. Even when she had a photography session with George Hurrell in 1937, she used a mirror so she could monitor exactly how she was lit. (He was furious.)[56] Third, although butterfly lighting may be combined with fill light and backlight to produce the familiar three-point scheme, the lighting produces its most dramatic effects when it is single-source. In a celebrated scene from *Shanghai Express*, Dietrich's character, Shanghai Lily, stands in the corridor of a train, flips a switch to turn off the lamps, and then looks up toward the lone remaining source. The resulting image is simultaneously very precise and radically simple. It is as if the filmmakers have reduced the craft of lighting to its barest essence, where everything rides on the pinpoint placement of a single lamp.[57] Look at how the butterfly pattern under Dietrich's nose comes *this* close to touching the curve of her lips (figure 3.7). Move the lamp an inch, and you lose the effect.

This look became iconic; the identical lighting appears in a still photograph taken by the Paramount photographer Don English to publicize this film. As we have seen, Garmes's preferred term for Dietrich lighting was *north light*. A true north light is indirect and therefore soft, with a gentle penumbra from highlight to shadow. Because Garmes's lighting is rarely this soft, his usage of the term is somewhat idiosyncratic. He could be referring to the idea of single-source lighting,

Lighting Characters 75

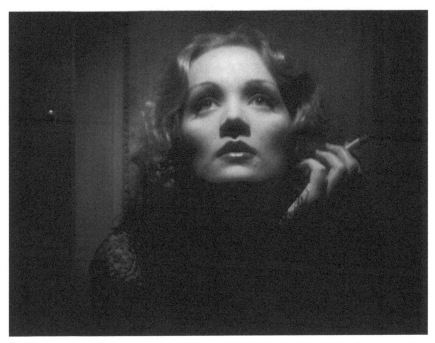

FIGURE 3.7. *Shanghai Express* (1932): As Shanghai Lily, Marlene Dietrich looks up toward a perfectly placed lamp.

where all the illumination appears to come from one lamp or window. Or he could be referring to light that comes from above. Or he could be referring to lighting that evokes the tenebrous atmosphere of a Rembrandt painting, with faces emerging mysteriously from a deep pool of shadows.[58] Garmes's *north light* is more of a rhetorical flourish than it is a technical term. It works to situate Hollywood lighting within the elevated tradition of northern European painting, even if it is vague as a functional descriptor.

The fact that Dietrich's close-up has become synonymous with Hollywood glamour reinforces the point that Hollywood consistently upheld white stars as exemplars of beauty. Still, we should avoid the simplistic conclusion that glamour lighting was a single set of techniques creating a single standard of beauty. Hurrell's photographs encompass everything from butterfly lighting to lighting from below. Unlike the ethereal ideal that it replaced, glamour works best when it is a little bit surprising.

Glamour also carried a hint of the exotic. This carefully managed sense of exoticism was the result of a transfer in which techniques originally associated with women of color were shifted toward white female stars. For instance, the MGM photographer Ruth Harriet Louise photographed Anna May Wong in 1928.[59] Louise used one strong source to illuminate Wong's face with loop lighting, and she let the rest of the shadows go very dark; the result is a startlingly high-contrast image

that gains much of its force from its rejection of the soft norms still in use in portraits of white women. Move the key light a few inches, and you get the style of lighting that von Sternberg would use a few years later to photograph Dietrich, Wong's costar in *Shanghai Express*. By then, the transfer had taken place: a technique once used to exoticize the Asian American Wong had become a technique used to exoticize a European star instead. We can think of the process as a kind of recentering, borrowing the associations of exoticism to make white feminine beauty seem more modern, daring, and transgressive.

A similar process shaped the arc of Hurrell's career. Hurrell first came to Shearer's attention after he had photographed the Mexican-born MGM star Ramon Novarro; he later photographed Dolores del Río and Lupe Velez, and he designed some of his boldest lighting effects for Anna May Wong. These examples suggest that the boundaries of Hollywood glamour were originally expansive enough to include Latin American and Asian American stars. (This was less true for Black stars, though Hurrell eventually produced several notable photographs of Black stars during his career resurgence in the 1980s and 1990s.) In a sense, stars such as del Río and Wong were the ideal subjects for glamour as it was originally conceived, precisely because their public images could so easily be constructed around an ideal of sexualized otherness. But the center soon shifted, as Hurrell and his peers took the modern ideal of glamour and applied it instead to Shearer, Crawford, and Jean Harlow, who became the new icons of glamour. Recall Gundle's proposal that glamour offers the promise of transformation. Hurrell's lighting transforms these women into different versions of themselves, and not just one new version but several: sometimes with their faces retouched to an impossible perfection, sometimes with their freckles showing, or sometimes with deeply tanned skin juxtaposed against a white dress or a platinum blonde hairdo. This was a modern privilege of whiteness: the ability to look totally different and normal at the same time.

Glamour's promise of (selective) transformation also applies to gender. Unlike the ethereal ideal, which was bound up with notions of soft femininity, the glamour ideal could be androgynous or masculine. Dietrich often appeared in drag, both in photographs and in film. As for Garbo, Alexander Doty explains that "queer sexuality and androgyny were already part of Garbo's star image by the 1930s."[60] Her regular photographers—first, Ruth Harriett Louise, then Clarence Sinclair Bull—used a wide range of techniques to represent her, sometimes conforming to the soft feminine ideal but just as often producing images with the strong contrasts previously reserved for men.[61] Applied to male subjects, the glamour treatment could look oddly conventional, as men were already associated with contrast and shadow, but it could turn transgressive whenever it transformed men into sexualized objects. (See, for instance, Hurrell's 1936 photograph of Robert Taylor, with elongated eyelashes and carefully modeled lips.)[62]

When the émigré photographer László Willinger arrived at MGM in 1937, he was unfamiliar with the word *glamour*. He was told that it combined sex with "a sort of

suffering look."[63] Sex and suffering—not a bad synopsis for a film noir. Indeed, the noir cycle would prove to be the perfect home for glamour photography, even after studio portraitists began switching to a more informal style in the 1940s. Noir's settings are usually modern, its characters are sexualized, and its themes involve danger and transgression, telling tales of mostly white protagonists exploring unfamiliar spaces on the margins of society. Yvonne Tasker has noted "the association of noir women with non-American national spaces and with ethnic tropes of Otherness."[64] Her examples include Kathie Moffat, played by Jane Greer, whose first scene takes place in Mexico; Gilda Mundson, living in Argentina and played by Rita Hayworth, the redheaded star with a complex ethnic heritage; and Elsa Bannister, also played by Hayworth, but now with a blonde hairstyle and a mysterious association with Asia.[65] (The films, of course, are *Out of the Past*, *Gilda*, and *The Lady from Shanghai*.) These are some of the most famous women in the noir canon. They are glamorous, and their glamour stems, in part, from this sense of the exotic.

With their deep shadows, many noir close-ups look like they could have been photographed by George Hurrell or one of his peers in still photography. But not all of them. As Lara Thompson has argued, light may illuminate a character's rise, and its absence may mark a fall.[66] The law of modulation can apply to glamour, too. The best cinematographers learned to be strategic: to savor those moments when they could light for maximum glamour and to look for moments where the lighting might shift to mark a turning point in the story.

MODELING AND MODULATION

My goal in this section is to list a few recurring narrative situations in noir, and to explain how cinematographers used the tools of figure lighting to render these situations creatively. What sorts of scenes called for glamour, and what sorts of scenes called for ordinariness, or even for ugliness? Of course, it is impossible to find one narrative template that fits all film noir. Some movies will feature several of the situations I discuss; some will not. The important point is that each of these narrative situations presented cinematographers with a recurring problem, a problem that modulation might solve.

> **Situation 1: Meeting the Most Beautiful Person in the World.** In one recurring scenario, a man looks up, and he sees a beautiful woman. She is so beautiful that he is willing to do anything for her, even commit a crime. This is perhaps the most canonical noir situation of them all. It does not appear in every noir, or even in half of them, but it represents a crucial turning point in the cycle's defining classics of the mid-1940s, such as *The Postman Always Rings Twice*, *The Killers*, and *Out of the Past*. (We might add *Gilda* to the list, but here the woman is not a femme fatale.) The challenge for the cinematographer is to create an image of *heightened* glamour, something that goes above and beyond the beauty standards that

cinematographers were expected to enforce every day. In *The Postman Always Rings Twice*, the cinematographer Sidney Wagner solves this problem by lighting the man and the woman differently—differently enough to ensure that the woman really stands out. Lana Turner receives loop lighting, eyelight, and a backlight. A flag casts a shadow over her forehead, drawing attention to Turner's sculpted eyebrows and sparkling eyes. In the wide shot, Turner angles her leg, which picks up a kicker light.

As in a painting of Venus, Turner's character Cora is looking at herself in a mirror. But the mirror is just a ruse: really, she is watching Frank carefully. (The scene is just as much about Cora watching Frank as it is about Frank watching her.) As Frank, John Garfield receives loop lighting, similar to Cora's but without the shadow over his forehead. His wrinkles remain visible, and there is even a slight hint of sweat on his brow. He looks handsome in a very physical way, like a man who just stepped in from a hot day. Frank leans back insouciantly. She is visibly posing; he is not, or at least he is posing to look like he is not posing.

The movie's representation of Cora differs from the book's descriptions. In Cain's text, Cora accuses Frank of mistakenly assuming she is Mexican because she has black hair, and she insists that she is white. Frank, in turn, speculates that her anxiety stems from being married to a Greek husband.[67] The movie has eliminated the issue by casting Turner as Cora and the British–South African actor Cecil Kellaway as her husband, Nick, now named Nick Smith. The result is an image of Cora as the incarnation of Hollywood's glamour ideals: young, white, blonde, and not at all ethereal.

> **Situation 2: Face to Face with the Grotesque.** Another recurring situation in film noir is the reverse of the previous one, focusing on a character who seems visibly unpleasant or even grotesque. Examples include the too-close close-ups of the corrupt lawyer Grisby from *The Lady from Shanghai* and the nightclub owner Phil from *Night and the City* (1950). Figure 3.8 shows a particularly extreme example from the period noir *Reign of Terror* (1949).

In the climactic scene, the members of the National Convention finally turn against Robespierre when he demands absolute power. The emotional key of the scene is intensely conflicted. This should be a satisfying moment, as we have been waiting for Robespierre's downfall for the entire movie. But the mob's bloodthirsty behavior is chilling, doubly so if we take their savagery as a metaphor for anticommunist hysteria in the United States. The editing moves briskly, and one deranged man after another calls for the death of Robespierre. When Norman Lloyd's character denounces Robespierre, Lloyd leans into a big close-up. The result is shocking, like the climax of a horror movie. The camera's wide-angle lens has the effect of distorting the actor's features. (To be more precise, the wide-angle lens allows the camera to get very close to the subject, and the proximity

FIGURE 3.8. *Reign of Terror* (1949): A montage of grotesque close-ups represents the fury of the mob.

yields an image with seeming distortion.)[68] By keying Lloyd from below, the cinematographer John Alton casts an unnatural-looking shadow up the center of his face, strengthens the wrinkles under his eyes, and produces an eyelight that is disturbingly off-center. A kicker completes the effect, highlighting the sweat on Lloyd's cheek and making the shadowed areas look darker via contrast. Like beauty, grotesquery is *made*, not captured: made by makeup, made by a performance, and made by the lighting.

Situation 3: The Tragic Fall. Many noirs have a tragic structure. The protagonist begins the story in a relatively happy place, but then things start to go wrong, and the tale ends in death. To modulate such a story, the basic logic is very simple: use appealing light when things are going well, and switch to less appealing light when things go wrong. The challenge is to devise a technique that will make the character look bad, but not *too* bad, since a star is a star after all. In *Edge of the City*, Sidney Poitier plays Tommy, a dockworker who befriends a troubled colleague played by John Cassavetes. Although Tommy dies before the end of the film, he is a rare example of a Black character who is also a fully developed noir protagonist—a tragic hero.

Poitier radiates charisma for most of the movie, and he is lit for star appeal, as in figure 3.9A, where a well-placed kicker draws extra attention to his dimpled smile. But then the story takes a bleak turn when a racist colleague baits Tommy

FIGURE 3.9. *Edge of the City* (1957): The lighting changes to amplify Tommy's tragic dramatic arc. *A (left)*: Tommy smiles. *B (right)*: Tommy faces death.

into a deadly fight, and the depiction of Tommy changes accordingly. The cinematographer Joseph Brun switches to a wide-angle lens for the fight scene. (Two years later, he would do the same thing for the climactic fight in *Odds against Tomorrow*.) The close-up is noticeably less flattering than before: there is no kicker to highlight Poitier's jawline, and the wide-angle lens appears to distort his features (figure 3.9B). The resulting close-up is not grotesque, as in *Reign of Terror*, but it is noticeably unglamorous. The sweat on Tommy's face carries an extra charge because the subject is Black, as Hollywood had long associated Black characters with signifiers of physical exertion. For much of the film, Tommy has been an engaging storyteller. Here, he is intensely physical, and physically vulnerable.

Situation 4: Walking into Danger. A character enters an unfamiliar space, somewhere charged with a sense of unease. The result is a passage of low-burn suspense: not yet an action scene, but a sequence of ominous atmospheric shots hinting at the danger the character is in. Versions of this type of sequence can be found in the horror-noir *Cat People* (1942), the political thriller *Cornered*, the detective movie *The Dark Corner* (1946), and the climax of Ida Lupino's *The Hitch-Hiker*. Most of the time, this sort of sequence challenges the cinematographer to light for milieu, creating an eerie setting that is suffused with tension. But lighting for milieu has knock-on effects for figure lighting. The space may look ominous because the people inside it look ominous, too.

I offer an example from a movie that is not usually classified as a film noir: *Green Dolphin Street* (1947), an adventure film set mostly in New Zealand (Aotearoa). In one scene, a roguish sailor visits a shop in China. The darkness immediately tells us that the sailor is walking into danger. A Chinese man (played by the Japanese American actor Tetsu Komai) is smoking a pipe in the background. A biracial woman steps into the foreground, and the sailor is struck by her exotic beauty. Lila Leeds, normally a blonde starlet, plays the role in yellowface makeup and a black wig. George Folsey's lighting is practically an homage to Lee Garmes's work in *Shanghai Express*: single-source, hard, with deep-black shadows. But Folsey has made a few adjustments to make the unnamed woman in *Green Dolphin Street*

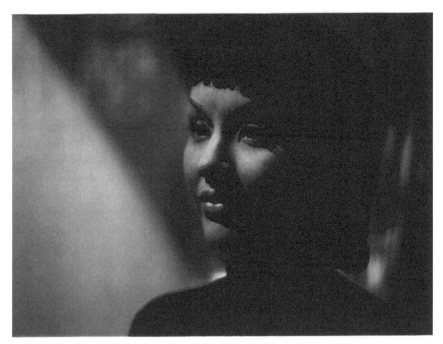

FIGURE 3.10. *Green Dolphin Street* (1947): Dim lighting identifies a biracial woman as dangerous.

look stranger, more dangerous. The short Rembrandt key light has been raised to an unusual height, and so Leeds's eyes disappear into the darkness (figure 3.10). In *Shanghai Express*, the eyelight lets us see Dietrich's eyes flit back and forth; her character seems alive with thought. In *Green Dolphin Street*, the shadow over Leeds's eyes makes her character's thoughts harder to read at a glance. Drawing on a pernicious anti-Asian stereotype, she has been depicted *as* inscrutable.

This is not to say that Asian and/or biracial characters are always lit this way in Hollywood movies. Dark and bizarre lighting remains one option among many—but it is made all the more likely here because of the specific demands of this scene. The ominous mood of the scene calls for darkness; the idea of seduction calls for glamour; the biracial identity of the character calls for something potentially unusual. Put these three together, and you get a shot like this, where a minor character appears dangerous, beautiful, and strange all at once.[69]

PROBLEMS, SOLUTIONS, AND PROBLEMATIC SOLUTIONS

I have offered this (very) partial list as a way of emphasizing the conventionality of Hollywood lighting. Hollywood movies told a familiar set of stories, and Hollywood cinematographers had devised a familiar set of tools to tell those stories. But conventionality did not preclude decision-making. Every depiction was also an

interpretation of the story: a decision to emphasize some aspects and de-emphasize others. Some solutions work perfectly; others reveal cracks in the process.

Consider a crucial turning point in Orson Welles's *The Lady from Shanghai*, photographed by Charles Lawton Jr. with an uncredited assist from Rudolph Maté. Michael and Elsa are sitting in a theater, which is staging the performance of a Chinese play. At long last, Michael realizes that Elsa is the primary villain. Should Elsa's lighting change? It is a scene of revelation, so maybe Elsa should be lit like a criminal, in shadow or from below. It is also a scene of dangerous exoticism, where Elsa's beauty is associated with the idea of Asia, so maybe Elsa should be lit glamorously but strangely. And it is a scene that hints at an idea that subsequent scenes will explore further, that Elsa may be insane, so maybe she should be lit bizarrely. That said, there are also good reasons *not* to change Elsa's lighting. It can be nonsensical to change a character's lighting midscene without proper motivation, even in a movie as nonsensical as this one. More to the point, studio bosses consistently pressured Welles to include more close-ups of Hayworth, and they certainly expected them to be beautiful.

An initial glance at figure 3.11 would suggest that the studio bosses won the day. For this crucial turning point, Rita Hayworth is lit the way she has been lit for the vast majority of the movie: in butterfly lighting, which casts a crisp shadow under her chin and a small, symmetrical shadow under her nose, while producing a vivid glimmer of light in both eyes. The glamour is especially noticeable in this case because it contrasts so starkly with the lighting on Welles, which recalls the grotesque lighting previously associated with Grisby: a side light from the right, a kicker from the left, and a dark shadow over both eyes. He looks sweaty and anxious, all the more so because she is lit to look ultrasmooth. Put simply, these actors do not look like they are inhabiting the same space. (Given that the movie was shot in fragments and reedited extensively, they may not have been.)[70]

The lack of modulation actually serves to make a dramatic point, a troubling one. As Andrew Britton writes, "Elsa is dangerous precisely because it is so terribly

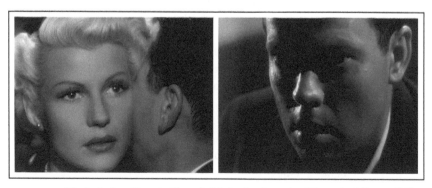

FIGURE 3.11. *The Lady from Shanghai* (1947): Michael realizes that Elsa is the killer. *A (left)*: Elsa, her glamour unchanged. *B (right)*: Michael, lit to look anxious.

difficult to deduce what she is really like from what she appears to be."[71] And so, the anti-Asian stereotype of inscrutability attaches itself to the lady from Shanghai, even in close-ups that heighten her dyed-blonde glamour.[72] Britton is no fan of this movie. He rightly charges that it indulges in the very misogyny that *Gilda* at its best manages to critique. Here, the misogyny takes the form of denying Elsa the kind of visual arc that is granted to Michael. Innocent victim or murderer, Elsa looks the same. That is why she seems so dangerous, so much the iconic femme fatale.

We can see filmmakers wrestling with similar sorts of storytelling problems in my two main examples, *The Letter* and *Phantom Lady*: how to light female protagonists and how to give shape to their dramatic arcs. Set on a plantation outside Singapore, *The Letter* uses figure lighting to articulate and reinforce a set of thematic contrasts and parallels. The contrasts involve race, gender, class, power, and colonialism; the parallels suggest hidden affinities across these oppositions. *Phantom Lady* is more overtly glamorous, with darker shadows and bolder arrangements. But the movie is also curiously antiglamour, suggesting that glamour threatens the protagonist's safety and perhaps even her identity.

THE LETTER (1940)

The Letter has never attained the status of a canonical film noir. The movie is not listed in the most recent edition of the *Film Noir* encyclopedia, even though it had appeared in earlier editions.[73] Perhaps the movie's release year (1940) has kept it on the edges of the canon, traditionally delimited by the years 1941 to 1958. Or perhaps the film's affinity with the women's melodrama has led noir aficionados to prefer other Bette Davis vehicles. Regardless, *The Letter* features many of the traits that would come to define the noir cycle: crime, fatalism, and darkness. At the very least, *The Letter* serves as a fascinating transitional case, showing how more canonical noirs built on existing studio conventions.

The story is set on a rubber plantation outside Singapore. Bette Davis plays Leslie, who murders a man named Hammond in the opening scene. She explains that Hammond had tried to sexually assault her. At first, her lawyer, Howard, believes that her case will go smoothly, but then he learns that the victim was married to a mysterious woman, identified as Mrs. Hammond and described as Eurasian. The trouble is that Mrs. Hammond possesses a letter that contradicts Leslie's story. The original draft of the screenplay was soundly rejected by Joseph Breen, the head of the Production Code Administration. As Breen explained, "This is the story of a wife, who murders her lover, but who, by lying, deceit, perjury, and the purchase of an incriminating letter, defeats justice, and gets off 'scot-free.'"[74] Breen recommended his usual remedy: punishing the woman in the name of compensating moral values. The screenwriter Howard Koch concocted a new ending. After Leslie wins her trial, she is murdered by Mrs. Hammond, who is then arrested by the police.

A longtime employee of Warner Bros., cinematographer Tony Gaudio had lit Davis several times before, most recently in *The Old Maid* (1939) and *Juarez* (1939).

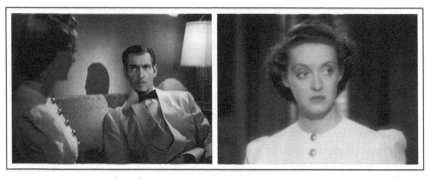

FIGURE 3.12. *The Letter* (1940): The lighting models Howard and Leslie differently. *A (left)*: Rembrandt lighting on Howard. *B (right)*: Flat butterfly lighting on Leslie.

Like many of his colleagues in the late 1930s, Gaudio was excited about Kodak's latest film stocks, which preserved more detail in the shadows: "On the old film you saw just a heavy mass of black graininess, now you see a real shadow."[75] A real shadow was not flat, but dense with detail. Gaudio also positioned himself as the leading champion of the Mole-Richardson Company's new spotlights, which allowed him to practice a technique he called "precision lighting."[76] The idea was to reduce the level of general illumination and use spotlights to pick out the details he wanted to emphasize. The results, he insisted, were more realistic, suggesting that characters were illuminated by sources from within the story's world. We can see Gaudio's precision lighting at work in a dialogue scene between Leslie and Howard. The characters sit on opposite ends of a small couch, which is positioned next to a practical lamp. The actor James Stephenson receives Rembrandt lighting from the right; Bette Davis receives flat butterfly lighting, with generous fill and a touch of backlight (figure 3.12).

Three points may be noted. First, both lighting schemes conform to existing norms for lighting men and women. The Rembrandt lighting sculpts Stephenson's features more strongly, while the flat butterfly lighting delineates Davis's chin, minimizes her nose, and emphasizes her eyes and mouth. Second, both schemes teach us about these characters, depicting them as people of a certain age; they are well-groomed but not dazzling. Gaudio chose a scheme that lets us notice the wrinkles on Stephenson's forehead and the lines under his chin. The actor's real age (fifty-one) is not the point; the point is that Gaudio depicted the character *as* a middle-aged man, and not as a fresh-faced romantic lead. By etching Howard's wrinkles, the lighting gently underlines the absurdity of his situation: here is a mature and respectable man compromising his ethics for the sake of a woman he does not even trust. Davis was thirty-two years old, and the smoother lighting emphasizes the age difference between her character and Stephenson's. At the same time, the flat butterfly pattern remains relatively simple, avoiding the excessive backlights or intricate flag work we might expect if the film were to depict Leslie as a glamorous socialite. There is so much diffusion on the lens that the image looks a little old-

fashioned, more Mary Pickford than Rita Hayworth. The lack of modern glamour is important because Leslie is not a calculating seductress. Leslie may destroy herself and everyone around her, but she is not malevolent. She is depicted as a soberminded adult—an ordinary woman in an extraordinary situation.

The third point is that Gaudio strikes a compromise between keeping the actors well lit and adhering to the spatial logic of the scene. The lamp behind Howard's shoulder motivates both the Rembrandt pattern on Howard's face and the flat butterfly pattern on Leslie's. The light does not come from nowhere; it comes from a source within the scene. Still, Gaudio is willing to cheat when necessary. At one point, Leslie turns her head, and a tiny precision spotlight turns on to illuminate Davis's head in the new position. It is utterly implausible if we notice it, but that is what makes it a successful bit of cheating: we are not supposed to notice it.

Over the course of the movie, Leslie's lighting shows a great deal of modulation, creating thematically significant parallels and contrasts. The first time we see Leslie, she is stepping outside and firing her gun. Her face is in moderate darkness, and we can see that the main house is illuminated by electric light. Cut to the newly awakened Head Boy, played by Tetsu Komai, who is sleeping in an open-air shelter. His face is relatively bright, and we can see that the shelter is illuminated by moonlight. The film is not yet a minute old, and it has already sketched a meaningful contrast, associating Leslie's house with electricity and the Head Boy's quarters with moonlight. This contrast duplicates the logic of colonialism, as Leslie's electricity carries connotations of technology and progress, while the workers' moonlight carries connotations of nature and cyclical time. Having sketched this contrast, *The Letter* immediately throws it into question. The clouds cover the moon, darkening Leslie and the Head Boy alike. For all their obvious differences, Leslie and the Head Boy are both shown to be subject to the laws of nature, as uncontrollable as the covering and uncovering of the moon.

Leslie will appear in a range of lighting arrangements over the course of the movie: under venetian blinds in her room, in the dim light of a window in the hospital, in the bright light of the courtroom. One of the movie's best scenes is very brightly lit. Howard tells Leslie's husband how much it cost to purchase the letter, and the dialogue remains entirely between the two men—but the high-key lighting lets us keep our eyes on Leslie, sitting tensely in the background of the shot as her life falls apart. It is a marvelous early instance of the deep-staging technique that Wyler would pursue more rigorously with Gregg Toland on *The Little Foxes* (1941).

For all its variability, Leslie's lighting remains more or less within Hollywood's norms for lighting white women, shifting between loop lighting and butterfly lighting. Mrs. Hammond's lighting breaks from those norms more radically. Her lighting is strange—indeed, estranging. The character of Mrs. Hammond was described as Chinese in the original story and in the subsequent play; the movie has redefined the part as biracial. The studio briefly considered Anna May Wong for the role, but instead it cast the Swedish American character actor Gale Sondergaard, acting in yellowface makeup.[77] I would say that Sondergaard's lighting conforms to the

conventions for lighting multiracial characters, but I think the crucial point is that Hollywood cinematographers did not have well-thought-out conventions for lighting multiracial characters, and so Gaudio did whatever he could do to make her look bizarre, threatening, and above all different. This is the craft of depicting-as: lighting renders Mrs. Hammond as ominously strange.

The contrast is particularly stark in the scene in which Leslie and Mrs. Hammond meet to exchange the fateful letter. Leslie and Howard go to a Chinese neighborhood in Singapore, and suddenly it seems as if the movie has changed genres, abandoning the high pretensions of the prestige drama in favor of the low suspense of the Chinatown thriller. In the original short story, Howard's assistant Ong must light a match to guide the characters through a hallway.[78] Here, Ong (Victor Sen Yung) leads his guests through a secret passageway to a smoke-filled room where a man is smoking an opium pipe. As Philippa Gates explains, dark passages and smoke-filled rooms were already familiar clichés of crime films set in American Chinatowns.[79] To prepare for this sequence, the Warner Bros. Research Department was asked to provide "Chinese den suggestions," summarized as "dark alleys, etc."[80]

In this mysterious environment, Mrs. Hammond steps out from behind a beaded curtain. Emphasizing the theme of racial boundaries, the lighting heightens the visual contrast between Mrs. Hammond and Leslie. Sondergaard receives lighting from two distinct sources: a top light that casts a long nose shadow down across her mouth, and a tiny spotlight that illuminates both eyes while two nets keep the spotlight off the top and bottom of her face. There is no rim light; instead, a diagonal pattern cast onto the ceiling ensures that Sondergaard's black wig stands out as black against the background (figure 3.13A). By contrast, Davis's key light makes her skin look smooth, and her backlight makes her hair look blonde, especially when contrasted with the darker background. At one point, Leslie leans forward, and the key light grows noticeably brighter, emphasizing the whiteness of her skin and adding a glow to Davis's famous eyes (figure 3.13B). This is probably the most glamorous image of Davis in the film; indeed, it resembles a publicity photograph for the movie, taken by none other than George Hurrell, who was now working at Warner Bros.

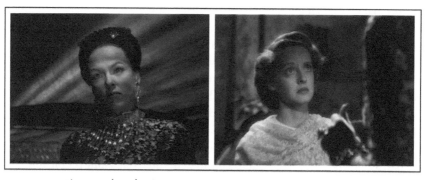

FIGURE 3.13. *The Letter* (1940): Shadows emphasize racial difference. *A (left)*: Bizarre lighting on Mrs. Hammond. *B (right)*: More glamorous lighting on Leslie.

This moment of high glamour is also a turning point in the story—the very moment when Mrs. Hammond expresses her utmost contempt, tossing the letter to the floor.

Gaudio employs different lighting schemes for the movie's Asian men. The man with an opium pipe is made up to look sweaty and unpleasant. By contrast, Ong looks smooth and elegant throughout the film. His elegance draws an equivalence between Ong and his employer, Howard; both men receive loop lighting, a subtle backlight, and bright fill. This seemingly egalitarian approach actually reinforces the film's skeptical presentation of Ong. Victor Sen Yung performs the part of Ong with exceptional precision, but Howard implies that he does not trust Ong because Ong works so seamlessly within the British legal establishment. The lighting supports Howard's (racist) critique, using the most unobtrusive techniques to comment on Ong's (implicitly dangerous) unobtrusiveness.

The lighting is usually dimmer on the Head Boy, who is much more closely linked to Mrs. Hammond. At the end of the film, a policeman arrives to arrest Mrs. Hammond and the Head Boy. A flashlight illuminates Mrs. Hammond and then the Head Boy, both from below. This lighting effect is characteristically noir, similar to the scene in which a policeman shines a flashlight on Doc and Dix in *The Asphalt Jungle*. But the technique also points backward to thrillers of the 1920s and 1930s, when it was a common tactic to demonize Asian villains by lighting them from below. The fact that the illumination comes from a flashlight continues the movie's opposition between moonlight and artificial light, as it is artificial light that exposes Mrs. Hammond and the Head Boy to scrutiny.

The scenes with the venetian blinds seem characteristically noir, but we should remember that Hollywood set designers routinely used them in films set in foreign countries. *The Letter* and *Torrid Zone* (another Warner Bros. production from 1940) are both set on plantations, but one is set near Singapore and the other in Central America. Both use venetian blinds to create an atmosphere of sultry tropicality. When the Twentieth Century-Fox cinematographer Arthur Miller discussed the use of blinds as a lighting technique, he cited his work on films set in "Eastern places": *The Rains Came* (1939), set in India; and *Anna and the King of Siam* (1946), set in Thailand.[81] *The Letter* takes the iconography of the blinds and ties it to the theme of fate. Early in the film, Leslie stands in her bedroom and looks at the moon, and a venetian blind effect casts diagonal lines across her face. It is a striking image, and the strikingness is the point: the image is so memorable that later variations on the motif feel like echoes. Later, Leslie opens the doors to the yard, initiating the evening walk that will culminate in her death. A wide shot shows Leslie's shadow cast along the floor, next to the shadow of the blinds. The rest of the scene continues this pattern of repetitions. A cloud covers the moon (again), Leslie's face darkens (again), and a murder takes place (again). Only now it is Leslie herself who is the victim.

The screenwriter Howard Koch described these climactic lighting effects in his script, and he even included a parenthetical comment emphasizing the very idea of repetition: "We see the dark shadow of the Eurasian woman cross the body. Then suddenly the shadow draws back and Leslie lies in the light of the moon. (The

purpose of this shot is to duplicate the previous business of Leslie's shadow on the body of Hammond.)"[82] Koch grounds the dramatic arc in the idea of an irreversible cycle. *The Letter*'s fatalism comes tinged with Orientalism, evoking a cyclical conception of time that is associated stereotypically with Asian cultures, especially in Hollywood movies. When Leslie steps outside, the repetition of the lighting effects (the blinds, the cast shadow, and the darkening of the moonlight) makes her death seem almost certain to happen. Note that the repetition need not be perfect to be legible as a repetition. Indeed, a key function of the repetition is to foreground variations and differences. In the first scene, Leslie is the killer; in the last, she is the victim. In the first scene, the sky darkens after the murder; in the last, it darkens before. In the first scene, the murder seems shocking and inexplicable; in the second, the murder seems inevitable and perhaps even justified. For these comparisons to take hold, the movie must make its visual repetitions *obvious*—so obvious that no one will miss the implication that they are of a piece.[83] Hence the recurring imagery of blinds and shadows. The images function as motifs to be lodged in the memory and called on again. The repetitions are so obvious that Leslie herself seems to notice them. As she walks through the yard, she sees her shadow cast upon the ground, and there is a powerful suggestion that she knows, deep down, that she is about to experience the night of the murder a second time.

This second murder brings three characters together for the finale: the white Leslie, the biracial Mrs. Hammond, and the Asian Head Boy. In the opening scene, the Head Boy was a passive witness, literally behind bars, powerless to stop Leslie from murdering Hammond. In the finale, the Head Boy takes a more active role, grabbing Leslie so that she may be knifed by Mrs. Hammond. The finale repeats the introduction, but it also inverts it. There is a strong hint of revolutionary consciousness in this inversion, suggesting that the servant is overthrowing the colonial master. However, the active/passive opposition is complicated in several ways. Leslie was not exactly active in the opening scene; she fired robotically, as if unaware of what she was doing. Arguably, Leslie is more active in the closing scene. If indeed she knows, on some level, that she is about to be killed, then Leslie has chosen her own death, like an existential noir hero. Meanwhile, the Head Boy's revolt against the colonizer is figured as a submission to Mrs. Hammond, following the Orientalist trope whereby Asian men are depicted as lacking in agency. For her part, Mrs. Hammond is driven by an impulse toward revenge, whether she destroys herself in the process or not. In different ways, all three characters are both active and passive, moving forward toward self-destruction. And so, this prestige drama from 1940 comes to a bloody end, featuring three people who have become characters in a film noir.

PHANTOM LADY (1944)

Phantom Lady was made by a formidable team of noir experts. The director was Robert Siodmak (*Criss Cross*, 1949); the producer was Joan Harrison (*Ride the Pink Horse*, 1947); the author of the source novel was Cornell Woolrich (*Deadline

at Dawn, 1946); and the cinematographer was Woody Bredell (*The Unsuspected*, 1947). The director and the producer would go on to make *The Strange Affair of Uncle Harry* (1945) together; the director and the cinematographer would collaborate again, too, on *Christmas Holiday* and *The Killers*.

The movie begins as a wrong-man thriller: Scott is falsely convicted of murdering his wife. But the story is not about Scott; it is about his secretary, Carol, who believes that Scott is innocent. With the help of Scott's friend Jack, Carol tries to find a mysterious woman (the "phantom lady") who can support Scott's alibi. What Carol does not know is that Jack is the killer, and that he is taking advantage of Carol's investigation to eliminate witnesses.

Cornell Woolrich published *Phantom Lady* in 1942 under his pseudonym, William Irish. In the novel, the revelation that Jack (known as Lombard) is the killer is delayed until the end. This allows Lombard to function as the book's coprotagonist, along with Carol. Woolrich adopts an alternating pattern, sometimes focusing on Lombard and sometimes focusing on Carol, as each character searches for the phantom lady. Oddly, most of Carol's scenes unfold without her name being mentioned: she is simply called *the girl*. The withholding of Carol's name sets up a twist: when Lombard finds a woman whom he takes to be the phantom lady, neither Lombard nor the reader knows that the woman is actually Carol, who is pretending to be the phantom lady to expose Lombard's villainy. The movie abandons this narrative trickery. Carol is clearly the protagonist, and Jack is clearly the antagonist. The movie's Carol also enjoys a victory that Carol does not enjoy in the novel: she finds the phantom lady. In her biography of the producer Joan Harrison, Christina Lane has explained how Harrison worked with Siodmak, screenwriter Bernard Schoenfeld, and star Ella Raines to reorient the novel around Carol's point of view.[84] The resulting film is a leading example of an important noir subcycle, which Helen Hanson has called the working-girl investigator story.[85] Carol sets aside her day job to solve a crime. In the process, she proves that the man she loves is worthy, tying the action plot and romance plot together.

The director Robert Siodmak was one of several German émigré directors who contributed to film noir. In Germany, he had codirected the proto-Neorealist *People on Sunday* (1930); in France, he had directed the proto-noir *Pièges* (1939), later remade by Douglas Sirk as *Lured*. Siodmak was particularly adept at the visual strategy I have called *modulation*, adapting his style from sequence to sequence to suit a story's changing mood. Several of his films of the 1930s, such as *Tumultes* (1932) and *The Burning Secret* (1933), begin with bright tonalities and then shift toward darkness as the drama intensifies. *Pièges* has a particularly vivid pattern of modulation. It is a musical comedy with a serial killer plot (!), and it alternates abruptly between light and dark. Alastair Phillips plausibly suggests that this alternation helped the film function as a calling card when Siodmak left France for Hollywood by showcasing the director's facility with a range of genres.[86] Siodmak brought these same skills to *Phantom Lady*, which also veers between light comedy and suspense.

The cinematographer Woody Bredell was one of noir's best—every bit as good, in my view, as John Alton and Nick Musuraca. As we have already seen (see figures 3.3B and 3.4), he explored the outer limits of what figure lighting could be, sometimes adopting aggressively unglamorous schemes (as in *The Killers*) and sometimes preferring excessively glamorous ones (as in *Christmas Holiday*). *Phantom Lady* is the story of a woman who adopts various personae to confront a series of unsavory men; as such, it gave Bredell the opportunity to vary the figure lighting throughout. Bredell's willingness to abjure Hollywood's glamour norms suited his collaborators. When Joan Harrison warned star Ella Raines that she might look shabby in certain scenes, Raines replied, "Goodness, Miss Harrison, I didn't work so very hard for years and years just to come to Hollywood and look pretty."[87]

In a landmark essay, Janey Place has shown how noir often contrasts two different types of women: the "spider woman" and the "nurturing woman."[88] One of Place's key insights is that the two types are lit differently: the spider woman receives more stylized lighting, while the nurturing woman tends to receive lighting that is more high-key. *Phantom Lady*'s Carol combines both archetypes: she is a nurturing woman who plays roles to help the man she loves, including roles that seem dangerous or sexualized. Her lighting shifts to match. Carol is introduced on a seemingly normal day at the office. Her life is conventional, and so is the lighting: loop lighting with a generous amount of fill and a kicker coming through the window (figure 3.14A). She looks appealing, but hardly unusual for a likable secretary in a 1940s film.

After the trial, Carol goes to a bar to confront the bartender, who falsely claims that he never saw the phantom lady. Carol's strategy is to unnerve the bartender by sitting at the bar and staring at him quietly all night. At first, she arrives wearing her work outfit: a blouse with white stripes. Later, she wears darker clothing, and the lighting is subtly different (figure 3.14B). Now there is less fill light, and the higher position of the key casts a slight shadow over her eyes. In comparison to the office scene, the lighting here is more unusual, with more modeling and stronger contrast, in keeping with the spider-woman connotations that Carol is trying to project. It is

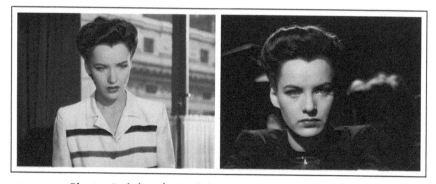

FIGURE 3.14. *Phantom Lady* (1944): Carol's lighting shifts when she moves from safety to danger. *A (left)*: Ordinary lighting at the office. *B (right)*: Glamorous lighting at the bar.

glamorous, but it deploys a particular kind of glamour: cold and unapproachable. With a few adjustments, the lighting might work for Marlene Dietrich.

The bar scene initiates a pattern whereby Carol's lighting changes with the situation. When Carol stands on a train platform during a tense suspense scene, she receives dim butterfly lighting on her face, similar to the beginning of *The Letter* and the ending of *Christmas Holiday* (see figure 3.4). When Carol meets Scott in prison, she receives a glorious backlight from a lamp beaming through the window. In between these two scenes, she appears in a notorious set piece with Cliff, a drummer played by the character actor Elisha Cook Jr. Cliff brings Carol to a room where his friends are playing jazz, and he starts to play the drums. Carol urges him on, and Cliff proceeds to play the drums with a demented frenzy that suggests masturbation. Carol's lighting is appropriately extreme: hard split lighting, with kickers on her cheeks but no fill light or eyelight (figure 3.15).

This image also owes a debt to glamour photography, but in a very different way, conveying forced sex appeal rather than sophistication. By the 1940s, the cultural status of glamour had become strikingly contradictory. In the pages of an elegant magazine, glamour still might suggest high culture: sophistication, wealth, and elegance. But glamour could also suggest raw sexuality and blatant commercialism. George Hurrell and his imitators had done much to exploit these lower connotations. The photographer once remarked, "Glamour to me was nothing more than just an excuse for saying sexy pictures."[89] His harder lighting and stronger shadows

FIGURE 3.15. *Phantom Lady* (1944): Split lighting leaves half of Carol's face in shadow.

were the perfect tools to sculpt an actor's face and physique. Bredell's lighting in the jam session scene is frankly garish, evoking a debased form of glamour photography. This shift in lighting teaches us about Carol's change in tactics. In the bar scene, Carol's tastefully dressed and carefully coiffed appearance suggests a quiet but unapproachable elegance, like that of someone firmly in control. In the jam session, everything about Carol's appearance is overdone—too much makeup, too many accessories, and too much modeling from those split lights and kickers. Carol is fully aware of her changed appearance. At one point, she looks at herself in the mirror with an expression of absolute disgust.

By using such extreme shadows, Bredell has taken advantage of a curious homology: the conventions of lighting women for glamour (whether of the elevated or the debased sort) are oddly similar to the conventions of lighting scenes for suspense. Both situations call for stronger shadows with more darkness. Another homology has to do with milieu: light and shadow can serve as signifiers of class. Carol's journey takes her through different social environments: middle, low, high, and back to the middle. Carol starts out with a respectable office job; then she visits a strange underworld of bars, streets, and jazz musicians; then she encounters a refined world of upscale designers and artists; finally, she ends up back in her office. Many of the locations during the first half of Carol's journey are conspicuously dark, including the bar, the elevated platform, the jam session, and Cliff's disheveled apartment. Many of the locations in the second half are conspicuously bright, including the upscale milliner's shop and the home of the phantom lady herself, who turns out to be a wealthy woman suffering from a mental illness.

The representation of class intersects with the film's representation of race, playing up the idea that Carol is a white woman who travels to the margins of society. In the book, Woolrich stresses the character's whiteness: "She was pretty. She was the Anglo-Saxon type, more so even than the Anglo-Saxons themselves are anymore. Blue-eyed and with her taffy-colored hair uncurled and brushed straight across her forehead in a clean-looking sweep."[90] The movie also emphasizes Carol's whiteness in various ways. Her oft-repeated nickname Kansas suggests a stereotypically white middle American identity, reminiscent of Dorothy Gale from *The Wizard of Oz*. In the courtroom scene, Carol is seated next to two curious onlookers when the verdict is read. Both of the onlookers are given slightly darker makeup than Carol's, and she receives a little extra light on her face, as if to ensure that we notice her fair-skinned features (figure 3.16).[91] Later, Carol meets with the police detective Burgess, who encourages her to investigate the crime. Burgess is played by Thomas Gomez, a Spanish American character actor. Burgess receives dim top lighting, which makes him look weary from guilt. Carol receives flat butterfly lighting, which makes her look smooth and ethereal by comparison. In both cases, the figure lighting (with the help of the makeup) is doing the work of depicting-as, depicting Carol *as* white, or even as white in an old-fashioned way, suggesting the innocent country girl who looks out of place in the modern city.

FIGURE 3.16. *Phantom Lady* (1944): Lighting and makeup emphasize the lightness of Carol's skin.

By contrast, the film associates its harder, more glamorous style of lighting with the diversity of the city. The first character to receive this style of lighting is the dancer Estela Monteiro (played by the Brazilian performer Aurora Miranda), who appears before Carol has entered the story. The phantom lady Ann and Scott are in a theater, and Estela is the main attraction. The lights dim, and a hard spotlight singles out Estela on the stage. The ensuing scene is played for comedy: Estela grows furious when she spots Ann in the audience and realizes they are both wearing the same style of hat. However silly, the joke introduces themes of identity and boundary crossing: Estela thinks of herself as unique, and she is upset to learn that this nondescript white woman can, in some sense, look like her, with the help of the right hat and a spotlight. The film will develop these ideas further when Carol gets dressed up to play a jazz-loving floozy to attract Cliff's attention. The sequence presents Carol as Ann's double. Like the phantom lady Ann, Carol is seated in the audience of Estela's performance. Like Ann, she is attracting attention with the help of an unusual costume. The parallelism highlights a contrast. Previously, Ann had inadvertently duplicated the look of a Brazilian dancer. Now Carol is self-consciously replicating the look of a jazz-loving "hepcat" (as Ella Raines called her).[92] Carol's performed identity comes loaded with connotations concerning jazz and therefore race. As David Butler has noted, film noir often exploited "existing stereotypes about jazz and, by extension, African American culture, linking its rhythmic pulse and hot

solos to notions of primitivism and bodies out of control, inevitably connecting jazz to sex."[93] When Carol enters the room with the jam session, she is entering a space that is coded as Black. Much of the scene's scandalous charge stems from the sight of Carol, a character previously associated with a white ethereal ideal, dancing to music that is so strongly associated with a sexualized notion of Blackness.

In the second half of the film, Carol's journey takes a different direction, toward the white upper classes, and she moves closer to the solution. Carol stops pretending to be a mysterious stranger or a hepcat, and her lighting returns to normal: bright butterfly lighting and loop lighting, with plenty of fill. Carol is also out of danger for the time being, which provides another reason to brighten the tonalities. The milieu has moved from low to high, providing a third reason to shoot scenes in a high key. Character, arc, and setting all call for brightness, and Bredell obliges with the high-key scenes in the milliner's shop and Ann's home.

After this pattern has been built up, the climactic scene in Jack's apartment poses a problem. Should the light remain bright because Jack's expensive apartment has been associated with bright daylight throughout the film? Or should the tonality turn dark because this is the moment when Carol faces the maximum amount of danger? Bredell's solution is to craft a compromise: the scene is dark, but not as dark as the scenes set in Cliff's apartment. Cliff lived in absolute squalor. (Jack: "I can feel the rats in the wall.") Jack's apartment looks much more elegant, even if it houses a quasi-fascist murderer.[94]

The location is rendered with just enough darkness to recall that earlier scene with Cliff, the scariest scene so far. Both scenes feature a quietly creepy performance from Franchot Tone. Both scenes culminate in a moment when Jack casts his shadow over his intended victim. And both scenes use light to showcase the killer's hands. In the earlier scene, Jack sits in the shadows and holds his arms up to the light as he delivers a monologue on the power of hands. In the later scene, Carol finds herself in a room with one of Jack's sculptures. The sculpture is a pair of hands, eerily illuminated to look exactly like Jack's hands before he killed Cliff.

To be honest, the climactic scene has always felt like a letdown to me. Carol has proved herself to be one of the most determined protagonists in the noir canon—a woman who spends the whole movie pursuing goals and overcoming obstacles. But the climactic scene makes her passive, waiting for Burgess to come to her rescue. The movie figures this shift in agency as a shift in lighting. Jack tells her to turn off the light, and she complies. She then finds herself in a bizarre space, where the main light sources are the spotlights that serve to illuminate Jack's artworks. Standing in the lights of Jack's apartment, she, too, seems like a sculpture—an object that he can manipulate and control.

The film's critique of Jack's manipulative artistry applies, oddly, to itself. A film is a pattern of lights and shadows. What do these lights and shadows do? They sculpt. They give shape. And so, the film's climax leaves us with this disturbing idea, perhaps the bleakest notion in what is actually a pretty optimistic film. For all her agency and all her energy, Carol, too, remains just a shape on the screen, modeled by the light.

4 · GENRE, ADAPTATION, AND THE ART OF UNFOLDING

As anyone who has read the seminal essays in the *Film Noir Reader* knows, critics do not agree on what sort of category the film noir should be. Is film noir a series, a tone, a style, or a genre?[1] How about a cycle, a movement, an offshoot, or a useful fiction? Surveying all these possibilities and more, Steve Neale makes a compelling case for skepticism:

> As a single phenomenon, noir, in my view, never existed. That is why no one has been able to define it.... Many of the features associated with noir—the use of voice-over and flashback, the use of high-contrast lighting and other "expressionist" devices, the focus on mentally, emotionally, and physically vulnerable characters, the interest in psychology, the culture of distrust marking relations between male and female characters, and the downbeat emphasis on violence, anxiety, death, crime, and compromised morality—were certainly real ones, but they were separable features belonging to separable tendencies and trends which traversed a wide variety of genres and cycles in the 1940s and early 1950s.[2]

To define noir, it all depends on the canon you choose. If you select *Double Indemnity* and *The Killers* as your exemplars, then flashback narration seems to be crucial, but not if you select *The Set-Up*, which is told chronologically. If you select *Scarlet Street* and *In a Lonely Place* (1950) as your exemplars, then a downbeat ending seems mandatory, but not if you select *Murder, My Sweet*, which ends with comedy and a kiss. And if you select *Stranger on the Third Floor* (1940) and *The Big Combo* (1955) as your exemplars, then expressionist black-and-white photography seems required, but not if you select *Niagara* (1953), which is photographed in garish color.

I agree with Neale that film noir was not a genre in the strong sense of the term—not until the 1960s or 1970s, when the neo-noir emerged as a recognized template that filmmakers could adapt and vary in the making and marketing of movies.[3] In particular, classical noir was not a genre that could be defined by a unique visual style, as there were plenty of non-noirs with shadowy styles, just as

there were noirs that look relatively bright. And yet I believe that genre was one of the most important factors in determining how classical noirs were lit. How can this be? Neale points toward a solution when he observes that most noirs would have been called *melodramas* in their time: "'Melodrama'—and the shortened and slangier 'meller'—were by far the commonest terms used to describe what are often now called noirs, whether they were hard-boiled detective films, gangster films, gothic thrillers and woman's films, paranoid thrillers, psychological thrillers, police films or semi-documentaries. However, if these terms were co-extensive with noir, they were by no means bound by its contours."[4] Unlike noir, *melodrama* was an industry term, appearing in trade journals, newspaper reviews, and industry memos. Filmmakers categorized many of the movies they made as melodramas, and this category presupposed a cluster of assumptions regarding narrative and lighting.

In film studies, the term *melodrama* most often refers to women's films, such as *Now, Voyager* (1942), or to sweeping family dramas, such as *Written on the Wind* (1956).[5] The studios used the term differently, often to refer to murder mysteries and/or thrillers. A common industry term for this type of film was the *suspenseful melodrama*. As Neale insists, this industrial category was much broader than the critical category of the film noir. Philip Marlowe movies were melodramas in this sense, but so were G-men thrillers and Nancy Drew mysteries. The category included assorted subgenres, cycles, and trends, whether identified by setting (e.g., the Chinatown movie), by emotional effect (e.g., the horror film), by narrative strategy (e.g., the sleuth movie), or by tone (e.g., paranoia). However expansive, the category was recognizable enough to appear in industry discourse for years. In an ad for the crime film *Alibi* (1929), one reviewer called the film "a highly suspenseful melodrama"; others called it a "meller," a "thriller," and an "underworld tale."[6] Over the next few decades, trade journals and fan magazines routinely used the term *melodrama* to identify crime films in their short reviews, and they often added the term *suspenseful* to modify that description, as in the references to the gangster film *He Was Her Man* (1934) as a "suspenseful melodrama"; to *The White Cockatoo* (1935) as a "mystery melodrama" and a "suspenseful melodrama"; to *The General Died at Dawn* (1936) as a "suspenseful melodrama in [a] Chinese war background"; to *The Mystery of Mr. Wong* (1939) as a "suspenseful mystery melodrama"; to *Suspicion* (1941) as a "well-produced, suspenseful melodrama"; to *Double Indemnity* as a "high-rating, suspenseful melodrama"; to *The Big Sleep* (1946) as a "tough, suspenseful melodrama"; to *The Unsuspected* as a "killer-chiller" and a "suspenseful melodrama"; to *Road House* (1948) as a "walloping, suspenseful melodrama"; to *Cause for Alarm* (1951) as a "suspenseful melodrama with a twist ending"; and to *The Hitch-Hiker* as a "taut and suspenseful melodrama."[7] A review of *The Woman in the Window* even noted that Fritz Lang was a "master of suspenseful melodrama from way back."[8] Other overlapping descriptions included "crime thriller" and "mystery thriller."

During the studio era, a film's genre would determine its lighting according to oft-articulated rules: If the movie is a comedy, brighten the tones. If the movie is a

romance, aim for the muted grays of a moonlit night. If the movie is a suspenseful melodrama, darken the shadows. With these rules in mind, one might propose the following ultrasimple explanation for the noir style: most Hollywood noirs look dark because cinematographers had classified them as *suspenseful melodramas* and lit them accordingly. I think that this straightforward claim is largely true, and that it explains a great deal about film noir. It explains why noirs look dark and acknowledges correctly that they are not the only films that look dark, since traditional detective stories and horror movies fall into the category as well. Just as important, the claim explains why noirs do not look dark all the time, since most suspenseful melodramas incorporate elements from romance, comedy, and other genres.

Some may worry that the straightforward claim goes too far. Stated baldly, it seems too all-encompassing, draining noir of its tension and edge. For years, scholars have argued that noir lighting is worth studying because it is antitraditional.[9] As Andrew Spicer explains, "Like any aesthetic innovation, film noir had to differentiate itself from the dominant conventions of what has been termed Hollywood's 'classical' style."[10] On this view, the classical style is clear and comprehensible, and noir stands out as daringly dark and obscure. My alternative account insists that darkness was a perfectly acceptable and even desirable feature in several important Hollywood genres, well before noir, in A films and intermediates as well as B films. This alternative has the happy effect of making the classical style seem more heterogeneous, but it may make noir seem *too* conventional, to the point that it seems uninteresting.

We can retain noir's potential for stylistic innovation (combined, in some cases, with social critique) by reintroducing the power of narrative dynamics that I discussed in chapter 2. Noir lighting conventions were rules of a particular sort: conventions of *configuration*, shaping our sense of each story's unfolding shape. Conventions of configuration work when they generate expectations that are fulfilled, and they also work when those same expectations are subverted or altered, as when a melodrama suddenly turns into a musical, or when a romance suddenly shifts toward suspense. Rather than assume that dark lighting is always a signifier of doom, we might ask how noirs exploit the full range of generic lighting conventions to lead us—and mislead us—toward the feelings of uneasy hope and blackly comic despair that continue to give these films a distinctive emotional appeal. From this perspective, the fact that many noirs are not uniformly dark is hardly an anomaly; the possibility of variation *enhances* their emotional range. A noir may shock us by playing a crime scene in broad daylight, or it may play on our deepest anxieties by making the bleakest outcomes seem all too predictable.

LIGHTING FOR GENRE

Proto-noir lighting effects appear in crime films from the 1910s, and they became fully standardized over the next few decades.[11] Articles in the trade journals spelled out the principles of lighting for genre clearly and often. As early as 1922,

Alvin Wyckoff explained, "In a scene with a happy atmosphere the shadows are light. If the scene calls for an expression of hatred those same shadows would be deeper and blacker."[12] In 1930, A. Lindsley Lane recommended brilliant illumination for farce and obscurity for murder mysteries.[13] The same year, Victor Milner proposed somber lighting for drama, high-key lighting for comedy, and strong contrasts for melodrama. His examples of melodrama included the contemporary thriller *Alibi* and the racist crime movie *Dr. Fu Manchu* (1930).[14] In 1933, Charles Lang postulated a spectrum of possibilities, with melodramatic stories on one side, broad comedies on the other, and dramas in the middle. His category of melodrama included topical crime films like *Scarface* (1932) and horror films like *Dr. Jekyll and Mr. Hyde* (1932).[15] John Arnold expanded the list to five categories: the drama, the melodrama, the realistic movie, the comedy, and the romance.[16] The melodrama's boundaries shifted from article to article, but the genre usually included some combination of mystery, crime film, realistic drama, and horror film. However variable, the category of the *melodrama* gave each cinematographer-theorist a baseline expectation that the movie would contain strong contrasts and deep shadow. The cinematographer Virgil Miller went from shooting *The Phantom of the Opera* (1925) in the 1920s to Mr. Moto movies in the 1930s to Sherlock Holmes movies in the 1940s, and he insisted that low-key effects were suitable for all.[17]

Throughout the 1930s, we can find proto-noir sequences in mysteries such as *Guilty Hands* (1931), gangster films such as *City Streets* (1931), horror films such as *The Island of Lost Souls* (1932), action movies such as *Prison Train* (1935), Asian-themed thrillers such as *The General Died at Dawn*, and even screwball-mystery hybrids such as *The Mad Miss Manton* (1938). Consider the case of *Miss Pinkerton* (1932), a comedic mystery starring Joan Blondell. The story is about a nurse who solves a mystery, and so it fits neatly into the suspenseful melodrama category as cinematographers were defining it. The most suspenseful scenes shift decisively toward shadow, as when a streetlamp casts a large shadow over the front of a house or when a suspicious butler is inexplicably lit from below. When Blondell's Nurse Adams uses a flashlight to look for clues in the dimly lit library, a side door opens, and a cast shadow reaches for Adams's throat (figure 4.1). Is this film a lost masterpiece—an unheralded precursor to film noir? Not really. Its tone is not remotely noir: the movie is upbeat, brisk, and a little bit silly. The film's cinematographer was Barney McGill, a competent professional but hardly an innovator. Most of the lighting is eerie but nonsensical, lacking the detailed attention to milieu that characterizes the best noir work. My point in citing *Miss Pinkerton* is not to champion this goofy mystery but to show that its darkness was pretty routine, even in the 1930s. Cinematographers had decided that tales of murder and mystery called for shadows long before the canonical noir period began.

Another recurring trait of the suspenseful melodrama was effect lighting—that is, the imitation of real-world lighting effects, such as lamplight or moonlight. Characters in melodramas stand over fireplaces, flashlights, and candles; they sit next to windows, with or without blinds, and underneath light bulbs, with or

FIGURE 4.1. *Miss Pinkerton* (1932): A cast shadow menaces the protagonist of a 1932 mystery.

without shades. In the topical melodrama *The Yellow Ticket* (1931), a climactic shooting happens next to a table lamp, which casts a hard shadow of the protagonist on the side wall. In the horror classic *The Mummy* (1932), an exercise in mind control takes place above a burning candle, which illuminates Boris Karloff from below. Both movies combine low-key lighting with effect lighting, using the latter to produce the former. The eminent cinematographer Arthur Miller once admitted that he used the terms *low-key lighting* and *effect lighting* interchangeably. He thought the techniques were equally well-suited to crime movies and romances.[18]

Almost all cinematographers agreed that suspenseful melodramas should look dark; they did not always agree on why. In his 1930 article, Lane hinted at a narratological explanation. Mysteries hide things by definition, so the lighting must include some dark patches to keep the spectators guessing.[19] John Arnold proposed a nearly opposite explanation, arguing that dark shadows work together with crisp highlights to make the action easy to read, suitable for melodramas with scenes of physical struggle.[20] Some characterized the mood of melodrama as harsh and realistic (appropriate for a story based on a headline-grabbing current event); others saw high-contrast lighting as strange and bizarre (appropriate for horror films and tales of abnormal psychology).[21]

The conventionality of low-key lighting becomes particularly apparent in comedies and dramas that switch to the mode of suspenseful melodrama when a character is about to commit a crime. As Arnold explained, "No picture is going to

sustain exactly the same mood throughout all of its many hundred scenes and set-ups."[22] Arnold's studio, MGM, produced several films starring Greta Garbo during the 1930s. They were photographed by William Daniels and operated by Lindsley Lane himself. All these movies could be categorized as romantic dramas, and they are filled with the beautifully crafted close-ups we expect from a Garbo movie. But many of these films also contain crime scenes, such as the theft in *Mata Hari* (1931), the attempted rape in *Susan Lenox—Her Fall and Rise* (1931), and the murder in *Grand Hotel* (1932). Whenever the story shifts toward melodrama, Daniels adjusts his style, generating harsher contrasts with more prominent shadows. For these short bursts, Greta Garbo's movies look oddly like Bulldog Drummond movies.

The shadowy conventions of melodrama gained familiarity in the trade journals. In 1938, *International Photographer* ran a series of still photographs with dark, looming shadows, exactly the sort of imagery that would later come to be known as noir. Although the journal described the lighting effects as "unorthodox," it referred to the photos as the "mystery and macabre effect type of shot," implying that the images were routine for certain kinds of stories.[23] By the 1940s, the basic idea that suspenseful melodramas called for dark lighting was accepted throughout Hollywood, and not just among cinematographers. Consider a pair of memos dictated by Darryl F. Zanuck, head of production at Twentieth Century-Fox. In 1945, Joseph L. Mankiewicz was preparing to direct *Somewhere in the Night* (1946), about an amnesiac war veteran investigating his mysterious past. In a memo to Mankiewicz and another producer, Zanuck wrote: "I am sure you both agree that *Somewhere in the Night* needs low-key photography with plenty of shadows and dark corners. The waterfront streets at night should always be glistening wet as if the fog has rolled in.... As I see the picture, it should be midway between *Laura* [1944] and *Hangover Square* [1945] from a photographic standpoint."[24] Zanuck expects the new movie's look to match that of Fox's existing suspense movies. This recommendation still leaves Mankiewicz room for variation, as the low-key style can lean toward the glamorous (*Laura*) or the gothic (*Hangover Square*).

A few years later, Zanuck dictated another memo, making his assumptions about the category even more explicit. Twentieth Century-Fox had just released *The Asphalt Jungle*, *Panic in the Streets*, and *Where the Sidewalk Ends* (all 1950). All three films had won critical acclaim, but all three were box-office disappointments. Ever alert to changing trends, Zanuck issued a warning to his stable of directors: "There have been entirely too many underworld stories—pictures of crime and stories with sordid backgrounds. This does not mean that all suspenseful melodramas of this nature are through. It merely means that the market has been overloaded and thus even excellent pictures in this category must suffer."[25] Zanuck was particularly worried about "downbeat" films with "unsympathetic" characters, especially those suffering from "psychiatric disorders"—exactly the sorts of movies that now seem canonically noir. Noting the recent success of MGM's *Father of the Bride* (1950), he encouraged his directors to explore family-friendly fare.

Zanuck's argument appealed to the overlapping logic of genres and cycles.[26] The suspenseful melodrama was a genre that had been around for a long time. The downbeat suspenseful melodrama seemed more like a cycle that had run its course. With his eye on the box office, Zanuck encouraged his directors to bring the cycle to an end.

Around the same time, John Alton was elaborating his theory of cinematography in *Painting with Light*. Known as a noir specialist, Alton had also mastered the conventions of comedy, as in the aforementioned *Father of the Bride*. Fittingly, he counseled variability as the key to the craft: "All throughout a dramatic picture the lighting fluctuates. We retain our gay sequences, which are lit brightly, gaily. Sad scenes are lit in a lower key. The mood of tragedy is enhanced by a strong contrast of deep blacks and glaring whites—shadows and highlights. In drama we light for mood, we paint poems. Lighting with its ups and downs becomes a symphonic construction, paralleling the dramatic situations."[27] Comparing lighting to music and then to drama, Alton reinforces one of his central ideas: lighting is a temporal art, working on our emotions as the story changes over time.

From the perspective of the noir historian, the fact that Zanuck and Alton agreed that suspenseful melodramas should be drenched in shadows may seem a bit disappointing. Far from being subversive, low-key lighting suddenly seems conventional, in the negative sense of the term: predictable, routine, traditional. One can imagine a less talented version of John Alton perusing a script and saying, "OK, this scene is comedy. Paint it bright. This scene is romantic. Paint it gray. And this scene is suspenseful melodrama. Paint it black." Every choice seems predetermined. Hollywood cinematographers boasted about painting with light. Were they just painting by numbers?

Happily, I think there is another perspective that allows us to read the genre conventions less rigidly, preserving the intuition that noir lighting at its best can be surprising and disturbing. This approach draws on the idea, familiar from literary theory, that genres shape our experience of a work's configuration.

THE CONFIGURATION OF THE STORY

Consider another passage from Lindsley Lane's 1930 article about mood lighting. Lane imagines a cinematographer lighting two hypothetical scenarios: the first, a story about a wealthy, happy wife preparing a birthday party for her beloved husband; the second, a story about an impoverished, sickly wife struggling to raise her child in a tiny flat. He advises the cinematographer to imagine the "psychologically-apropos chiaroscuro" for each scenario, and he suggests that the former will require a noticeably higher key, equating brightness with happiness and wealth. But then Lane adds a twist: What should the cinematographer do if the happy story turns suddenly to tragedy? While acknowledging that different filmmakers would answer this question differently, he recommends an *abrupt* shift toward intense shadows: "Thus is the blow delivered by the sudden tragedy to the audience

through the story participants, heightened by the subsequent abrupt and contrasting shadow chiaroscuro at the moment of tragedy."[28] Lane's solution is a clever bait and switch: use the bright lighting to trick spectators into expecting a happy story, and then surprise them with a sudden shift toward somber tragedy. The alternative solution—shifting gradually from moderately bright to moderately dark—would dull the impact of the effect by letting spectators predict the tragedy and prepare for it.[29]

Lane defines cinematic lighting as the manipulation of the spectator's emotions—a manipulation that unfolds over time. Once we are attuned to this time-based logic, we find it running underneath most of the era's recommendations about lighting for genre. For Victor Milner, "the lighting of a picture can not only heighten the dramatic atmosphere, but, like an overture, subtly prepare the minds of the audience to be in a receptive mood to that type of action."[30] The overture analogy is temporal, preparing the audience to experience a story that is about to unfold.[31] John Arnold's theory of genre asks readers to imagine an absurd counterfactual. What if a drama, such as *Romeo and Juliet* (1936), were photographed as a comedy? "We might confidently expect Romeo to do a comedy fall from Juliet's balcony!"[32] In this hypothetical, lighting serves to prepare the spectator for the scene to come, creating expectations (inaccurate ones) about what might happen next. The conventions of lighting melodrama function in much the same way, generating expectations that may or may not come true. Arnold describes dark shadows as "portentous"—that is, as omens pointing ahead toward a future that is about to get worse. Other articles in *American Cinematographer* refer to low-key lighting as "ominous" or suggest that lighting functions as a "visual prelude ... subtly paving the way for what is to follow."[33]

We can think of these lighting norms as conventions of *configuration*. I borrow the term from Peter Rabinowitz, a literary theorist who is interested in the norms that guide readers as they experience written texts. Rabinowitz explains:

> Rules of configuration activate certain expectations. Once activated, however, these expectations can be exploited in a number of different ways. Authors can make use of them not only to create a sense of resolution (that is, by completing the patterns that the rules lead readers to expect, either with or without detours) but also to create surprise (by reversing them, for instance, by deflecting them, or by fulfilling them in some unanticipated way) or to irritate (by purposefully failing to fulfill them). It is important to stress this point: a rule of configuration can be just as important to the reading experience when the outcomes it predicts turn out not to take place as when they do.[34]

Simply knowing that a work is a narrative creates a baseline expectation: something will happen.[35] We might not know what will happen, but we can reasonably expect some sort of event. Genres create more specific sets of expectations, which an individual work may exploit to achieve distinctive effects. If we know that a

work belongs to the genre of tragedy, then we can form the targeted expectation that things will probably end badly. One of Rabinowitz's main examples is Raymond Chandler's novel *The Big Sleep*. As a member of the mystery genre, the novel generates expectations that justice will triumph in the end. This expectation makes it all the more upsetting when the book ends with the wealthy and corrupt Eddie Mars unpunished.[36] This shattered expectation develops the novel's social critique—its charge that the rich enjoy the privilege of impunity. Rabinowitz draws a useful contrast between rules of configuration and rules of coherence. Whereas the former help readers predict where the work is heading, the latter help readers make sense of the work as a totality, especially when the work is done.[37] The very fact that Chandler's *The Big Sleep* leads readers to expect a final confrontation between Marlowe and Mars and then refuses to deliver on that expectation may be interpreted as a coherent choice in light of the book's bitter denunciation of wealth and power. (Compare this depressing ending to the ending of Howard Hawks's movie, where Mars receives a violent comeuppance.)

The concept of configuration gives us a flexible way of understanding the ways that cinematographers used genre conventions to tell stories *over time*. Far from requiring cinematographers to paint by numbers (matching comedies with bright highlights and melodramas with harsh shadows), genre conventions required cinematographers to make strategic choices moment by moment. Even the most upbeat Hollywood story may be filled with hints and feints, suggesting that the characters will fail before they are allowed to succeed. The rules of genre are powerful tools of direction and misdirection, precisely because they are so familiar. In the screwball mystery *The Mad Miss Manton*, the opening scene shows the title character, played by Barbara Stanwyck, investigating an empty apartment. The cinematographer Nick Musuraca carefully follows the rules of melodramatic lighting (figure 4.2). The pools of shadow set the stage for a suspenseful mystery, and indeed Manton proceeds to discover a dead body lying in this apartment. But then Manton's coat falls to the floor when she runs for the door, and we realize for the first time that she is wearing a baby doll dress (!), as if for a costume party. The movie has tricked us: what looked like a suspenseful melodrama will unfold as a screwball comedy with a mystery plot.

Melodramas are supposed to be dark, but so are dramas and romances. The overlap builds ambiguity right into the system. Are shadows suspenseful or serious? Is darkness scary or romantic? The resulting category confusion could prove to be a valuable storytelling tool. The suspenseful melodrama *Night Must Fall* (1937) features a tense scene between Danny, the enigmatic antihero, and Olivia, a woman who suspects that he may be a murderer. The scene unfolds in a kitchen, and the actors (Robert Montgomery and Rosalind Russell) stand around a candle burning in a lantern. The dominant mood is suspense: Olivia has found herself alone in a small room with a very dangerous man. The secondary mood is edgy romance: Danny insinuates to Olivia that she finds it exciting to be with him, and she worries that he might be right. Ray June's lighting is perfectly ambiguous, taking advantage

FIGURE 4.2. *The Mad Miss Manton* (1938): This 1938 mystery-comedy alternates between bright scenes of comedy and dark scenes of suspense.

of the fact that the conventions for lighting suspenseful melodrama and the conventions for lighting romance both call for shadows. The tonality is dark enough for suspense, but the modeling (Rembrandt lighting for Montgomery, loop lighting for Russell) is attractive enough for romance. What sort of scene is this: romance or suspense? It is hard to tell at a glance, and that is the point.

The examples from *The Mad Miss Manton* and *Night Must Fall* involve misdirection and ambiguity, but the genre conventions form equally meaningful configurations when they are employed with impeccable reliability. An uplifting comedy might favor bright lighting from beginning to end, accurately reassuring us that everything will work out no matter how many difficulties the characters encounter along the way. The brightness is not a just a blank or neutral choice; it signals to us that the dangers are surmountable. A serious tragedy might unfold in ceaseless shadows, giving the bleak conclusion a sense of inevitability by allowing us to predict it all along. The predictability is the point, casting a mood of gloom over everything we see.

Perhaps this last option fits the canonical ideal of the film noir: the unremittingly dark movie that expresses a tone of overriding despair. But most noirs are much more variable, activating many configurations at once.[38] As Hollywood films, they create an expectation of a happy ending. As suspenseful melodramas, they create an expectation of crime or action. As members of the downbeat cycle that was popular

in the late 1940s, they create an expectation of failure. The cinematographer may use the lighting to activate any or all of these narrative patterns, setting up a range of crisscrossing expectations, some of which will be fulfilled, some of which will not be. Approaching a film noir, we may ask three sets of interlocking questions:

1. How is this movie a suspenseful melodrama? When does it deploy shadowy lighting to activate the patterns of expectation associated with that genre? Does it fulfill those expectations or subvert them?
2. What other genres does the film draw upon? When does it deploy suitable lighting to activate the patterns of expectation associated with these alternative genres? Does it fulfill those expectations or subvert them?
3. How do these patterns of expectation interact and change as the movie unfolds?

By situating lighting within this configurational logic, we can better address the full range of lighting effects that appear in film noir: not just the prisonlike shadows but also the romantic backlights, the crisp newsreel effects, the somber grays, and the comedic bright spots.

A SHORT NOTE ABOUT BUDGETS

There is another way of drawing the link between genre and style, and that is to say that suspenseful melodramas were low-budget movies as a general rule, which benefited from the savings involved when they were photographed in a low key. This does not mean that all low-budget movies had dark lighting, but it provides at least a partial explanation for why many noirs look the way they do: shadows were a useful way to save money. Paul Kerr proposed this explanation in a thoughtful article from 1978, complete with a sensible warning against one-to-one correlations.[39] James Naremore added nuance to the argument, pointing out that many classic noirs were intermediates, rather than true B films, and that intermediates were in a good position to profit from the additional attention that an unusual style might draw.[40] And Sheri Chinen Biesen has adapted the argument to the wartime context, placing special emphasis on the era's restrictions on building costs and electricity.[41]

The cost-cutting argument seems like exactly the sort of argument that I might endorse. It is grounded in historical research, and it explains noir lighting in very practical terms, as a way of solving tangible problems that filmmakers faced every day. Still, I have my reservations about the cost-cutting argument. My initial worry is that the timing seems odd. If there is even a weak correlation between brightness and budgets, we would expect darker movies in the early 1930s, when Hollywood was struggling. When noir emerged in the first half of the 1940s, Hollywood was enjoying some its most profitable years ever.[42] Add in the fact that the cost of electricity was declining throughout the period, and it seems unlikely that a need to save money on electricity made movies darker in the 1940s.[43]

To be sure, lighting cost money. While electric current was comparatively cheap, the cost of paying the electricians to rig and operate the lamps could be significant. The low-budget classic *Stranger on the Third Floor* budgeted $520 for electric current and around $7,000 for electricians.[44] A few years later, the expensive flop *The Unsuspected* budgeted $750 for "electrical rental and expense" and over $60,000 for electricians.[45] The intermediate-level thriller *The Window* (1949) budgeted $700 for electricity in the studio, plus another $1,800 for a generator on location; labor costs were around $9,000.[46] These three movies spent similar amounts on current, but they spent more on labor. Still, the correlation between cost and brightness seems weak at best. All three of these movies contain expressive shadows, regardless of budget. Looking at the budgets for individual scenes raises further doubts. On the A film *Sorry, Wrong Number*, twenty-four electricians were budgeted for the night exterior scene outside Evans's home, and fourteen electricians were budgeted for the daytime interior scene in the penthouse hallway.[47] The former scene is one of the darkest in the movie; the latter, one of the brightest.

Perhaps these technical objections can be explained away, but the real source of my reservations has to do with how I conceive of Hollywood lighting as a general practice. The craft was grounded in dramatic progression, which requires both high-key and low-key lighting to work. Shifting the light from brightness to darkness at a key moment is one of the most powerful tools in the cinematographers' tool kit. I do not believe that big-budget filmmakers would have left this powerful tool unused. Most of the examples in this book are from major studios, and many of them are indisputably A movies. They show that high-budget filmmakers used low-key lighting, too—as long as the story demanded it. At the scene-by-scene level, the motivation is not cost cutting but storytelling.

ADAPTATION AND ATMOSPHERE

Of the hundreds of titles listed in the *Film Noir Encyclopedia*, over a third are adaptations of novels or published short stories.[48] Adaptation adds another layer to each film's configuration. The genre of the source material creates expectations about how the movie's story will unfold—expectations that the movie may go on to fulfill or overturn. Many of these expectations involve matters of plot and point of view, but they also involve descriptions, including descriptions of lighting.

The idea of adapting a paragraph about a shadow is slightly odd, I know. In literature, descriptions of lighting are optional: one can write an entire novel without mentioning a single lamp or shadow. In cinema, depictions of lighting are mandatory: every scene represents a space as light or dark, and every character stands in the illumination or the shadow. The art forms are very different, so much so that the most reasonable expectation might be to expect no real affinity at all. But a closer look at noir's source literature reveals that novelists thought very carefully about the contributions that lighting might (or might not) make to a story. Broadly

speaking, the writers of noir's source literature came to two different conclusions. On the one hand, some authors cultivated an atmosphere of suspense with long passages of description; on the other, some authors preferred to eliminate atmosphere in favor of a stripped-down aesthetic. The former approach appeared occasionally in the classic whodunit and became a major strategy of the suspense thriller. The latter, antiatmospheric approach was more characteristic of the hard-boiled style. This tension produced an odd historical irony. Film noir may have borrowed its cynicism from the hard-boiled novel, but it borrowed its atmospheric aesthetic from the suspense tradition.

David Bordwell has analyzed formal experimentation in three genres of mystery writing: the classic whodunit, the suspense thriller, and the hard-boiled detective story.[49] The classic whodunit features occasional passages of evocative description, as in this passage from a Sherlock Holmes novel: "There was, to my mind, something eerie and ghost-like in the endless procession of faces which flitted across these narrow bars of light."[50] Suspense novels take this atmospheric technique and stretch it to the limits, using the language of darkness and shadows to build a mood of uncertain fear that may last for pages on end. Mary Roberts Rinehart wrote the source novel for the previously mentioned thriller *Miss Pinkerton*. In several scenes, the nurse's narration lingers on the nuances of light and shadow:

> I had taken my pocket flash along, so that I had turned on no lights, and I went at once to the library. It was a dark and dismal room at any time, and I remember that, as I searched, there were innumerable creaks and raps all around me. I would find myself looking over my shoulder, only to face a wall of blackness that seemed to be full of potential horrors.
>
> And, not unexpectedly, the search produced nothing.[51]

Rinehart's prose, which I am calling *atmospheric*, relies on description to generate emotional appeals. We are told about the sights and sounds of this place (a "wall of blackness" with "innumerable creaks"), and we are told, unambiguously, what sorts of emotions these sensations might evoke (the darkness is "dismal," and the overall effect is one of "horrors"). A common feature of atmospheric prose is its dilatory effect on timing: the action seems to slow down. As Robert Spadoni has explained, atmosphere may deepen a story's emotional appeals even when it brings the action to a halt.[52] Here, we learn that the nurse's investigation "produced nothing" (for the time being).

During the 1940s, Cornell Woolrich emerged as a leading practitioner of this atmospheric tradition, and he supplied the source material for nearly a dozen noirs, including *Phantom Lady*, *The Chase* (1946), and *The Window*.[53] Like Rinehart, Woolrich crafts long passages of atmospheric prose to pull suspense out of scenarios where nothing happens. Many of these passages seem self-consciously cinematic; Woolrich is clearly writing with the movies in mind. Consider *Deadline at Dawn* from 1944. The protagonist Bricky is a streetwise taxi dancer who tries to

help Quinn, a naive boy from her hometown who is in danger of being arrested for murder. In one scene, Bricky and Quinn walk down a street at around 2:00 A.M. Woolrich writes:

> They came out into the slumbering early morning desolation, flitted quickly past the brief bleach of the close-at-hand streetlight, and were swallowed up again in the darkness on the other side of it. The streetlights, stretching away into perspective in their impersonalized, formalized, zigzagging pattern, only added to the look of void and loneliness. There was not a single one of those other, warmer, personal lights to be seen anywhere about, above or below, denoting human presence behind a window, living occupancy within a doorway.
> It was like walking through a massive, monolithic sepulcher.[54]

Woolrich chooses words with strong negative connotations: a streetlight *bleaches* the characters, the darkness *swallows* them up, and the overall impression is of a *void*. He reinforces how impersonal the illumination is by contrasting it with a warmer alternative. This counterfactual description leads to an evocative, if unsubtle, simile, comparing the city to a tomb.

Even the purplest prose can be purposeful. In *Deadline at Dawn*, the entire suspense plot is built on the foundation of time: the characters soon find a dead body, and they realize that they have just a few hours before the body is discovered. For the rest of the book, readers must situate the actions of the characters in relation to this very specific deadline. With its careful evocation of an empty city street, this passage establishes the idea of "early morning" firmly in our minds, just as the countdown toward dawn starts to tick. Later we learn that Bricky has a theory about the difference between day and night. The city is always evil, but at night it is *obviously* evil. If Bricky and Quinn can reach the bus station before dawn, they will be able to leave the city because its evil will seem obvious. If they wait until the daytime, then the city will look more manageable, tricking them into staying. A few pages after the passage quoted earlier, Quinn notes that the city looks "shady and dim" by night, "not very friendly." Bricky goes farther: "It's bad. And it's alive, it's got willpower of its own."[55] She continues to personalize the city for the rest of the night, positing it as the primary antagonist they must overcome. Bricky is, in a sense, an expressionist, asking Quinn to look beyond the surface appearance of things and to experience a deeper meaning.

Contrast Woolrich's atmospheric prose with a notably terser alternative from a hard-boiled classic. During the 1920s, Ernest Hemingway experimented with an approach later described as "camera-eye narration," limiting his prose to dialogue and seemingly neutral descriptions of outwardly visible actions and expressions.[56] His short story "The Killers" (1927) opens with the following passage:

> The door of Henry's lunch-room opened and two men came in. They sat down at the counter.

"What's yours?" George asked them.

"I don't know," one of the men said. "What do you want to eat, Al?"

"I don't know," said Al. "I don't know what I want to eat."

Outside it was getting dark. The street-light came on outside the window. The two men at the counter read the menu. From the other end of the counter Nick Adams watched them.[57]

Apart from the title, nothing in the passage indicates that the two men are hired assassins. They are simply described as two men who enter a lunchroom. Even the dialogue gives us no access to their thoughts, since both men claim not to know what they want. As the narrative theorist Seymour Chatman explains, "The reader must infer themes from a bare account of purely external behavior."[58] To be sure, the impression of neutrality is just an impression, carefully cultivated. The spare description evokes hardness, a masculinist rejection of emotional excess. The lighting—dim outside, with a streetlamp shining through the window—establishes the time of the day without elaborating on mood.

During the 1920s and 1930s, several hard-boiled authors, notably Dashiell Hammett and James M. Cain, adopted a similarly stripped-down approach. Their books feature extended passages of back-and-forth dialogue with minimal atmosphere. On the rare occasions when they describe how a space is lit, they do so tersely, with a quick reference to a lamp or shadow. In Hammett's novel *Red Harvest* (1929), the narrator is the Continental Op, a nameless tough-guy detective. (*Op* is short for *operative*.) Hammett renders the Op's no-nonsense attitude by giving him a dry, unsentimental narratorial voice. In one scene, the Op finds himself under fire from a nearby gunman shooting bullets through the window. He narrates:

> Across the street, I knew, was a four-story office building with a roof a little above the level of my window. The roof would be dark. My light was on. There was no percentage in trying to peep out under those conditions.
>
> I looked around for something to chuck at the light globe, found a Gideon Bible, and chucked it. The bulb popped apart, giving me darkness.[59]

The prose describes the progression from light to dark because it matters directly to the action. As long as the gunman is in shadow and the Op is under illumination, the Op is in danger. It does not matter if the shadow is *velvety* or *gloomy* or *ink black*, and it does not matter if the light is *harsh* or *blazing* or *soft*. Following the principle of economy, Hammett abjures such adjectives. The resulting prose accelerates the scene's momentum, giving the impression that the Op is a man who reacts quickly to his environment.[60] In mortal danger, the Op looks around, assesses the threat immediately, and devises a defensive solution. The Bible becomes nothing more than an object to be thrown across the room; light and shadow become aspects of the physical world to be manipulated for competitive advantage.

Hammett's lean prose is suited to his action-driven plots, just as Woolrich's more expressive prose is suited to his penchant for drawn-out suspense.[61] More philosophically, Hammett's bare description works to reinforce the Op's existential worldview, which refuses to ascribe special meaning to the facts of the physical world. Just a few pages prior to this scene, the Op has told a captured criminal: "I couldn't find anything to say except something meaningless, like: 'Things happen that way.'"[62] This is how the Op describes the world around him: things happen that way.

Unlike the Op stories, Hammett's novel *The Maltese Falcon* (1930) unfolds in third person. The result is even more resolutely external. Rather than tell us what Spade is thinking, Hammett offers one-word descriptions of the light that appears in a character's eyes. Sam's eyes *glitter* when Miles's wife wonders if Sam committed the murder. Brigid's eyes *glisten* with tears when Sam demands all her money. Casper's eyes *twinkle* when he negotiates with Sam for the black bird. Sam's eyes *shine* as he opens up the bundle containing the falcon.[63] The prose is terse, but again it is hardly neutral. These words are trimly connotative, and Hammett occasionally amplifies their significance with similes. When Joel learns that Spade has the bird, "his dark eyes [have] the surface-shine of lacquer."[64] The reference to lacquer suggests the idea of collecting antiques; it also adds a touch of exoticism to Joel, who is persistently described with Orientalist language characterizing him as a mysterious outsider.

The hard-boiled rejection of atmosphere was deeply ideological. For the hardest of the hard-boiled practitioners, traditional mystery writing was gendered as feminine. They endorsed a sparer style on the grounds that it seemed more masculine. According to James Naremore, Dashiell Hammett inspired the admiration of many modernists precisely because he "reacted against the vaguely 'feminine' tone of 1890s aestheticism by introducing a profound skepticism into realist narrative, and he stripped literary language of what Pound and others called 'rhetoric.'"[65] The rejection of rhetoric is itself a form of rhetoric, characterizing the masculine narrator as honest and unflinching or perhaps as brutal and cynical. James M. Cain makes the gendered implications of this antirhetorical rhetoric explicit in *Double Indemnity* (originally published in 1936). Walter's narration takes the form of a written confession. Assuming that readers know about the murder already from newspaper accounts, Walter takes pains to distance himself from the overwrought style of tabloid journalism. When he describes the decor of Phyllis's house, he notes, "The blood-red drapes were there, but they didn't mean anything. All these Spanish houses have red-velvet drapes that run on iron spears, and generally some red velvet wall tapestries to go with them."[66] Recognizing that red drapes lend themselves to connotative readings, Walter insists that no such reading is warranted: the red is simply a typical feature of this sort of California home. Near the end of the book, Walter returns to the problem of the drapes: "A woman feature writer had got in there and talked with Phyllis. It was she that called it the House of Death, and put in about those blood-red drapes. Once I saw that stuff

I knew it wouldn't be long. That meant even a dumb cluck of a woman reporter could see there was something funny out there."[67] Walter's misogyny extends to his prose style. He claims to have given a straightforward presentation of the facts, in contrast to the "woman reporter" who has overdramatized the story by calling the drapes "blood-red" and calling the location the "House of Death." It is women, he charges, who indulge in atmospheric description.

Of course, we have no reason to trust Walter or his judgments. Atmospheric prose can be highly effective not just as a tool for suspense but as a vehicle for psychological insight. Elisabeth Sanxay Holding's novel *The Blank Wall* (1947) tells the story of Lucia, a woman who covers up a crime to protect her family. This book inspired Max Ophuls's classic film *The Reckless Moment* (1949). Like Hammett, Holding avoids the creaky hallways that had become suspense-novel clichés. Unlike Hammett, Holding regularly gives us access to her protagonist's thoughts and feelings, both via her free indirect prose style and via her judicious use of atmosphere. Near the end of the book, Lucia must decide whether or not to betray the blackmailer Donnelly to the police, even though Donnelly has tried to protect her. To render Lucia's thoughts, Holding dedicates a paragraph to a description of sunlight: "She walked over to the window, and she was startled to see how it looked out there in the world; everything bathed in a clear lemon light; the course grass looked yellow, the leaves on the young trees were a translucent green, and trembling strangely in the strange light."[68] The pastoral imagery expresses Lucia's feelings as she imagines Donnelly escaping to freedom: she is *startled* to see this *clear, strange* light. A moment later, Lucia realizes that a detective has the power to make her betray Donnelly, and the light changes immediately: "She turned to face him [the detective]. The room was growing shadowy, and that made him very pale, his hair very black." A changing description evokes a changing mood. More generally, the book offers an extended exploration of Lucia's ever-shifting feelings about being a housewife, a role that sometimes gives her the strength to act decisively but that here traps her into making a choice she does not want to make.

The suspense novelist Dorothy B. Hughes also explored this intersection between the psychological and the social. In her novel *Ride the Pink Horse* (1946), the protagonist Sailor is a gangster who goes to Santa Fe to blackmail a corrupt politician. Sailor cannot find a place to stay, and so he wanders to the edge of town: "He walked on in the darkness, the shops growing meaner, the way more dark. Nothing across, a blatant movie house dark, he could pitch a tent in the lobby if he had a tent. Murky bars with muted sounds and sounds not muted. . . . And standing there the unease came upon him again. The unease of an alien land, of darkness and silence, of strange tongues and a stranger people."[69] The passage seems classically noir. Not only does the word *dark* appear several times; it is linked, quite explicitly, to the protagonist's feelings of alienation. What makes the passage memorable is Hughes's insistence on identifying the social causes of Sailor's alienation. The protagonist is a white man from Chicago, and the confusion he is feeling is a loss of identity as he realizes that he is in a city with a large and unfamiliar population, both Indigenous

and Mexican American. For the first time in his life, Sailor feels like an outsider. Faced with this alienation, Sailor turns around, hastily retreating from the margins back to the center. Many hard-boiled novels focus on alienated white male protagonists, but few subject their protagonists' alienation to this level of social critique.

PAGE TO SCREEN

Unlike a hard-boiled novelist, a filmmaker does not have the luxury of eliding the lighting from the scene whenever it seems irrelevant to the story. Every time, the filmmaker must strike a specific balance between narrative and description. The problem allowed a range of possible solutions. Adapting a book written with spare and unemotional prose, one filmmaker might prefer a flat visual style that does justice to the book's tone, but another might prefer intense chiaroscuro to take full advantage of cinema's expressivity. Adapting a book written with lavish description, one filmmaker might prefer a precise rendering of the novel's many moods, but another might prefer to reimagine its world from the ground up.

The 1946 adaptation of *Deadline at Dawn* is remarkably faithful to Woolrich's atmospheric aesthetic. The cinematographer was Nick Musuraca, who had been refining the craft of suspense lighting for years, rather amusingly in *The Mad Miss Manton*, more chillingly in *Cat People*. His lighting generates suspense by suggesting that bad things *might* happen, even when the suspense ends up being a false alarm. In one scene from *Deadline at Dawn*, Alex (Quinn in the book) goes upstairs to the room where he first discovered the dead body. A few moments later, June (Bricky in the book) goes upstairs and enters the same room. A wide shot reveals a man in shadow on the right side of the screen, and June steps forward into a classic noir composition: two silhouettes on opposite sides of the frame. The soundtrack spikes, suggesting a classic Woolrich uptick in suspense. Is June walking into a trap? And then we get a classic Woolrich deflation. June turns on a lamp, and the suspense dissipates immediately. The man in the corner is the harmless Alex, and he was more frightened of June than she was of him. The movie contains several moments like this—little scenes where the lighting works with the music to suggest that the characters are in danger. Sometimes, they really are in danger; just as often, they are not. Either way, the lighting does narrative work by generating an expectation of risk, which may be fulfilled, subverted, or subverted then fulfilled. It is this sense of anxious anticipation that creates the film's worldview—one in which threats seem to be omnipresent but nothing is certain.

Musuraca has given Woolrich the Woolrich treatment: lush and atmospheric. A more unexpected example of atmosphere appears in the opening scene of *The Killers*, directed by Robert Siodmak and photographed by Woody Bredell. Far from replicating Hemingway's faux neutrality, the movie's opening scene uses cinematic tools to play on our emotions, working in a stylistic register that is openly expressive. The musical score creates tension with its repeated bass notes and

unexpected stingers. The costume design makes the killers look out of place. The actors (Charles McGraw and William Conrad) give their characters cold and determined expressions. And the lighting is in rich chiaroscuro. At first, the two killers stand in near-total darkness. Then they step forward into the harsh glare of the streetlamp. As they turn and approach the diner, they become silhouettes, and one of the men casts an elongated shadow onto the street. Notice how my own language has slipped into a more connotative register to describe the effect of the film: *harsh* glare, *elongated* shadows. These are exactly the sorts of modifiers that a hard-boiled author might trim away.

When we recall that Siodmak and Bredell had collaborated on *Phantom Lady* two years earlier, it all starts to make sense. They have given Hemingway the Woolrich treatment. If this classic noir is such a deeply atmospheric adaptation of such a determinedly hard-boiled source, then it is just a short step to an interpretation that seems surprising: the crime movies that are so central to the noir canon were photographed in a style that tough-guy writers had mocked as *feminine*. In a sense, the movies are not hard-boiled at all: they are beautiful, evocative, atmospheric.[70]

Perhaps the movie that comes the closest to capturing the antiatmospheric aesthetic of hard-boiled literature is John Huston's 1941 adaptation of Dashiell Hammett's *The Maltese Falcon*. Just as Hammett's novel trims away the adjectives and similes in favor of precise description, the movie's cinematography eliminates the shadowy filigrees in favor of sharpness and clarity. Huston did not settle on this approach right away. The film's screenplay contains the following passage: "A flashing electric mobile sign makes Spade's shadow race ahead, and another shadow, the youth's, overtakes him." And, later, the following: "[Spade] walks quickly through the striped shadows the fire escape casts, toward the mouth of the alley-way."[71] These are the sorts of atmospheric effects we have come to associate with the film noir: a blinking sign, a pattern of bars. But the finished film contains relatively little play with shadows. Most of the time, the characters sit in brightly lit rooms, and they carefully study each other's brightly lit faces. Far from being a defect, the brightness helps the film capture the feel of Hammett's novel. Hammett had asked us to solve the mystery by taking careful note of external details, rendered with precision. The movie does the same, asking us to watch the characters' faces as closely as possible.

Most remarkably, the movie manages to capture the book's terse but effective descriptions of the light in characters' eyes. The cinematographer Arthur Edeson generously supplies his actors with eyelights, and the actors take full advantage of them. When Brigid tells Sam about her relationship with the recently murdered Floyd Thursby, there is a wonderful gleam of light in Brigid's eyes (figure 4.3). Astor leans back and turns her head up, putting her eyes in a perfect position to receive the light. Bogart turns away from the light, keeping his eyes in relative shadow. Sam is doing what we are doing: watching Brigid's eyes as she looks up, over, up, down, and then up again. Just prior to this moment, Sam has marveled at Brigid's ability to play the damsel in distress convincingly: "You're good. Chiefly your eyes, I think,

FIGURE 4.3. *The Maltese Falcon* (1941): A glimmer of light draws attention to Brigid's eyes.

and that throb you get in your voice." By drawing extra attention to Brigid's eyes, the eyelight invites us to share in Sam's amused and cynical reaction. Brigid's dishonesty is not a sin to be condemned but a marvel to be appreciated.

Unlike *The Maltese Falcon*, both of my extended examples work on the atmospheric side of the spectrum. *I Wake Up Screaming* is a bizarre generic hybrid, simultaneously a suspenseful melodrama and a lighthearted romp starring Betty Grable and Victor Mature. Remarkably, the lighting does justice to both of these genres—and more. *Strangers on a Train* is a triumph of adaptation. Patricia Highsmith's book contains several passages of atmospheric description that offer tremendous insight into the psychology and morality of the protagonist Guy. The movie never adapts these passages word for word—and yet the lighting manages to offer surprisingly similar insights into Guy's mind.

I WAKE UP SCREAMING (1941)

I Wake Up Screaming is a dark and suspenseful melodrama starring Betty Grable. Or is it a Betty Grable romantic comedy with a mystery plot? The filmmakers saw no need to choose. The story swerves from suspense to romance and back again, and the style swerves to match, mixing beautifully lit glamour shots of Grable and her costars with startlingly dark chiaroscuro. The result is a shamelessly commercial concoction, jumbling a bunch of mismatched genres together to attract a

wider audience. The surprising thing is that the concoction works. The romantic comedy scenes increase the stakes of the suspense scenes because the characters under attack are so likable. And the mystery scenes make the romantic resolution more satisfying because the formation of a happy couple has been cast into so much doubt.

If you had looked at the film's credits and nothing else, you could be forgiven for predicting that the movie would be a light comedy with a few dance numbers. Betty Grable was on her way to becoming one of the industry's most bankable musical stars, having appeared in *Down Argentine Way* (1940) and *Tin Pan Alley* (1940) the previous year. Costars Victor Mature and Carole Landis had just acted together in *One Million B.C.* (1940), a campy adventure movie. The screenwriter was Dwight Taylor, best remembered for the Astaire-Rogers musical *Top Hat* (1935). The cinematographer was Edward Cronjager, a versatile stylist with experience in dramas and musicals; he would go on to become a specialist in Technicolor photography. The director, H. Bruce Humberstone, had worked on some Charlie Chan mysteries, but he was more of an all-purpose employee than a specialist in suspense. The only credit that seems truly noir is the source novel: a pulpy mystery by Steve Fisher.

Though lacking Chandler's wit, Fisher shares Chandler's grim view of Los Angeles. In the book, the narrator often conveys his sense of alienation by describing the lighting. Sitting in a "depressing" room, he notes that the "bulbs in the electric globes were twenty-five watt and they were very dim."[72] At a hamburger stand, he observes the "dim light" and explains that there were "all kinds of bugs around the light and some of them stuck to the globe."[73] As in Chandler, the descriptions often associate the city's alienation with its racial demographics: the casually racist narrator feels particularly out of place when he visits neighborhoods that he characterizes as Mexican or Filipino. The film abandons this aspect of the novel, moving the setting from Los Angeles to New York and draining the geography of its social specificity. Instead, the movie picks up on another idea that appears in the book: the idea that lighting can characterize a villain. Here is the moment in the book when the narrator discovers his nemesis: "In the shadow that fell across the room from the window his face was long and evil."[74] The shadowed character is not the killer, but the shadow clearly conveys the idea he is malevolent.

For all its lightheartedness, the movie works brilliantly as a mystery. This is in no small part due to the effectiveness of the lighting, which tricks us into mistaking the innocent and the not-so-innocent for killers. The protagonist is Frankie Christopher, a slightly sleazy press agent (Victor Mature). One of his clients is Vicky Lynn (Carol Landis), a waitress in a hash house. Vicky gets murdered, and suspicion soon falls on Frankie. Other suspects include Harry, a hotel clerk; Robin, a has-been actor; and Larry, a gossip columnist. The most suspicious person of all is Cornell (Laird Cregar), the policeman investigating the case. Frankie tries to clear his name with the help of Vicky's sister Jill (played by the top-billed star, Grable), and Jill becomes a co-protagonist in the story.[75] In the end, the duo

learns that Harry the hotel clerk committed the murder but that Cornell was culpable for a cover-up. The story has all the pieces of the mystery melodrama: a murder, a gallery of suspects, and a twist ending.

The filmmakers took this pulpy story and added a dash of narrative trickery. As David Bordwell explains, *I Wake Up Screaming* was one of several major studio releases to experiment with flashbacks in the early 1940s.[76] When the movie begins, Vicky is already dead, and the police are interrogating Frankie and Jill in separate rooms. Vicky's story is then revealed in a series of alternating flashbacks—Frankie's, Jill's, Frankie's, then Jill's. The rest of the story unfolds chronologically, with one brief flashback from Larry's perspective. Visually, the movie is bolder still. The film's set-piece scenes, such as the interrogation scene and the climactic scene in which Harry confesses his guilt, are unusually expressive, even by the standards of the suspenseful melodrama.

The quickly shifting visual style is perfectly suited to the film's genre—better yet, to its mix of genres. Over the course of the film, Cronjager's lighting accomplishes at least four distinct effects, each one appropriate to a different type of film. First, the lighting creates the misdirection that drives the *mystery* plot, casting suspicion on several different characters before revealing the true culprit. Second, the lighting switches at appropriate moments to the mode of *romantic comedy*, generating and then fulfilling the expectation that Jill and Frankie will fall in love. These two genres play off each other perfectly, creating doubt as to whether the Jill-Frankie plot is a genuine romance or another piece of misdirection. Third, the lighting works *parodically*; the shadowy melodrama can be excessive, so over-the-top that it is a little bit funny. The fourth genre is the most characteristically noir and also the most hidden, buried underneath all the layers of mystery, romance, and self-parody. In its penultimate scene, *I Wake Up Screaming* becomes, quite unexpectedly, a *tragedy*: the somber story of a man with no reason to live.

Let us start with the mystery melodrama plot. The movie works by casting suspicion on at least five plausible suspects: Frankie, Robin, Larry, Harry, and Cornell. Most of this suspicion has little to do with the evidence. There may be a few clues involving cigarettes and flowers, but for the most part the movie avoids Agatha Christie puzzles. Instead, it casts its suspicion visually: Which characters *look* guilty? The movie tricks us into thinking that Cornell is the killer not because of any hard evidence but because of his appearance. He is guilty by reason of casting, guilty by reason of performance, and above all guilty by reason of lighting. More than any other character, Cornell is lit like a villain in a suspenseful melodrama. The lighting activates the rules of configuration, encouraging us to guess (wrongly) that Cornell will be the killer.

Cornell first appears as a mysterious silhouette during the interrogation scene, standing behind a glaring lamp (figure 4.4A). He is the lead detective, but already he looks like a murderer. When Jill begins to tell her story, she mentions seeing a suspicious-looking man who would stare at Vicky from outside her hash house. Jill appears in the ensuing flashback with attractive loop lighting, but the

Genre, Adaptation, and the Art of Unfolding 117

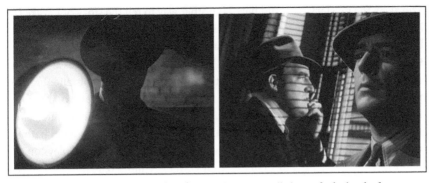

FIGURE 4.4. *I Wake Up Screaming* (1941): Somehow, Cornell always finds the shadow. *A (left)*: Cornell in silhouette. *B (right)*: Cornell next to the blinds.

suspicious-looking man is lit unattractively, with a low-placed key light casting a dark shadow across his nose and cheek, plus a kicker to emphasize the size of his neck. We later learn that the interrogating policeman and the suspicious-looking man are one and the same: Cornell. Jill distrusts Cornell immediately, and we are encouraged to share her misgivings—not so much because of any hard evidence but because the lighting has characterized Cornell as an ominous figure lurking in the shadows.

After the interrogation, Cornell appears unexpectedly in Frankie's bedroom, where he is illuminated by a blinking neon sign that is visible outside the window. Cornell then visits the assistant district attorney's office to cast aspersions on Frankie. These scenes in the attorney's office present an interesting challenge for the cinematographer, who must make Cornell look suspicious even though the set is brightly lit. Cronjager meets this challenge by positioning Cornell near the venetian blinds, which cast a prominent shadow on Cornell but no one else (figure 4.4B). When Cornell goes to Jill's apartment, he casts a large shadow on the wall next to her. Once again, his dialogue makes the case that Frankie is the killer, but the lighting undercuts his argument by making Cornell himself look guilty.

The pattern remains rigorous: Cornell is lit for shadow no matter where he goes. Other characters receive harsh treatment from time to time, but Cornell seems to receive it in every scene. Silhouette effect? Check. Lighting from below? Check. Blinking neon sign? Check. Venetian blinds? Check. Cast shadow on a wall? Check. It is as if Cronjager were hanging a sign over Cornell, saying "He is the murderer!" Yet we eventually learn that he is not the murderer. Harry is the murderer, and Cornell has been covering it up. By overloading Cornell with the signifiers of suspense, Cronjager enhances the mystery's capacity to deceive, pointing persistently to the wrong man.

Rules of configuration work just as well when they mislead the reader as when they guide the reader to the correct conclusion. This is axiomatically true of the whodunit, but it can be just as true of any genre, including the romantic comedy.

Strip away the mystery plot, and here is another way to tell the story of *I Wake Up Screaming*. Jill and Vicky are sisters. Jill is a hardworking typist with a girl-next-door persona; Vicky is a wisecracking waitress who wants to be rich and famous. Both are blonde and beautiful. Frankie, a handsome press agent, comes along, and he takes Vicky to clubs so she will get noticed. This sets up the meet-cute: Frankie spends so much time waiting for Vicky to get dressed that he gets to know her sister Jill, and they fall in love instead. Jill and Frankie go to the movies, to a club, and to a swimming pool, where they both get the chance to look cute in bathing suits. Whenever they look into each other's eyes, "Over the Rainbow" plays on the soundtrack. At first, Jill and Frankie seem comically ill-matched, since she is a good girl and he is a bad boy. Later they meet in the middle, after she shows her rebellious side in a zany escape scene, and he shows his decent side by fighting for her release. Vicky's story ends up being a cautionary tale, and so, the moral of the story is clear: the good girl gets the guy. No one would dream of classifying the movie I just described as a film noir, but there it is, the plot of a noir classic. Add a couple musical numbers, and it could be called *I Wake Up Singing*.

This other movie repeatedly breaks through the shadowy surface of the suspenseful melodrama and brightens the entire screen. Vicky, oddly, is never lit like a murder victim. She is lit like the second lead in a romantic comedy about two sisters interested in the same guy. In Vicky's close-ups, butterfly lighting provides smooth, symmetrical illumination over her entire face, and a double backlight gives her blonde hair the requisite glow.

Jill's lighting is more variable and much more interesting. Sometimes, she is lit like a character in a suspenseful melodrama, and sometimes she is lit like a character in a romance. The switching does important narrative work, creating fearful expectations and then flipping them toward optimism. The result is a sense of genre confusion that makes both storylines more effective. Watching the movie unfold, the question "What will happen next?" becomes inextricably bound with the question "What sort of movie is this?" If it ends up being a mystery, there is a decent chance that Frankie will be guilty, in which case this romance is going to end very poorly. If it ends up being a romantic comedy, there is an excellent chance that Frankie will be innocent, in which case he will be cleared, and the lovers will be united. It all comes down to figuring out which genre this movie will commit to. Because the lighting never settles into a single style, the movie keeps us guessing right up to the end.

Jill first appears in the interrogation scene, where everything looks shadowed and mysterious. There is Rembrandt lighting on her face, a moderate amount of fill, and a hard cast shadow on the back wall (figure 4.5A). Later in the same scene, we see a tighter shot of Jill in a canted frame with rim lighting outlining her profile, and then we see her with two diagonal shadows crossing over her forehead and shoulders. These aggressive lighting schemes plant the idea, very firmly, that this will not be an ordinary Betty Grable movie. Once this idea is firmly planted, the style shifts—to something more like an ordinary Betty Grable movie. In almost all

Genre, Adaptation, and the Art of Unfolding 119

FIGURE 4.5. *I Wake Up Screaming* (1941): Jill's lighting changes as the movie's genre alternates between crime movie and romance. *A (top left)*: Cast shadows, as in a crime movie. *B (top right)*: Appealing figure lighting, as in a romance. *C (bottom left)*: Lighting from below, as in a crime movie. *D (bottom right)*: Glamour, as in a romance.

of Jill's scenes with Frankie, Jill appears in a flattering three-point scheme. She looks bright and well-modeled in the living room, in the club, and at the swimming pool.[77] Late in the film, when Jill affirms her faith in Frankie after a period of doubt, a tight close-up celebrates Grable's face with loop lighting, fill, a highlight in her hair, a veil over her forehead, and two points of light in each eye (figure 4.5B). "Over the Rainbow" plays on the soundtrack. Really, it does. It looks like this movie is going to be a romance after all.

Then something shocking happens: the movie swerves back toward mystery and implies, briefly, that Frankie might really be guilty. Cornell enters and announces that he has new evidence of Frankie's guilt: a pair of brass knuckles. Flustered, Jill steps out of the apartment for a moment. She reenters to an entirely new lighting arrangement: a low-placed key light that casts a hard shadow onto the wall, with a background of broken diagonal lines (figure 4.5C). She looks uncertain, as if seeing Frankie anew. We are encouraged to share in her uncertainty, but for slightly different reasons. Jill must ask if the evidence against Frankie is convincing. We must ask if this is the sort of movie where Frankie will be guilty or not. Has it settled on suspenseful melodrama? Then he is probably guilty. Or is it still a romantic comedy? Then he is surely innocent. The looming shadow effect is

a convention of the suspenseful melodrama, perhaps even a cliché. The more clichéd it is, the better. The effect's recognizability enhances its power—its power to trick us into thinking that the movie must be a suspenseful melodrama, the sort of movie in which Frankie remains a viable suspect.

It is all a trick. Jill is not really harboring fresh doubts; she is just trying to figure out an effective way to rescue the man she loves. After a few moments of suspense, the movie swerves briskly toward comedy. Jill knocks Cornell out with a blow to the head, in an ironic echo of Vicky's murder. Jill and Frankie then escape, and the scene ends with a slapstick gag involving a policeman and a Murphy bed. The next scene shows Jill and Frankie in an empty bicycle shop, and the lighting is quite dark (figure 4.5D), darker than it was when Cornell was threatening Frankie. At first, this darkness might seem puzzling. If Frankie and Jill are affirming their love, why does the movie still look like a suspenseful melodrama? But we should remember that suspense films were not the only films that called for low-key photography. Dramas and romances benefited from shadows, as well, and this scene is unabashedly romantic. "Over the Rainbow" returns to the soundtrack, and the orchestration favors sentimental violins. Jill and Frankie kiss, and he tells her that his real name is Botticelli (a painter most famous for his rendering of the goddess of love).

To appreciate the romantic connotations of the new lighting scheme, compare figure 4.5D with figure 4.5A, with its expressive diagonals, or even with figure 4.5B, with its magazine appeal. The bicycle shop scene's low-key approach is the most glamorous of the three. Grable's lighting in figure 4.5D resembles classic Dietrich lighting, with a single key producing a butterfly pattern under Grable's nose and a symmetrical shadow under her chin. There is special emphasis on Grable's eyes: notice how the lower half of her face is subtly darker than the upper half. Everything works to heighten Grable's attractiveness. These are not the shadows of suspense; these are the shadows of romance.

Whether melodrama or romance, *I Wake Up Screaming* is not a movie that settles for moderation. Its suspenseful lighting can be intensely dark, with cast shadows and diagonal patterns that look ahead to the noir style of John Alton. Its glamorous lighting can be deeply beautiful, with close-up photography that looks back to the Paramount style of Josef von Sternberg. The alternations are so extreme that they border on self-parody. Indeed, at least one scene goes well beyond that border, treating its own lighting as a ridiculous joke. In the middle of the film, the assistant district attorney asks Cornell to investigate more suspects, and Cornell obliges by bringing in the ham actor Robin for questioning. As the police lead Robin to the interrogation room, Robin notices that the room is pitch-dark. Standing before a black void, Robin hesitates. "No lights?" he asks. Frankie has also been brought in, and he jokes with Robin, "You're an actor. Pretend you're going to your execution." The remark introduces reflexivity to the scene, reminding us that darkness is a well-worn theatrical convention, used to set the mood for specific types of scenes, as in the execution scenes from Robin's plays—or in the interrogation scenes from the very movie we are watching right now. The darkness

increases over the next few moments, tightening the suspense. Robin and Frankie enter the darkened chamber, and a policeman closes the door. The screen goes black, utterly black, unrelieved except for a thin band of light under the doorway. And then, just as *I Wake Up Screaming* has reached its darkest point, a movie projector turns on, and the characters realize they are not in a regular interrogation room but in a makeshift theater.

The police are showing them footage from Vicky's screen test, on the theory that watching Vicky onscreen will force one of the men to crack. The effect is marvelously absurd, and the lighting heightens the absurdity. On one side of the room are the men, lit like the tough cops and the murder suspects they are. On the other side of the room is Vicky, lit like the movie star she wanted to be. Robin seems close to cracking, and his lighting is particularly extreme: Rembrandt lighting with virtually no fill and no backlight. The effect is unmistakably, jokingly suspenseful. Meanwhile, Vicky receives loop lighting and careful edge lighting, turning her blonde hair into a perfect oval halo. The effect is unmistakably, jokingly glamorous. By contrasting an extreme form of feminine lighting with an extreme form of masculine lighting, the scene ridicules Hollywood's gendered lighting conventions. Frankie's joke about the execution had implied that the police would torture Robin with expressionistic chiaroscuro, making the atmosphere so dark that no one could bear it. Instead, they torture him with Vicky's unbearable glamour.

More obliquely, this tone of parody informs the film's climax, which duplicates the movie-projector scene in several respects. Frankie stands in intersecting shadows to observe Harry, a hotel clerk played by noir's ultimate character actor, Elisha Cook Jr. Harry picks up the phone and hears the voice of Jill, pretending to be the deceased Vicky. The performance causes Harry to lose control, and he quickly confesses to his crime. Previously, in the movie-projector scene, the detective Cornell had stood above a weak man in a dark room and watched him crack when a simulacrum of Vicky appeared. Now Frankie stands above a weak man in a dark room and watches him crack when a (vocal) simulacrum of Vicky appears. Earlier, Frankie had mocked the use of theatrical lighting conventions to create a chilling atmosphere. Now Frankie takes advantage of the hotel's creepy atmosphere to produce the same torturous effect. When Frankie stands in the shadow of the elevator cage, the imagery seems classically noir: a man in a fedora, a pattern of crisscrossing shadows, a canted frame. In the context of a film that took itself more seriously, we might interpret such an image as a metaphor for modern man, unbalanced and imprisoned. In the context of this more tongue-in-cheek production, the shadows and the canted frames seem like tricks, just the sort of theatrical gimmickry that works on dupes like Harry, and perhaps on us. Once one decides that *I Wake Up Screaming* is making fun of its own suspenseful atmosphere, it can be difficult to take any of its scenes quite so seriously anymore. It is all theater, all fakery: the story, the stars, and the lighting.

Released in 1941, *I Wake Up Screaming* is one of the earliest films to have attained canonical noir status. I have cast doubt on that designation in two complementary

ways: first, by showing that the romance of Frankie and Jill is actually quite light-hearted; second, by arguing that the movie invokes the shadowy conventions of the suspenseful melodrama in order to make fun of them. But the movie occasionally allows glimpses of a bleaker worldview, of the sort that would later be called noir. This worldview finds its richest expression through the figure of Cornell. As played by Laird Cregar, the villain appears to have hidden depths. Several moments lend themselves to a queer reading, as when Cornell pops up in Frankie's bedroom, or when Cornell cheekily invites Frankie to frisk him. Perhaps Cornell is driven by his attraction to Frankie, rather than his obsession with Vicky? Either way, the character of Cornell emerges as a man who knows he can never have what he desires. At one point, Jill asks him, "What's the good of living without hope?" Cornell lowers his gaze and replies, "It can be done." If Frankie and Jill are conventional Hollywood protagonists, who set goals and accomplish them, then Cornell is a noir antihero, pursuing a hopeless goal that leads to his own destruction.

Cornell's somber final scene brings us back to Rabinowitz's distinction between configuration and coherence. Rules of configuration lead us to predict where the book or movie is going (though the predictions often turn out to be wrong). Rules of coherence help us make sense of a work's features in light of the whole. Throughout *I Wake Up Screaming*, Cornell has received more melodramatic lighting effects than any other character: silhouettes, lighting from below, venetian blinds, the works. While watching the movie unfold, we may take these shadows as conventional signs of villainy, leading us to suspect that he is the murderer. At the end of the film, we learn that he was not the murderer but a forlorn man in the grips of a delusion. This revelation may prompt a reevaluation, especially if we recall that shadowy lighting is a convention of the serious drama as well as the suspenseful melodrama. Maybe this movie was not a murder mystery or a romantic comedy, after all. Maybe it was a tragedy.

STRANGERS ON A TRAIN (1951)

Strangers on a Train tells the story of Guy (Farley Granger) and Bruno (Robert Walker), two men who meet by chance. Both men harbor a deep hostility for someone close—Guy, for his wife, Miriam; Bruno, for his father. When Bruno proposes that they swap murders, Guy jokingly agrees. After Bruno kills Miriam, he tries to convince Guy to follow through on the plan and murder the father. Hitchcock's movie is based on a 1950 novel by Patricia Highsmith—the first in her distinguished career writing literary thrillers. The screenplay is credited to Czenzi Ormonde and Raymond Chandler, though the latter's contributions were reportedly minimal.[78] The book differs from the movie in several ways, most notably when it comes to the murder of Bruno's father. In Highsmith's novel, Guy follows Bruno's instructions and murders the father. In Hitchcock's movie, Guy goes to the father's house to warn him instead. On the one hand, this alteration completely upends the novel's theme, turning it into a much more conventional suspense

story of good battling evil. On the other hand, the change still allows the filmmakers to preserve the idea that Guy bears considerable responsibility for Miriam's death. Outwardly innocent, Guy may still be guilty in intent.

So, guilty or innocent? Here in brief is the problem that the filmmakers faced when it came to lighting the film. They could use lighting to amplify a straightforward suspense storyline, where Guy is good and Bruno is evil. Or they could use lighting to undercut Guy's goodness and hint that he is closer to Bruno than he would care to admit. The filmmakers solved this problem rather ingeniously, developing a light-versus-shadow scheme that could be interpreted in multiple ways, as reinforcement for the good-versus-evil suspense plot or as a subversion of that very plot. This solution allows the movie to hint at the novel's themes, even as it radically alters its story.

Highsmith writes in a free indirect style, dipping into the thoughts of Guy or Bruno even when the prose remains in the third person. Much of the book's imagery juxtaposes light with dark. In the following passage, Guy approaches the father's bed to commit the assigned murder. (The italics are in the original.) "Suppose the old man saw him first? *The night light on the front porch lights the room a little bit*, but the bed was over in the opposite corner. He opened the door wider, listened, and stepped too hastily in. But the room was still, the bed a big vague thing in the dark corner, with a lighter strip at the head."[79] The scene's atmospheric details are filtered through Guy's consciousness. The opening question registers a momentary worry that passes through his thoughts. The italicized phrase suggests that Guy is hearing Bruno's voice inside his head. Even the description of the bed ("a big vague thing in the dark corner") is filtered, rendering what the bed looks like *to Guy*. In the ensuing scene, Guy seems passive, more like a victim than a perpetrator. Firing the gun, Guy imagines that he is not even there. As he escapes, "darkness ran up higher and higher about him."[80] Highsmith makes darkness itself the subject, as if Guy had no control over his surroundings.

The lighting is deeply symbolic—for readers, but also for Guy. He sees the lights and shadows, and he attempts to interpret them. After murdering Bruno's father, Guy wanders through the woods for several hours:

> It was a time of dubious balance between night and day, still dark, though a low iridescence lay everywhere. The dark might still overcome the light, it seemed, because the dark was bigger. If the night could only hold this much until he got home and locked his door!
>
> Then daylight made a sudden thrust at the night, and cracked the whole horizon on his left. A silver line ran around the top of a hill, and the hill became mauve and green and tan, as if it were opening its eyes.[81]

The exclamation point suggests how deeply Guy wants to get home and lock his door, and the evocative diction in the second paragraph ("thrust," "cracked," "as if it were opening its eyes") expresses Guy's fear that dawn has come too soon,

figuratively defeating the night that is providing him with safety. The notion that the battle between day and night symbolizes the battle between good and evil initially seems trite, but that is the point: the battle seems symbolic *to Guy*. The passage mocks Guy's naive fascination with day and night, as if he is looking for some deeper significance to his own psychological struggle.

At first glance, Hitchcock's adaptation of the novel would appear to betray Highsmith's central theme by affirming Guy's innocence. The movie's goal-oriented structure is actually quite conventional for a suspense movie: the protagonist wants one thing, the antagonist wants another, and in the end the protagonist gets what he wants. However, the movie persistently undercuts this classic suspense scenario by suggesting that Guy is less heroic than he seems. Bruno may be the antagonist, but metaphorically he is also Guy's double, fulfilling the hero's unconscious desires. In a classic analysis, Robin Wood argues that the film encourages viewers to sympathize with Bruno, even when he kills Miriam. Rather than indulging in criminality for its own sake, Hitchcock is making a moral point, pushing viewers to recognize that they might easily be just as complicit as Guy is. According to Wood, Hitchcock uses several cinematic devices to develop this theme—most notably, the "light-and-darkness symbolism" that shows Guy turning away from the light and toward the darkness.[82] With Wood's reading in mind, I want to keep two complementary points in balance. The lighting does indeed support the ordinary suspense plot—one that departs from the book by turning Guy into a more conventional hero who acts to defeat the villain. But the lighting also hints at symbolic meanings that qualify or undercut that suspense plot, acknowledging the book's central theme by suggesting that Guy and Bruno are alike.

Consider the scene in which Guy refuses to murder Bruno's father. Hitchcock's version initially follows the book's account of the scene: Guy ascends a staircase, walks down a hallway, and approaches the father's bed. Then Guy steps into a shadow and speaks, making it clear that he wants to warn the father, not kill him. As lit by the cinematographer Robert Burks, the subsequent shot initially depicts a dark figure silhouetted against a bed frame. Then Bruno turns on the bedside lamp, his face is illuminated, and an enlarged shadow appears on the back wall (figure 4.6). The lighting is directly woven into the chain of actions. Bruno keeps the light off *because* he wants Guy to mistake him for his father. Guy speaks to Bruno *because* the silhouette effect has tricked him into thinking that the father is there. Bruno turns the lamp on *because* he wants to astonish Guy with his own cleverness, a cleverness that has allowed him to see through Guy's dishonesty. The light changes because the characters are manipulating it to further their own goals.

At the same time, the lighting manages to evoke the dreamlike quality that the atmospheric prose evokes in the book. For nearly three minutes, Guy silently walks through the shadowy corridors of a house he does not know, and then he encounters a figure whose face he cannot see. The lighting also gestures toward the oneiric by evoking Highsmith's theme of doubling. When Guy says, "Mr. Anthony, don't be alarmed, but I must talk to you about your son," his face is not visible. The

Genre, Adaptation, and the Art of Unfolding 125

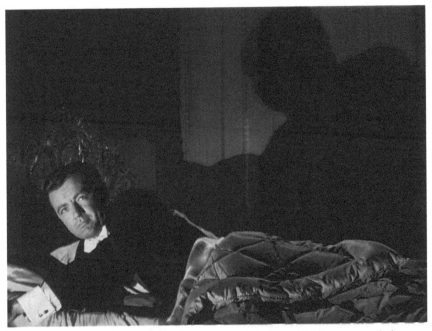

FIGURE 4.6. *Strangers on a Train* (1951): Bruno turns on a lamp, which casts a symbolic shadow.

silhouette effect creates an analogy between Guy and Bruno, whose head is also in silhouette as he impersonates his father. When Bruno turns the lamp on, it appears to cast a giant shadow on the back wall. The shadow reinforces the theme of the double, and it echoes a recent shot of Guy, trailed by his own cast shadow as he entered the bedroom. These layers of symbolism reassert Highsmith's themes. Guy may be refusing to commit the murder, but the doubling imagery suggests that, deep down, the two men are alike.

I have spent much of this book cautioning against the urge to see an alter ego in every cast shadow. Why am I so eager to find symbolism here? Partly, it is because Hitchcock has a well-earned reputation for symbolic effects. And partly it is because the lighting makes this particular cast shadow so inescapably salient. The shadow takes up a large portion of the screen, its tonality is quite dark, and its appearance completely changes the composition. The effect calls out to be noticed and interpreted.

And yet, even here it can be instructive to set symbolism to one side and inquire about the lighting's other functions, such as its impact on narrative dynamics. Bruno manipulates the lighting to trick Guy into thinking that the father is really there. Hitchcock does the same thing to us: he manipulates the lighting to trick us into thinking that the father is really there. In her book about writing suspense fiction, Patricia Highsmith insisted that the best way to complicate a suspenseful plot was to add scenes of surprise, and that is what Hitchcock is doing here: amplifying

suspense with surprise.[83] The scene starts out as a suspense plot, oriented toward a gap in the future: Will Guy commit the murder? As Guy climbs the stairs, he encounters a menacing-looking dog. This sharpens the suspense: Will he find a way around the dog? As Guy walks quietly toward the bedroom, he runs the risk of making too much noise. Will he awaken anyone? At the level of the action, the darkness of the house creates another obstacle for Guy to overcome. He must use his flashlight without making it too bright, and he must navigate the path without the benefit of lamps. The darkness of the house creates a generically familiar mood of menace, which supports the (false) assumption that we are watching a potential murder scene. But then the scene shifts toward surprise. First, we get the mildly surprising revelation that Guy has no intention of murdering the father. Then we get the more surprising revelation that Bruno has set a trap for Guy.[84]

The movie also mixes surprise and suspense in the scene of Miriam's murder, and here again the film's shadows trick the spectator into making false assumptions. Bruno is stalking Miriam at a carnival. With two companions, she rides a boat through the Tunnel of Love; Bruno follows on a separate boat. Inside the tunnel, two shadows are cast upon a wall: the shadow of Miriam, and the shadow of a companion trying to embrace her. A third shadow enters the frame: Bruno, silently watching. Bruno's shadow grows larger and moves closer, closer, and closer—until it appears that he is right on top of Miriam. The film cuts to an outside view, and Miriam screams. Has she been killed? No—we have been tricked. Miriam and her companions exit the tunnel safely; she was screaming to protest her companion's embraces, and Bruno is still several feet away. The scene works because it sets two different ways of interpreting shadows against each other: the literal and the symbolic. Literally, the shadows deliver (misleading) information about the spatial layout of the storyworld. It appears that Bruno is physically approaching Miriam, eventually getting so close that he might be in a position to kill her. Symbolically, the gradually increasing size of the shadow suggests Bruno's ever-increasing threat. The symbolism is obvious, intentionally so. It is precisely by leading us into reading the cast shadow as an obvious symbol of evil that Hitchcock tricks us into thinking that the murder is happening right now, when in fact Bruno is still a dozen yards away from his victim. Soon the murder will happen for real—right after Bruno has illuminated Miriam's face with a lighter. The lighter completes the little game Hitchcock is playing with light-and-shadow symbolism. A menacing shadow has turned out to be harmless; a tiny lighter leads to death.

After the murder, Bruno visits Guy outside his apartment and informs him of his accomplishment. In the resulting conversation scene, the lighting repeatedly splits the characters' faces in two, with one side illuminated and the other in shadow. The Hitchcock scholar Richard Allen has noticed this pattern in several films, and he argues that it evokes the idea of the Janus face—a figure with two faces, one good, one evil. He explains that the Janus face "is suggested in one of two ways: either through a lighting design which divides the face of a character in two, or through

Genre, Adaptation, and the Art of Unfolding 127

the emphatic use of the profile shot whose one-sidedness suggests a hidden, dark side beneath."[85] His examples range from *The Lodger* (1926) to *Psycho* (1960). The fence scene from *Strangers on a Train* is an extended exercise in the Janus-face technique, offering several variations on the basic pattern. Taken as a whole, the lighting develops the idea that Guy and Bruno are two sides of the same personality. But the very idea carries two possible meanings. An optimistic interpretation of the idea reinforces Guy's goodness. If this is a story of good battling evil, then Guy is good, and Bruno is evil. A pessimistic reading undercuts Guy's goodness. If good and evil exist equally in both characters, then Guy must be just as bad as Bruno. The emotional dynamics of the scene support both readings. Guy accuses Bruno of being a crazy fool who misinterpreted what he said on the train. Bruno accuses Guy of being equally guilty of Miriam's murder since Bruno was fulfilling Guy's deepest desires. The fact that they both have a point reinforces the complex nature of Hitchcockian suspense. The suspense plot is built on the familiar formula of good battling evil, but Hitchcock persistently destabilizes that opposition, making it easy to root for Bruno to succeed in his evil plans.

Hitchcock may have developed the Janus-face convention in earlier films, but each movie—indeed, each scene—presents unique problems in aligning the pattern with other storytelling goals: figure, milieu, and arc. The scene unfolds beat by beat. With each change in tactics, the characters move to a slightly different position in relation to the fence. If the lighting is to create symbolism, it must do so within this spatial context, where two men stand precisely here and precisely there.

1. When the scene begins, Guy is a silhouetted figure stepping out of a cab. Then his face is partly lit when he notices Bruno. The partial lighting creates an immediate contrast with Bruno, who is standing in the shadows of a fence. This opening section also establishes the primary source of light in the storyworld: a tall streetlamp.
2. When Guy arrives at the fence, a series of shot-reverse-shots show the two men with broad split lighting. In Guy's case, the effect is very clear: half in light, half in shadow (figure 4.7A). Bruno's lighting is more unusual. The side of Bruno's face that is turned toward the light remains partly in shadow because the fence casts a pattern on his cheek: initially a cross-like pattern (figure 4.7B), and then a vertical pattern when Bruno steps forward. This arrangement manages to keep two contradictory ideas in play: Guy is like Bruno (both have an *attached* shadow), and yet Bruno is unlike Guy (Guy still looks handsome, but Bruno's face is deformed by *cast* shadow).
3. Trying to leave, Guy steps in front of the fence and turns around. In the subsequent close-up, Guy's face is split down the middle again—but now the effect is a cast shadow, not an attached one (figure 4.7C). A frontal key illuminates Guy's face, and the foreground fence casts a strong vertical shadow over his right eye, as well as a curved shadow over his chin. The matching close-up shows split

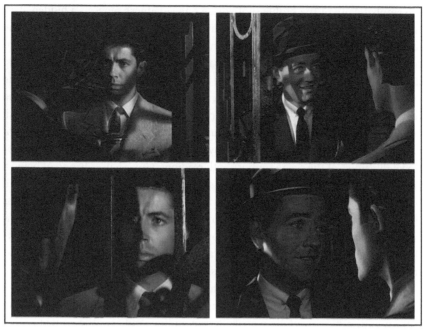

FIGURE 4.7. *Strangers on a Train* (1951): In the fence scene, the lighting changes beat by beat. A *(top left)*: Split lighting on Guy. B *(top right)*: The shadow of the fence on Bruno's face. C *(bottom left)*: The shadow of the fence on Guy's face. D *(bottom right)*: Bruno, almost entirely in shadow.

lighting on Bruno, with a different curved shadow on his cheek. Here is where the Janus-face reading is at its most convincing: the pattern seems unusually salient because it is in such high contrast (juxtaposing a dark shadow against an otherwise bright face), so prominent (covering half of the lead actor's face), and frankly so implausible (violating the previously established spatial logic, since Guy should not be lit from the front when the streetlamp is now at his back).

4. A police car drives up, and Guy steps behind the fence. The next round of shot-reverse-shot features yet another shift. Guy, previously the recipient of an attached shadow and a cast shadow, now receives both at the same time: his far cheek is dark because of the attached shadow, and his near cheek is partially dark because of the cast shadow. The effect is similar to the effect on Bruno for the bulk of the scene so far. Perhaps Guy is becoming more like Bruno? Or perhaps not—Bruno's lighting has also changed, so there is still a marked difference between the two men. Bruno is now turned away from the streetlamp. A kicker mimics the effect of the streetlamp illuminating Bruno's cheek from behind. A dim frontal light enables us to see Bruno's expressions, especially his eyes, which stare cruelly at Guy and then dart nervously back and forth as Bruno's manner turns from menacing to flirtatious (figure 4.7D).

This scene is a little masterpiece of Hollywood cinematography, deploying the Janus-face convention in many different ways: as an attached shadow, as a cast shadow, as a simple split down the middle, as a split intersected by a curve, and as a shadow taking over more and more of the face. These variations keep multiple layers of meaning in play, such as the idea that the battle between Guy and Bruno is a battle of good and evil, the contrary idea that Guy is like Bruno in his capacity for evil, and the combined idea that Guy is like Bruno but Bruno still manages to be worse.

That said, it is important to remember that symbolism is not the only function of lighting in this scene. *Strangers on a Train* has not escaped the central obligation of depiction: to establish who is standing where. We can see at a glance that Guy stands on the opposite side of the fence, and that the fence is over a foot away from his face. Later, we can see just as clearly that Guy is standing on the same side of the fence, and that the fence is just a few inches from his face. Knowing who stands where is important: the entire scene is a dance of proximity and distance, where one man (Bruno) wants to be close to the other, and the other man (Guy) wants to step away but cannot. It is because of these depictive contributions that we need not look for symbolism in every tiny detail. Why is there an eyelight in Bruno's eyes at the end of the scene, when he threatens Guy and then pleads with him? One could find a symbolic meaning here, and it might be a good one, but surely a large part of the explanation is much more literal: we need to see his face. As an actor, Robert Walker is doing a lot of work with his eyes; it is one of the ways that he performs the idea that Bruno is gay. The eyelight is there to make sure we do not miss the nuances of Walker's performance. Why is there a little sparkling highlight on Bruno's tiepin? The highlight helps us see the tiepin: its size, its shape, its texture. The tiepin provides one more reminder that Bruno and Guy are separated by class. Unlike Guy, Bruno comes from a wealthy family, and he can afford to buy such accessories. To be sure, there may be some additional symbolic meanings at play. It seems significant that a mother-obsessed man who strangles women wears a pin to hold the tie his mother has given him. But the literal-minded explanation works just as well by itself: the highlight lets us see the shape of an object that is consistent with the character's vanity and wealth.

In this scene, the lighting changes beat by beat, as the actors move from one mark to the next. In a later sequence, the light changes even more dramatically because time is passing. At the fairground, Bruno waits for nightfall so he can plant the lighter and incriminate Guy in Miriam's murder. Meanwhile, Guy boards a train so he can reach the fairground and catch Bruno. The scene deploys extensive work in special effects: in some shots, the sun is added to the sky as an optical effect; in others, the sun appears in rear-screen projection. As in the day-to-night montage in *Odds against Tomorrow*, the filmmakers show a careful concern with the nuances of depiction. Bruno's face is moderately bright, and then moderately dim, and then positively dark. The blinking highlights initially are difficult to see, and then they are noticeable, and then they are hard to miss. The sky in the background

is light gray, and then dark gray, and then black. The sequence is a beautiful illustration of the power of cinematography to represent change over time. Even if we were to set the narrative aside, we might enjoy and appreciate the careful rendering of each moment.

But the movie makes it impossible to set the narrative aside. This narrative is literally *about* the light, and the storyline infuses each moment with suspense. Guy is not looking at the sunset because it is pretty but because he is afraid that the sun's setting will allow Bruno to plant the evidence. The farther the sun goes down, the more likely it is that Guy will fail and that Bruno will succeed. This is the main reason why Burks and the special effects team have rendered the details with such care. The more accurately the images can show us what time it is, the more finely the film can tighten the suspense. In *Odds against Tomorrow*, there is a much looser linkage between the sun's movement and the protagonists' goals. The sun is going to go down either way, and the three men are going to attempt the heist either way. In *Strangers on a Train*, time seems like an obstacle that cannot be overcome. In *Odds against Tomorrow*, time seems more pointless, like a philosophical puzzle that cannot be understood.

Highsmith's novel ends with Guy's arrest. Guilty of the father's murder, Guy surrenders to a detective. The penultimate sentence of the novel restates the central theme: "Guy tried to speak, and said something entirely different from what he had intended."[86] Intention and action remain split in Highsmith's novel. The film's version of Guy is not so ineffectual as the book's version. Guy intends to defeat Bruno, and he does. He is a Hollywood hero who accomplishes his goal. But Guy's victory remains rather hollow because the movie has spent much of its running time showing us just how passive our hero can be. The sunset sequence sticks with me as a vivid illustration of Guy's passivity. He is sitting on the train, and he is desperately willing the train to go faster. He wants something he cannot have, for Guy cannot control the movement of the train—any more than he can control the movement of the sun.

5 · LIGHTING MILIEU

In the 1950 thriller *Mystery Street*, Elsa Lanchester plays Mrs. Smerrling, the landlady of a cheap apartment building. A tenant, Vivian, is talking on the telephone, and Mrs. Smerrling approaches to remind Vivian about the outstanding rent. When Vivian ignores her, Mrs. Smerrling retaliates in the pettiest way possible: she turns off the lamp above the phone. "Light costs money," Mrs. Smerrling explains. The moment teaches us about the characters; we learn by observing where they live. Vivian and Mrs. Smerrling stand *here*, in this dingy hallway with this ugly little lamp.

Lighting for milieu is one of the most recognizable features of the noir style, evoking an entire iconography of dangling lamps, blinking neons, and venetian blinds. These milieus draw on and contribute to the larger culture of electric light in the United States.[1] I borrow this phrase—a *culture of light*—from Frances Guerin's study of lighting in Weimar cinema.[2] As Guerin notes, light is always a part of the medium of film, but artificial light can become a narrative subject when a film takes a critical look at the place of technology within modern culture.[3] In its most critical mode, noir represents the culture of electric light in the United States as inherently unequal and alienating. Even as the electricity industry was promoting the story of a world growing brighter every day, noir exposed the lingering darkness of places left behind.[4]

This chapter moves from noir's basic set-lighting techniques to larger patterns of cultural meaning. The first five sections explain how Hollywood practitioners approached the challenge of representing story-specific settings by developing a cluster of techniques known as *source lighting*. The next four sections explain how noir filmmakers used those lighting techniques to comment critically on the broader culture of electric light. The chapter concludes with two close analyses: *Sweet Smell of Success* and *Touch of Evil*. Both films depict worlds shaped by the culture of electric light—a culture where the brightness of a space is inextricably linked to questions of economic and political power.

EFFECTS AND SOURCES

Lighting for milieu grows out of a cluster of techniques that Hollywood cinematographers had been using for years, known variously as *effect lighting* and *source*

lighting. A 1942 article in *American Cinematographer* by the B movie cameraman Phil Tannura defines the former concept: "My impression of the meaning of the term 'effect-lightings' would run something like this: it's any type of lighting which attempts to reproduce the effect of the illumination you'd actually see in any particular room or place under the conditions of the story, as apart from the smooth, overall illumination of a conventional lighting."[5] His article lists half a dozen examples: moonlight streaming through a window, a shaded lamp on the table, a fire crackling in its fireplace, a truck driving past a streetlamp, a car driving through the moonlight, and sunlight bouncing off a lake. Although Tannura admits that the term is expansive, he draws a line between effect lighting and conventional lighting. Conventional lighting is "full," with no distracting shadows.[6] Effect lighting produces shadows by definition, for it is shadows that produce the sense that the light is directional, coming from a specific place within the storyworld.

Source lighting is a more ambitious concept, elevating effect lighting to the level of a guiding principle. Rather than save an effect for a one-off sequence involving a lake or a fireplace, the cinematographer starts each scene by considering how the setting would be illuminated within the storyworld. Because it is applied to all scenes, source lighting blurs the distinction between conventional lighting and effect lighting. For the cinematographer Arthur C. Miller, source lighting is so basic that he simply calls it *key lighting*: "The key light is the main source of light. 'Keylighting' means lighting a set directionally or keying the lighting to the natural source of illumination established by the set or the story—a large window admitting strong sunshine, a large chandelier overhead, etc."[7] The terms *key light* and *key lighting* are related but not identical. The former remains a term of figure lighting, referring to the primary illumination on the shot's subject, usually a character. The latter refers to the overall illumination of the set. For Miller, a key light is typically singular: a specific light modeling the character's face. (If the shot has two or more major characters, there may be two or more key lights, one per face.) Key lighting, by contrast, may involve dozens of lamps positioned above the set. As long as the majority of these lamps are pointing in the same direction, they will create the impression that all the light comes from a singular source, such as a streetlamp or the sun. The result is an integrated composition: the figure lighting fits within the story's world.

In 1949, Charles Loring contributed an informative article on source lighting to *American Cinematographer*, featuring illustrations from two recent Hollywood films: *Act of Violence* (1948), a classic film noir directed by Fred Zinnemann and photographed by Robert Surtees, and *Johnny Belinda* (1948), a serious drama directed by Jean Negulesco with cinematography by Ted McCord.[8] Loring uses these examples to make the case that source lighting is the very foundation on which all lighting technique must rest. Whether shooting a daylight exterior or a nighttime interior, the task facing the cinematographer is to render the natural source's quality and direction. The *quality* may be hard-lined or diffuse, depending on the physical size and proximity of the source; the *direction* may be from the front, above, below, or to the side, depending on where the source might be in the

fictional world. Loring returned to these themes in several other articles over the years, and he would publish a nearly identical version of the 1949 article in *American Cinematographer* eight years later, under the title "Natural Source Set Lighting."[9] All of Loring's articles are aimed at amateur readers, but they articulate principles familiar to professionals throughout the noir period.

Source lighting could be a guiding principle regardless of genre. The cinematographer of a Western needed to suggest the brightness of the sun, and the cinematographer of a romance needed to render the subdued illumination of moonlight. For the wartime drama *Since You Went Away*, the cinematographers Stanley Cortez and Lee Garmes aimed to stay true to life: "The light always came from precisely the correct source, with nothing cheated at all."[10] Still, practitioners agreed that the approach was particularly important to the suspenseful melodrama.[11] Crime movies offer a wide array of effect-heavy situations, such as murderers hiding in alleyways, detectives carrying flashlights, and victims lying in the shadows. The genre also places a relatively low priority on glamour, enabling cinematographers to push certain effects farther than usual. And the genre is tightly associated with low-key lighting, which makes the directionality of each source more noticeable.

IMMEDIATE, IMITATED, AND IMPLIED

Source lighting comes in various forms, which I will call *immediate*, *imitated*, and *implied*. The terms are mine, but I think that they capture distinctions that were relevant to studio-era practitioners. When the lighting is immediate, there is a practical source onscreen, such as a dangling bulb, and that source is in fact providing most of the illumination. You literally see the source of the light. An imitated effect also shows a fictional source such as a light bulb, but the onscreen bulb is not doing the primary work. Instead, the cinematographer has added extra illumination to mimic the light's fall. A third option is to have the source be entirely implicit, as when we see a shadow on the wall and must infer that an unseen fictional-world lamp is casting the shadow.

An example from *Act of Violence* shows an effect that is (mostly) immediate. The effect was eye-catching enough that it appeared in Loring's previously mentioned article from 1949, as well as in a separate article signed by the cinematographer Robert Surtees himself.[12] Van Heflin plays Frank, an upright citizen who betrayed his fellow soldiers during the war. With the help of Mary Astor's character Pat, Frank meets a corrupt lawyer who helps him arrange a contract killing. The screenplay called for a scene set in "an ill-lit, third-rate saloon," and the meeting takes place under an ugly overhead lamp.[13] A cinematographer would describe such a lamp as a *practical*: a working lamp that is part of the set. Surtees has placed a photoflood bulb in the practical lamp. (A photoflood is an ordinary-looking light bulb that burns unusually bright for a shorter period of time.) The result is source lighting at its most literal: the primary illumination really does come from that lamp. In figure 5.1, the dangling lamp produces a harsh top light on Astor, leaving her eyes in shadow.

FIGURE 5.1. *Act of Violence* (1948): A photoflood bulb has been placed in the practical lamp above Pat's head.

The place looks grim and unpleasant, and that is the point: to show how far Frank has fallen. He may live in a neat little bungalow, but his world of postwar comfort masks a grimmer reality of poverty, corruption, and guilt.

Due to the limitations of the film stock, shots in which a single practical bulb provides all of the illumination were quite rare—and, indeed, Surtees has added fill light to illuminate the rest of Astor's face. Many cinematographers go a step farther, creating the illumination separately while using the practical to suggest a plausible source. In *He Ran All the Way*, the cinematographer James Wong Howe lights a scene with three characters: two parents and a criminal interloper. Howe positions a practical lamp above the mother's head. This lamp provides some of the illumination on her shoulder, but it provides none of the illumination on the criminal, played by John Garfield. Instead, Howe has added a lamp offscreen right, casting Garfield's shadow onto the back wall (figure 5.2). The effect is one of mimicry or imitation: Howe's image creates the *appearance* of a man illuminated by the practical source. By contrast, Mary Astor really is illuminated by that practical bulb in *Act of Violence*, even if Surtees has supplemented the effect.

Where the Sidewalk Ends illustrates a third possibility: the implied source. Karl Malden plays Lieutenant Thomas, a police detective who has just bungled a case. Initially standing in a sunlit office, Thomas receives an order from his boss to beat a confession out of a suspect. Dutiful and ashamed, Thomas enters the interrogation

FIGURE 5.2. *He Ran All the Way* (1951): The key light mimics the effect of the table lamp in the foreground.

room to administer the beating. The cinematographer Joseph LaShelle designs a top-lighting effect for the moment when the lieutenant confronts the suspect. We do not actually see a light bulb dangling from the ceiling, but the top light is so strongly sketched that it implies the bulb's presence (figure 5.3). The representation of the milieu sharpens the film's critique of the police by aiming it at the systemic level. The lieutenant's violence does not come naturally to him. It is built into the institution, into the very architecture of the station, where one room projects responsible bureaucracy and another room projects hidden brutality.

Some might question whether the example from *Where the Sidewalk Ends* counts as source lighting at all, given that we do not see the source. But the industry's definition of source lighting was, in a sense, narratological. Source lighting represents a fictional space that is illuminated by some light-emitting source within the storyworld. It is an essential fact about storyworlds that they extend *beyond* the boundaries of the frame.[14] Source lighting adds to the impression of worldhood by creating this sense of extension, even and perhaps especially when the light implies sources that we never see.

SOURCES AND SCENES

Cinematographers are picture makers, and the initial appeal of source lighting lies in its depictive achievement. Like a still life painter trying to capture the precise

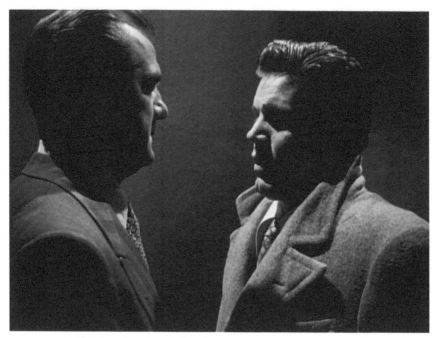

FIGURE 5.3. *Where the Sidewalk Ends* (1950): Top lighting implies the existence of an overhead bulb.

look of the surface of a lemon or a landscape painter trying to render the exact appearance of sunlight as it strikes the grass, a cinematographer may spend considerable time worrying about the tiniest details. Does this beam look like moonlight? No, not quite. Raise it up a bit. Yes, now it looks like moonlight. Does this shadow look like it comes from that dangling lamp? Almost. How about if we move the shadow down a bit? That's better—now it looks right. Cinematography is called *painting with light* for a good reason: both crafts attend to the subtle nuances of shape and shade. But cinematographers are also dramatic storytellers. They situate these nuances on a stage where events unfold. Each image becomes a part of a larger scene.

Let us suppose that you are a cinematographer, and that you are working closely with the director and the set designer in preproduction. Discussing a crucial scene in the screenplay, you start with basic questions about time and place. Where are the characters? Are they inside or outside? In an apartment or a house? Is it a cheap apartment or a fancy one? Now let us say that you all agree on the setting: a frugal city apartment. The next step is to ask: How would this space be lit in the storyworld? By dim bulbs hanging from the walls? By a tiny table lamp next to the bed? By a streetlight flickering from the outside? You agree that there will be a single table lamp in the center of a room. Maybe the set designer supplies a sketch. Next comes the challenge of blocking the characters in such a way that their movements will

take advantage of this hypothetical lighting source. You all look at the script again: today's scene is about a gangster threatening a witness. The director tosses around some ideas. Maybe this gangster could spend the bulk of the scene standing in the shadows and then step forward when he makes the threat. Having the gangster stand over the lamp will enable some creepy lighting from below. Or maybe the gangster does the reverse. He sits calmly by the table lamp for the bulk of the scene and then retreats to the shadows to make the threat. Or maybe the gangster stands in the same spot throughout, and it is the witness who walks around nervously, in and out of the shadows. There are countless ways to stage the scene—some worn out and clichéd, some clichéd but still effective, and some understated or surprising.

In this case, your team has arrived at the solution by starting with the milieu ("Let's put the lamp on the table"), then working toward the dramatic arc ("Let's use the light to mark a turning point"), and then making decisions about character ("Let's have the actor step forward into the light"). But there is no reason why you cannot arrive at the solution some other way. You might start with the dramatic arc ("Let's shift the lighting to underline the scene's turning point") and then conclude that the lamp must be placed in the middle of the room, where the character will be standing at the crucial moment. Or you might start with a particular kind of figure lighting ("Let's use split lighting because it makes the actor look good") and then conclude that a character should open a window to provide a more reasonable source. The order of the decision-making need not give priority to any part of the solution: the figure, the milieu, or the arc. The ideal is to produce a kind of fusion, where figure, milieu, and arc work together as the story unfolds in time.

This ideal can be awfully hard to achieve; it takes negotiation and compromise. Suppose you have settled on a table lamp in the center of the room. With this lamp as the reasonable source, you can create backlighting for a romantic encounter, or short loop lighting for a star who insists on it, or a moody shadow effect for a crime scene. But you probably cannot do butterfly lighting, since butterfly lighting always comes from above. What if your actor looks best under butterfly lighting? Well, you might need to sacrifice glamour to produce a more reasonable effect. Or you might compromise the milieu, deploying butterfly lighting even though it does not make any logical sense. Or you might rethink the approach altogether, redesigning the set or reblocking the actors to get them into the positions where they can be lit differently.[15] Every scene poses its own little puzzle.

My hypothetical scenario emphasizes collaboration and planning, but these variables will differ from case to case. Maybe the director is a dictator, stipulating a precise plan for the crew to follow with no deviations allowed. Or maybe the cinematographer has been excluded from the preproduction meetings and must solve the lighting problems on the fly before each take. Or maybe the art director is working on a tight budget that limits the size of the room. All these variables introduce new challenges, but the central challenge remains the same. The scene must be staged, placing bodies in space.

The solutions range from the simple to the complex. At one end of the spectrum, there is a solution that we might call the *simply sourced scene*. The scene has an obvious source of light, and the actors stand next to it. When Moe awaits her execution in *Pickup on South Street*, the actor Thelma Ritter does not move, and the cinematographer merely needs to imitate the look of the pinup lamp above her head (see figure 2.1). More ambitiously, filmmakers might complicate the blocking, asking the actors to move in and out of the light at a turning point in the scene. In *Gilda*, photographed by Rudolph Maté, Rita Hayworth's title character delivers a monologue about superstition and fate. As she does so, she grabs a whip and walks around the room. First, Gilda speaks hesitantly, unsure if she should confide in the maid. Then she steps into a shadow and reveals her thoughts. The shadow marks a transition. When Ballin knocks on the door, Gilda steps out of the shadow, signaling the end of this private moment.

Another way to give shape to the scene would be to design a scheme that gets brighter or darker over time. Perhaps a lamp falls to the ground and breaks, as in *Out of the Past*, where Jeff dries Kathie's hair and then tosses the towel aside so carelessly that it knocks over the scene's visible source. Or perhaps the scene's lamps are turned off one by one, as in Fritz Lang's *The Blue Gardenia* (1953), where the protagonist darkens the room and lights some candles to prepare for an imagined dinner date with her faraway boyfriend. These scenes have a shape because the lighting changes from one moment to the next. (Both are shot by Nick Musuraca.)

The most complex scenes form a category that I will call the *fully integrated set piece*. In such a scene, the light changes two or more times over the course of a scene, and those changes are directly related to the sequence of goals and counter-goals that make up the plot. The sequence in the drummer's apartment in *Phantom Lady* is a fully integrated set piece; so is the interrogation scene in the makeshift movie theater in *I Wake Up Screaming*. Foster Hirsch argues plausibly that several recurring noir situations lend themselves to the set-piece treatment: "a chase, a murder, a showdown, a release of tension, [or] a moment of madness."[16] Other classic noir set pieces include the murder in the attic in *The Picture of Dorian Gray*, the finale at the airport hangar in *The Big Combo*, and the surrender to the police in *I Want to Live!* (1958). One of my favorite set pieces is the climax of *Force of Evil*, the anticapitalist classic directed by future blacklist victim Abraham Polonsky. In the climactic scene, Joe (John Garfield) learns of his brother's death and turns on the gangster-businessmen responsible, Tucker and Ficco. The scene follows a plant-and-payoff structure. During the buildup to the gunfight, we learn three key facts about the scene's geography. Fact 1: the office has a single lamp providing most of the light. Fact 2: some moonlight filters through the window. Fact 3: a doorway leads to a dimly lit space. During the gunfight itself, the characters use every one of these facts to gain a competitive advantage. Tucker lunges for the gun in his bag, and Joe deliberately knocks over the table lamp (fact 1). The resulting darkness causes Ficco to miss his shot, and all three characters take up positions

hiding in the shadows. The dim moonlight (fact 2) enables Tucker to grab his gun. Joe sits in the shadow of Tucker's chair, which obscures half of his body and face. Ficco also hides in the shadows, but he makes a fatal error, firing his gun at a silhouetted man crawling toward the doorway. The dying man pushes open the door, gradually exposing Ficco to the outer light (fact 3). Another gun fires, and Ficco dies. Only now is it revealed who has won the battle: Joe, stepping out into the light. A fully integrated set piece unfolds beat by beat, taking full advantage of the setting's layout.

TOWARD MILIEU

Source lighting could perform a wide range of functions: identifying time and place (as in *Pickup on South Street*), marking a turning point in the scene (as in *Gilda*), establishing a mood of lost romance (as in *The Blue Gardenia*), and playing a decisive role in the characters' goals and schemes (as in *Force of Evil*). Ideally, the lighting will accomplish these functions while doing something else: teaching us about the characters' milieu. A milieu is not just a place; it is a social environment. A fully rendered milieu gets the details right, asking us to notice the tattered little lamp in the corner of the cheap motel or the elegantly shaded lamp on top of the desk in the swanky office. By observing the light and its sources, we can learn about the environment where the characters live and act, whether that environment is domestic or industrial, up-to-date or in decay, tastefully decorated or thrown together in haste.

As in Poetic Realism, noirs use lighting and set design to show how character and milieu interact. The characters have shaped the setting, which has the power to shape them in turn.[17] Milieu is particularly important to the subset of noir known as *film gris*. As Thom Anderson explains, the term refers to a series of socially engaged films produced, written, or directed by the left-wing filmmakers who were later blacklisted or fell under suspicion for their political beliefs.[18] The distinguishing feature of the cycle is its critical examination of social issues, such as racism, anti-Semitism, and capitalism. Visual style varies from film to film, but careful attention to milieu brings these social themes to the fore. In *Force of Evil*, the art director Richard Day creates a tangible contrast between the world of the corporate titans and the world of the everyday workers. Tucker's apartment features smooth white walls and a swooping staircase. Leo's office has dirty walls and even dirtier window shades. The cinematographer George Barnes amplifies this contrast through lighting. For Tucker's apartment, the movie's screenplay calls for "the brightness of a Central Park window."[19] Barnes satisfies the call with a huge window pattern, as if from a skylight, creating a pattern of curved lines for Joe and Tucker to walk through. As usual, it is possible to find symbolism in the pattern. Perhaps Joe is trapped in some kind of web. I prefer a more literal-minded reading: the skylight characterizes Tucker's world as light, open, and rich. Tucker's display of conspicuous wealth makes it all the more disheartening to see the tight confines of

Leo's office, where a bunch of basically decent people must hide from the police to do a job that the murderous Tucker does on a much vaster scale. Again, the screenplay's language vividly sets the scene: "This dark, fetid apartment is untenanted by domestic furniture, lighted by unprotected bulbs."[20] Barnes's lighting is appropriately dark, and we learn a lot about Leo just by looking. He is involved in an illegal activity, so he keeps the windows shaded. His business is small-scale, so he saves money on decor by relying on cheap hanging fixtures that are fitted with low-wattage bulbs. The office is ugly, but blame for this ugliness should not fall on Leo; it should fall on the economic system that forces Leo to exploit others just so he can be exploited by his own brother.[21]

My proposal is that cinematography and the set design work together to teach us about the film's milieu. I have chosen the word *teach* because I want to suggest an active process; the lighting makes a positive contribution to each scene. My goal here is to distance myself from another way of thinking about source lighting—namely, an approach that would situate lighting within the framework of the invisible style. Hollywood filmmakers frequently argued that they did not want spectators to notice their techniques; style should be invisible, or at least undistracting.[22] We can hear this note of restraint in some of the articles I have quoted, as when Loring insists that "special effect lighting should never call attention to itself."[23] On this more modest account, source lighting might be understood as a sophisticated way of *masking* the work of cinematography, making the crew's work seem less noticeable by creating the illusion that the lighting comes from sources within the storyworld.

I have come to believe that the idea of the invisible style explains less than it promises to do, not just in film noir but in dramatic cinema more generally. It is primarily a negative account, explaining how cinematographers hid their effects without explaining why they created them in the first place. If cinematographers really wanted their lighting effects to be so unnoticeable, they could have eliminated those effects altogether in favor of dull, simple brightness. Instead, they developed a complicated set of practices to depict sunlight, moonlight, candlelight, and all the rest. Cinematographers went to all this trouble not for a negative reason but for a positive one: because these effects added something to each scene. What they added, above all, was a vivid sense of an environment. At a glance, we can see that Tucker in *Force of Evil* is rich. At a glance, we can see that Frank in *Act of Violence* has come to a gritty part of town. For these lessons to take hold, they must be noticeable. This need to be noticed may explain why noir cinematographers were so attracted to the image of a beam of light slicing through the fog. Fog can turn any light into a source light, an aspect of the storyworld that we are meant to attend to and consider. Examples of the beam-of-light effect can be found in *Citizen Kane*, *Moontide* (1942), *Phantom Lady*, and *He Walked by Night* (1949). Rather than hide the effect, the extra motivation calls attention to it. An even surer way of calling attention to a lighting effect is to have a character refer to it. In *Side Street*, when two characters enter the unlit stairway of a cheap apartment building, one of them

complains, "What some people won't do to save a dollar. You'd think one little light cost a fortune." Far from making the darkness seem unobtrusive, the dialogue draws our attention to the lighting (or lack of it) to ensure that we recognize, right away, that the characters are entering a marginal space.

It might sound like I am celebrating noir for *breaking* with Hollywood's invisible norms, but my proposal is broader, questioning whether fictional dramatic storytelling can ever be truly invisible at all. As a general rule, I assume that we can get invested in a movie's story and recognize that the movie is a construction at the same time. Indeed, the first presupposes the second, for the very concept of story is a means-end concept. To say that something is a narrative is to accept, right from the beginning, that the work in question has been *constructed* to produce effects: emotion, curiosity, engagement.[24] The same goes for my understanding of depictions: they are constructed works, visibly so. The illusionistic idea of watching the world through a transparent window simply does not enter into my understanding of fiction film. We are watching an organized series of pictures, and we know it. Even more, we *see* it.

A means-end approach to pictures is consistent with another curious fact about source lighting: cheating was perfectly acceptable. Loring stated as much in his article: "A certain amount of 'cheating' is permissible and even necessary in some cases."[25] Most of my illustrations so far contain cheating. In *Act of Violence* (see figure 5.1), there is some extra fill light on Mary Astor's face, which makes her expression more readable without destroying the impression of a woman standing under an ugly lamp. In *Where the Sidewalk Ends* (see figure 5.3), the top-lighting effect is quite convincing—but then the lieutenant pushes the suspect into the corner, and there is an extra shadow on the wall, which is totally inconsistent with the previously implied source. The cheat makes little sense according to fictional-world logic, but it makes perfect sense according to means-end logic: it provides a better look at the suspect's face. Cheats may seem contradictory, but they rely on our awareness that a movie may aim to accomplish several things at once. The essential thing about lighting for milieu is to get across the idea of the social environment. Vividness is more important than consistency. The goal throughout is to create an impression, an impression delivered at a glance.

SOURCE LIGHTING ON LOCATION

During the postwar period, location shooting appeared in many noirs, especially in semidocumentary crime movies such as *The House on 92nd Street* (1945), *Call Northside 777*, and *The Naked City*. As Lisa Dombrowski explains, the films in this cycle typically combined several features: "a scripted story based on real espionage or crime-related events, an objective voiceover narration, selective use of non-actors in secondary and extra roles, little to no musical score, and, most importantly, at least partial shooting on actual locations."[26] Location shooting could save money on fast-rising construction costs, while creating films that could

be sold on the basis of their pictorial appeal. At Twentieth Century-Fox, Darryl F. Zanuck proved to be an enthusiastic supporter of the trend, in crime films and sometimes in other genres.

Some filmmakers argued that location shooting allowed, and perhaps even required, a rougher style of cinematography. Norbert Brodine, a leading practitioner, reportedly called for "eliminating photographic 'frills' and using simpler, more realistic lighting patterns."[27] Another industry professional emphasized the necessity of avoiding Hollywood's "over-polished, back-lighted" aesthetic.[28] A rhetoric of realism gave cinematographers license to loosen the rules regarding figure lighting, with backlight becoming an obvious target for elimination. At the same time, realism arguably increased the expectations regarding milieu. The more important the location became, the more important it was to light that location to advantage.

The task brought new challenges. Consider the problem of shooting a daytime interior on location. In the studio, shooting a daytime interior was fairly easy. Simply shine a lamp through the window to signify daytime, and then illuminate the characters so they appear to be lit from that general direction (at least roughly). On location, this simple task became surprisingly difficult. First, the electrical crew would need to supply power to their lamps. They could tap into the main power lines, or they could bring generators; either way, they might face a limit on the number of lamps they could use.[29] Second, the cinematographer would need to select the right lamp to provide the general illumination. Recall that *general illumination* refers to the baseline level of illumination on a set, typically supplied by the high-powered lamps pointing down on the set from above. A grid of lamps was obviously unavailable on location, requiring the electrical crew to devise some jerry-rigged contraption to get the job done. On *The Naked City*, the cinematographer William Daniels asked his crew to construct portable metal frames that could hold four photoflood bulbs.[30] On *13 Rue Madeleine* (1947), Norbert Brodine used arc lamps for large rooms, but he also had strips of photofloods available to use in smaller rooms.[31] These solutions required compromises. In a studio setting, the general illumination throws shadows on the floor, where they can be kept out of the shot fairly easily. On location, a makeshift rig might throw shadows on the walls, possibly contradicting the logic of source lighting by suggesting a light that is angled toward the window, not through it.

A third recurring problem involves the window itself. In a studio, the window opens onto a set, which can be lit to balance with the interior. On location, the window opens onto the real world, which is illuminated by the sun. Because sunlight is so very bright, there is always the risk of a huge discrepancy between the illumination outside and the illumination inside. Here, every solution carries risks. You can try to squeeze some arc lamps into the room, making the interior bright enough that you can expose for the exterior. The risk here is that the added light will fill the room with awkward shadows. Or you can add a moderate amount of illumination to the interior, enough for modeling purposes, but not enough to bring the interior into balance with the exterior. Now the danger is that the win-

Lighting Milieu 143

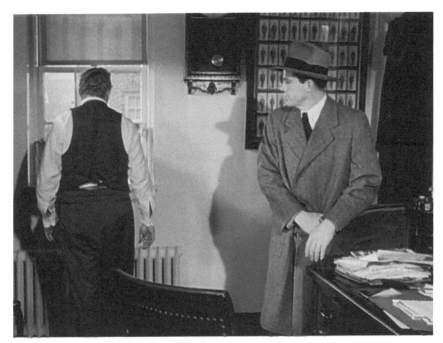

FIGURE 5.4. *Boomerang!* (1947): A difficult location results in some awkward shadows.

dow will be overexposed, to the point that it will look like a large white rectangle with no visible detail. Or you can avoid the problem entirely by staging the scene in another part of the room, so that the window is never seen. You might even add implied window light. Now the danger is that you have sacrificed the production value gained from shooting on location in the first place. It might look like the scene was shot on a set.

With apologies to Norbert Brodine, I offer figure 5.4 as an example of what it might look like when things go wrong.[32] The movie is *Boomerang!* (1947), a semi-documentary photographed in various locations in Connecticut. Here, the actors have been crammed into a small room, and Brodine must light the scene with whatever units he can fit inside. On the plus side, Brodine has succeeded in balancing the lighting between the interior and the exterior; we can look out the window and see detail in the buildings beyond. On the downside, Brodine has accomplished that goal with one bright light from offscreen right and another bright light from offscreen left. The resulting illumination looks flat, even as it creates two overlapping shadows on the back wall. There is no sense that this is a room lit by daylight.

If daytime interiors posed a serious challenge to noir cinematographers, nighttime exteriors presented them with a great opportunity, especially in urban settings. A streetlamp may provide a logical source for the key light. The general illumination may be motivated as weak moonlight or eliminated altogether. The resulting image will look high contrast, with bright highlights and deep pools of

shadow. The contrast is crucial to the effect, and not just because low-key lighting seems stereotypically noir. A high-contrast image makes the source-driven logic of the lighting even more salient. When there is just one beam of light cutting through the darkness, that beam of light stands out. It encourages the viewer to ask, "Where is this light coming from?" It is by answering this question that the viewer learns about the milieu.

Figure 5.5 shows a night exterior from the opening sequence of *Panic in the Streets*, photographed in New Orleans. The film came out near the tail end of the semidocumentary cycle in 1950, so late that the director Elia Kazan was worried about lapsing into clichés. He wrote to Zanuck, "If there is anything staler at the moment than just another documentary, I don't know what it is."[33] The movie eliminates the semidoc's stentorian narrator but amplifies the use of location shooting. In this scene, a man suffering from a plague is murdered by some criminals, who do not know that they will be ill soon themselves. It is a classic noir situation: a doomed man threatened by men who do not know that they are also doomed. And it is a classic noir image: two silhouettes against a backlight, which casts their shadows long and thin across the ground. The cinematographer Joe MacDonald has used several techniques to make the source lighting noticeable, perhaps even unmissable: (1) the fog makes the light's beam more visible; (2) the cast shadows create diagonal lines that point back toward the source; (3) the lamp is reflected on the surface

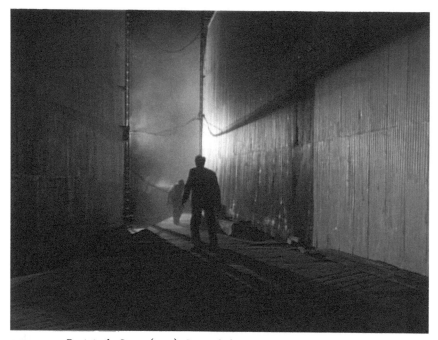

FIGURE 5.5. *Panic in the Streets* (1950): Source lighting connects this city space to the water in the background.

of the corrugated metal, and the resulting glare is the brightest spot in the entire image; and (4) the light in the background is actually two lights, one of which beams steadily while the other brightens and dims, implying the passage of a nearby ship. There are other lights and shadows in the shot, some motivated, some not, but this light in the background seems impossible to ignore. Its salience increases the light's effectiveness. By pulling our eyes to the background of the shot, the light ramps up the scene's mood of grim suspense: we see that there is a possible avenue of escape, and we see that this avenue is quickly blocked. While we are looking at the background, we might notice a rope with a strange circular object on it: a device to prevent rats from boarding ships. The rat motif hints at the plague theme, and the rope will play a role in the film's climax. The billowing fog implies the presence of water, which extends our understanding of the milieu. Figure 5.5 is the culmination of an impressively long panning shot. Earlier in this same shot, the camera has shown buildings in the downtown district, a train passing by, and a warehouse. Now we see an opening to the river. It is all connected: downtown, the trains, the port. The movie will take this idea of connectedness and turn it into a central theme, as the plague threatens to link neighborhood to neighborhood and city to country, whether the characters want it or not.

Clearly, the shot is rich in theme, but what really makes it memorable is its sense of physical texture. Over the course of the shot, we have seen an extraordinary range of textures: the brick walls in the distant background, the glass window on the front of the train, the cracks in the pavement outside the warehouse, and the water pooling near a drainpipe. Now we see the hardness of the corrugated metal, the slats of wood underneath the sick man's feet, and the fog billowing off the water as unseen ships float by. It is all connected: metal, wood, and fog. None of these textures would be as visible, as palpable as they are, without that light.

This milieu is simultaneously in the center of the city and at its edge, visibly connected to the electrical grid and yet terribly empty. In my view, depicting a space as electrified is one of the most important things that light can do in a film noir, especially one set in the modern world. An electrified space is a social space, with a look and feel shaped by history. As the historian Edward Dimendberg has explained, film noir explores the phenomenology of "characteristic twentieth-century spaces such as the skyscraper, the jazz nightclub, the magazine or newspaper office, the bus terminal, the diner, the automobile, the traffic-congested street, and the highway."[34] To evoke the feeling of these places, a cinematographer must attend to how they are lit, whether by streetlights, bare bulbs, fluorescent lamps, or neon signs. Every one of these sources carries preexisting social meanings—meanings that filmmakers could cite, revise, or completely overturn.

NARRATIVES OF PROGRESS

What sorts of social meanings did electric light have? To answer this question, let us step outside the film context for a moment to look at electric light in the broader

culture. The electricity historian David Nye argues that the production and consumption of power (including electricity) can be told in many ways: for instance, as a story of "natural abundance," "human ingenuity," or "existential limits."[35] Well before the emergence of film noir, the electricity industry had worked hard to define the story of electricity in optimistic terms. A 1948 article in the *Magazine of Light* provided a bar chart illustrating the total number of lumen-hours from electric lamps in the United States, with each bar representing another ten-year increment. For the first few decades of the century, there was a steady rise, approaching 500 trillion in 1938. Then there was a huge jump, "increasing nearly three and a half times in ten years," shooting well past a quadrillion lumen-hours in 1948.[36] We might have expected the Great Depression to have slowed the growth of the electricity industry, but its effect was very brief: after a short decline in the early 1930s, electricity consumption rose for the rest of the decade and continued rising into the 1940s. One 1936 article noted, "Even in these days of economic distress, the consumption of electricity for lighting is increasing at better than 10 percent per year."[37] The war brought blackouts to many neighborhoods, but still the overall trend was toward increased usage of electricity, partly owing to a boost in factory lighting.[38] As one architect explained, factories covered their windows and installed "continuous artificial lighting."[39] It seems counterintuitive, but the dark style of the film noir emerged in a time of increasing illumination.

Although growth was the dominant trend, it was decidedly uneven, producing visible differences across regions and neighborhoods. The utilities industry was reluctant to wire farmland on the grounds that the low population densities did not justify the investment; eventually, the government had to address this need, first through the Tennessee Valley Authority and then with its Rural Electrification program.[40] In the cities, street lighting lagged behind other areas, such as lighting for retail and offices.[41] To reach domestic consumers, the industry encouraged homeowners to vary their lighting from room to room according to a principle of logical differentiation. For instance, one 1945 article offered remarkably specific advice to its readers, assumed to be women in charge of domestic decor. A chair used for reading might require 45 foot-candles, but fine sewing might require over 100. (A foot-candle is a measure of illuminance.) A standard game table needed only 10 foot-candles, but Ping-Pong required 40.[42] These recommendations treated domestic consumers as amateur cinematographers, tasked with illuminating the stories that might unfold inside each room. Another article in the same publication explained, "The home is a stage, where not only one, but several people, play their many roles in life."[43]

Whereas the ideal house was divided into different zones of illumination, factories and offices had cavernous spaces where a large number of people were engaged in the same activity. Progress took the form of increasing homogeneity. One 1949 article in the *Magazine of Light* shows how the office of the Corps of Engineers had changed over the years. The 1929 illustration shows the office under a "semi-direct" lighting scheme, with rows of glass balls in the ceiling that illuminated

some desks but left others in relative shadow. The 1948 illustration demonstrates a "luminous indirect scheme," with fluorescent lamps bouncing most of their light off the ceiling, producing an evenly distributed, virtually shadowless effect.[44] General Electric had introduced fluorescents to the public in 1938. Wartime factories began adopting them in the early 1940s, and GE was soon marketing them to offices, department stores, schools, and even homes.[45]

By the 1940s, the electricity industry had disseminated an elaborate iconography of artificial lighting—an iconography familiar to millions of consumers. Just as important, the industry had situated that iconography within a narrative of progress whereby each innovation made modern life brighter and better. Hollywood borrowed this iconography, even as it revised the accompanying narrative of progress to suit its own storytelling purposes. When it was working in an optimistic register, Hollywood might turn the iconography of light into an inspiring biopic, as in *Edison, the Man* (1940). When it was working in a more critical register, Hollywood might use the iconography of electric light for satire. Consider a scene from the crime drama *Marked Woman* (1937) in which a gangster named Vanning is inspecting a club that he wants to turn into a clip joint. He gives the club's harried owner a list of alterations to be made, including a radical change to the lighting: Vanning wants to eliminate the fancy chandelier. The owner protests that the chandelier is French; Vanning says, "It's still crummy. None of the classiest spots use that kind of stuff anymore. I want the kind that sticks up in the ceiling." A henchman adds, "Indirect lighting," and Vanning agrees. This minor gag in an otherwise serious film shows that filmmakers had a familiarity with the latest products from the electricity industry—a familiarity they expected contemporary spectators to share. But note the shifting tone. When the *Magazine of Light* advises using indirect lighting, a rhetoric of science and progress reinforces the recommendation. *Marked Woman* has placed the chandelier and the indirect lighting into a different kind of energy narrative: not a story of technological advance but a story of fashion manipulated for profit. Film noir would extend this project, offering a set of counternarratives to the electricity industry's mythology of progress.

NOIR'S COUNTERNARRATIVES, PART I: THE DARK

Jennifer Fay and Justus Nieland have argued that noir around the world responds to global processes of capitalistic modernization, which inevitably heightens inequalities within and between societies. Noir, they write, "is particularly attuned to this dark truth, emerging in response to the world-wide trauma of the Great Depression, when the promises of stable capitalist development rang especially hollow."[46] Whereas the electricity industry promoted a narrative of the world getting brighter every day, noir seems equally interested in the spaces left behind.

Flip through the pages of the *Magazine of Light*, and you will find lists of decorating mistakes to avoid: bare lightbulbs, excessive contrast, distracting shadows, ugly drop cords, and glare. This list of mistakes provides the basic iconography of

film noir. We have encountered several of these poorly lit spaces already: Cobby's back room in *The Asphalt Jungle*; Evans's hotel room in *Sorry, Wrong Number*; the drummer's sleazy apartment in *Phantom Lady*; or Mrs. Smerrling's hallway in *Mystery Street*. These places are not just dark; they seem obsolete, illuminated by fixtures installed years ago.[47]

Obsolescence can mean many things, even in a single movie. In *Pickup on South Street*, obsolescence carries a different set of meanings for Thelma Ritter's stool pigeon Moe than it does for Richard Widmark's pickpocket Skip. Moe's scenes deploy darkness critically. It is clearly unjust that this quick-witted woman has been forced to earn a meager living selling ties and information—a living so meager that she is still residing in a dim little apartment with a tiny pinup bulb over her bed frame. By contrast, Skip's scenes celebrate obsolescence as idiosyncrasy. Skip is a vibrant young white man in postwar New York, and he could probably make a decent living if he wanted to do so. Instead, he has opted to live in a shack on the river. This shack is apparently unconnected to the electrical grid, and Skip uses an oil lamp for illumination. For Skip, obsolescence is a choice: an act of defiance. The resulting juxtaposition between Moe and Skip intensifies the movie's ambivalence, which wavers between systematic critique of postwar society and the celebration of individual choice as an all-American ideal.

The electricity industry had wired some areas more rapidly than others. The result was a world of visible inequalities, where certain spaces (especially corporate offices in big-city downtowns and suburban homes in predominantly white neighborhoods) were quite literally brighter than others.[48] This is the sort of cultural knowledge that filmmakers could draw on, using light and shadow to reinforce dramatic contrasts. When *American Cinematographer*'s Herb Lightman published an appreciative article about *A Double Life* (1947), he wrote: "Every lighting set-up is accurate to the source and dramatically forceful. The luxurious apartment of the sophisticated actress is illuminated by the intimate glow from discreetly shaded lamps; the shabby walk-up of the doomed waitress is thrown into coarse relief by the harsh light from a single overhead bulb."[49] The lighting explicitly differentiates characters by class, rich versus poor, bright versus dark. More loosely, the lighting gestures at the movie's theme of racial boundary crossing. The protagonist of *A Double Life* is an actor who murders a waitress because he has identified himself too strongly with Othello, a role he is playing in blackface. The unshaded bulb marks the waitress's apartment as a space at the margins of (white) respectability. By choosing the right fixture, filmmakers can call up a cluster of associations involving geography, race, ethnicity, poverty, and urbanity.

Let us consider a particularly vivid example that uses an obsolete lighting fixture to sketch the history of a town—in this case, a history defined by ethnic boundaries. The movie is not noir, but it deploys the chiaroscuro that would come to be associated with the cycle. The wartime drama *The Human Comedy* is set in a small town in California. Mickey Rooney's character, Homer, works in a telegraph office. The lighting in the telegraph office is solidly functional, modern enough to

situate it within the contemporary world but not so modern as to suggest big-city sophistication. Homer's house looks different. The Tiffany-style stained glass lampshades evoke a nostalgia for an older time of Arts and Crafts. Contrast both of these spaces with the home of Mrs. Sandoval, a Mexican American mother (played by Ann Ayars in brownface makeup). Mrs. Sandoval lives in a neighborhood that is visibly separate and visibly more impoverished. Her house lacks electricity; instead, she relies on an oil lamp for her primary illumination, along with a candle illuminating a small religious sculpture. In a quietly devastating scene, Homer informs Mrs. Sandoval that her son has died in the war. She sits down next to the oil lamp, and then Homer imagines her in her youth, sitting with her infant son in her lap. Even in this fantasy scene, Mrs. Sandoval is sitting beside that same oil lamp. The movie renders her through Homer's eyes: sympathetically, but also as someone from an unfamiliar culture, oddly outside of modernity even as she has sacrificed her son to a very modern war. In this way, *The Human Comedy* uses lighting to teach us about its milieu, one that separates Mexican American families from white families like Homer's, producing visible patterns of segregation that are economic, technological, and cultural, as well as spatial.

Film noir uses similar tactics to represent spaces of unassimilated white ethnicity. As Dan Flory has explained, noir often explored how whiteness "was seen as rigidly and hierarchically micro-ranked by society, with Anglo-Saxons on top and 'lesser' whites listed in descending order," albeit with privileges denied to non-whites.[50] Low-key lighting combined with an obsolete practical source can identify a neighborhood as unfamiliar and strange, especially to the more normatively white protagonist who visits it. In the introduction to this book, I discussed an example from *Call Northside 777*, where the darkness contributes to the film's characterization of Wanda Siskovich's apartment building as a site of decay in a specifically Polish American neighborhood—in contrast to the comfortable home where the protagonist McNeal (presumably Irish American) lives. The film's screenplay shows how easily the characterization could express bluntly racist attitudes: Wanda's husband, Boris, is described as "big, massive, menacing," with "a gun in his big, black, hairy fist."[51] The movie handles Boris rather differently, but the scene still uses darkness to cultivate connotations of danger and strangeness. A similar scene appears in *The Dark Corner*, starring Mark Stevens as Brad, a hard-boiled detective trying to solve a case with the help of Kathleen, played by Lucille Ball. When Brad and Kathleen go searching for a man named Fred Foss, the lighting works in concert with several other cinematic devices to suggest that Foss lives in a low-rent apartment building. Brad and Kathleen walk past a row of metal trash cans in the hallway, and then they pause outside Foss's door. In the background, a two-bulb practical looks dim and obsolete. Brad proceeds to enter Foss's apartment uninvited. He walks through an unlit room and finds Foss, illuminated by a kicker from an implied source. Foss is understandably astonished that a stranger with a gun has broken into his home, and he exclaims, "Mamma mia!" The words complete the picture. Drawing on familiar iconography (and a few stereotypes),

the filmmakers have sketched this man who goes by the name of Foss as an immigrant from Italy who lives frugally in a bare-bones apartment. The dim source lighting has sketched a milieu of ethnic otherness.

As in the screenplay to *Call Northside 777*, the association between criminality and blackness may draw on baldly racist associations.[52] In Raymond Chandler's hard-boiled novel *Farewell, My Lovely*, Philip Marlowe visits an unfamiliar bar that is explicitly set in a Black neighborhood; Marlowe, Molloy, and the police all use a variety of racist terms to associate the darkness of the place with the Black patrons of the bar.[53] The film adaptation, *Murder, My Sweet*, simply eliminates the Black characters from the location entirely. Far from eliminating the racism, the relocation indulges in another form of racism: erasure. Julian Murphet points out that noir was erasing its Black characters right at a historical moment when many Black Americans were moving to the cities: "Anything but 'lonely' in contemporary reality, then, the existential void of film noir's lonely streets depends upon a repression of that black quotidian sphere."[54] Noir's iconography of shadows invokes ideas of marginality and otherness, generating suspense that the protagonist is traveling to the boundaries of the white world. But the movies paradoxically evoke this quality of otherness while populating its edgy milieus with characters who are overwhelmingly white.[55]

In place of Black characters, a noir may create a dark and shadowy milieu, the function of which is to show how far a white character has fallen. Consider a passage from Art Cohn's screenplay to *The Set-Up*. The story is about an aging boxer, and Cohn's atmospheric descriptions evoke the iconography of despair: "We see a small, dingy bedroom in a typical fourth-rate flea-bag: bare walls, paper faded and peeling; an ancient, battered bureau, pock-marked with cigarette burns and whisky rings; begrimed, sleazy curtains; a rug, spotted and torn; a water basin and pitcher; a naked electric bulb in the center of the ceiling (attached with a long string), shedding a dismal, depressing light."[56] Everything suggests that this hotel is stuck in the past: the wallpaper has *faded*; the bureau is *ancient*; the curtains are *begrimed*. There is a racial connotation to this atmosphere, even though the movie tries to keep it hidden. In the original poem that inspired the movie, the protagonist was a Black boxer. In the adaptation, the boxer is white, played by Robert Ryan.[57] The movie gains much of its emotional charge from the sense that Stoker is out of place: here is a white man who has wound up near the bottom. The governing idea is fallenness. Once, Stoker was closer to the top. Now he has fallen here.

The idea of representing a nonwhite space as dark and dangerous was also common in the Chinatown thriller of the 1920s and 1930s, as in *The Mysterious Mr. Wong* (1934), where two white characters find a secret doorway leading to a dimly lit brick hallway. The specific genre of the Chinatown thriller seemed old-fashioned by the 1940s, and noirs would lace their occasional bits of Chinatown imagery with irony.[58] *The Chase* is based on a story by Cornell Woolrich, and its plot is equal parts suspenseful and ridiculous. The protagonist is Scotty, played by nice-guy specialist Robert Cummings. Scotty travels to Cuba, where he falls under suspicion of

murder. In an attempt to clear his name, he leads the investigating detective to Chin's Curiosity Shop. At first, the shop is lit darkly, with a shaded lamp dangling over the head of the proprietor. To the detective's surprise, this woman announces that she is Chin, even though she is clearly not Asian. She then pulls a switch and illuminates the entire space. The movie has given us a cluster of stereotypical associations—darkness, Asianness, and criminality. Then it has pulled two of them away: it is no longer dark, and the proprietor is not Asian. This reversal makes it understandable when the detective doubts the location's criminality, as well.

The electricity industry had worked hard to convince people that the dangling bulb was obsolete—an old-fashioned form of lighting that no sensible consumer should accept anymore. The same sense of obsolescence became attached to the cast shadow, the harsh glare, and the makeshift shade. These campaigns provided film noir with a powerfully expressive iconography. Simply by representing a milieu with one of these forbidden sources, a film might depict that place as fallen and strange, split off from the ideal of white suburban domesticity.

NOIR'S COUNTERNARRATIVES, PART II: THE LIGHT

Noir's bright spaces also come up for critique. The electricity industry had promised that brightness would bring happiness; noir undercuts this optimism by depicting certain modern places as overlit, alienating, and uncomfortable. A vivid example of brightness as a symptom of alienation appears in *Young Man with a Horn* (1950). Lauren Bacall plays Amy, an unhappy woman who takes an interest in Rick, an ambitious musician played by Kirk Douglas. When Amy brings Rick to her apartment, she walks around and turns on all the lamps, precisely to show off her expensive decor. First, she hits a switch and twelve fluorescents come on, arranged in artful patterns above the doorway. Next, she turns on a table lamp with a simple modern base, then another table lamp with an Orientalist motif, and then a third table lamp with a classical sculpture as a base. We soon learn that Amy is disgusted with herself for her failure to master any of the various crafts she has attempted to learn. She mentions that interior decorating was one of those crafts, and suddenly the decor makes sense. It is gaudy and overdone, the work of an insecure rich woman who tries too hard. The scene lasts for four minutes, and nothing much happens in the way of plot. The lamps are there to teach us about Amy's social environment—to propose that her bright, expensively illuminated world is more dangerous to Rick than the grittier, multiracial world of jazz clubs he inhabits.

Other films represent bright spaces not just as technological marvels but as places of surveillance.[59] In 1939, the *Magazine of Light* had celebrated the soft overall illumination of Union Station in Los Angeles.[60] Eleven years later, a Hollywood movie (*Union Station*, 1950) would characterize the same station as a place where everyone is watching everyone else at all times, sometimes for good but sometimes for evil. Similarly, most of the action in *The Big Clock* takes place in a brightly lit modern office building. The cinematographer John F. Seitz devised a novel

approach to these office scenes: bounce lighting. He explained, "Since we had so many people talking at once and so much camera movement I did practically the whole picture by reflected light, reflected from the ceiling and sometimes the floor. It was quite an innovation. We had lights above the cloth."[61] This technique is the exact opposite of what we expect to see in a film noir. Instead of using hard lights to pick out details in a pool of shadows, Seitz uses soft light to illuminate an entire area, leaving virtually no shadows on the walls. Seitz's technique follows the recommendations of the electricity industry, which had been advocating homogeneous, indirect lighting for offices for years.[62] Far from disqualifying the film as noir, the brightness works to deepen its critique. Like *Union Station*, *The Big Clock* is a movie about the dangers of being seen. Ray Milland plays George Stroud, a journalist-investigator who must pin a crime on a mysterious man—even though Stroud knows that he himself is the mysterious man for whom he is searching. The movie's brightness increases the sense of paranoia; Stroud feels like a man with nowhere to hide. Even the movie's dark opening sequence develops the idea that brightness is the true threat. The camera pans over the nighttime skyline of New York and settles on a conspicuously modern corporate office building where Stroud works. Some of the floors are dark, and some are lit. As the camera begins to dolly toward the building, an additional floor turns bright. Soon, the camera appears to enter the building, where it locates Stroud hiding in the shadows. At first, the sequence fulfills all our expectations about the noir style: we see a nighttime cityscape, pools of shadow, and a camera that pursues the beleaguered hero into the darkness. But the film actually inverts the standard noir meanings. It is not the shadows that threaten Stroud, but the light. Stroud's sense of entrapment is expressed by the image of a huge modern office building being lit up, floor by floor, until every corner is exposed. In this world, the power of the corporation is signaled by omnipresent, controllable artificial light.[63]

Paul Schrader famously wrote that he wanted to reduce noir to its primary colors: "all shades of black."[64] But we should remember that noir depicts a wide range of milieus: the up-to-date as well as the obsolete, the bright as well as the dark. For these brighter scenes, noir's art directors needed to equip their sets with fluorescents, indirect sources, and softening shades. And noir's cinematographers needed to increase the general illumination, add diffusion to the lamps, and perhaps even bounce their lights to create the even overall illumination that the most modern spaces required. As a noted noir protagonist once remarked, "It's a bright, guilty world."

FROM MILIEU TO ARC

Once we notice the bright as well as the dark, we can think about how the movies organize their milieus into dramatic arcs. Does the character start in brightness and end in darkness, or does the arc go the other way around? Does the environment grow more modern over the course of the story or more obsolete? Is there

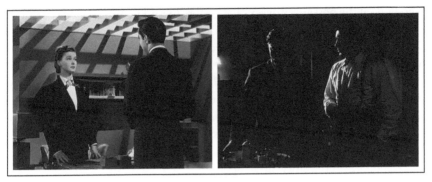

FIGURE 5.6. *Nightmare Alley* (1947): The lighting renders the modernity of some milieus and the squalor of others. *A (left)*: Lilith's modern office. *B (right)*: The squalid hotel room.

one scene that stands out as much brighter or darker than the rest? Or does everything stay maddeningly the same? Different arcs will create different shades of meaning. For instance, *Nightmare Alley* (1947) tells a classic rise-and-fall story. The protagonist Stan is a lowly carnival worker who becomes a celebrity mind reader. He forms a criminal alliance with Lilith, a high-class psychoanalyst. She outsmarts him, and Stan ends up descending to the lowest depths. The lighting shows tremendous range. Rather than cast everything into shadow, the cinematographer Lee Garmes emphasizes the radical unevenness of Stan's world—a world where some places seem up-to-date and other places seem stuck in the past. When Stan visits Lilith at her office, she stands underneath a grid of overhead lights. Garmes uses an arc lamp to cast the shadow of the grid onto the back wall (figure 5.6A). The effect is so bold that it may plausibly be read as symbolic: Lilith is like a spider at the center of a web. But the literal meanings are just as interesting as the symbolic ones. The decor characterizes Lilith by showing us her well-appointed world. At a glance, we can see that she is successful. At a glance, we can see that she has no interest in stereotypically feminine decor. At a glance, we can see that she wants to project an image as someone who is clean, organized, and above all modern.

Nightmare Alley was released in October 1947. A few months earlier, the *Magazine of Light* had printed an article illustrating the appearance of an up-to-date office; it featured an overhead louvered system that is almost identical to the one that appears in *Nightmare Alley*.[65] There is no need to suppose that the filmmakers stole the idea from the magazine. They did not need to; the electricity industry had remade the physical culture already. Fixtures like this were all around, with a whole set of cultural meanings that could be adopted and repurposed. Here, the filmmakers take the connotations of cleanness and efficiency and turn them into connotations of coldness and control.

Later, Garmes designs an extraordinarily dim lighting effect to teach us how far Stan has fallen. After his mind-reading act has been exposed as a fraud, Stan goes on the run. Staying at a cheap hotel, Stan has a verbal exchange with a bellboy,

who hints at the possibility of sex. The gesture toward homosexuality is meant to convey the sordidness of the location; lighting amplifies the sense of squalor. Garmes backlights both men and uses very little fill, rendering the appearance of an ugly little room illuminated by a tiny bulb (figure 5.6B). The same grimy bulb could be placed into the hotel room in *The Set-Up*, but here the familiar noir imagery is given a distinct charge because of its place within the dramatic arc. Stoker's fall happened a long time ago. *Nightmare Alley* has raised our hopes only to dash them. This hotel scene is a stage in Stan's ongoing fall—his fall back to a world he thought he had escaped.

Depending on the story, these oppositions and contrasts could take on radically different political meanings. *The Lawless* (1950), another *film gris*, was directed by Joseph Losey, who soon after moved to Europe to escape the blacklist. The movie's lighting develops its critique of racial injustice. The protagonist Larry is a white reporter who edits a small town's newspaper, *The Union*. He meets Sunny Garcia, a Mexican American who works for her father's Spanish-language newspaper, *La Luz*. The film's progressive politics are marred by its white-savior storyline and by the casting of Gail Russell in brownface as Sunny, but it represents a bold attempt to address incidents of anti-Mexican racist violence, as in the wartime Zoot Suit Riots, when white servicemen attacked Mexican American teenagers, who were then blamed for the attacks.[66] Visually, the movie develops an instantly recognizable contrast between the two newspapers. *The Union* is associated with modern lighting. In one early scene, there are fluorescents hanging from the ceiling, and they are all on, even though the office receives ample illumination from the large windows. The high degree of general illumination mimics the appearance of the bright, uniform space that was the normative ideal for the modern office (figure 5.7 A). When Larry leaves the office, he turns on the neon sign outside—another modern touch.

The offices of *La Luz* feature older fixtures: dangling bulbs with metal shades. In the closing scene, shadows on the back walls suggest that the space is lit more

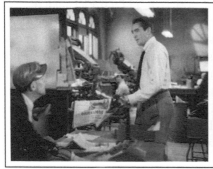 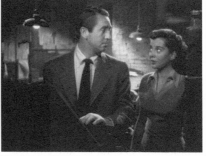

FIGURE 5.7. *The Lawless* (1950): The two newspaper offices represent two different milieus. A *(left)*: Larry's office has bright modern fluorescents. B *(right)*: Sunny's office has dim dangling lamps.

sparsely (figure 5.7B). *The Union* office is bright and modern; that of *La Luz* is dim, like a publisher from another era. But here is the crucial point: the dimness of *La Luz*'s office is depicted positively. When the film begins, Larry is a man whose life has grown a bit too comfortable. His office is too nice, too modern. Sunny and her father are the ones who are engaged in true journalism, even if their offices lack the polish of *The Union*. At the end of the film, Larry comes to *La Luz*—literally, the light—and finds a comparatively shadowy space that gives him hope, precisely because it lacks the amenities of his previous office. Most noirs use darkness to represent failure and despair. *The Lawless* has inverted the pattern, suggesting that physical brightness is not necessarily a sign of goodness, and that sparse lighting might be consistent with hope.

On the other side of the political spectrum, the semidocumentary *The House on 92nd Street* celebrates the FBI and its powers of surveillance, consistently associating the bureau with the most up-to-date technology. Remarkably, one of the film's images—a high-angle view of the FBI's wartime office—is almost identical to a photograph that had appeared two years earlier in the *Magazine of Light*. The article in question celebrates how recent improvements had brought the Armory building in Washington, DC, up to the industry's bright, homogeneous standards for the modern office.[67] Again, it is not a question of the film citing the magazine so much as it is a question of a shared iconography whereby an array of lamps could serve as an emblem of modernity.

These two examples remind us that there is no dictionary fixing the meaning of a particular image, whereby darkness is always bad and brightness is always good. My first example, *Sweet Smell of Success*, features bright spaces and dark spaces. And they are both bad.

SWEET SMELL OF SUCCESS (1957)

More than any other cinematographer in Hollywood, James Wong Howe defined himself as a realist. He looked to the photography in *Life* and *Look* for inspiration, and he welcomed the influence of World War II documentaries.[68] This urge for immediacy led him to experiment with handheld camerawork, most notably in the boxing scenes from *Body and Soul* (1947). Howe's realism also took the form of an abiding commitment to source lighting. As early as 1931, Howe was advising his peers, "In almost every instance there should be one definite source from which the light should appear to come. This gives the illusion of reality, if it is not overdone."[69] Decades later, Howe advocated an even more stringent form of the same philosophy: "I work with a theory to eliminate lights anyway; I only use a light when it's absolutely necessary."[70] In negative terms, Howe sought to excise unnecessary touches like backlights and dappled patterns; in positive terms, he created a vast gallery of immediate, imitated, and implied effects, situating his characters within worlds that seem illuminated from within.

The eliminationist aesthetic inclined Howe toward darkness: his peers nicknamed him "Low Key" Howe. But the commitment to source lighting also pushed Howe in another direction, or rather in several directions at once, sometimes dark and sometimes bright, depending on the needs of each milieu. During the noir period, he depicted small-town sitting rooms (*Kings Row*), big-city boxing rings (*Body and Soul*), western cabins (*Pursued*, 1947), nighttime jungles (*Passage to Marseille*, 1944), and modern-day warehouses (*He Ran All the Way*).[71] When he started shooting *Sweet Smell of Success*, Howe was at the top of his profession, having won an Oscar for *The Rose Tattoo* (1955), a naturalist movie that is remarkable for its "flat and unsightly" lighting.[72] *Sweet Smell of Success* gave Howe the opportunity to depict several New York City milieus, both on location and in the studio. The protagonist of the story is Sidney Falco (Tony Curtis), a press agent who wants to get back in the good graces of J. J. Hunsecker (Burt Lancaster), the city's most powerful columnist. To do so, he must drive a wedge between J.J.'s sister Susan and her boyfriend Steve Dallas. Sidney's plan backfires, leading to a beating for Sidney, a possible escape for Susan, and a lifetime of loneliness for J.J. Much of the movie's impact comes from its memorable supporting roles; there are no wasted scenes. To give just one example, Lurene Tuttle gets exactly one scene as Loretta Bartha, the unhappy wife of a rival columnist, but she registers as a fully developed character, first responding to Sidney's charm and then fighting back bravely against his corruption.

Ernest Lehman wrote the original drafts of the script (based on his novella and some short stories), and Clifford Odets wrote the sharp-tongued final drafts. The eminent noir historian James Naremore has written the definitive account of the movie, from its troubled production to its eventual inclusion near the top of the noir canon.[73] Setting aside the urge to quote the movie's juiciest lines, I will keep my focus squarely on Howe's achievement: the representation of character through space. I mean it: I will not quote the dialogue a single time. Not if you served me Cleopatra on a plate.

The opening scene shows Sidney at a hot dog stand, where he learns that J.J. is continuing to freeze him out of his column. Howe renders the fluorescent-lit look of the location with great immediacy; much of the illumination comes from the practical lamps we see onscreen (figure 5.8). The lighting is soft not in the sense that it seems welcoming but in the sense that it looks flat, as the large sources cover the entirety of the space. The impression of realism comes from the conspicuous rejection of Hollywood lighting conventions. Howe refuses to treat the star differently than the extras, and he refuses to add glamorizing touches: there is no crisp backlight, no eyelight, and no shadow under Curtis's jawline. At the same time, Howe's composition evokes another set of conventions: the seemingly unplanned aesthetic of street photography. The centripetal force of Curtis's presence is balanced by the centrifugal force of many other details, such as the diagonal lines that point our eyes toward the lower right, a man in the foreground who pulls our eyes to the left, and some fluorescent reflections that yank our eyes to the

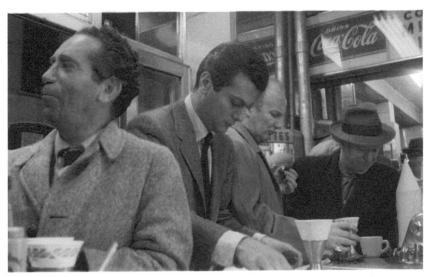

FIGURE 5.8. *Sweet Smell of Success* (1957): Fluorescents illuminate a hot dog stand.

upper right. The lighting looks modern not because it seems futuristic or advanced but because the technology of fluorescence seems ordinary, creating a zone of undifferentiated brightness in the middle of the night.

Another fluorescent-lit space appears when Sidney visits Mary, J.J.'s savvy assistant, played by Edith Atwater. Sidney flirts with Mary, partly because he enjoys it but mostly because he wants her to give him preferential treatment. She agrees to help him—but she also makes it perfectly clear that she knows exactly what Sidney is doing. This studio-built set captures the look of a midcentury New York City office building, complete with fluorescents stretching far into the background. The fluorescents complement the mock daylight streaming through the offscreen window. (The lamps appear to be in false perspective, making the background look larger than the set really is.) Howe employs well-balanced illumination to mimic the appearance of this room: there are no pockets of shadows, just an overall wash of light with a zone of brightness close to the window (figure 5.9). The scheme allows Howe to add some felicitous touches, such as the kicker outlining Sidney's profile when he lights Mary's cigarette. Sidney looks handsome throughout the scene, and we can see why Mary enjoys looking at him. At the same time, Mary never loses control of the situation. This is her office, and she sits in the perfect position, where the windows to the outside give her a view of the entire sunlit city and the windows to the inside give her a view of the entire artificially lit office. The milieu teaches us about Mary. Her office is functional, spacious, and cluttered without being chaotic.

Mary's modern office makes such an impression because it differs so visibly from Sidney's, which is ugly and unpleasant—like fish four days old. The Falco office is located in an older building, with fewer windows and an assortment

FIGURE 5.9. *Sweet Smell of Success* (1957): Sidney meets Mary in her modern office.

of shaded lamps scattered around the room. A back door leads to Sidney's bedroom—a telling architectural detail, since sexual exploitation is a part of Sidney's business. An early scene implies that Sidney has had a sexual relationship with his assistant Sally (Jeff Donnell in one of her many iconic noir performances). Later, in one of the film's most wrenching scenes, Sidney uses trickery, insults, and calculation to bully his friend Rita (Barbara Nichols) into having sex with the sleazy columnist who has agreed to plant the smear. The early scene with Sally is not overly shadowy; it just looks dull and gray. The later scene with Rita feels different. Only one of the bedroom's three visible lamps has been turned on, allowing Howe to render the scene in much darker tones. When Sidney pleads with Rita to make her (coerced) decision, she stands in a conspicuous pool of shadow.

That shadow is partly motivated and partly cheated. On the one hand, there is a practical lamp located offscreen right, and this lamp explains the split lighting on Sidney's face and the kicker on Rita's neck. On the other hand, it is not clear where the dim light on Rita's face is coming from, or why there is a stripe of shadow running across her forehead. Howe gets away with flagrant cheating here because the lighting accomplishes its goals so well: the shadow marks the scene as a dramatic turning point for Rita (and a new low for Sidney), and it does so by sketching the milieu so vividly. The front of Rita's face is in shadow, at least in part, because of where she is in this room: turned away from the lamp and facing a door that she does not want to open. However illogical, the lighting gets the idea across. We can look and see exactly what Sidney's office is like: grim, confining, and utterly unromantic.

Elsewhere, Howe uses lighting for milieu to enhance his figure-lighting goals. One of his governing strategies is to make Burt Lancaster, the film's producer and

FIGURE 5.10. *Sweet Smell of Success* (1957): In the last scene, Susan steps into the sunlight.

star, look unfriendly and unappealing. His primary tactic is to hide Lancaster's eyes. In a scene at a television theater, Howe mimics the effect of a tiny bulb over a water cooler. With no fill light and no eyelight, J.J.'s eyes simply disappear in the darkness. It is an accurate rendering of this particular place, and also a marvelous etching of Lancaster's face, letting us see the crease in his forehead and the tension in his jaw as J.J. wonders what to do with Sidney, this cookie full of arsenic.

Several scenes were photographed on location, and the nighttime exteriors seem canonically noir, as when Sidney appears half silhouetted against the glare of the traffic. As good as these nighttime shots are, one of the most memorable location shots is a daytime shot that appears near the end of the film. After attempting suicide and implying that Sidney may have assaulted her, Susan finds the strength to leave J.J. forever. The sun is rising, and Susan steps into a shaft of light. She turns to look at the city behind her, and then she moves forward to an uncertain future (figure 5.10). I suppose that some noir aficionados might find the sunrise imagery overly optimistic: the sort of syrup you pour over waffles. I offer four points in defense of this shot, sunrise and all.

First, the image itself is a remarkable technical achievement. It is not easy to photograph a space with so much contrast between the highlights and the shadows, but Howe has executed the task perfectly, opening the aperture enough to let us see information in the shadows but not so much that the sky goes white or Susan's fair skin loses detail. Second, the image makes New York City look thoroughly modern, a city of skyscrapers and street signs, storefronts and scaffolding. And Susan is here, on the street, not surveying the city from above but moving through it with purpose. Third, the image extends an overlooked tradition, the tradition of noirs that end in sunlight. Susan is like Mike O'Hara in *The Lady from*

Shanghai, stepping out of the hall of mirrors and into the dawn. Or maybe Susan is like Joe in *Force of Evil*, walking through an iconic urban landscape, imposing and vast. Whether hopeful, ironic, or indifferent, sunlight provides a powerful ending to each film's dramatic arc precisely because it differs so markedly from what has come before. This brings me to my fourth point, which is that the ending of *Sweet Smell of Success* inverts the beginning, quite systematically. Recall the early image of Sidney at the hot dog stand. We see a man looking down as he stands in a tight space, surrounded by a crowd at night under the diffuse shadows of an artificial source. The image of Susan is the opposite in every way. A woman looks up and walks through a vast open space alone; it is daytime, and a burst of hard, crisp sunlight illuminates her face.

The director Alexander Mackendrick and his collaborators struggled to craft a satisfying ending to the drama, and I am not sure that they succeeded. Susan remains a deeply troubled and troubling character. But Howe has given the movie a vivid and fitting visual conclusion. For most of its running time, *Sweet Smell of Success* has been a funny but nasty little story of two men who seek to dominate each other and everyone around them. And yet the movie has featured a surprising number of unforgettable characters who are women, from Rita and Sally to Mary and Loretta. Maybe the closing image of Susan striding toward the dawn is implausibly hopeful, but it seems oddly perfect that this male-driven movie with these scene-stealing performances should end like this, depicting a woman at the center of the modern city.

TOUCH OF EVIL (1958)

When Orson Welles directed *Touch of Evil*, it was his first Hollywood film in ten years. The studio, Universal, imposed a series of ill-advised changes to the final cut, ignoring many of Welles's detailed suggestions. The resulting movie did not perform well at the box office. Years later, Universal released a restored version that followed Welles's notes more closely—though Jonathan Rosenbaum has argued plausibly that *restored* is not the right term, since the movie had never existed in quite this form before.[74] No matter the version, *Touch of Evil* boasts remarkable photography by Russell Metty. Best known for his color work with Douglas Sirk, Metty had collaborated with Welles before, most notably on *The Stranger* (1946).[75]

The story is set in Los Robles, a fictional town located at the United States–Mexico border. In the opening scene, the Mexican narcotics investigator Ramon Miguel Vargas, called "Vargas" or "Mike" (Charlton Heston in brownface makeup), and his American wife, Susan (Janet Leigh), witness a car bombing on the U.S. side of the border. After a short investigation, the American detective Hank Quinlan (Orson Welles) determines that a young man named Manolo Sanchez is guilty, but Mike is convinced that the racist Hank is framing Sanchez. Meanwhile, the local criminal leader Uncle Joe Grandi directs the members of his gang to terrorize Susan. (The film strongly hints at scenes of rape and drug use; it later denies those

hints.) In the end, Hank's longtime associate Menzies finally accepts Hank's culpability, and he agrees to help Mike get evidence of Hank's guilt.

The style of *Touch of Evil* is often described as *baroque*.[76] The term suggests both belatedness and excess: belatedness because the film arrived after the classic noir period had ended, and excess because the movie seems like a compendium of all the stylistic devices that had come before. Perhaps the most stylized sequence in this outrageously stylized film is the murder of Joe Grandi, which features canted frames, high and low angles, handheld camerawork, wide-angle distortion, rapid editing, and grotesque makeup. The lighting is equally mannered. Throughout the scene, an unseen sign blinks on and off, intermittently plunging the screen into near-total darkness.

By 1958, the blinking-light effect had become something of a noir cliché. In *I Wake Up Screaming*, a light is blinking on and off when the lying detective Cornell appears unexpectedly in Frankie's bedroom. In *Phantom Lady*, another light is blinking on and off when the drummer attacks Carol, and it is still blinking when Jack, the murderer, arrives to kill the drummer. Movies often use the blinking-light technique to establish the seediness of the milieu. In *Murder, My Sweet*, a sign written in Chinese is blinking outside Philip Marlowe's office when he meets Moose Malloy. There are no significant Chinese characters in the movie, so the sign is not there to set up a plot point. Instead, it is there to suggest that Marlowe works in a complex modern city—and more specifically that he operates somewhere beyond the limits of middle-class white respectability. Other noirs (or noir-adjacent works) that featured blinking signs include *Scarlet Street*, *Raw Deal* (1948), *The Prowler* (1951), *Hard, Fast, and Beautiful* (1951), *The Thief* (1952), *The Blue Gardenia*, and *The Big Combo*.

The technique owes some of its popularity to its potential for symbolism. Discussing *When Strangers Marry* (1944), Frank Krutnik writes that a character "is rendered a creature half of darkness, half of light—part angel, part woman of the shadows."[77] At a more basic level, the technique works depictively, showing us at a glance what the characters' world is like. Here are five things that a blinking light might teach us about a specific milieu. (1) The milieu is *modern*. Even when we do not see the source, we know that the light is electrical because the regularity of the blinking light differs from the irregularity of a candle or a flame. (2) The milieu is *urban*. The light that blinks on and off tells us that there is a city outside the window, whether or not we see the city. (3) The milieu is *commercial*. Houses do not have blinking signs; businesses do, either as temporary advertisements or as permanent fixtures. (4) The milieu is (probably) *cheap*. In the world of Hollywood economics, poverty is signaled by the image of someone who cannot afford a decent set of curtains to block the light. (5) The milieu is *dehumanizing*, creating a separation between people and technology; the characters simply cannot control the light, no matter how annoying it may be. Put these five points together, and you have a surprisingly sharp critique of modern life. With its blinking lights, the contemporary city can seem too dense, too commercial, too unequal, and too technological.

When designing a blinking-light effect, a cinematographer must make decisions about composition, direction, rhythm, dimming, and contrast. Should the effect be cast discreetly onto the background, or should it be cast directly over the characters? Should the lamp be positioned as a backlight, as a flat light, or somewhere in between? Should the on-off rhythm be fast or slow? Should the transition be immediate or gradual? And should the effect be paired with a high degree of general illumination or none at all? Welles and Metty consistently choose options to make the effect as vivid and noticeable as possible. Early in the scene, the light fades gradually; later in the scene, the light switches to black directly. As the rhythm increases, the shifts seem less regular, less predictable. Meanwhile, the direction of the effect changes whenever the movie cuts to a new angle—and those cuts happen increasingly often as the editing rate rises to the level of a quick-cut montage.

Welles and Metty have created such an ostentatious effect to get across a crucial idea: this milieu is a place of *indifference*. Hank, Joe, and Susan may be engaged in a life-or-death struggle, but the exterior light just keeps turning on and off, unresponsive to the characters' wants and fears. We can guess that the source of the light is some sort of sign, built for purposes that are commercial and probably crass, with little interest in making this place more inhabitable. When Susan wakes up, she steps outside into the blinking light. She needs desperately to be seen. Coincidentally, Mike is driving by on the street below, but he fails to register Susan's presence at all.

The darkness of the hotel room is instructive in another way. Just as Hank is preparing to murder Joe, he calmly asks Joe to turn off the wall lamp. Joe does so. Flipping the switch makes the contrast between the light and shadow a little bit more extreme, but the remarkable thing is that the change is so small: the contrast was already extreme before Joe flipped the switch. If we take a look at the wall lamp, we can see why. The set designers have equipped this set with a very distinctive practical: a combination fixture with one arm pointing up to hold an unlit gas sconce and another arm pointing down to hold an electric bulb (figure 5.11). That is why the room is so dark: its lighting is utterly out-of-date. This hotel—known as the Ritz—may have been a nice place to visit years ago, but now it is visibly obsolete.

Obsolescence is a recurring theme throughout *Touch of Evil*, and indeed in Welles's work more generally. Like the horse-drawn carriage in *The Magnificent Ambersons* (1942), the gas-electric fixture in Susan's hotel room is an emblem of obsolescence. Indeed, it is doubly out of date. It was obsolete whenever it was installed, combining a new electrical socket with an old gas lamp in case one power source was unavailable. And it is even more obsolete when the story takes place, with a gas lamp that is now completely useless and a socket that holds the dimmest electric bulb imaginable.

Noir set designers had been using the gas-electric combination fixture to decorate cheap settings for years. Other examples appear in *Journey into Fear* (1943, directed by Norman Foster but sometimes credited to Welles), *The Brasher Doubloon* (1947), *Call Northside 777* (see figure 1.2), *Where the Sidewalk Ends*, and *The Thief*. In *Touch of Evil*, the fixtures also appear in the Ritz Hotel hallway where

Lighting Milieu 163

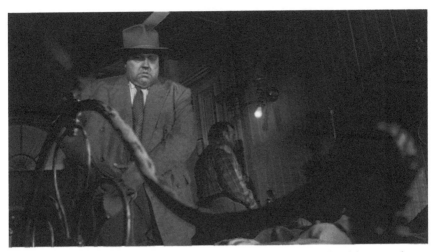

FIGURE 5.11. *Touch of Evil* (1958): The hotel room's only lamp is an outdated fixture with a dim electric bulb and an unlit gas sconce.

Hank is hiding before the murder, and there is even one that can be seen in the somewhat more upscale hotel where Mike and Susan are staying. These oddly twisted lamps add to the film's iconography of decay.

The most obsolete space of all is the brothel where Hank goes to visit his old acquaintance, Tanya. Tanya is played by Marlene Dietrich, and Welles's wrongheaded decision to cast several parts with white actors in brownface makeup seems willfully absurd here, as Dietrich makes no effort to shed her natural German accent. We know that the brothel is obsolete before we even see it, as Hank is drawn to its old-fashioned pianola playing a sentimental tune. "Customers go for it," Tanya explains. "So old, it's new. Got the television, too." The room is filled with clutter, including a collection of lamps that appear to be several decades out-of-date. One lamp has a Tiffany-style glass lampshade and a carved wooden base. Another lampshade evokes the Arts and Crafts style with its heavy pyramid-shaped lampshade (figure 5.12). But these lamps may not be as old as they look. They are juxtaposed with several other items, old and new, including a silly-looking chipmunk sculpture. And they hold electric light bulbs that are considerably brighter than the bulbs in the ugly hotel room where Uncle Joe will meet his death. They are faux-obsolete, taking outdatedness and turning it into a nostalgia that can be sold.

The brothel scene's lighting is also obsolete in another sense, duplicating the techniques of Dietrich lighting that had been used to photograph the star for nearly three decades. For her first close-up, Dietrich receives a flat butterfly pattern, which creates a hard shadow outlining her chin, a small butterfly-shaped pattern under her nose, and a tiny glimmer in both eyes. Makeup darkens the shadows under her cheekbones, while adding the trademark white stripe down her nose. It is classically glamorous and utterly ridiculous, with a single-source clarity that

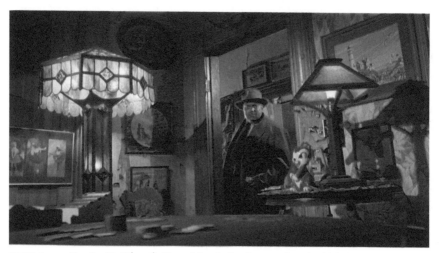

FIGURE 5.12. *Touch of Evil* (1958): Tanya's brothel is decorated with old-fashioned lamps.

makes no sense in the context of this cluttered, lamplit milieu. In chapter 3, I argued that glamour lighting worked by associating white women with exoticism without undercutting their whiteness. Here we see that combination pushed to the point of absurdity. Rather than depict Dietrich as a woman of Mexican or Roma ethnicity, *Touch of Evil* depicts her with a strange literalness: as Marlene Dietrich wearing brownface makeup and a wig.[78]

The brothel is on the Mexican side of the border; the Ritz hotel is on the U.S. side. Other obsolete locations include the garbage-strewn riverbed where the final confrontation takes place, and the motel where the gang terrorizes Susan. (The motel is in the United States, and Mike is disappointed that the casually racist Susan assumes she will be safer there than in Mexico. It has fallen into disrepair ever since the highway was moved a few miles away.) The fact that obsolescence can be found on both sides of the border supports the film's critique of borders in general. Not only are they arbitrary; they seem to facilitate the kind of exploitation that declares people and places obsolete so readily.[79]

The celebrated opening scene presents a complex and vivid picture of the border itself. The picture is not entirely negative: Los Robles seems dense and lively, and Mike and Susan initially enjoy the flurry of people they see. But the overall tone is grim. We know that a bomb is about to explode, and we are encouraged to view this milieu as a place of danger and decay, densely populated in some areas and oddly empty in others. The lights provide visible markers of disorder, placing the obsolete and the up-to-date side by side. An astonishing array of practical sources glides across the screen over the course of the three-and-a-half-minute opening shot: the fluorescents in the liquor store, the metal-shaded lamp above the parked car, the liquor store's neon sign, the incandescent bulbs outlining three of the colonnade's arches, the neon tubes outlining the four adjacent arches, the fatal

car's headlights, another neon sign for another liquor store, the three lamps illuminating the interior of a second colonnade as Mike and Susan walk by, the unshaded bulbs outside a drugstore, the neon sign for a soda fountain, the bulbs with metal shades outside the barber shop, the lights of the border kiosk, the four lamps illuminating the Mexico sign, and the three lamps illuminating the customs and immigration sign. Many of these lamps may have existed in the original location (Venice, California), but many have been installed to make the space seem chaotic and complex.[80] Together, they give the location a history: a history defined by repeated attempts to acquire the latest eye-catching technology, only to have that technology become obsolete almost immediately.

As we have seen, there is a risk in reading every shadow as a metaphor for doom. That risk comes in the form of an implied logic: if the dark is so bad, then the light must be good. Instead, *Touch of Evil* presents the culture of light as part of the problem. Electric light rarely makes life better. The jumble of lights in the opening shot seems chaotic; the lamps in Tanya's brothel appeal to cheap nostalgia; the gas-electric fixture in the Ritz Hotel is useless. An early scene in Mike and Susan's hotel expresses the film's attitude clearly. A member of the Grandi gang uses a flashlight to harass Susan as she tries to change her clothes; she responds by grabbing a light bulb and throwing it at him. For both, light is best used as a weapon.

In fact, much of *Touch of Evil* takes place during the daytime. Its entire story unfolds over the course of a night, a day, and the succeeding night. James Naremore rightly praises the film's representation of time passing, as in an early scene showing the streetlamps turning off as dawn arrives, the sky looking just a bit brighter in every shot.[81] We can add *Touch of Evil* to the list of noirs interested in time passing, a list that includes *Odds against Tomorrow* (see chapter 2) and *Strangers on a Train* (see chapter 4). In *Touch of Evil*, the increasing brightness makes ironic points about seeing and knowledge. When Mike exits the interrogation of Sanchez, he enters a shop and calls Susan on the telephone. Outside the window, Menzies arrives with Grandi. If Mike had noticed Grandi's arrival, he might have been able to realize that Susan was in extreme danger, staying at Grandi's motel. But he does not. Mike happens to be sitting next to a blind woman as he makes the call, and the symbolism is rather explicit: the idealistic Mike is blind to the situation that Susan is in. An added layer of irony comes from the fact that Mike's blindness is figured in an image of absolute clarity: in deep focus, looking through glass toward a sunlit exterior.

In this world, brightness is no better than darkness: one of the ugliest places in the entire movie is an interior space with plenty of light. To prove that Hank has a history of planting evidence, Mike visits an archive packed with ceiling-high filing cabinets. The room is equipped with several practical lamps, mostly fluorescent units hanging from the ceiling. Metty relies on the direct illumination from these practical sources, as well as the light from some supplementary lamps hidden throughout the room. The fluorescents mark this milieu as visibly modern—not in the sense that it looks stylish and fresh but in the sense that it looks utilitarian

and bureaucratic. Years earlier, the electricity industry had marketed fluorescent lamps as the perfect alternative to daylight, on the grounds that they, too, could provide illumination that was cool and indirect.[82] By the late 1950s, such promises seemed hollow. Mike has exited the daylight to come here, where the lamps make the room look grid-like, manufactured, and alienating.

The film's attitude toward this bright, bureaucratic space is bound up with its complex attitude toward Mike. As Robin Wood has explained, the canonical Welles story is a tale of two men: "one old and corrupt, the other young and pure, the film moving towards the betrayal of the older by the younger."[83] The young man may serve as the film's moral center, but the older man serves as the film's emotional center. Mike is the moral center here. He is absolutely right about Hank, a racist cop with a history of framing his suspects. But Welles wants to prevent us from taking the easy pleasures of identifying with Mike outright. It is not a point in Mike's favor that he feels comfortable in this room of fluorescent-lit filing cabinets—this room that seems a little too bright and a little too functional. Even the cheap and manufactured nostalgia of Tanya's brothel may seem preferable to this alienating place.

V. F. Perkins reminds us that stories take place in worlds, and that worlds have histories.[84] This insight informs every scene of *Touch of Evil*, where each lighting fixture has a history, a history stretching back for decades or more. It informs every scene of *Sweet Smell of Success*, too, even though most of these spaces have histories that are more self-consciously modern. Together, these two late noir classics show how a movie might deploy lighting to render a milieu—vividly, but also critically. The electricity industry had crafted a history of lighting as a tale of progress. Noir proposed a counternarrative, where electric lighting has only made certain milieus of the modern world visibly unequal, visibly dehumanizing, and visibly fallen into decay.

6 · SUBJECTIVITY, SYMBOLISM, AND DEPICTION

There is a remarkable passage in Vera Caspary's novel *Laura* where the title character explains how her feelings change when the light shifts. Laura Hunt is one of the book's three narrators, along with columnist Waldo Lydecker and detective Mark McPherson. Each narrator tells the story in a different style. Waldo's language is literary, Mark's is matter-of-fact, and Laura's is personal. In one scene, Waldo offers to help Laura, who is suspected of murder. Laura wonders if Waldo is promising his support only because he deems her guilty. She narrates: "Phosphorescent light gave green tints to Waldo's skin. I felt that my face, too, must reflect the sickly tint of fear. With an almost surreptitious movement, I pulled the cord of the lamp. Out of the shadows my room grew real. I saw familiar shapes and the solidity of furniture."[1] Laura's account juxtaposes the revolting appearance of Waldo in shadow with the more reassuring appearance of the room under light. The contrast reflects Laura's confused psychological state as she wonders whether she should trust the man who is promising to support her even as he accuses her of murder. (She should not.) Laura is actually a more reliable narrator than Waldo is, but she doubts her own reliability. In the next paragraph, she admits, "This is no way to tell a story. I should be simple and coherent, listing fact after fact, giving order to the chaos of my mind."[2] It is as if Laura wants to be a hard-boiled narrator but cannot.

The filmmakers of the 1940s were a bit like Laura Hunt. They wondered if they should describe/depict their worlds of light and shadow with a tone of neutral observation or if they should suffuse their representations with subjective feeling. In a decade of narrative experimentation in Hollywood, many of the most memorable experiments involved subjective storytelling.[3] There were dream sequences, fantasy sequences, and at least one sequence that turned out to be a lie. There were flashbacks, flashbacks within flashbacks, and flashbacks within flashbacks within flashbacks. There were films about psychologists and films about psychopaths. Although the experimentation was by no means exclusive to noir, many of the boldest films have since become noir classics: *The Killers*, with its patchwork of memories; *Sunset Blvd.*, with its flashback from beyond the grave; and *Lady in the Lake* with its extended experiment in point-of-view shooting.[4]

How did noir lighting contribute to these experiments in storytelling? This chapter proposes five ways that a film's lighting might (or might not) evoke an internal state: the *imagined, inflected, consonant, dissonant,* and *localized.* Making these distinctions brings a crucial aspect of noir storytelling to the fore: no film employs subjective lighting from start to finish. Subjectivity emerges and recedes as each film's story unfolds in time.

IMAGINED, INFLECTED, CONSONANT, DISSONANT, LOCALIZED

Suppose we are watching a Philip Marlowe movie. The light suddenly grows dim, casting Marlowe's face into shadow. Here are five different ways we might make sense of the sudden effect. First, we might say that the shadow is *imagined.* Perhaps Marlowe is having a nightmare. The menacing shadow creeping over Marlowe's face exists only in his subjective experience. Second, we might say that the shadow is *inflected.* The lighting is a flagrantly artificial touch added to express something about Marlowe's state of mind—isolation, say, or despair. We see the artistic touch, but there is no reason to believe that Marlowe sees what we see, not even in his imagination. Third, we might say that the shadow is *consonant.* Perhaps Marlowe has just entered a darkened room, and the gloomy atmosphere perfectly expresses his emotions, his anxiety in entering this dark space. Albeit expressive, the darkness is still a part of the fictional world. Fourth, we might say that the shadow is *dissonant.* Far from amplifying our understanding of Marlowe's mental state, the room's darkness runs counter to the tone of the scene—conspicuously so. Maybe Marlowe is cracking jokes the whole time, and the point of the scene is to play on the tension between the eerie look of the place and the unruffled feelings of the character who inhabits it. Fifth, the darkness may be *localized.* The lighting renders the look of the place, and Marlowe's mental state simply does not enter into the equation. The room is dark here and now.

I do not offer this five-item list as exhaustive, or as a system with fixed borders. Some lighting effects might not fit any of these categories, and some might fit more than one, depending on how we understand them. Indeed, my goal in this chapter is to show how noir storytelling benefits when the light shifts from one mode to another. With that in mind, let us take a closer look at the five options.

The first alternative is the *imagined* lighting effect. In *Notorious* (1946), Alicia realizes she is being poisoned moments before the poison causes her to collapse. The movie cuts to Alicia's point of view. Her husband, Alex, and his mother, Madame Sebastian, are looking directly at Alicia with expressions of feigned concern. Suddenly, the lights dim, turning Alex and his mother into near silhouettes (figure 6.1). An optical effect creates a visible wobble, stretching the shapes of everything onscreen; another optical effect intensifies the image's contrast, making the silhouettes look increasingly dark against a brightening background. The sound design changes, too: Alex's voice begins to echo, even though he remains in the same spot he was in just a few moments earlier. Together, these effects convey a powerful

Subjectivity, Symbolism, and Depiction 169

FIGURE 6.1. *Notorious* (1946): The lights appear to dim as Alicia succumbs to the poison.

impression of subjectivity. The movie is representing Alicia's experience—her loss of consciousness as the poison does its work.

I have chosen the term *imagined* light to characterize the dimming effect in this shot. Some might prefer the term *experienced* or *phenomenological*, but I think the word *imagined* does the best job of suggesting that the dimming effect exists only in Alicia's mind. To understand what is happening to Alicia in this scene, we must keep two points in balance:

1. Alicia sees Alexander and his mother in shadow.
2. Alexander and his mother are *not* in shadow.

The imagined effect is, in this sense, counterfactual. Alicia sees something that is not the case.

Do all point-of-view shots count as examples of imagined lighting? I think not. Robert Montgomery's 1947 adaptation of *Lady in the Lake* famously unfolds as a series of point-of-view shots. One could fairly describe all the lighting effects in these shots as mediated by Marlowe's subjectivity, but I think it would be far less useful to describe these effects as imagined. They lack that quality of counterfactuality that makes the *Notorious* shot so striking. Marlowe's perceptions are generally accurate (except for the occasional moments when he, too, passes out). When Marlowe sees Adrienne Fromsett sitting in front of a bright window,

FIGURE 6.2. *In a Lonely Place* (1950): A spotlight emphasizes the crazed look in Dix's eyes.

it is because Adrienne is, in fact, sitting in front of a bright window. There is no suggestion that his experience is warping reality. The lighting is functionally descriptive, not intrinsically subjective.

Inflected light is also subjective but in a different way. A classic example of inflected light appears in Nicholas Ray's *In a Lonely Place*. Humphrey Bogart's character, Dix, is sharing an evening with his friend Brub and Brub's wife, Silvia. When Dix begins to explain how the murder might have been committed, the lighting seems quite ordinary. But then Dix gets absorbed in his own story, so absorbed that he does not notice it when Brub absentmindedly tightens his grip around Silvia's neck. To mark Dix's escalating absorption, the lighting changes, spotlighting the crazed look in Bogart's face. Flagging Bogart's forehead makes the gleam in his eyes even more noticeable (figure 6.2). As Janey Place and Lowell Peterson remark, the effect "injects a sinister, demented quality" into Dix's performance.[5]

There is no reason to believe that some unseen character has entered the room and pointed a spotlight at Dix's face. The lighting is counterfactual, showing us something that is not the case. To understand what is going on, we must keep two points in balance:

1. The image represents Dix with a circle of light around his eyes.
2. Dix does not have a circle of light around his eyes, and no one sees him that way.

The situation resembles that of the imagined effect, but without the suggestion that the image shows what a character sees. Recall that the image in *Notorious* represents a character's warped experience, as if through her eyes. The image in *In a Lonely Place* does not—at least, not directly. Dix is not looking at his own face, and he is probably not imagining himself with a spotlight on his face, since he is too absorbed in his story to be thinking about what he looks like at all. Let us also assume that Brub and Silvia do not imagine Dix this way, either. It is a debatable assumption, but a plausible one. If that assumption holds true, then no one in the fictional world sees Dix like this, not even in imagination. And yet the effect still seems strangely subjective. George M. Wilson has described a similar effect as a mode of "reflected subjectivity." In this mode, we allow "properties of the way in which the fictional world looks to us on the screen stand in for properties of the way in which the world is experienced by the character."[6] Dix is experiencing a moment of complete self-absorption, so caught up in the story he is telling that he becomes blind to the world around him. The lighting has been adjusted to reflect or express that state of mind. The dimming of the room evokes his narrowing field of awareness. In grammar, a speaker might *inflect* a word by changing its form to convey information about tense or mood. In this scene from *In a Lonely Place*, the filmmakers have taken an external view of Dix and inflected it, modifying it to convey his dangerous descent into solipsism.[7] As Dana Polan explains, the technique can seem surprisingly artificial. For many viewers, the Dix scene is almost comical, sticking out rather awkwardly in the context of a film that generally avoids paradigmatically noir lighting effects.[8]

The next two examples work at the intersection between character and milieu; they evoke emotion even as they render the details of particular places. When the lighting endows a setting with a *consonant* mood, the image has a dual valence. The place has a mood, and a similar mood is felt by a character. A vivid example appears in Michael Curtiz's *The Unsuspected*.[9] A criminal, Mr. Press, is holed up in a cheap hotel called the Peekskill. He is listening to a radio broadcast; the announcer proposes that criminals are forever plagued by a hidden sense of guilt. Outside Press's window, the hotel's sign is blinking intermittently (figure 6.3). From inside the room, it looks like there is a single word flashing on and off: *Kill*. As in the example from *In a Lonely Place*, the lighting effect gives us insight into the character's state of mind. We learn that Press is struggling with a range of feelings: guilt for his past crimes, the fear that he will be caught, and the anxiety that his guilt leaves him subject to blackmail at any time. The scene is just as richly insightful as the scenes from *Notorious* and *In a Lonely Place*, but with one crucial difference: there is no suggestion that the image is counterfactual. To understand what is going on, we must keep these two points in balance:

1. The blinking expresses Press's state of mind.
2. The sign really is blinking outside that hotel room.

172 FILM NOIR AND THE ARTS OF LIGHTING

FIGURE 6.3. *The Unsuspected* (1947): A blinking sign expresses a character's thoughts.

That hotel sign is a physical object in the story's world, and it will keep on blinking long after the killer is gone. I think of the effect as one of *consonance*. There is an alignment between mind and world.

A fourth alternative severs this alignment; the lighting runs contrary to the character's state of mind. And yet, this effect of *dissonance* still requires us to consider the character's feelings. The setting has one mood, the character has another, and the two are at odds. The murder scene in the park from Orson Welles's *The Stranger* provides an example. Welles plays Kindler, a Nazi who is living under the assumed name of Rankin in a small town. His former colleague Meinike visits him, and at first Rankin is happy to see him. They take a stroll through the trees (figure 6.4). Over the course of a four-minute shot, Rankin realizes that he must murder Meinike to protect his own identity.

The scene gains much of its dramatic impact from the contrast between its setting, which is sunlit and sylvan, and its dramatic content, which is sordid and sinister. To appreciate this contrast, we must keep two ideas in mind:

1. Rankin and Meinike really are in a beautifully lit park.
2. The park's beauty does not express Rankin's state of mind, and indeed the beauty runs diametrically opposed to it.

This is not to say there is no connection between the location and the scene: Meinike and Rankin speak of heaven and sin, and the setting may bring to mind thoughts of

FIGURE 6.4. *The Stranger* (1946): A murder happens in a sunlit forest.

the Garden of Eden. But these connections are mostly ironic: the overwhelming impression is of a radical split between the setting's leafy atmosphere and the scene's grim tone.

A fifth alternative is *localized* lighting, where the emphasis has been shifted onto the place itself, away from the character's mental state. The brightness or darkness of the room is an existential fact about the world. I offer a scene from *Thieves' Highway* (1949) as an example. Directed by the soon-to-be-blacklisted Jules Dassin, the movie is a central example of the *film gris* cycle. The theme is the entwinement of capitalism and exploitation: the protagonist Nick is delivering a shipment of apples to Mike, who routinely uses trickery and violence to force truckers to accept lower prices. Hierarchy is built into the system, right at the level of the architecture and decor. Mike has a private office on the second floor; his workers are in a collective space down below. Mike's office is not exactly plush, but it is brighter than the workers' space, where the illumination is functional but patchwork (figure 6.5).

To appreciate localized lighting, we must keep two ideas in our minds:

1. Mike's office really is a fluorescent-lit space on the second floor.
2. We can learn about Mike simply by focusing on point 1.

To be clear, I am not arguing that the movie gives us no access to Mike's mental states. Lee J. Cobb gives a typically vigorous performance, and we learn that Mike works rather too hard at his job—one that involves the struggle for domination in

FIGURE 6.5. *Thieves' Highway* (1949): Mike has a brightly lit office.

every interaction. The movie asks us to understand his mental state by observing his behavior and by looking at the place where he works. This activity of watching differs from the activity of interpreting the mood of a place as an expression of a character's feelings.

Perhaps you still have your doubts. Maybe you think *In a Lonely Place* is imagined rather than inflected, or maybe you think *Thieves' Highway* is more consonant than I suggest. I have my doubts about some of these classifications, too, and indeed I think these doubts are unavoidable. In the dynamic model of storytelling, there may be no fact of the matter about which sorts of scenes are subjective—or objective. Judgments about imagination, inflection, consonance, and all the rest must be made on the fly as the movie unfolds. If the story is sufficiently complex, we must be ready to adjust our assumptions about the world and its characters at all times, sometimes radically, sometimes incrementally and cumulatively.

Many noirs use the ambiguity of subjectivity to their advantage. In *The Locket* (1946), Laraine Day plays Nancy, a kleptomaniac who may also be a murderer. We learn her story via a set of nested flashbacks, which eventually go three layers deep. Laraine Day had a wholesome star image, and Nancy can look like an ordinary woman, or like a femme fatale, or like a woman who is perceived (or misperceived) as a femme fatale by those around her. The movie does not resolve these tensions so much as it keeps them in play, sometimes tilting the scales against Nancy and sometimes tilting them in her favor. When Nancy looks dangerous (or respectable), does she look that way because she is inherently dangerous (or respectable)? Or does she

look that way because she is *seen to be* dangerous (or respectable) by the men who remember her? Or does she look that way for entirely innocent reasons—because she just happens to be standing next to a lamp or a window or a fireplace? When Nancy narrates her flashback to Norman (a painter played by Robert Mitchum), there is a shadow over her eyes. That shadow might express her emotions as she struggles with a difficult memory. Or maybe it expresses Norman's emotions instead, since the scene takes place in his flashback. Or maybe the effect is simply an elegant rendering of this particular place, a painter's studio with moonlight beaming through the window. For much of the film, the lighting cultivates this ambiguity precisely because cinematographer Nick Musuraca remains firmly within Hollywood's figure-lighting and effect-lighting conventions. If the lighting were overtly distorted, we could more easily dismiss it as a fantasy, treating each flashback like an unreliable dream sequence. But the lighting is usually *not* overtly subjective. Many of the effects have storyworld sources. The result is a persistent sense of uncertainty about whether an effect is localized, consonant, or inflected.

Ida Lupino's *Hard, Fast, and Beautiful* provides an even more focused example of ambiguity used for dramatic effect. Claire Trevor plays Milly, the mother of a tennis star. Milly is determined to see her daughter succeed, but her selfish behavior leads everyone to abandon Milly. In the penultimate scene, Milly finds herself standing alone on the tennis court under broad daylight. The movie might end there, but Lupino dissolves to one final shot. It is now nighttime, and Milly sits alone in the stands. The camera cranes back to reveal the tennis court, now completely empty except for a few pieces of trash being blown by in the wind. The lighting is dim and harsh; a top light casts shadows over Milly's eyes. The movie is generally not considered a noir, but this ending is as haunting as anything in the noir canon. Much of its power stems from its ambiguity. At first, the shot seems consonant: a sad person sitting in a sad space. Everything about the shot—the grim lighting, the emptiness, the crane away—creates a feeling of solitude, which perfectly expresses what Milly is feeling. This consonant reading puts equal weight on subjective and objective facts. But we might shift the weight toward imagination by saying, "Milly is not really sitting in a trash-strewn stadium at night. She is just envisioning her world that way." That option makes the ending seem even more depressing: Milly is so alone that she is trapped in her own thoughts. Or we might shift the weight toward localization, producing a reading that is depressing in another way. The image depicts the hard facts. Milly really has been sitting there for hours, and she really has nowhere else to go but this trash-strewn stadium. None of these readings is definitive, and that may be the point. The ending lingers in our memory because it can be interpreted in multiple ways.[10]

SUBJECTIVITY AND SYMBOLISM

Many of the preceding examples could be described as symbolic. Perhaps the shadow over Nancy's eyes symbolizes the theme of blindness, or perhaps

the spotlight on Dix's face symbolizes his isolation. I considered making symbolic lighting a sixth category, but I think it is more useful to think of symbolic lighting as a broad, rhetorical category that can be combined with any of the others: imagined-symbolic, localized-symbolic, and everything in between. This approach is more consistent with the mediated model of storytelling I have adopted throughout this book. Narrative theory draws a distinction between the level of the rhetorical address and the level of the storyworld. At the level of the rhetorical address, a movie is designed according to the intersecting logics of its many functions: suspense, say, or social commentary. To achieve these rhetorical effects, a movie may (or may not) work through the mediating layer of its story's world, where characters want things, do things, move around, and fail.[11] This means that any designed cinematic device is *always* rhetorical, a part of the film's address, and that it *may or may not* be fictional, located within the story's world. Orchestral music is always rhetorical, in that it is designed to shape a viewer's responses, but it is usually not fictional because it is usually not located within the story's world. The same goes for camera movement: always rhetorical, but usually not a part of the story's world.[12] Lighting is different: it is rhetorical, and it is usually fictional, too, located within the story's world. If we seek to explain why the light on Mr. Press's face is blinking on and off in *The Unsuspected*, we might say, "The light is blinking because Mr. Press is staying in a cheap hotel, and cheap hotels in this world often have blinking signs outside the windows." This explanation makes sense of the lighting by looking to the logic of the fictional world—its logic of time, place, and class. Alternatively, we might say, "The lighting is blinking because the blinking symbolizes the return of the repressed, suggesting that the urge toward violence is ever present inside Mr. Press, and perhaps in everyone." This second answer finds the explanation in the film's rhetorical address—in the film's use of lighting to achieve some larger functional aim. A film can and usually does operate on both levels at once. A film works *through* its fictional world to get to viewers. The filmmakers have constructed a fictional world complete with cheap hotels and blinking lights, and they have used that world to make a point about the inescapable pull of violence. On this account, even a localized lighting effect can be symbolic, for the symbolism will be rhetorical, aimed at viewers.

To be sure, symbolism is only one of the rhetorical effects that a film may seek to produce. Previously I have tried to set symbolism aside to focus on other rhetorical effects, such as generating suspense about where the story is heading next or commenting on the visible inequality of the modern world. If I am bringing symbolism back into the model now, it is because the problem of symbolism overlaps with the problem of subjectivity in such interestingly imperfect ways. It is one thing to ask if the lighting is symbolic at the rhetorical level—that is, for us. It is another thing to ask how the character in the storyworld experiences the lighting—that is, if it is imagined, inflected, consonant, dissonant, or localized. And it is still another thing to ask if the character interprets the lighting as charged with symbolic meaning—that is, whether the lighting is accepted as a perfectly ordinary part of the world or whether it is taken to carry some added significance. In *The Unsus-*

pected, Mr. Press clearly takes the "Kill" sign as meaningful. But the symbolism it holds for him ultimately differs from the symbolism it holds for viewers. For Mr. Press, the "Kill" sign is a part of the world he lives in. For viewers, the "Kill" sign is a part of Mr. Press's world, and Mr. Press's world is part of a constructed artwork. More commonly, the lighting in a film noir is symbolic *only* for viewers, creating meanings that are completely unavailable to the characters, for the simple reason that viewers are watching a constructed artwork, and characters are not. In many cases, the symbolism operates at a character's expense, emphasizing what the character *fails* to know. If we decide that the grid-like pattern in Lilith's office in *Nightmare Alley* represents a trap that will ensnare the protagonist Stan, then the symbolism is for us, not for Stan, who is too cocky to realize how much danger he is in. If we decide that a silhouette effect in *The Dark Mirror* (1946) is there to mark one of the twin sisters as evil, then the symbolism is for us, not for the other sister, who continues to look at her silhouetted sister with misplaced trust. The more obvious the symbolism, the more it seems like the characters are lacking some key piece of knowledge.

Blinds as bars, shadows as doubles, beams as circles of solitude—these are all familiar noir tropes, and they do their work well. They draw on a much longer tradition of using light to suggest symbolic meanings not just in the cinema but also across centuries of painting, as in religious paintings that used shadows to evoke ideas of spirt and incarnation.[13] That said, lighting effects need not be symbolic to be effective. Even a venetian blind may work well on an entirely literal-minded level. Vera Caspary's novel *Laura* became a celebrated film noir directed by Otto Preminger. Preminger favored a tone of cool detachment, and the movie mostly abandons the multiple-narrator approach of the novel. (Waldo narrates some scenes, including a flashback, but there is no sense that the movie as a whole unfolds from his point of view.) In one scene from Waldo's flashback, Waldo visits Laura in her office to apologize. An unseen set of venetian blinds casts a pattern on the back wall. At this point in the story, Laura remains a relative unknown. The representation of Laura's milieu *teaches* us about the movie's title character by showing us her social environment. Laura works as a graphic designer. The venetian blinds add to the impression that this office is a designed space—maybe even an overdesigned one. The diagonals of the blinds intersect rather conspicuously with the grid on the back wall, and then they curve around the vertical shape of an incongruously classical column. The room's design is stylish and mostly modern but also overly busy and lacking in refinement. This reading sets symbolism aside to focus on social facts. Rather than say that the blinds symbolize Laura's situation, I would say that they *characterize* her at this stage of her career. Via localization, we learn about Laura and the world she comes from—a world defined by class, gender, modernity, and other social factors, all of which are made visible via the set design, costume design, and the lighting.

Compare this example from *Laura* with a previously discussed scene from *Sweet Smell of Success* (chapter 5), when Sidney Falco visits J.J.'s assistant, Mary.

Both scenes show a man visiting a woman in her office. Both scenes use the tools of mise-en-scène to teach us, at a glance, what sort of world these women live in. We see at a glance that Mary has her own office and that Laura does not. We see at a glance that Laura's office is overdesigned and that Mary's office is highly practical. We see at a glance that both women are professionally dressed, and that both are hard at work. Lighting completes each picture; the venetian blinds are as perfectly suited to Laura's office as the fluorescent lamps are to Mary's.

To be sure, there is no need to frame the issue as an either-or matter. In the right context, lighting can symbolize *and* spatialize. That blinking sign in *The Unsuspected* is surely symbolic; simultaneously, it contributes to the film's milieu. At a glance, we can recognize the contrast between Mr. Press's downscale social environment and the upper-class environment where much of the story takes place. The contrast articulates a social critique, condemning the blithe indifference of the movie's primary villain (whose silky voice plays over the entire scene) and expressing some measure of sympathy for the exploited Mr. Press. Whether literal or symbolic, noir filmmakers create meaning by working *through* the fictional world: by creating a world where these lighting effects can take place.

SUBJECTIVITY AND EXPRESSIONISM

When applied to a film, the term *expressionistic* can mean many different things at once: subjective but also distorted, angular, Germanic, symbolic, and more. In a classic study of Weimar-era cinema, Lotte Eisner describes the German Expressionist classic *The Cabinet of Dr. Caligari* (1920) in terms of "abstraction and total distortion."[14] She goes on to argue that the lighting in Lupu Pick's *kammerspiel* films is not expressionist—indeed, is antiexpressionist in its emphasis on "everyday ambience," no matter how richly rendered the chiaroscuro might be.[15] This account stresses the contrast between the distorted and the everyday. Noir scholarship has tended to use the term more broadly, covering naturalistic lighting effects as well as stylized ones, to the point that the term *expressionistic lighting* has become a familiar shorthand for the noir style even when its darkness is perfectly localized.[16] My instinct is to favor Eisner's narrower approach, tightening its traditional connotations of subjective distortion.

An example from *The Cabinet of Dr. Caligari* provides a quick illustration of the term's potential for ambiguity. The police have just discovered the body of a murder victim. If I were to describe the image in figure 6.6 as *expressionistic*, here are six things I might mean. (As usual, the list is not meant to be exhaustive. The polysemy is the point.)

1. The word might signal that the image is strikingly *flat*. It depicts a three-dimensional world, but it does so in a way that makes two-dimensional properties seem unusually salient, as in the juxtaposition of the rectangular bed frame with the triangular shape in the lower left-hand corner.

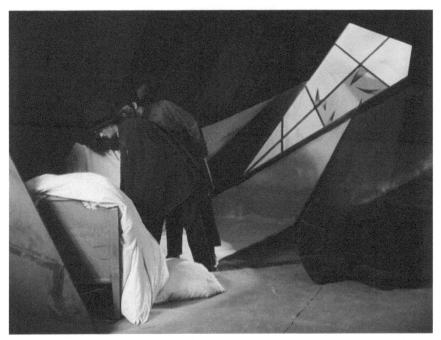

FIGURE 6.6. *The Cabinet of Dr. Caligari* (1920): Diagonal lines represent a scene of violence.

2. Building on the first meaning, the word might signal that the image is flat in a particular way. Expressionism tends to be associated with *angular* shapes and strong *contrasts*.[17]
3. Going farther, the word may suggest that the image is *distorted*. Expressionist artists argued that they wanted to see past the surface of things to get at the essence.[18] Here, the triangular shape of the window stands out not just because it is a triangle but because it departs from our expectations about the ordinary shapes of windows, as if the artists have taken a standard rectangular window and twisted it into this alternate shape.
4. Going farther still, the word might imply that the image is distorted because it is *subjective*, expressing the inner world of a character.[19] We later learn that the protagonist Francis is narrating this story from an insane asylum; the distorted shapes may represent his distorted imagination.
5. Heading in a slightly different direction, the word might imply that the distorted shapes are *symbolic*. The triangular window looks like a knife, which symbolizes the murder that just happened, and perhaps also the violence that pervades this world. These symbolic meanings are available to us even if the characters are unaware of them.
6. Synthesizing these possibilities, the word might imply that the image is distorted, symbolic, and subjective *all at once*. The image of the triangular window represents the workings of Francis's unconscious; his repressed feelings of

(subjective) hostility have been reworked into this image of a (distorted) window that looks like a (symbolic) knife.

When the word *expressionistic* is applied to a film noir, it might carry any of these meanings, either alone or in combination. Let me review my previous examples. The scene from *Notorious* is expressionistic in several ways: the image goes flat as it gains more contrast, the warped figures are clearly distorted, and the overall effect expresses a character's subjective state. *In a Lonely Place* does not seem unusually flat to me, but it is distorted in the sense that the lighting breaks from the logic of the fictional world by dimming so unexpectedly; the distortion seems subjective and symbolic. In *The Unsuspected*, the lighting expresses a character's state of mind, but it does so in a way that is not distorted: the blinking sign is a part of the character's world. Notably less expressionistic are the dappled shadows in the murder scene from *The Stranger*. The scene self-consciously avoids the harsh contrasts and diagonal lines that characterize the rest of the film; the imagery instead evokes the symbolic idea of the garden. *Thieves' Highway* seems realist in its emphasis on localized details, even though it contains as many crisscrossing lines as anything in *Caligari*. The empty tennis court at the end of *Hard, Fast, and Beautiful* is expressive of Milly's internal state, and the trash seems symbolic of the ruin that Milly has made of her life. And *Laura*? In spite of its venetian blinds, the scene is not distorted and not particularly symbolic. Describing it as expressionist runs the risk of overlooking what the filmmakers are trying to do, which is to situate the characters within a social environment. Preminger himself said that expressionism was for painters, not filmmakers: "When you shoot with a camera, then it must be real."[20]

Adding another layer of complication, the word *expressionistic* can convey an entirely different cluster of ideas when applied to film noir: ideas about influence and authorship. The Hollywood noir enjoyed extensive contributions from émigré filmmakers who had worked in the Weimar film industry. The list of directors includes Fritz Lang, Billy Wilder, Robert Siodmak, Curtis Bernhardt, Max Ophuls, Edgar Ulmer, and John Brahm; the list of cinematographers includes Franz Planer, Karl Freund, and Eugen Schüfftan. To say that *Phantom Lady* is expressionistic is not just to say that it is shadowy, subjective, and symbolic; it is also to say that the movie is shadowy, subjective, and symbolic *because* of Robert Siodmak's involvement (at least in part). The description makes a causal claim. In this case, the causal claim is quite plausible. Anthony Veiller's screenplay to Siodmak's later film *The Killers* contains the following instruction: "Two shadowy figures, framed a la Siodmak, stand with drawn guns."[21] The writer was familiar with Siodmak's work and used Siodmak's name as a shorthand for a particular kind of shot: a moody silhouette.

This is perhaps a rather extreme example. Most scholars would be reluctant to argue for a direct and unmediated link between German Expressionism and film noir. Raymond Borde and Etienne Chaumeton describe German Expressionism

as "a marked and persistent influence," but they also note that American films of the 1930s were just as influential.[22] Foster Hirsch cites the model of German Expressionism repeatedly, but he makes a point of noting that noir filmmakers combined its subjective techniques with the more objective styles of documentary and Neorealism.[23] Ginette Vincendeau reminds us that many German filmmakers also worked in France during the 1930s, where they helped develop French Poetic Realism, arguably a more proximate model for the noir style.[24] And Robert Porfirio argues that the psychological realism of the German *kammerspielfilm* was more influential than the strange distortions of *Caligari*.[25] For these scholars, German Expressionism was one shaping factor among many.

Marc Vernet has gone farther, arguing that the influence of German Expressionism has been wildly overstated: he shows that Hollywood filmmakers had been using strong shadows in crime movies for decades.[26] Thomas Elsaesser offers a subtle alternative, emphasizing how Hollywood's hiring of émigré filmmakers involved "creative mis-matches" and "over-adaptation" to the industry's ideas of Germanness.[27] This argument highlights various ironies in the historical record. Apart from Lang and Freund, most of the émigré filmmakers had little previous experience with German Expressionism per se, and indeed many got their start in satirical comedies or realist dramas.[28] If filmmakers like Ulmer and Siodmak ended up making a large number of noirs, it is partly because of cultural stereotypes associating the Germanic with the dark and serious, which led to a number of assignments shooting horror movies and downbeat crime pictures.[29] I have echoed Vernet's arguments in the past, both in my first book and in chapter 4 of this volume. Hollywood filmmakers used shadows for crime movies in the 1910s and 1920s, well before German Expressionism exerted its influence, and they continued using them throughout the 1930s, not just in horror movies but also in dramas and moonlit romances.

To be clear, I do not want to go so far as to toss aside the word *expressionistic*. The word is undoubtedly a part of the noir lexicon, and it is a powerful shorthand for some of noir's most familiar lighting effects. Reportedly, Welles screened *The Cabinet of Dr. Caligari* for the cast and crew of *The Lady from Shanghai* before everyone set off for Acapulco.[30] The influence is undeniable in the funhouse scene that climaxes the movie. At one point, Michael wanders through a strangely shaped room that would fit right into the world of *Caligari* itself. The turn to expressionism enhances the scene's vertiginous quality. Are the characters losing their minds? Or has their world gone mad?[31]

I prefer to use the word *expressionistic* to suggest the idea of subjective distortion, as in scenes that are imagined or inflected. I avoid the term in cases where the lighting seems to be undistorted, as in localized scenes and even in consonant ones. There are advantages to taking this limited approach. A narrow definition can prevent us from making the dubious assumption that every low-key lighting effect is expressionistic, or that every high-key effect is classical and conventional. Hollywood cinematographers thought of low-key lighting as a useful tool in a

range of situations: for crime pictures, horror movies, and dream sequences but also for glamour, tragedy, and ordinary night scenes. Sometimes the lighting seems expressively distorted, sometimes it seems gloomy and realistic, and sometimes it just seems dark. The meaning and effect depend on the film's narrative dynamics, which shapes our understanding of the film's fictional world as the movie unfolds. Another advantage of a narrow approach is that it allows us to appreciate some of the nonexpressionist contributions that émigré filmmakers made to noir lighting, such as the exploration of lighting for milieu that I discussed in chapter 5. As Alastair Phillips has explained, Robert Siodmak and Anatole Litvak in the 1930s showed a powerful interest in representing life in the modern city, whether Berlin or Paris.[32] Lighting for milieu typically refuses distortion in favor of a precise rendering of the culture of light in all its impressive (or ugly) modernity. Several émigré filmmakers brought sharply observant eyes to midcentury American culture. When Billy Wilder was asked if German Expressionism was an influence on *Double Indemnity*, the director replied, "No. There was *some* dramatic lighting, yes, but it was newsreel lighting."[33] Like the films of Preminger, *Double Indemnity* is rich in observation precisely because it avoids excessive distortion. With its dusty parlors and corporate offices, the movie is a triumph of lighting for milieu.

A narrower approach can also prevent us from making the equally dubious assumption that filmmakers with experience in the Weimar industry made dark movies as a matter of course, either before their arrival in Hollywood or after. Frances Guerin points out that many of the earliest German Expressionist films were lit somewhat flatly, allowing the set design to create the chiaroscuro.[34] Piotr Sadowski argues that there were "many different cinematic Expressionisms," including some movies that use brightness and daylight for horror.[35] And Tom Gunning explains that Fritz Lang's noirs from the 1950s are almost blindingly bright.[36] Let us abandon the idea that Germans had a unique affinity for darkness and distortion and recognize that émigré directors brought a wide array of skills and talents.

This account of the relationship between film noir and German Expressionism still leaves ample room for expressionistic devices to make a decisive contribution. Rather than suppose that all noirs are expressionistic by definition, I prefer to ask, "*When* are noirs expressionistic? In what sense?" In extreme forms, bizarre lighting can mark a moment as flagrantly subjective—so subjective that the reality of the film's world seems temporarily distorted. In less extreme forms, bizarre lighting can mark a moment as potentially or ambiguously subjective, making it difficult to determine if the image is an artfully inflected picture of a place perceived or if it is a carefully localized image of a socially specific setting. And, of course, the *absence* of expressionism can be equally significant. Whether dark or bright, the milieu-driven movie insists that the luminance really belongs to the place itself and not to a character's experience of that place.

Stranger on the Third Floor is a strong contender for the title of the most overtly expressionist noir of them all. The movie was directed by Boris Ingster, a Latvian émigré who had experience working at UFA (Universum-Film Aktiengesellschaft)

in the 1920s.[37] The protagonist Mike worries that his testimony will send an innocent man to prison. Mike then dreams that he is arrested for a neighbor's murder. That night, the neighbor is indeed murdered, and Mike is indeed arrested. Mike's girlfriend Jane then becomes the protagonist of the film, and in the last act she locates the real killer, played by Peter Lorre, famous as the murderer from Fritz Lang's *M* (1931). As Sheri Chinen Biesen explains, RKO's publicity department encouraged critics and viewers to describe the movie in quasi-expressionist terms, such as *distorted, exaggerated,* and *unreal.*[38] In spite of this ad campaign, the movie is not expressionist from beginning to end; it shifts between modes to suggest the increasing fragmentation of Mike's state of mind.

1. Early in the film, Mike and Jane talk about the trial outside the courtroom. On the back wall is a pattern of venetian blinds (figure 6.7A). A symbol of imprisonment? Eventually, yes—but not yet. For now, the lighting is doing the work of *localization*. The courtroom has large windows; the reporters' room does not. The blinds adhere to the logic of source lighting, showing us that the characters begin their conversation in one space and then move to another.
2. At the newspaper office where he works, Mike begins to have doubts. The shadow of a chair is cast on the wall behind him, creating a pattern of bars that

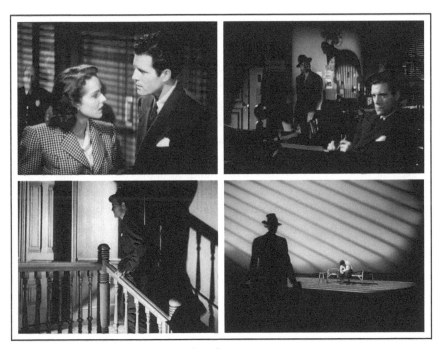

FIGURE 6.7. *Stranger on the Third Floor* (1940): The status of the lighting changes over the course of the story. *A (top left)*: Localized lighting outside the courtroom. *B (top right)*: Inflected lighting at the office. *C (bottom left)*: Consonant lighting in the stairway. *D (bottom right)*: Imagined lighting during the dream sequence.

stretches toward the ceiling (figure 6.7B). There is no good reason to suppose that there is a lamp on the floor casting the shadow of the chair onto the wall. Nor is there a good reason to suppose that Mike is imagining the shadow, since he is not thinking about the wall at all. I think of the light as *inflected*, as if the image were a reflection of Mike's state of mind—a state of mind where he cannot stop thinking about imprisonment.

3. On the way home, Mike walks by the stranger, and then up the steps of his apartment building. Again, there are bars on the wall, and the bars seem to express what Mike is thinking (figure 6.7C). In voice-over, Mike comments on the lighting: "What a gloomy dump. Why can't they put in a bigger lamp?" This simple line of dialogue changes the status of the shadow. Recall that inflected lighting is counterfactual, contradicting our understanding of how the fictional world is lit. Here we are given a perfectly logical reason why the stairway looks so dim. The result is consonance, not inflection. There is a deep affinity between the (gloomy) appearance of the place and the (gloomy) mood of the protagonist. The consonance is so strong that he even complains about it.

4. In his apartment, Mike recalls his past confrontations with a disagreeable neighbor. In one of the flashbacks, we see a brighter version of the banister pattern. If we suppose that the banister pattern simply looks brighter during the daytime, then the lighting seems localized. If we suppose that Mike is remembering the daytime stairway inaccurately by inserting bar patterns where there were none, then the lighting seems imagined. The trustworthiness of Mike's memory is in question.

5. During the ensuing dream sequence, Mike imagines being locked inside a stylized prison, represented as an enormous room with the shadows of bars cast upon the back wall and the floor (figure 6.7D). This image is intensely expressionistic: flat, angular, distorted, subjective, and symbolic, all at once.[39] The dream sequence clearly marks the lighting as *imagined*, but it is imagined in a particular way. Rather than conjure up the image from nowhere, Mike has taken the previously localized venetian blinds from the courtroom and the previously consonant banister bars from the stairway and distorted them. Similarly, the various low-lighting effects seem to be distortions of the lighting in Mike's apartment, where a table lamp illuminates him from below. The imagined dream has a truthful core.

6. After Mike is arrested, Jane becomes the protagonist of the film, and the style shifts toward a more objective mode. The shift reinforces the contrast between the unreliable Mike, who gets lost in his own thoughts, and the reliable Jane, who focuses on the facts of the case and locates the murderer. Even the climactic confrontation with the stranger is lit in a comparatively restrained style. When Jane pounds on the door of an apartment building, the cinematographer Nick Musuraca could have used the banister to enmesh her in a pattern of bars, but he does not. Turning away from expressionism arguably makes the suspense more chilling: the stranger really is right there, just a few feet away.

Musuraca would go on to shoot classic noirs (*Out of the Past*), noir-adjacent horror movies (*Cat People*), and even some noir Westerns (*Blood on the Moon*, 1948). He earned a reputation as RKO's "mood expert."[40] These later movies are also dreamlike, but none is quite so exaggeratedly dreamlike as the nightmare scene in *Stranger on the Third Floor*. Even the flashback-within-a-flashback-within-a-flashback from *The Locket* seems quite realistic by comparison. Paradoxically, the greater realism of the later works can be disturbing. The nightmare in *Stranger on the Third Floor* is so obviously distorted, so obviously fake, that we know all along it is just a dream. In Musuraca's later noirs, the fictional reality is presented in a vaguely dreamlike way; sometimes, we cannot be sure if the danger is real.

ON PAINTING WITH LIGHT

The analogy between film noir and German Expressionism smuggles in another analogy: the analogy between film noir and painting. Like the word *expressionistic*, *painterly* is a word that can carry a wide range of meanings. In chapter 2, I used the term to refer to a cinematographer's interest in rendering the nuances of figures in space. Just as a still-life painter might select a lighting arrangement that will make the texture of a lemon more visible, a cinematographer might help us see the bumps and crevices in a brick wall by using cross lighting, which makes the shadows more salient by striking the set from the side. Although it is possible for a cinematographer to focus on these painterly details and ignore the story, the ideal among story-centered Hollywood cinematographers was a kind of fusion, where the nuances of the depiction make the storyworld more vivid, and the unfolding story infuses each image with emotion.

The example of German Expressionism suggests a very different sense of the word *painterly*, with a greater emphasis on abstraction. An image may be painterly in the sense that it is visibly composed of blacks, grays, and whites, of straight lines and curved lines, of rectangular blocks and triangular shapes. Many noir images are painterly in this second sense. They are memorable because of the deep blackness of the shadow areas, the steep slope of the diagonal lines, or the conspicuous lack of symmetry.

It could be argued that this abstract understanding of the painterly is diametrically opposed to the understanding I have been urging so far. Previously, I have emphasized the representational content of the image: the three-dimensional storyworld. Now I am discussing the two-dimensional traits that make up the image. How can the painterly image be both representational and graphic at once? Actually, I do not see a contradiction here, not even a little bit. Instead, I assume that it is possible to be aware of both of these aspects simultaneously. Indeed, I follow several theorists in believing that representational pictures rely on this twofold awareness. To look at a picture is to see a figure *in* the image.

The idea that we may see both of these aspects at once has a long history. In the 1930s, Rudolf Arnheim built an entire theory of cinema on the idea that the

perception of a film differs from the perception of reality. One difference, he argued, is that the viewer of a film sees simultaneously in three dimensions and in two. For instance, a viewer watching an image of two trains will realize "that one train is coming toward him and the other is going away from him (three-dimensional image)" and "that one is moving from the lower margin of the screen toward the upper and the other from the upper toward the lower (plane image)."[41] Decades later, Richard Wollheim proposed the influential term *seeing-in*, which "permits unlimited simultaneous attention to what is seen and to the features of the medium."[42] This theory, which Wollheim modified and refined over the years, draws a distinction between the picture's "representational aspect" and its "configurational aspect."[43] Wollheim's ideas remain controversial, and philosophers have debated whether they can be extended from painting to cinema. I am not qualified to settle or even to adequately summarize all the debates around it.[44] However, the *seeing-in* idea has enough defenders that I will help myself to one of the core assumptions of the theory: the assumption that we can see the representational aspect and the configurational aspect *simultaneously*. Perhaps I am drawn to the theory because it provides additional support for my narratological convictions. The rhetorical-functionalist approach to narrative theory (and, indeed, to representation) assumes that we typically make sense of a narrative by approaching it as a purposeful construction, with a design that appeals to means-end thinking.[45] We respond to the story's events while recognizing that the events have been constructed to shape our responses. If some version of the seeing-in theory is correct, then we can look at a picture and *see* that it is constructed.[46]

This brings me back to the word *painterly*. If indeed some version of the seeing-in theory is correct, then all images in a Hollywood movie may be described as painterly in a broad sense of the term. Even when we are watching an ordinary movie, we can look at a screen and describe at least a few of its compositional traits: whether the image onscreen is large or small, whether it is black-and-white or color, or whether it contains diagonal lines or horizontal lines. We can offer these descriptions in principle, even though we may not attend to those features in practice. And, yet, there are also movies that are painterly in a stronger sense than this. When a movie impresses us with the beauty or the energy of its cinematography, it is not just that we *can* attend to these compositional traits if we choose to do so; it is also that the movie *rewards* our attention to its lines, shapes, and tonalities. German Expressionist movies are painterly in this stronger sense. They draw our attention to their compositional traits, and, just as important, they reward us for attending to those traits, which enrich each movie's sensory, thematic, and emotional appeals. Many of the best noirs are painterly in this sense, too, whether they employ expressionist distortion or not.

If there is one noir cinematographer with a reputation for being painterly, it is John Alton. The Hungarian-born cinematographer enjoyed a productive career in Argentina before beginning his Hollywood career in 1940. He worked on low-budget black-and-white movies for several years, making his reputation with styl-

ish thrillers such as *T-Men* and *Raw Deal*. In 1949, he published *Painting with Light*, a textbook about the craft of cinematography, mostly illustrated with stills from Alton's own movies. He then signed with MGM, where he shared an Oscar for the art-themed musical *An American in Paris* (1951), leading to a late-career specialization in color cinematography. In 1960, he retired rather abruptly from MGM to travel and paint.[47] Although Alton was not the first person to use the phrase *painting with light*, that phrase is now indelibly associated with his career: because of his book, because of his explicitly painterly work in *An American in Paris*, and because of his insistently artful approach to lighting.

Given Alton's reputation for aestheticism, we might expect him to advocate abstraction above all. His imagery is characterized by deep blacks and slashing diagonals. The resulting compositions look dynamic whether we care about the story or not. But Alton refuses to treat cinematography as an abstract medium and instead spends several pages in his textbook explaining how to render depth in a two-dimensional medium.[48] To make a painting with light is to make a painting *of* something. It is a representational art. In practice, Alton consistently produces images that are twofold in the richest possible way, soliciting and rewarding our attention to the configurational aspect and the representational aspect simultaneously.

Consider a remarkable bit of pictorial storytelling in *Raw Deal*, the 1948 thriller directed by Alton's frequent collaborator Anthony Mann. The story is the familiar stuff of noir. A wrongly incarcerated man (Joe, played by Dennis O'Keefe) is caught between two women. One of these women links him to the criminal world (Pat, played by Claire Trevor). The other one links him to the legal world (Ann, played by Marsha Hunt). The twist is that Pat is delivering the film's voice-over narration, and so the movie becomes in a sense her story, about a woman who must make the difficult choice to give up the man she loves.[49] Early in the film, Pat goes to a prison to visit Joe, and she is disappointed to learn that he is already in a meeting with Ann. Forced to wait outside, Pat sits down, and the movie cuts to a shot of Ann and Joe inside the visiting room. The cut performs an astonishing act of substitution, like a magic trick. One moment, we are looking at Pat on the far-left side of the screen (figure 6.8A). Then the cut happens, and suddenly we are looking at Ann, who is now located onscreen in the *exact* position that Pat was in just a moment ago (figure 6.8B). Pat's profile has become Anne's profile. The dim lighting on Pat has become the bright lighting on Ann. The asymmetrical composition of Pat alone has become a symmetrical composition of Ann-plus-Joe.

The editor and the director deserve some of the credit here, but Alton's compositional panache is the key to the effect. The first composition favors diagonal lines and asymmetry. In figure 6.8A, look at the line of shadow that runs from the window along the wall to the doorway on the far right. It is a diagonal line, forming an acute angle with the two diagonal lines created by those beams in the ceiling. Note that we probably would not describe any of these lines as diagonal if we were sitting in the room with Pat. In Pat's world, they are horizontal. Similarly, we probably would not describe the hallway as asymmetrical if we were there with Pat. In

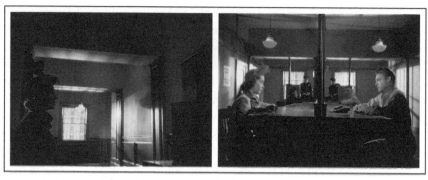

FIGURE 6.8. *Raw Deal* (1948): Pat waits in the hall while Ann meets with Joe. *A (left)*: An asymmetrical shot of Pat. *B (right)*: A symmetrical shot of Ann and Joe.

Pat's world, the hallway is roughly symmetrical. It is the composed picture that has these strong diagonals, and it is the composed picture that is asymmetrical.

Figure 6.8B shows a different approach to composition: a symmetrically arranged picture that represents a symmetrical space. The cut makes the shift conspicuous, encouraging us to notice Alton's compositional choices. Alton is admittedly showing off his skills, but that is not the only thing he is doing. With the help of the director and editor, Alton is using composition expressively, to comment on Pat's state of mind. This scene is about Pat's fears of being replaced by Ann. To express those fears, Alton has created a pictorial sequence wherein Pat's image gets replaced by Ann's image. Pat's image initially seems out of balance and incomplete, as if missing something on the right side. And then Ann's image appears, with Joe on the right, and the whole screen is suddenly in a conspicuous state of balance, with everything on the left side of the screen balanced by something on the right. Alton has even cast one ray of sunlight through the left window and another ray of sunlight through the right. Suddenly, the world has two suns. It violates the logic of source lighting, but it does so for a higher purpose: to get across the very idea of symmetry. The rightness of the Ann-Joe relationship is made visible at a glance.

None of these meanings is available to Pat, Ann, or Joe. Pat's narration is just one component of the movie itself, and she is of course not watching a movie. These meanings are available to us because we can see the pictures, which are twofold, simultaneously offering a representational aspect (Pat and her world) and a configurational aspect (the asymmetry of the first image, the symmetry of the second). Like a painter, Alton rewards our attention to the entire picture: not just the represented subject but also its configuration onscreen.

And yet Alton remains a storyteller. As I argued in chapter 2, storytelling produces a complex experience of time: our attention to the present moment is infused with a sense of memory and expectation. Lighting is a narrative technique whenever it solicits our attention to the present moment while also pointing outward to some other time. As we watch a movie unfold, we develop an (ever-shifting) understanding of the story's (changing) world and the characters' (changing) experi-

ences. Confronted with an unusual lighting effect, we can make sense of it in a variety of ways: perhaps by adjusting our understanding of the world's physical facts ("Oh, there is sunlight coming through the window"); perhaps by expanding our understanding of a character's psychological experiences ("No, that light exists only in the character's mind"); perhaps by considering the picture as a part of the film's overall rhetorical address ("Actually, that light is a symbol of fate"); perhaps by shifting our attention to the configuration ("Wow, that light creates a really sharp diagonal line"); or perhaps by doing some combination of all four.[50] A dynamic narrative keeps us on the move, ready to build on (and, if necessary, revise) our understanding at all times.[51]

My final two examples are both bold exercises in pictorial storytelling. In one, the female protagonist is manipulated into doubting her own perceptions. In the other, the female protagonist knows what she sees, but she struggles to make sense of it.

GASLIGHT (1944)

In his book on Hollywood cinema of the 1940s, Thomas Schatz questions the line that is often drawn separating the female-dominated gothic film and the (allegedly) male-dominated film noir. He points out that both cycles tell surprisingly similar stories in which "an essentially good although flawed and vulnerable protagonist [is] at odds with a mysterious and menacing sexual other," and that both cycles employ dark, expressive lighting.[52] Helen Hanson goes even farther, wondering if it makes sense to say that the female gothic "shares" the noir style, since female gothics were actually more central to the industry's output. "The gothic woman's cycle," she explains, "was commercially and creatively very successful at the moment of its production, much more so, in fact, than film noir."[53] *Gaslight* is a case in point. In 1944, the movie placed in the Top 15 at the box office, and it went on to win two Academy Awards, including Best Actress for Ingrid Bergman. Only a handful of noirs could claim a similar degree of financial and critical success.[54] My inclusion of *Gaslight* in this discussion is not meant to suggest that it borrowed ideas from film noir. Given the success of *Gaslight*, the borrowing was at least as likely to go the other way; it set a distinguished example of mood lighting that many later filmmakers could follow.[55]

The cinematographer Joseph Ruttenberg won four Oscars over the course of his distinguished career; he was equally proud of his nominated work on *Gaslight*. As he explained in a later interview, "That film had the most valuable thing a film can have: mood."[56] The movie's darkest scenes are as dark as anything in *Stranger on the Third Floor*, but the darkness does a different kind of work. *Stranger on the Third Floor* assures us that many of its shadows exist only in its protagonist's mind. *Gaslight* ultimately assures us that its shadows are all too real.

The title tells the story: light will be a crucial part of *Gaslight*'s plot. Paula (Ingrid Bergman) marries her accompanist, Gregory (Charles Boyer), and takes

him back to her family home in London. There, Gregory systematically tries to drive Paula insane by hiding various objects and accusing her of stealing them. At night, Gregory sneaks into the attic to search for hidden jewels. (We later learn that Gregory is an assumed name, and that he murdered Paula's aunt many years ago.) In the finale, Paula turns the tables on Gregory and questions his perceptions the way he has questioned hers.

There are few other films in which light plays such an active role in the causal chain. The light in the house dims *because* Gregory has turned the light on in the attic. Paula feels increasing doubts about her own perceptions *because* the light is changing for no obvious reason. Gregory denies that the light is getting darker *because* it furthers his plan of driving Paula insane by shattering her trust in herself. The term *gaslighting* has entered the contemporary vernacular as an evocative way of describing a certain kind of exploitation, whereby one person manipulates another into doubting the target's own beliefs and perceptions. Paradigmatically, gaslighting exploits existing imbalances of power, as when a man repeatedly belittles a woman's ideas and feelings as unfounded and imaginary. As the philosopher Kate Abramson explains, gaslighting goes beyond disagreement and simple cases of lying. The process is "quite unlike merely dismissing someone, for dismissal simply fails to take another seriously as an interlocutor, whereas gaslighting is aimed at getting another not to take herself seriously as an interlocutor."[57] Undercutting Paula's sense of self is Gregory's goal. Beyond covering up the fact that the lights are dimming whenever he goes to the attic, Gregory forces Paula to experience profound doubts about her place in the world. She wonders if she can trust her own understanding of facts and events, even when she has perceived them directly.

In a classic essay on the gothic genre, Diane Waldman has argued that "the central feature of the Gothics is ambiguity, the hesitation between two possible interpretations of events by the protagonist and often, in these filmic presentations, by the spectator as well."[58] In *Rebecca* (1940), *Suspicion*, *Undercurrent*, *Dragonwyck* (1946), *Secret beyond the Door*, and *Sleep, My Love*, the woman begins to have doubts about her mysterious husband. For a significant portion of the running time, the movie maintains ambiguity, neither confirming nor disconfirming the protagonist's doubts. *Rebecca* and *Suspicion* uphold patriarchal ideology in the end by suggesting that the woman's suspicions were unfounded. Subsequent variations are more critical, affirming that the woman was right all along. As Waldman explains, these later films "place an unusual emphasis on the affirmation of feminine perception, interpretation, and lived experience."[59] *Gaslight* belongs to this later trend in the cycle.

Because doubt is such a central theme in *Gaslight*, the status of the film's lighting becomes an essential question. For the story to work, we must understand that the gaslight really dims whenever Gregory goes to the attic. And yet we must also understand that Paula is wondering if the darkness is real or imagined. The status of the lighting—whether or not it is subjective—has never been more consequential. Whenever the lighting seems distorted and subjective, it actually supports

Gregory's systematically false representation of events, suggesting that Paula's perceptions may be flawed, after all. It is only when the lighting seems consonant or localized that the movie exposes Gregory's lies for what they are, upholding Paula's perceptions as accurate and her deepest suspicions as true.

So, is the movie's lighting expressionistic or not? A great deal rides on this question. And, on this question, the movie is increasingly, unnervingly ambiguous. Much of the time, the lighting follows the logic of source lighting, assuring us that the gaslight is most certainly dimming and that Paula is not imagining any of it. But every so often, the lighting turns toward expressionism, hinting that the images we see are inflected or perhaps even imagined. This teasing expressionism is actually one of the movie's most problematic traits. If the lighting were any more expressionistic, it would undercut the movie's themes entirely, putting Paula's powers of perception in doubt. Instead, the movie strikes a tenuous balance, asking us to share some of Paula's doubts while reaffirming her perceptual experience of the world in the end.[60]

Ambiguous lighting appears early in the film, even before Paula's suffering begins. During a music lesson, Paula admits to her teacher that she is having difficulty singing a tragic song because she has fallen in love. The teacher offers his emotional support: "Real tragedy has touched your life, and very deeply. But now there is a chance to forget tragedy, my child. Take it.... Happiness is better than art!" As the teacher talks of tragedy, Paula turns away from the window, and her face is in shadow (figure 6.9A). When the teacher talks of happiness, Paula leans forward into the light. The cinematographer amplifies the effect with the help of a dimmer; the key light grows noticeably brighter as Paula breaks into a warm smile (figure 6.9B). For the moment, the lighting symbolizes the redemptive power of love. It is heartwarming and affirmative—and utterly misleading, as this love will turn out to be anything but redemptive. If lighting symbolizes redemption, then it does so only in Paula's own mind. With this early use of inflection, the movie is already hinting at its primary theme, asking us to wonder how much the image has been inflected by Paula's emotions.

When the setting shifts to London, the movie features several carefully sourced lighting effects. The sourcing is important, reinforcing the point that the lighting's shifts are indeed taking place in the fictional world. Paula and Gregory arrive at the London flat, and she asks him to turn on the gas. He does so, and the lighting on Paula changes accordingly, eventually illuminating her with loop lighting, a backlight, and fill. It is as if Gregory has re-created Hollywood's three-point lighting at her request. The changing lighting teaches us about Paula's state of mind: she is slowly growing more comfortable as the room gets brighter. Her dialogue explicitly associates light with life and darkness with death, and so the scene as a whole delivers a strong impression of consonance. Her emotions are in tune with the atmospheric lighting precisely because she has such a heightened perceptual awareness of the place around her. At the same time, the scene hints at a crucial plot point: the lighting is subject to Gregory's control.

FIGURE 6.9. *Gaslight* (1944): The light brightens as Paula affirms her love. *A (left)*: Paula in shadow. *B (right)*: Paula in brightness just a moment later.

Later, when we see the gas dimming for the first time, director George Cukor takes care to film the scene as objectively as possible, in a one-minute-long take that shows us Paula in the foreground, the lamp in the middle ground, and the bedroom in the background. This relatively distant framing assures us that we are not experiencing the scene through Paula's point of view. There is no suggestion that Paula is imagining the dimming light, or that the image is inflected by her subjectivity. The lighting shift is located firmly within the space. The short Rembrandt lighting on Paula's face is (roughly) consistent with the gaslight source, and the dimming of the fill light is perfectly timed with the dimming of the gas. Counterintuitively, the film has used its objective technique to increase our identification with Paula, even as it has refrained from showing the gaslight through her eyes. She has seen the light change, and so have we. She cannot explain it, and neither can we.

Paula soon begins to doubt if the gaslight effect is real. Meanwhile, the lighting shifts to a more subjective register, as if echoing Paula's doubts. In place of master shots, the screenplay recommends intercutting between shots of Paula looking and shots of what Paula sees: "She sits, staring at the gaslight with puzzled eyes, wondering whether she is imagining things."[61] I want to stress how striking this turn toward subjectivity is. It could be argued that the movie's themes would be better served by a resolutely localized technique. Remaining objective would make it absolutely clear, at all times, that Gregory is a liar. Instead, the movie includes several images in which the lighting seems illogical, playing on the possibility that certain effects are inflected or imagined. For instance, one of the most chilling scenes comes when Gregory accuses Paula of having stolen a picture from the wall. Shockingly, we learn that the incident has happened before, even though this is the first time we are seeing it. This new information opens up a split between our knowledge of the story's events and Paula's.

As Gregory steps forward to confront Paula, his lighting changes completely. At first, he is standing in a standard three-point setup. It is not exactly realistic, but it is not an anomaly, since it is consistent with Hollywood's well-established figure-lighting norms. Then he steps through a shadow, and it is as if he has entered

Subjectivity, Symbolism, and Depiction 193

FIGURE 6.10. *Gaslight* (1944): Gregory's lighting changes when he steps close to Paula.

an entirely different room (figure 6.10). Two closely placed lamps create a spotlight effect on Boyer's face, leaving his forehead and chin in shadow. There is less backlight than before; the unusual eyelight is even more prominent. The sudden change in light is so anomalous that it seems to call out for an explanation, but there is no explanation available in the physical layout of the fictional world. No one has turned down the gaslights; no one has thrown a log onto the fire. The best available explanations are subjective or symbolic. Perhaps the lighting is imagined, offering a faithful record of Gregory *as Paula sees him* in this moment of crisis. Or perhaps the lighting is inflected, using artful distortions to express Paula's confused state of mind without suggesting that she sees him in just this way. Or perhaps the lighting is purely symbolic, freely reshaping the fictional world to make a point about Gregory's devilry that is aimed entirely at us, bypassing Paula's state of mind entirely.

It is at times like this that I fear the movie is gaslighting its own viewers in a way, getting viewers to doubt their own perceptions. We see Gregory, lit from below, and we may find ourselves unsure what sort of trust we are supposed to place in what we see. That sense of doubt is the point. The more Paula doubts her perceptions, the more the movie asks us to question our own.

The movie continues in this ambiguous register until the end. After Gregory humiliates Paula at a public concert, he threatens to have her committed to an asylum. At home, Paula leans helplessly against the fireplace, which creates a flickering light from below. The effect initially seems logical, perfectly in keeping with

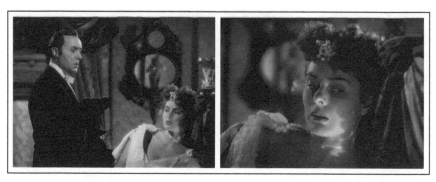

FIGURE 6.11. *Gaslight* (1944): The lighting changes dramatically. *A (left)*: Fill light moderates the shadows on Paula's face. *B (right)*: The fill light dims as the camera approaches.

the fire (figure 6.11A). But then the camera dollies in to a large close-up, and the fill light dims noticeably. Now the fire effect is even more prominent than before, especially when Paula turns toward the fireplace, allowing her face to capture more of the flickering light (figure 6.11B). A moment ago, the lighting seemed consonant: expressive but consistent with the layout of the place. Now the lighting seems inflected, taking the reality of the fireplace effect and distorting it to suggest the warping effects of Paula's subjective experience. The effect is disturbing: Gregory is obviously lying, and yet the ambiguously subjective style echoes his (feigned) doubts about her state of mind. Meanwhile, the lighting inverts the pattern established in the scene with the music teacher. Previously, the lighting brightened to express the emotions Paula was feeling after falling in love with a man. Now the lighting darkens as that same man treats her with unbearable cruelty.

During the climactic sequence, the inspector Brian (Joseph Cotten) tells Paula that he will go outside and prevent Gregory from reentering the house. Paula walks down the hallway toward her room—but then the camera tilts up to reveal that Gregory is already entering through the boarded-up door to the attic. It is a scene of peak tension, and Ruttenberg borrows a familiar trick from the criminal melodrama: the pattern of bars cast upon the wall. Clearly, the moment is suspenseful: Paula is in grave danger. Clearly, the moment is symbolic: Paula is still trapped in her prison of a house. But is the moment also expressionistic, in the sense that it is distorted and subjective? It is maddeningly hard to say. Perhaps not: there could be a gaslight on the lower level of the house, and it could be casting a consonant shadow onto the upper floors. Or perhaps it is deeply expressionistic: the source is not visible, and so the lighting may be inflected, offering a counterfactual representation of the space that expresses Paula's feelings of entrapment. The ambiguity continues into the next scene as Gregory tries to convince Paula that she has imagined Brian altogether. "I couldn't have dreamed it," she says. Then she walks through a shadow and into the light, as if marking an inflected transition. Gregory stares at her impassively, and she gives in to her doubts: "Did I dream? Did I really

dream? Dream, dream . . ." Again, the shadow that Paula walks through seems so expressive and so symbolic that the entire image seems inflected by her horrible belief that she may be living a false reality.

Ruttenberg boasted that the film was a triumph of mood lighting. That it certainly is—but the mood lighting ends up doing something strange and perhaps counterproductive. The more expressionistic the light gets, the more the movie undercuts its own protagonist. Happily, the movie sets aside its own gaslighting tactics and affirms Paula's beliefs in the end. (And Ingrid Bergman clinches her first Oscar with a brilliant monologue as Paula finally confronts Gregory with his lies.) As Helen Hanson has explained, the ending illustrates an important contrast between gothics such as *Gaslight* and noirs such as *Stranger on the Third Floor*: "Noir male protagonists are frequently questionable," but "it is actually very rarely the case that the gothic heroine's perceptions are proved to be imagined or incorrect at the close of the gothic film."[62] Paula may be lit like a noir protagonist for much of the film, but she ends up being a gothic heroine in Hanson's sense of the term: her perceptions are proved correct.

SECRET BEYOND THE DOOR (1947)

Secret beyond the Door was the work of Diana Productions, an independent company organized around the trio of producer Walter Wanger, star Joan Bennett, and director Fritz Lang. The company had a distribution deal with Universal, which had recently merged with International Pictures. Traditionally a maker of B movies, Universal-International was attempting to shift to A movies with the help of independent production arrangements such as this one.[63] Alas, *Secret beyond the Door* was not a financial success. Universal-International returned to its traditional focus on B movies, and Lang ended up directing his next movie for Republic Pictures.[64]

Silvia Richards, who had written the psychological thriller *Possessed* earlier in the year, authored the screenplay. The protagonist Celia (Joan Bennett) marries Mark (Michael Redgrave), a man she barely knows. When she moves into his family home, she learns that he has curated a series of rooms in the basement. Each room is a place where a murder has taken place. One of these rooms is locked, and Celia knows that she has a secret to uncover—or, rather, two secrets. She needs to find out what is beyond door number seven, and she needs to uncover the repressed memory that is causing Mark to behave so strangely.

Secret beyond the Door is an unusual mixture of elements: a gothic thriller mixed with the Bluebeard myth, plus a dash of pop-Freudian psychology. Like *Gaslight*, the movie is about a woman who is threatened by her husband, but here the threat is potentially more lethal and yet more ambiguous. Mark thinks of himself as someone destined to commit murder, and he comes perilously close to doing so. However, Celia is able to bring him back to his senses once she tells him the truth about his repressed memories. In addition to the gothic, the other salient genre is the psychological drama, a major cycle in the immediate postwar period, as in

Spellbound (1945), *Possessed*, and *The Snake Pit* (1948). In the latter two films, a team of male psychiatrists works to cure a woman who is suffering from mental illness. In *Spellbound* and *Secret beyond the Door*, the man is the patient, and the protagonist is a woman who uncovers his repressed memories and guides him toward a cure.

Many scholars have carefully analyzed the movie's overt appeals to psychoanalytic theory.[65] My focus will remain on the film's lighting, which ties together three distinct themes I have discussed throughout this book. First, the lighting is richly symbolic not just for viewers but also for the characters, who notice certain lighting effects and interpret them. Second, the lighting is tightly integrated with the film's narrative dynamics. At the level of the storyworld, light and shadow contribute directly to the sequence of goals and obstacles that makes up the plot; at the level of the film's rhetorical address, light and shadow build expectations about where the story is heading—expectations that turn out to be spectacularly wrong. Third, the lighting is wonderfully *reflexive*. To a remarkable degree, Lang's movie is about light and shadow. Mark proposes a theory about the look of places, and the movie puts his theory to the test.

Symbolic Lighting

Perhaps more than any other noir filmmaker, Fritz Lang uses lighting to make big symbolic gestures, evoking ideas of entrapment, sin, and redemption. In *You Only Live Once* (1937), a prisoner shoots a priest, and the foggy lighting ironically evokes the gates of heaven. In *Scarlet Street*, a street sign blinks as the protagonist ponders his own guilt, which seems as inescapable and relentless as the rhythm of the light. In *Human Desire*, a conversation about murder takes place on the boundaries between light and dark (see chapter 2). These three movies were shot by different cinematographers: Leon Shamroy, Milton Krasner, and Burnett Guffey, respectively. Each faced the task of taking Lang's abstract ideas and turning them into concrete images.

The cinematographer for *Secret beyond the Door* was Stanley Cortez, best known for his exceptionally dark imagery in *The Magnificent Ambersons* and *The Night of the Hunter*. Like Nick Musuraca, Cortez typically uses hard lights to cast crisp shadows on the set. Then he minimizes or eliminates the general illumination, letting the shadows go black. If anything, Cortez was more radical than Musuraca, who preferred not to throw his actors into near-total darkness. In *The Magnificent Ambersons*, the ball scene ends with one of the darkest compositions I have ever seen in a Hollywood movie: three silhouettes against a background of gray and black. *Since You Went Away*, a wartime drama, features some astonishingly dark imagery—so dark that the producer David O. Selznick fired off one of his memos to complain.[66]

For much of its running time, *Secret beyond the Door* is brighter than both of these movies, but Cortez's lighting choices remain as daring as ever. In several key scenes, Cortez casts a shadow over Mark's face, emphasizing his unknowability.

Subjectivity, Symbolism, and Depiction 197

The symbolism of the device is clear, but it remains an exceptionally bold choice. The producers have hired a respected British actor (Michael Redgrave) to play the part. And Cortez has thrown his face into shadow!

The strategy emerges gradually and changes over the course of the movie. At first, Cortez adheres to Hollywood's gendered lighting conventions. As I argued in chapter 3, butterfly lighting and loop lighting were the default norms for women, while Rembrandt lighting and split lighting were the default norms for men. When Mark introduces himself to Celia, he walks through a shadow and sits down. Celia is already seated, and she receives butterfly lighting when she turns to face him. This tactic produces a crisp shadow under her chin, a small shadow under her nose, and a spark of eyelight in both eyes (figure 6.12A). Meanwhile, short Rembrandt lighting creates a triangle of light on Mark's camera-side cheek (figure 6.12B). His skin tone looks noticeably darker than hers, partly because of makeup and partly because of lighting: his brighter background makes his skin look tan by contrast, just as her dark background makes her skin look bright. This variation in the rendering of skin tone was a fairly routine way of differentiating men and women, but it has the added effect here of emphasizing Celia's whiteness, which is at stake in this scene because the characters are in Mexico, and they have just witnessed a knife fight. Her fascination with the violence has revealed a side to her character that is perhaps at odds

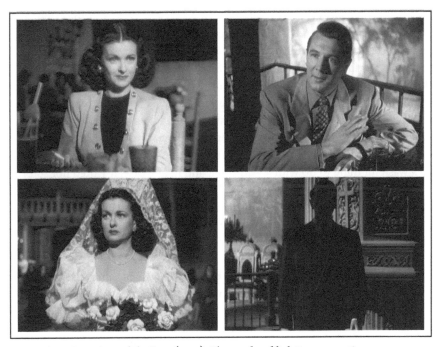

FIGURE 6.12. *Secret beyond the Door* (1947): The gendered lighting conventions grow ominous. *A (top left)*: Butterfly lighting on Celia. *B (top right)*: Rembrandt lighting on Mark. *C (bottom left)*: Bright lighting on Celia. *D (bottom right)*: Mark becomes a silhouette.

with what we might expect from an upper-class white woman visiting Mexico from abroad. She is passionate, the scene suggests, and she feels immediate desire for this mysterious man sitting in the shadows.

The scene I just described is actually a flashback. The flashback structure, coupled with Celia's present-tense voice-over narration, allows for the possibility that the scene might be inflected, as if influenced by Celia's memories. When the flashback ends, the voice-over continues to give us direct access to Celia's thoughts. "Suddenly, I'm afraid," she says. "I'm marrying a stranger . . . a man I don't know at all." As Celia experiences these thoughts, she turns to look at Mark (figure 6.12C), who steps forward and walks through a shadow to join her in the light (figure 6.12D). The movement through the shadow repeats a moment from the previous scene, when he walked through another shadow to speak to Celia for the first time. But now the shadow is exceptionally dark, so much so that Mark briefly becomes a featureless silhouette. What was once a fairly ordinary gendered lighting opposition (butterfly pattern versus Rembrandt pattern) has become a radical binary split (brightly lit versus implacably dark). The symbolism is hard to miss: silhouette as unknowability. Amazingly, the symbolism is so flagrant that Celia seems to notice it. Doubt creeps into her face as she watches Mark approach, and the voice-over lets us know exactly what she is feeling the moment that he steps into the shadow. (It happens between the sentence "I'm marrying a stranger" and the phrase "a man I don't know at all.") Celia seems to register how uncanny it is that her mysterious husband has just stepped into a complete silhouette. It is as if she recognizes the symbolism before her. To be sure, the barrier between Celia's world and the viewer's world remains. Celia is not watching the movie and analyzing it; she believes instead that she is in a world charged with meaning. She sees Mark step into a silhouette, and she experiences a gnawing awareness that some force (God? fate?) is giving her a warning sign about the dangerous choice she is making.

Having planted the motif in such a vivid and memorable way, the filmmakers proceed to repeat it, rework it, and eventually overturn it. Naturally, Lang and Cortez do not throw Redgrave's face into shadow in every single scene. That would be a wasteful thing to do with a lead actor, and in any case, it would not suit the story. Mark's behavior fluctuates; he is charming in some scenes and neurotic or aloof in others. The filmmakers pick their spots carefully, saving the unknowability motif for a few key scenes. Each scene differs subtly from the last, developing a variation rather than a strict repetition.

1. Mark's neurotic behavior begins on the wedding night, after Celia playfully locks a door. When Celia asks him about it later, Mark's face is in shadow. There are symbolic bars in the background (figure 6.13A). For now, the shadow-on-the-face motif is linked to the *locked door* and to the idea of *entrapment*.
2. After Celia learns about Mark's unusual hobby of collecting rooms, she asks him directly, "Mark, what's in the seventh room?" His back is turned. When he turns around, he appears in short split lighting and distant framing for the rest

Subjectivity, Symbolism, and Depiction 199

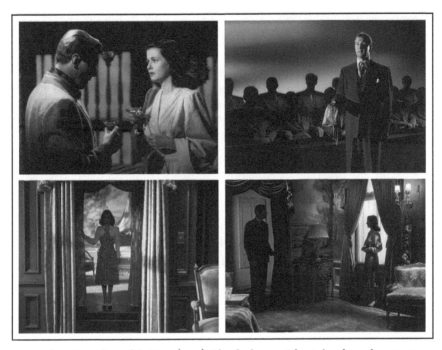

FIGURE 6.13. *Secret beyond the Door* (1947): The shadow motif switches from character to character. *A (top left)*: Mark in shadow. *B (top right)*: The jurors in shadow. *C (bottom left)*: Celia in shadow. *D (bottom right)*: Mark and Celia in shadow.

of the scene. Although Mark is not in a complete silhouette, his face is very hard to see. The shadow is still linked to the *locked door* but also to the recurring image of Mark's back being turned.

3. When Celia tries to escape the house, she gets lost outside on the lawn. Then she sees the silhouette of a man slowly approaching her. She assumes that the man is Mark, coming to kill her. Now the shadow evokes the idea of *murder*. It also plants the idea of the *mistake*. Later we will learn that the man was not Mark at all but the harmless Bob.

4. For several minutes, the movie tricks us into thinking that Mark has killed Celia. We hear his voice-over, not hers, and we see an entirely imagined scene as Mark ponders a hypothetical trial. The scene is thoroughly expressionistic: subjective and distorted. Mark is both the defense witness and the prosecuting attorney. The judge and the jury are faceless silhouettes (figure 6.13B). Now it is Mark who is visible; it is the *law* that is obscured.

5. Soon after his reverie ends, Mark goes to Celia's suite of rooms. He looks up and sees Celia standing in the shadows (figure 6.13D). Stepping into the light, Celia explains that she still loves Mark and that she intends to stay, "for better or for worse." The dialogue explicitly recalls the wedding scene. In that earlier scene, Mark stepped through the shadows into the light, and Celia's voice-over

expressed her doubts. Now, Celia is stepping through the shadows into the light, and Celia is reaffirming her faith in the *marriage* not just in voice-over but out loud.

6. A culminating variation on the shadow motif appears in a somber little scene in which Mark announces he must leave for New York. He warns Celia that she will be alone in the mansion, but she assures him she is not afraid. He tells her he loves her, and she replies, "I know." They are both in shadow (figure 6.13D). Previously, the shadow motif was firmly attached to Mark alone; then it was attached to Celia; now it is attached to the *couple*. Previously, the motif emphasized the idea that a spouse is unknowable; now it reinforces Celia's assertion of *knowledge*. She understands her husband better than he understands himself.

Over the course of the movie, the shadow motif has flowed from Mark to Celia to the couple. In so doing, its symbolism has shifted. What was once an ominous threat has become a somber symbol of togetherness. Celia has chosen to join Mark in the shadows.

Lighting and Narrative Dynamics

The theory of narrative dynamics places special importance on three emotional effects: suspense, curiosity, and surprise. As Meir Sternberg explains, all three are oriented around some kind of gap.[67] Suspense is oriented toward a gap in the future, as when the movie plays on our fear that Mark will murder Celia. Curiosity is oriented toward a known gap in the past, as when the movie encourages us to wonder what happened in Mark's past to cause him to behave so strangely in the present. And surprise is a complicated mechanism whereby the movie misleads us into making certain assumptions about the storyworld, and then reveals that our past understanding was mistaken. *Secret beyond the Door* tricks us into thinking that Celia is dead, only to reveal that she is very much alive.

Lighting plays an unusually important role in a number of these narrative effects. In chapter 5, I described certain types of scenes as *fully integrated set pieces*. At the level of the storyworld, the light furthers goals or frustrates them. At the level of the film's rhetorical address, these events produce effects of suspense, curiosity, and surprise. The scene in which Celia discovers what is in the seventh room is a fully integrated set piece. At the level of the storyworld, Celia uses a flashlight to help her find the seventh room. Then she turns on the lights and realizes it is a replica of her own room. She hides in the shadows to avoid being seen by Mark, who is tinkering with another room. Then she runs upstairs, and the mysterious Miss Robey appears, turning on a lamp to assure Celia that she is safe. Throughout the scene, the characters use light and shadow to accomplish their goals: discovering, hiding, reassuring. Their actions in the storyworld produce a series of emotionally charged narrative effects, such as the feeling of suspense that surges when Celia may get caught or the feeling of satisfied curiosity that arises when the room is finally revealed.

The movie's production of surprise is perhaps its most striking narrative tactic. With a bit of shameless trickery, the film actually convinces us, for several minutes, that Celia is dead. When the twist is revealed, it feels as if the film was lying to us, breaking an unwritten contract between the movie and its audience. To be clear, surprise always involves some misdirection, and the emotion of surprise is a routine feature of many Hollywood films, in spite of classicism's reputation for maximal clarity. As I mentioned in chapter 2, *Foreign Correspondent* tricks us into thinking that a diplomat has been killed, when in fact he is alive, and *Random Harvest* tricks us into thinking that the leading man and woman have fallen out of touch, when in fact the woman is working with the man every day. Hollywood cinema is a narrative-driven cinema, and surprise is a quintessential narrative effect. When watching any narrative movie, we should expect the unexpected. Lang himself would orchestrate a much more shocking surprise in a later film, *Beyond a Reasonable Doubt* (1956).[68] What makes the twist in *Secret beyond the Door* so audacious is its radical handling of focalization. The entire first half of the movie is focalized around Celia's point of view. She appears in every scene; the voice-over gives us access to her thoughts, and the flashback gives us access to her memories. Her centrality makes it seem very unlikely that she will be killed—which makes it all the more disturbing when she disappears from the movie altogether for several minutes, her voice-over replaced by Mark's thoughts, her memories replaced by Mark's fantasy. The lighting completes the shift toward Mark, using expressionist shadows to signal unambiguously that the trial scene takes place in his imagination. The movie is dipping into his deepest thoughts—even as it keeps his secrets hidden.

Reflexive Lighting

Perhaps more than any other film discussed in this book, *Secret beyond the Door* uses its lighting reflexively. It is *about* the meanings that we attach to places, and it asks us to ponder lighting as a theme. In a remarkable pair of scenes, Mark outlines a theory of architectural design. In so doing, he offers a commentary, indirect but insightful, about the role of cinematic lighting in classical-era cinema. *Secret beyond the Door* will put Mark's theory to the test.

In the first scene, Mark leads a group of guests on a tour, showing them his collection of rooms. Each room reconstructs a place where a man has killed a woman. Mark then proposes his theory of "felicitous" rooms. "Under certain conditions," he states, "a room can influence or even determine the actions of the people living in it." Mark is an architect, and his remarks are primarily about each room's decor, but they apply just as well to each room's lighting. All three rooms are lit atmospherically, two by candlelight, one by an unshaded electric bulb. One guest, a young woman who is identified as a brain psych major, questions Mark's theory. She agrees that the third murderer could not help what he was doing, but she offers a psychoanalytic explanation: "Something happened to him here. Perhaps in his childhood, and he'd made a resolution in this room to kill. His conscious

mind had forgotten all about it." She then points to a possible cure: if the murderer could have told someone about his past, he could have overcome the urge to kill.

We learn more about Mark's theory later, when Celia asks him to explain what he means by *felicitous*. He replies, "Felicitous doesn't mean happy, darling. Look it up in the dictionary. It means happy in effect. Fitting, apt. I use the term to describe an architecture that fits the events that happen in it." This expanded definition is somewhat looser than the one that Mark had offered on the tour. There, he argued for a strong causal connection between room and action. Here, he argues for a relationship of affinity: the room fits the action that happens inside it.

Describing these scenes as reflexive, I do not mean to suggest that Mark, Celia, or the brain psych major is offering a fully developed theory of film lighting. No one refers to lighting explicitly, and no one is thinking about films at all. But *Secret beyond the Door* is using these conversations to raise a number of themes that have become quite common in noir criticism: the idea that people may lose control over their own actions, the idea that a place may carry inescapable reminders of the past, and the idea that there is some sort of an affinity between calamitous events and the settings where those events take place. These themes are raised so prominently, so insistently, that they provoke questions about the very movie we are watching. Are the settings in this movie felicitous? In what sense? Indeed, these are questions that may be asked about film noir more generally. Is noir lighting felicitous? In what sense?

Throughout this book, we have encountered noir spaces that are felicitous in Mark's initial sense of the term, whereby the setting has such a powerful emanation of feeling that it can *cause* characters to do certain things. Perhaps Mr. Press's hotel room in *The Unsuspected*, with the "Kill" sign blinking on and off, is an example: the space itself is telling him that he will kill again. Maybe the blinking light in *Scarlet Street* pushes Chris Cross to attempt suicide, just as the fading lamp in *Gaslight* causes Paula to doubt her sanity. More loosely, the very idea of milieu as a social environment suggests a potential causal relationship, as discussed in chapter 5. In *Sweet Smell of Success*, the contrast between Sidney's crummy office and J.J.'s luxurious apartment exerts some degree of social pressure on Sidney, driving him to act the way he does. The same goes for Joe in *Force of Evil*; he is aware of the contrast between Leo's office, just as crummy, and Tucker's apartment, equally luxurious. Milieus are also meaningful in narrative cinema because the causal relationship goes the other way, from the character to the space. A space may look bright or grim or elegant or obsolete because the characters have caused it to look like that. That is why milieus can teach us about the characters who inhabit them. In *Nightmare Alley* (also in chapter 5), the psychiatrist's office looks so modern because the psychiatrist wants it to look modern, as a way of projecting her own expertise. In *Mystery Street* (chapter 5, again), the hallway looks so dim because Mrs. Smerrling wants it that way to save money on electricity.

These examples rely on the idea that the lighting may be felicitous *within* the storyworld. Felicity here is a kind of causal logic that connects actions and spaces.

Mark's comments to Celia also raise another way that we might approach the question of felicity: from the standpoint of the movie's address. For Mark, a felicitous space is "happy in effect." Many or perhaps most noir lighting effects are felicitous in this more rhetorical sense: designed with the viewer in mind, with an eye toward producing some sort of dramatic impact. Think of all those scenes that use dark lighting to generate fear or suspense. In *Call Northside 777*, a cast shadow creates suspense when McNeal prepares to enter Wanda Siskovich's apartment (chapter 1). In *Cornered*, a silhouette effect creates suspense when Gerard looks at the silhouetted face of his nemesis, the fascist Jarnac (chapter 2). In *Phantom Lady*, dim lighting creates suspense when Carol waits nervously on a subway platform late at night (chapter 3). In *Strangers on a Train*, a darkened hallway creates suspense when Guy walks through the father's house with orders to kill him (chapter 4). In *Touch of Evil*, a blinking light creates suspense (and horror) as Quinlan prepares to murder Joe Grandi (chapter 5). The lighting works through the fictional world to get to the viewer. It is from the viewer's perspective that the lighting might seem felicitous.

We can extend this principle to noir's happier moments, as well. Just as bleak scenes unfold in shadow, happy scenes unfold in sunlight. *Phantom Lady*'s ending is upbeat, and so is its lighting (chapter 3). The ending of *Sweet Smell of Success* is admittedly more mixed, but the sunrise imagery works to magnify Susan's difficult triumph (chapter 5). Again, the lighting seems fitting, apt.

The cinematographer of *Secret beyond the Door*, Stanley Cortez, believed in this kind of felicity. He compared cinematography to music, which uses allegro passages to "produce sensations of lightness and gayety," and largo passages to produce "sensations of depression and sadness."[69] Whatever its merits as a theory of music, Cortez's proposal works rather well as a theory of studio-era Hollywood cinematography—but not all the time. Pushed to the extreme, it can make lighting too predictable, where every happy scene gets a highlight and every sad scene gets a shadow. Misdirection is a part of storytelling, too, and lighting can be felicitous even when it is off-mood. It may be "happy in effect" because it tricks us into thinking that everything will go right, even though everything goes wrong. Or the lighting may be "happy in effect" because it tricks us into thinking that everything will go wrong, even though everything goes right.

This tension between the various meanings of felicity is very much at stake in the finale of *Secret beyond the Door*. It is a marvelously odd finale. One odd thing is that this very dour movie actually ends rather happily, with Celia and the newly cured Mark embracing in the sunlight. Another odd thing is this: just a few minutes prior to this endearingly romantic ending, Cortez has executed the darkest ten seconds in all of film noir. Recall that Mark enters the seventh room intending to kill Celia, and that Celia brings him back to his senses by telling him the truth about who locked the door in his childhood. Suddenly, the storm outside causes the chandelier to go out. Approximately ten seconds later, Mark breaks down the door, and they escape into the hallway. In between there is blackness: no light at

all, except for a brief moment when the door cracks open for a split second.[70] It is an incredibly bold effect, the sort of thing that could get a cinematographer fired from a big-studio project. Ten seconds of absolute darkness! In a cruel irony, Mark's theory of felicity is proved correct at the moment he is closest to death. Surely, the lighting is apt: Celia and Mark appear to be in a hopeless situation, and they are in a room devoid of light. But actually, the lighting is not so apt after all. For all its suspense, the moment remains triumphant: Celia has just accomplished her goal of setting Mark on a path toward a cure, and Mark has snapped into action to save them both. Mark is given a moment of rather conventional masculine heroism, and we are reminded just how courageous Celia has been.[71] She has chosen to return to this room, and she has unlocked its secrets. When Celia and Mark escape, they prove that the lighting (or, rather, the lack of lighting) was not as well suited to the moment as it seemed.

Maybe the brain psych major had a point. She was right about the repressed memories, after all, and the movie has shown that she was right about something else, too: stories are shaped by time. A setting can call to mind some earlier setting, and the memories of that earlier setting can impact the experience of the present one. The darkness of the lights-out scene recalls so many moments that have come before in this very film: those shadowed faces, that silhouette in the fog, the dream sequence. Stretching back farther, the darkness of the lights-out scene brings with it the memories of countless other moments, seen and reseen in one film noir after another over the years: the shadows stretching across the streets, the basements with their hanging bulbs, the crisscross patterns on the walls. All these memories from all these other films may infuse this moment with expectation, the expectation of certain death for the protagonists.

But it turns out that the black screen is, rather happily, infelicitous.

All the signs have pointed toward death, and all the signs have been wrong.

7 · CONCLUSION

John Alton famously compares cinematography to painting with light.[1] Another great Hollywood cinematographer, William Daniels, offers a somewhat different analogy: "We try to tell the story with light."[2] Alton defines the cinematographer as a picture maker; Daniels, as a storyteller. Both analogies are true; each has its limitations. The problem with the *telling* analogy is that it is insufficiently visual, failing to capture how lighting lets us see the story's world in a series of pictures. The problem with the *painting* analogy is that it is insufficiently temporal, overlooking the fact that cinematic lighting shifts over time. And yet both cinematographers are correct. The cinematographer must do both, must be both kinds of artist. On the one hand, the cinematographer must use lighting to render the painterly here and now, creating the sense that the characters are acting in a richly particular moment. On the other hand, each one of these painterly moments contributes to a larger pattern, a dramatic story. As a movie unfolds, it builds up expectations and memories, and those expectations and memories charge each image with meaning and emotion.

In the introduction, I asked you to think of a prototypical film noir. What did you see? Perhaps the long shadow of a man walking down a city street. Perhaps a street sign blinking on and off through a window. Perhaps the glimmer in the eyes of a woman standing in the gloom. I hope you still see those images, but I hope you also see a few more. Perhaps a modern office with dull fluorescent lights. Perhaps a daytime exterior growing grayer, almost imperceptibly, as the sun sets. Perhaps a character who looks utterly harmless when we know that the character is not. These, too, are noir.

In this book, I have tried to expand the iconography of noir without diminishing its power to disturb and delight. To do so, I have proposed a general account of what lighting in Hollywood cinema is supposed to do: depict figures in a milieu as the dramatic arc unfolds in time. The account admittedly simplifies some points and overlooks others, but all its components share a similar trait. They presuppose that lighting must be variable, with enough intricacy to depict complex and changing storyworlds. By fine-tuning the figure lighting, a movie might depict its characters as glamorous, hardened, youthful, or weary. By adjusting the lighting for milieu, a movie might depict its settings as chic, broken-down, corporate, or

homey. By modulating the light over the duration of an arc, a movie might depict its narrative trajectory as ascending, descending, turning, or collapsing. Each movie presented a distinct set of storytelling problems. Lighting allowed filmmakers to find pictorial solutions to those ever-shifting problems. Cinematographers insisted they were storytellers as well as picture makers. In the best noirs, they were both at once.

ACKNOWLEDGMENTS

As a teacher and a scholar, I feel fortunate to have been shaped by exceptional mentors. This project is rooted in things I learned from David Bordwell. David continues to inspire me with his perceptive comments, his brilliant writing, and his enthusiasm for the art of cinema. Two of his books in particular, *Reinventing Hollywood* and *Perplexing Plots*, have reshaped my understanding of classical Hollywood cinema and the mystery genre. David has equipped me to see more in movies than I thought I knew.

Back when I was an undergraduate, I wrote my senior essay about film noir under the expert supervision of Scott Bukatman. He helped me appreciate noir's cultural significance without losing sight of its sensory appeal. I watched several noirs for the first time on Scott's recommendation; his advice to watch *The Big Clock* ended up being pivotal to the ideas in this book some three decades later.

During the pandemic, I joined an online film discussion group with Maria Belodubrovskaya, Vince Bohlinger, and Lisa Dombrowski. It was wonderful to have such great intellectual companions in such a challenging time.

Trinity University has supported this project in many ways, funding archival research, providing a summer research stipend, and offering a generous subvention to support the cost of printing illustrations. Thanks especially to Althea Delwiche, chair of the Department of Communication, and to Dean Nels Christiansen. I have been lucky to have great conversations about movies with work friends, including Sarah Erickson, Andrew Kania, Julie Post, Kathryn O'Rourke, and Curtis Swope, and I have had the privilege of teaching Film Noir three times. My students, including Connie Laing and Jerod Bork, have offered fresh insights about these movies on countless occasions.

During my research, I consulted documents at the Warner Bros. Archive at the University of Southern California; Special Collections at the University of California, Los Angeles; the David O. Selznick Papers at the Harry Ransom Humanities Research Center at the University of Texas at Austin; and several collections at the Margaret Herrick Library of the Academy of Motion Picture Arts and Sciences. Thanks to Bree Russell at USC and all the other archivists who helped me find such fascinating material. Another invaluable resource was Lantern, which provided access to back issues of *American Cinematographer* on demand (and under lockdown).

Thanks to Nicole Solano at Rutgers University Press for guiding me through the process and for showing support and patience as I pushed my deadline back several times. Murray Pomerance provided encouragement and insight from beginning to end. I particularly enjoyed tossing around possible examples together. Thanks also

to the two anonymous readers for their astute suggestions and ideas, and to Susan Ecklund for her perceptive suggestions in the copy-editing stage.

This book pulls together ideas I have been developing and revising for years. Thanks to Andrew Spicer and Helen Hanson, the editors of *A Companion to Film Noir*, where I first tested out a number of the ideas in this book, and to Noël Carroll, who invited me to contribute to *The Palgrave Handbook for the Philosophy of Film and Motion Pictures*, where I gathered my thoughts about cinematography and narrative. Thanks also to the editors of *Film History* and the *Journal of Cinema and Media Studies*, which published pieces about such topics as electricity, glamour, and time.

Over the years, many scholars and friends have discussed lighting with me, including Lea Jacobs, Dana Polan, Jennifer Fay, Jordan Hoffman, Daisuke Miyao, and Dan Morgan. I received welcome invitations to present versions of this material from Rob Spadoni at Case Western Reserve University, Dominic Topp at the University of Kent at Canterbury, Kristi McKim at Hendrix College, Leger Grindon at Middlebury College, and Chris Cagle at Temple University. Thanks to all who attended those talks, as well as audiences at Columbia University, the University of Chicago, Harvard University, and the University of Barcelona.

Growing up, I enjoyed the loving support of my parents, Maria and Dennis. They gave me my first copy of the *Film Noir Encyclopedia*. My father has the delightful habit of writing an inscription on the first page of each book he offers as a gift. Several of the books I consulted for this project bear that inscription. Thanks also to my sisters, Coleen and Amy, who have supported my cinematic and non-cinematic interests.

There are eleven major examples in this book, and Lisa Jasinski has watched every one of them with me. She has read many chapters and done the difficult but necessary work of telling me what I need to cut. She did all this while helping us get through a pandemic, supporting friends and family through difficult times, welcoming our cat Oliver, and, oh, yes, writing a book of her own. If you're curious, it's called *Stepping Away*, and it's available from this very same press.

NOTES

CHAPTER 1 INTRODUCTION

1. Both essays can be found in *Film Noir Reader*, ed. Alain Silver and James Ursini (New York: Limelight, 1996). See Paul Schrader, "Notes on Film Noir," 57; Janey Place and Lowell Peterson, "Some Visual Motifs of Film Noir," 67, 74.
2. Alain Silver and James Ursini, *The Noir Style* (New York: Overlook Press, 1999), 38, 90, 204.
3. In fact, the shadow is a bit too low to be consistent with the height of the table lamp. I discuss the matter of "cheating" such lighting effects in chapter 5.
4. In an interview, Edeson noted that *The Maltese Falcon* and *Citizen Kane* (1941) both called for "modernistic" photography. See Walter Blanchard, "Aces of the Camera XXII: Arthur Edeson, A.S.C.," *American Cinematographer* 23, no. 11 (November 1942): 491.
5. Adrian Martin, *Mise-en-Scène and Film Style: From Classical Hollywood to New Media Art* (New York: Palgrave Macmillan, 2014), 131, 144.
6. When the newly arrested Brigid steps into an elevator at the end of the film, a close-up shows the shadow of a bar across Mary Astor's face. The shadow is unusually salient, and the symbolic reading seems well warranted. Still, the shadow remains well grounded in the world of the film, as it helps us read the tight confinement of the elevator at a glance.
7. Vivian Sobchack, "Lounge Time: Postwar Crises and the Chronotope of Film Noir," in *Refiguring American Film Genres*, ed. Nick Browne (Berkeley: University of California Press, 1998), 129–170.
8. Edward Dimendberg, *Film Noir and the Spaces of Modernity* (Cambridge, MA: Harvard University Press, 2004), 3. Dimendberg's use of the term *nonsynchronous* is influenced by the work of Ernst Bloch.
9. Place and Peterson, "Some Visual Motifs of Film Noir," 66.
10. Andrew Spicer, *Film Noir* (Harlow, UK: Pearson Education, 2002), 46–47.
11. Raymond Borde and Etienne Chaumeton, *A Panorama of American Film Noir, 1941–1953*, trans. Paul Hammond (San Francisco: City Lights Books, 2002), 1–2. The original French version was published in 1955.
12. Foster Hirsch, *Film Noir: The Dark Side of the Screen* (Cambridge, MA: Da Capo Press, 1981), 72.
13. Raymond Durgnat, "Paint It Black: The Family Tree of the Film Noir," in *Film Noir Reader*, 38; Place and Peterson, "Some Visual Motifs of Film Noir," 65.
14. James Naremore, *More Than Night: Film Noir in Its Contexts*, 2nd ed. (Berkeley: University of California Press, 2008), 276.
15. See Patrick Keating, *Hollywood Lighting from the Silent Era to Film Noir* (New York: Columbia University Press, 2010). As will become clear, the present book revises some of my earlier positions.
16. David Bordwell, *Poetics of Cinema* (New York: Routledge, 2008), 54.
17. John Huston, interviewed in Andrew Sarris, *Interviews with Film Directors* (New York: Avon, 1967), 268.
18. For an example of this approach to authorship, see Philip Cowan, *Authorship and Aesthetics in the Cinematography of Gregg Toland* (Lanham, MD: Lexington Books, 2022).
19. Sarah Kozloff, *The Life of the Author* (Montreal: Caboose, 2014), 45. For a study that focuses on the relationship between cinematographers and directors, see Christopher Beach, *A Hidden History of Film Style: Cinematographers, Directors, and the Collaborative Process* (Berkeley:

University of California Press, 2015). For a discussion of authorship in relation to studio style and industry-wide trends, see Chris Cagle, "Classical Hollywood, 1928–1946," in *Cinematography*, ed. Patrick Keating (New Brunswick, NJ: Rutgers University Press, 2014), 34–59.
20. For a nuanced account of the theme of destiny in Lang's films, see Tom Gunning, *The Films of Fritz Lang: Allegories of Vision and Modernity* (London: British Film Institute, 2000), 10.
21. Herb A. Lightman, "Realism with a Master's Touch," *American Cinematographer* 31, no. 8 (August 1950): 286.
22. The light bulb is probably a photoflood—an unusually bright bulb that cinematographers often placed in the set's practical lamps.
23. Lightman, "Realism with a Master's Touch," 286.
24. This spotlight probably has a snoot on it, as it illuminates the cheek but not the forehead or jaw. A snoot is a cylindrical piece of grip equipment that can be attached to the front of a lamp.
25. Ben Maddow and John Huston, "Screenplay," *The Asphalt Jungle*, October 12, 1949, John Huston Papers, Academy of Motion Picture Arts and Sciences, Margaret Herrick Library, Beverly Hills, CA.

CHAPTER 2 THE DRAMATIC ARC

1. I draw inspiration for this claim from Gary Saul Morson, "Narrativeness," *New Literary History* 34, no. 1 (Winter 2003): 59–73, especially the discussion of suspense on page 68.
2. David Bordwell, *Reinventing Hollywood: How 1940s Filmmakers Changed Movie Storytelling* (Chicago: University of Chicago Press, 2017), 126.
3. Bordwell explains the structure of the causal chain in part I of David Bordwell, Janet Staiger, and Kristin Thompson, *The Classical Hollywood Cinema: Film Style and Mode of Production to 1960* (New York: Columbia University Press, 1985), 12, 29, 64. However, it should be noted that his more recent work on Hollywood cinema places more emphasis on variations and experiments, which would include plots based on coincidence.
4. Janet Staiger, "Film Noir as Male Melodrama: The Politics of Film Genre Labeling," in *The Shifting Definitions of Genre: Essays on Labeling Films, Television Shows, and Media*, ed. Lincoln Geraghty and Mark Jancovich (Jefferson, NC: McFarland and Company, 2008), 88n11.
5. I outline and defend a rhetorical-functionalist approach to narrative in Patrick Keating, "Narrative and the Moving Image," in *The Palgrave Handbook for the Philosophy of Film and Motion Pictures*, ed. Noël Carroll, Laura T. DiSumma-Knoop, and Shawn Loht (London: Palgrave Macmillan, 2019), 119–141.
6. *Random Harvest* illustrates a variation on the goal-oriented plot structure. The plot generally focuses on Charles, but Paula is the one driving the action, especially in the second half.
7. This section clarifies and revises some ideas that I first proposed in Patrick Keating, "Emotional Curves and Linear Narratives," *Velvet Light Trap* 58 (Fall 2006): 4–15.
8. See, for instance, Raymond Borde and Etienne Chaumeton, *A Panorama of American Film Noir, 1941–1953*, trans. Paul Hammond (San Francisco: City Lights Books, 2002), 12; J. P. Telotte, *Voices in the Dark: The Narrative Patterns of Film Noir* (Urbana: University of Illinois Press, 1989), 12; and Andrew Spicer, *Film Noir* (Harlow, UK: Pearson Education, 2002), 74.
9. On the 1940s, see Bordwell, *Reinventing Hollywood*. On the mystery genre, see David Bordwell, *Perplexing Plots: Popular Storytelling and the Poetics of Murder* (New York: Columbia University Press, 2023).
10. Robert Porfirio, "No Way Out: Existential Motifs in Film Noir," in *Film Noir Reader*, ed. Alain Silver and James Ursini (New York: Limelight, 1996), 80.
11. Frances Marion, *How to Write and Sell Film Scripts*, repr. ed. (New York: Garland, 1978), 132.
12. Elizabeth Cowie, "Film Noir and Women," in *Shades of Noir*, ed. Joan Copjec (New York: Verso, 1993), 135.

13. Cowie, 133–135.
14. Philippa Gates, "Independence Unpunished: The Female Detective in Classic Film Noir," in *Kiss the Blood Off My Hands: On Classic Film Noir*, ed. Robert Miklitsch (Urbana: University of Illinois Press, 2014), 21.
15. On the distinction between action-driven plots and pathos-driven plots, see Linda Williams, "Melodrama Revised," in *Refiguring American Film Genres: History and Theory*, ed. Nick Browne (Berkeley: University of California Press, 1998), 58.
16. See the prototypical plot outline in James Damico, "Film Noir: A Modest Proposal," in *Film Noir Reader*, 103.
17. For an overview of this scholarship, see Helen Hanson, "Feminist Film Criticism and the Femme Fatale," in *The Femme Fatale: Images, Histories, Contexts*, ed. Helen Hanson and Catherine O'Rawe (New York: Palgrave Macmillan, 2010), 217–221.
18. Angela Martin, "'Gilda Didn't Do Any of Those Things You've Been Losing Sleep Over!': The Central Women of 40s Film Noirs," in *Women in Film Noir*, new ed., ed. Ann Kaplan (London: British Film Institute, 1998), 209.
19. Julie Grossman, *Rethinking the Femme Fatale in Film Noir: Ready for Her Close-Up* (New York: Palgrave Macmillan, 2009), 46.
20. On the role of coincidence in this film and other noirs, see Dana Polan, *Power and Paranoia: History, Narrative, and the American Cinema, 1940–1950* (New York: Columbia University Press, 1985), 195–201.
21. Leonard J. Leff and Jerrold L. Simmons, *The Dame in the Kimono: Hollywood, Censorship, and the Production Code*, rev. ed. (Lexington: University Press of Kentucky, 2001), 48.
22. Robert Pippin, *Fatalism in American Film Noir: Some Cinematic Philosophy* (Charlottesville: University of Virginia Press, 2012), 12.
23. Gaylyn Studlar, "'The Corpse on Reprieve': Film Noir's Cautionary Tales of 'Tough Guy' Masculinity," in *A Companion to Film Noir*, ed. Andrew Spicer and Helen Hanson (Malden, MA: Wiley-Blackwell, 2013), 373–374.
24. Andrew Britton, "Betrayed by Rita Hayworth: Misogyny in *The Lady from Shanghai*," in *The Book of Film Noir*, ed. Ian Cameron (New York: Continuum, 1993), 220–221.
25. Telotte, *Voices in the Dark*.
26. Bordwell discusses all these examples, and more, in *Reinventing Hollywood*.
27. Elisabeth Bronfen, "Gender and Noir," in *Film Noir*, ed. Homer B. Pettey and R. Barton Palmer (Edinburgh: Edinburgh University Press, 2014), 151, 158.
28. Deborah Thomas, "Psychoanalysis and Film Noir," in *Book of Film Noir*, 80.
29. Marie-Laure Ryan, *Possible Worlds, Artificial Intelligence, and Narrative Theory* (Bloomington: Indiana University Press, 1991), 156.
30. See the list of films with "if only" plots in Staiger, "Film Noir as Male Melodrama," 83.
31. See, for instance, David Howard, *How to Build a Great Screenplay: A Master Class in Great Storytelling* (New York: St. Martin's Griffin, 2004), 29, 64.
32. See the discussion of abnormal suspense in Noël Carroll, "Toward a Theory of Film Suspense," in *Theorizing the Moving Image* (New York: Cambridge University Press, 1996), 111–113.
33. Patrick Keating, *Hollywood Lighting from the Silent Era to Film Noir* (New York: Columbia University Press, 2010), 6.
34. This paragraph borrows most of its language and ideas from Patrick Keating, "Light and Time in the Narrative Fiction Film," *Journal of Cinema and Media Studies* 61, no. 3 (Spring 2022): 69–70.
35. Paul Ricoeur, *Time and Narrative*, vol. 1, trans. Kathleen McLaughlin and David Pellauer (Chicago: University of Chicago Press, 1984), 9. Ricoeur works out his own proposal through a discussion of Augustine and Aristotle. He borrows the term *threefold present* from the former.
36. Gentileschi painted variations on this theme throughout her career. I am referring to the painting in the collection at the Detroit Institute of Art. For an insightful analysis of this painting

and three others, see Elena Ciletti, "*'Gran Macchina è Bellezza'*: Looking at the Gentileschi Judiths," in *The Artemisia Files: Artemisia Gentileschi for Feminists and Other Thinking People*, ed. Mieke Bal (Chicago: University of Chicago Press, 2005), 63–105.
37. Ciletti, "*'Gran Macchina è Bellezza*,'" 98.
38. The fill light grows a little brighter on Moe's face as the camera approaches Thelma Ritter, probably because there is a lamp attached to the camera itself.
39. In Keating, "Light and Time," I use the word *description* as a substitute for *depiction*. Here, I prefer the latter term because it better suggests the idea of picture-making.
40. Seymour Chatman, *Coming to Terms: The Rhetoric of Narrative in Fiction and Film* (Ithaca, NY: Cornell University Press, 1990), 32.
41. Seymour Chatman, "What Novels Can Do That Films Can't (and Vice Versa)," *Critical Inquiry* 7, no. 1 (Autumn 1980): 129.
42. Chatman, *Coming to Terms*, 31–32.
43. For a defense of the idea that a fiction film may depict characters (and not just actors), see Catherine Abell, "Cinema as a Representational Art," *British Journal of Aesthetics* 50, no. 3 (July 2010): 273–286. I discuss my use of the phrase "seeing-in" in chapter 6. Note that Abell's theory differs from the seeing-in theory in ways that I pass over here.
44. Fuller, quoted in Robert Miklitsch, *The Red and the Black: American Film Noir in the 1950s* (Urbana: University of Illinois Press, 2017), 82.
45. This tradition of thinking goes back to Aristotle: "Tragedy, then, is a representation of an action which is serious, complete, and of a certain magnitude." See Aristotle, *The Poetics of Aristotle*, trans. Stephen Halliwell (Chapel Hill: University of North Carolina Press, 1987), 37.
46. Meir Sternberg, "Narrativity: From Objectivist to Functional Paradigm," *Poetics Today* 31, no. 3 (Fall 2010): 642. I have discussed Sternberg's theory in more detail elsewhere, especially in Keating, "Narrative and the Moving Image."
47. The preceding paragraph borrows from Keating, "Light and Time," 66.
48. John Alton, *Painting with Light* (Berkeley: University of California Press, 1995), 56.
49. Therese Grisham and Julie Grossman, *Ida Lupino, Director: Her Art and Resilience in Times of Transition* (New Brunswick, NJ: Rutgers University Press, 2017), 25. Grisham and Grossman also note that Lupino took the Italian Neorealist filmmaker Roberto Rossellini as an inspiration (51).
50. Lauren Rabinovitz, "The Hitch-Hiker," in *Queen of the 'B's: Ida Lupino behind the Camera*, ed. Annette Kuhn (Westport, CT: Greenwood Press, 1995), 92.
51. Charles Loring, "Source Lighting," *American Cinematographer* 30, no. 9 (September 1949): 336–337.
52. According to Jennifer Langdon-Teclaw, the studio and Dmytryk wanted to weaken the antifascist themes, for fear of offending the Argentine government. Producer Adrian Scott ended up replacing John Wexley with John Paxson, but the film's antifascist themes still come through. See Jennifer Langdon-Teclaw, "The Progressive Producer in the Studio System: Adrian Scott at RKO, 1943–1947," in *"Un-American" Hollywood: Politics and Film in the Blacklist Era*, ed. Frank Krutnik, Steve Neale, Brian Neve, and Peter Stanfield (New Brunswick, NJ: Rutgers University Press, 2007), 157–161.
53. For a thoughtful analysis of this character and Grahame's performance, see Grossman, *Rethinking the Femme Fatale*, 61–63; and Steve Neale, "'I Can't Tell Anymore Whether You're Lying': *Double Indemnity*, *Human Desire*, and the Narratology of Femme Fatales," in *The Femme Fatale: Images, Histories, Contexts*, ed. Helen Hanson and Catherine O'Rawe (New York: Palgrave Macmillan, 2010), 190–197.
54. For an overview of Guffey's career, see Wheeler Winston Dixon, *Black and White Cinema: A Short History* (New Brunswick, NJ: Rutgers University Press, 2015), 120–126.
55. On *beat* as a screenwriters' term, see Robert McKee, *Story: Substance, Structure, Style, and the Principles of Screenwriting* (New York: HarperCollins, 1997), 37–38. Sharon Carnicke suggests

that directors and actors owe the basic idea of dividing a scene into significant actions to Stanislavski; the term *beat* may derive from the pronunciation of the word *bit* by Russian émigré acting teachers. See Sharon Carnicke, *Stanislavski in Focus: An Acting Master for the Twenty-First Century*, 2nd ed. (New York: Routledge, 2009), 214; and Constantin Stanislavski, *An Actor Prepares*, trans. Elizabeth Reynolds Hapgood (New York: Routledge, 1989), 121–138.
56. V. F. Perkins, *Film as Film: Understanding and Judging Movies* (New York: Penguin, 1972), 117–121.
57. Here I have benefited from the discussion of Perkins in Seth Barry Watter, "On the Concept of Setting: A Study of V. F. Perkins," *Journal of Cinema and Media Studies* 58, no. 3 (Spring 2019): 75.
58. Herb A. Lightman, "Psychology and the Screen," *American Cinematographer* 27, no. 5 (May 1946): 160.
59. Lightman, 161.
60. Herb A. Lightman, "Mood in the Motion Picture," *American Cinematographer* 28, no. 2 (February 1947): 48.
61. Lightman, 49.
62. Herb A. Lightman, "'Sleep My Love': Cinematic Psycho-Thriller," *American Cinematographer* 29, no. 2 (February 1948): 47.
63. *Kings Row* and *Sleep, My Love* both appear in the appendix of Borde and Chaumeton, *Panorama of American Film Noir*. This appendix was based on the original 1955 edition, as well as its 1979 revision.
64. In addition to the previously cited articles, see Herb A. Lightman, "'The Killers': Teamwork on Film Production," *American Cinematographer* 27, no. 12 (December 1946): 436–437, 458, 463; Herb A. Lightman, "'The Naked City': Tribute in Celluloid," *American Cinematographer* 29, no. 5 (May 1948): 152–153, 178–179; and Herb A. Lightman, "'The Lady from Shanghai': Field Day for the Camera," *American Cinematographer* 29, no. 6 (June 1948): 200–201, 213.
65. This category overlaps with the gothic romance, which I will discuss in chapter 6.
66. A narrator reads this definition at the beginning of several episodes included on volume 1 of *The Best of Suspense*, a compact disc published by the Old Time Radio Catalogue. For more on the radio series, see Jesse Schlotterbeck, "Radio Noir in the USA," in *Companion to Film Noir*, 430.
67. On the comparison with *Citizen Kane*, see Telotte, *Voices in the Dark*, 77.
68. For an overview of Litvak's career and contribution to noir, see Vincent Brook, *Driven to Darkness: Jewish Émigré Directors and the Rise of Film Noir* (New Brunswick, NJ: Rutgers University Press, 2009), 197–205.
69. Lucille Fletcher, "Final Screenplay," *Sorry, Wrong Number*, December 22, 1947, Hal Wallis Papers, Academy of Motion Picture Arts and Sciences, Margaret Herrick Library, Beverly Hills, CA.
70. Fletcher.
71. Amy Lawrence, *Echo and Narcissus: Women's Voices in Classical Hollywood Cinema* (Berkeley: University of California Press, 1991), 137.
72. Fletcher, "Final Screenplay." Ellipsis in the original.
73. On the movie's shifting status as the final entry in the original cycle, see Robert Miklitsch, "Periodizing Classic Noir: From *Stranger on the Third Floor* to the 'Thrillers of Tomorrow,'" in *Kiss the Blood Off My Hands*, 205–212.
74. Belafonte, quoted in Eithne Quinn, *A Piece of the Action: Race and Labor in Post–Civil Rights Hollywood* (New York: Columbia University Press, 2020), 128.
75. Thomas Cripps, *Making Movies Black: The Hollywood Message Movie from World War II to the Civil Rights Era* (New York: Oxford University Press, 1993), 266–267.
76. For an overview of Belafonte's career, see Steven J. Ross, *Hollywood Left and Right: How Movie Stars Shaped American Politics* (New York: Oxford University Press, 2014), 185–226.

77. The unusually slow pace of this third section is perhaps an extreme illustration of Kristin Thompson's argument that four-part movies often use their third parts as mechanisms of delay. Kristin Thompson, *Storytelling in the New Hollywood: Understanding Classical Narrative Technique* (Cambridge, MA: Harvard University Press, 1999), 28.
78. Cripps, *Making Movies Black*, 250.
79. Belafonte, quoted in Ross, *Hollywood Left and Right*, 204.
80. Kelly Oliver and Benigno Trigo, *Noir Anxiety* (Minneapolis: University of Minnesota Press, 2003), 9–10.
81. Paul Buhle and Dave Wagner, *A Very Dangerous Citizen: Abraham Lincoln Polonsky and the Hollywood Left* (Berkeley: University of California Press, 2001), 184.
82. The cinematographer Joseph Brun explained that he used wide-angle lenses throughout the movie, with focal lengths ranging from the moderately wide 30mm to the exceptionally wide 14mm. Joseph Brun, "Odds against Tomorrow," *American Cinematographer* 40, no. 8 (August 1959): 478.
83. Eric Lott, "The Whiteness of Film Noir," *American Literary History* 9, no. 3 (Autumn 1997): 545.
84. A production still of the scene appears in Brun, "Odds against Tomorrow," 478.
85. Wise presented the lack of dissolves as a major breakthrough in Murray Schumach, "Movie Director Explains His Method," *New York Times*, October 5, 1959, 26.
86. Brun, "Odds against Tomorrow," 479.

CHAPTER 3 LIGHTING CHARACTERS

1. For a study of the psychology of the effect, see Vilayanur S. Ramachandran, "Perceiving Shape from Shading," *Scientific American* 259, no. 2 (August 1988): 76–83. John Alton illustrates the rounded and flat illumination of a sphere in *Painting with Light* (Berkeley: University of California Press, 1995), 30.
2. For an early reference to modeling, see Lewis Physioc, "Does the Camera Lie?," *American Cinematographer* 8, no. 10 (January 1928): 21–24. I discuss this article in more detail later in this chapter.
3. As far as I know, the term *butterfly lighting* was not used in the 1940s, but it has been around for decades by now. For an early use of the term, see Ralph Hattersley, *Photographic Lighting* (Englewood Cliffs, NJ: Prentice-Hall, 1979), 148. Hattersley also calls this technique "high front lighting," and he associates it with 1930s and 1940s glamour photography (152). A few years later, another textbook associates the technique with Marlene Dietrich. See John Hart, *50 Portrait Lighting Techniques for Pictures That Sell* (New York: Amphoto, 1983), 22. A couple decades later, another textbook defines butterfly lighting as "Paramount lighting" or "glamour lighting." See Christopher Grey, *Master Lighting Guide for Portrait Photographers* (Buffalo, NY: Amherst Media, 2004). The same publisher has produced several books using the same terms. See Bill Hurter, *Simple Lighting Techniques for Portrait Photographers* (Buffalo, NY: Amherst Media, 2008), 73; Allison Earnest, *Sculpting with Light: Techniques for Portrait Photographers* (Buffalo, NY: Amherst Media, 2009), 46; and Pete Wright, *Cinematic Portraits: How to Create Classic Photography* (Buffalo, NY: Amherst Media, 2015), 42. A 1952 article on amateur cinematography comments on butterfly-shaped patterns on a subject's face, but the illustration shows that the term is used differently than I am using it here. See Leo J. Heffernan, "The Facts of Light," *American Cinematographer* 33, no. 6 (June 1952): 255.
4. Hurter, *Simple Lighting Techniques*, 73; Grey, *Master Lighting Guide*, 37; Wright, *Cinematic Portraits*, 38.
5. Hattersley, *Photographic Lighting*, 154; Wright, *Cinematic Portraits*, 32; and David Busch, *Quick Snap Guide to Lighting* (Boston: Course Technology, 2009), 126.

6. On painting in film noir, including this movie, see Steven Jacobs and Lisa Colpaert, *The Dark Galleries: A Museum Guide to Painted Portraits in Film Noir, Gothic Melodramas, and Ghost Stories of the 1940s and 1950s* (Ghent: Aramer, 2013).

7. Allison Earnest describes Rembrandt lighting as "closed loop" lighting, in contrast to "open loop" lighting. See Earnest, *Sculpting with Light*, 44. See also Hurter, *Simple Lighting Techniques*, 73; and Grey, *Master Lighting Guide*, 40.

8. I discuss this earlier meaning of Rembrandt lighting in Patrick Keating, *Hollywood Lighting from the Silent Era to Film Noir* (New York: Columbia University Press, 2010), 31–33.

9. Several contemporary film and video textbooks associate top lighting with *The Godfather*, as in Blain Brown, *Motion Picture and Video Lighting for Cinematographers, Gaffers and Lighting Technicians*, 3rd ed. (New York: Routledge, 2019), 146.

10. Roger Hicks and Christopher Nisperos, *Hollywood Portraits: Classic Shots and How to Take Them* (New York: Amphoto Books, 2000), 34.

11. Herb A. Lightman, "'The Killers': Teamwork on Film Production," *American Cinematographer* 27, no. 12 (December 1946): 458.

12. William Stull, "Summing Up Modern Studio Lighting Equipment," *American Cinematographer* 16, no. 10 (October 1935): 424.

13. "Report of the Studio Lighting Committee," *Journal of the Society of Motion Picture Engineers* 28, no. 1 (January 1937): 34.

14. In addition to the Stull article cited earlier, see "How Lighting Units Are Developed Today," *American Cinematographer* 18, no. 5 (May 1937): 189; and Elmer C. Richardson, "Recent Developments in Motion Picture Lighting," *American Cinematographer* 18, no. 8 (August 1937): 319.

15. By using less general lighting, Alton could hire a smaller crew and film more quickly. On Alton's speed, see Todd McCarthy, "Deep Focus," *Variety*, March 11, 1993, https://variety.com/1993/voices/columns/deep-focus-3-104874/.

16. William C. Mellor, quoted in "Lighting the New Fast Films," *American Cinematographer* 20, no. 2 (February 1939): 69.

17. This can be difficult to appreciate without the right screening environment. Shadows that look black on a home screen may retain detail on the film print.

18. For eyelight, see Kris Malkiewicz, *Film Lighting: Talks with Hollywood Cinematographers and Gaffers* (New York: Touchstone, 2012), 186–188. For catch light, see Hurter, *Simple Lighting Techniques*, 78; Wright, *Cinematic Portraits*, 38, 40.

19. Jay Holben, "Eye Lights," *American Cinematographer Blog*, September 1, 2018, https://ascmag.com/blog/shot-craft/eye-lights. For a related story that the scars came from makeup poisoning, see John Kobal, *The Art of the Great Hollywood Portrait Photographers, 1925–1940* (New York: Alfred A. Knopf, 1980), 79.

20. Geoffrey Macnab, *Searching for Stars: Stardom and Screen Acting in British Cinema* (London: Continuum, 2000), 66.

21. See also the discussion of the Houdini lamp in Arthur Rowan, "New Glamour for Close-ups," *American Cinematographer* 33, no. 5 (May 1952): 205, 220–221.

22. For a useful list of these and other lighting terms, see the glossary in Malkiewicz, *Film Lighting*, 241–252.

23. Keating, *Hollywood Lighting*, 127–129.

24. Miller, quoted in "Motion Picture Set Lighting . . . an Interview with Arthur C. Miller," *American Cinematographer* 42, no. 5 (May 1961): 320. This was the second of a two-part series.

25. Charles Loring, "Set Lighting for Commercial Films," *American Cinematographer* 36, no. 8 (August 1955): 493. The article is aimed at industrial filmmakers, but it uses Hollywood examples to support its arguments.

26. Lewis Physioc, "The Witchery of Lights," *Picture Play Magazine* 14, no. 4 (June 1921): 60–61; Lewis Physioc, "Does the Camera Lie?," 21–24; Lewis Physioc, "By Request," *American*

Cinematographer 9, no. 11 (February 1929): 19–22; Lewis Physioc, "Lighting: The Magic of Cinematography," *International Photographer* 5, no. 3 (April 1933): 28–31.
27. Physioc, "Lighting," 30.
28. The idea became something of a photographic joke or cliché. See, for instance, the photograph of Joan Crawford as the Venus de Milo in Robert Dance and Bruce Robertson, *Ruth Harriet Louise and Hollywood Glamour Photography* (Berkeley: University of California Press, 2002), 128; and the photograph of Lana Turner as the Venus de Milo in Hicks and Nisperos, *Hollywood Portraits*, 101.
29. Physioc, "Witchery of Lights," 60.
30. Karl Freund, "Key-Light vs. Background Illumination," *American Cinematographer* 23, no. 4 (April 1942): 155.
31. Lee Garmes, "On Cinematography," *Journal of the University Film Association* 28, no. 4 (Fall 1976): 15. See also Leon Shamroy's claim that he took inspiration from Rembrandt and Rubens in Herb A. Lightman, "Painting with Technicolor Light," *American Cinematographer* 28, no. 6 (June 1947): 201.
32. Jennifer Scott and Helen Hillyard, *Rembrandt's Light* (London: Dulwich Picture Gallery, 2019), 18.
33. A south-facing window in the Southern Hemisphere will produce a similar light. To some extent, so will any window at a time of day when the sun is not shining directly through it, as when it is overcast.
34. Richard Dyer, *White* (New York: Routledge, 1997), 118.
35. Alton, *Painting with Light*, 84, 164.
36. See the chapter titled "The Hollywood Close-Up," which covers technical details, and the chapter titled "Day and Night, Ladies, Watch Your Light," which advises women in everyday life to observe the lights in their surroundings and position themselves advantageously. Alton, *Painting with Light*, 80–116, 171–184.
37. Perc Westmore, "Corrective Makeup as an Aid to Cinematography," *American Cinematographer* 16, no. 5 (May 1935): 188, 198; Leigh Allen, "Corrective Makeup Aid to Cinematography," *American Cinematographer* 38, no. 1 (January 1957): 36, 44–45. The latter article borrows (uncredited) passages from the former.
38. Rosson, quoted in Leonard Maltin, *The Art of the Cinematographer: A Survey and Interviews with Five Masters*, enl. ed. (New York: Dover, 1978), 97.
39. The quotation comes from the producer Pandro S. Berman, who was summarizing Mayer's views. Berman, quoted in Thomas Schatz, *Boom and Bust: American Cinema in the 1940s* (Berkeley: University of California Press, 1999), 263.
40. Stephen Gundle, *Glamour: A History* (New York: Oxford University Press, 2008), 20. Throughout this paragraph, I draw quotations and phrases from Patrick Keating, "Artifice and Atmosphere: The Visual Culture of Hollywood Glamour Photography, 1930–1935," *Film History* 29, no. 3 (2017): 105–135.
41. Gundle, *Glamour*, 6–7.
42. Keating, *Hollywood Lighting*, 50.
43. Katherine Albert, "Charm? No! No! You Must Have Glamour," *Photoplay* 40, no. 4 (September 1931): 38.
44. Albert, 101.
45. Mark Vieira, *George Hurrell's Hollywood: Glamour Portraits, 1925–1992* (Philadelphia: Running Press, 2013), 41.
46. Vieira, 11.
47. Vieira, 75.
48. For examples, see a 1931 portrait of Jean Harlow, a 1933 portrait of Joan Crawford, and a 1933 portrait of Harlow in Vieira, 90, 115, 128.

49. See the illustration and the accompanying discussion in Liz Willis-Tropea, "Glamour Photography and the Institutionalization of Celebrity," *Photography and Culture* 4, no. 3 (November 2011): 269.
50. See, for instance, the nine-photo display in *International Photographer* 12, no. 10 (November 1940): 6–8.
51. Young, quoted in Kobal, *Art of the Great Hollywood Portrait Photographers*, 101.
52. For a useful list of photographers, categorized by studio, see Joel Finler, *Hollywood Movie Stills: Art and Technique in the Golden Age of the Studios*, 2nd ed. (London: Reynolds and Hearn, 2008), 43.
53. Josef von Sternberg, *Fun in a Chinese Laundry* (London: Columbus Books, 1987), 318.
54. Garmes, interviewed in Charles Higham, *Hollywood Cameramen: Sources of Light* (Bloomington: Indiana University Press, 1970), 38.
55. Seitz, interviewed by James Ursini, in Robert Porfirio, Alain Silver, and James Ursini, eds., *Film Noir Reader 3: Interviews with Filmmakers of the Classic Noir Period* (New York: Limelight, 2002), 205.
56. Vieira, *George Hurrell's Hollywood*, 220–225. This passage also contains a good account of the differences between von Sternberg's lighting and Hurrell's.
57. Garmes, interviewed in Higham, *Hollywood Cameramen*, 42. My discussion of single-source lighting here draws on my remarks in Patrick Keating, "Dietrich Lighting: A Video Essay," *Movie: A Journal of Film Criticism* 8 (2019), https://warwick.ac.uk/fac/arts/film/movie/8_audio_visuals.pdf.
58. In the previously cited article, Garmes's phrasing suggests that he has the single-source idea in mind. Elsewhere, his remarks suggests that north light is a synonym for lighting from above. See Garmes, "On Cinematography," 15; and Higham, *Hollywood Cameramen*, 40–42.
59. The image can be found in Dance and Robertson, *Ruth Harriet Louise*, 118.
60. Alexander Doty, "Marlene Dietrich and Greta Garbo: The Sexy Hausfrau and the Swedish Sphinx," in *Glamour in a Golden Age: Movie Stars of the 1930s*, ed. Adrienne McLean (New Brunswick, NJ: Rutgers University Press, 2011), 111.
61. See, for instance, a 1928 portrait by Louise (broad Rembrandt lighting, minimal fill, no backlight, and a deep black background) or a 1931 portrait by Bull (key from below, two kickers, sharp focus, and another deep black background). Both can be found in Robert Dance and Scott Reisfield, *Garbo: Portraits from Her Private Collection* (New York: Rizzoli, 2005), 128, 162.
62. Kobal, *Art of the Great Hollywood Portrait Photographers*, 14.
63. Willinger, quoted in Kobal, 258. Willinger, in turn, is quoting Howard Strickling, a publicity man at MGM.
64. Yvonne Tasker, "Women in Film Noir," in *A Companion to Film Noir*, ed. Andrew Spicer and Helen Hanson (Malden, MA: Wiley-Blackwell, 2013), 360.
65. On the relationship between Hayworth's star image and her ethnicity, see Adrienne L. McLean, "'I'm a Cansino': Transformation, Ethnicity, and Authenticity in the Construction of Rita Hayworth, American Love Goddess," *Journal of Film and Video* 44, no. 3–4 (Fall–Winter 1992–1993): 8–26.
66. Lara Thompson, *Film Light: Meaning and Emotion* (Manchester: Manchester University Press, 2015). Thompson's examples here are *Blonde Venus* (1932) and *Gentlemen Prefer Blondes* (1953).
67. See James M. Cain, *The Postman Always Rings Twice* (New York: Vintage Books, 1989), 6–7.
68. I explain wide-angle lenses in Patrick Keating, "The Art of Cinematography," in *The Palgrave Handbook for the Philosophy of Film and Motion Pictures*, ed. Noël Carroll, Laura T. DiSumma-Knoop, and Shawn Loht (London: Palgrave Macmillan, 2019), 86.
69. Those who are curious about this film might also study the climax, where the white protagonists feel threatened by a group of Māori characters, who are shown to be justifiably angry. All the characters, both white and Māori, are lit from below.

70. Simon Callow, *Orson Welles*, vol. 2, *Hello Americans* (New York: Penguin, 2006), 361.
71. Andrew Britton, "Betrayed by Rita Hayworth: Misogyny in *The Lady from Shanghai*," in *The Book of Film Noir*, ed. Ian Cameron (New York: Continuum, 1993), 218.
72. See also the discussion of Elsa's construction "as both white femme fatale and treacherous Asian" in Kelly Oliver and Benigno Trigo, *Noir Anxiety* (Minneapolis: University of Minnesota Press, 2003), 52; and the analysis of Elsa in E. Ann Kaplan, "'The Dark Continent of Film Noir': Race, Displacement, and Metaphor in Tourneur's *Cat People* (1942) and Welles's *The Lady from Shanghai* (1948)," in *Women in Film Noir*, new ed., ed. E. Ann Kaplan (London: British Film Institute, 1998), 183–201.
73. For an edition that includes *The Letter*, see Alain Silver and Elizabeth Ward, eds. *Film Noir: An Encyclopedic Reference to the American Style*, revised and expanded edition, (Woodstock: Overlook Press, 1988). For an edition that excludes the film, see Alain Silver, Elizabeth Ward, James Ursini, and Robert Porfirio, eds., *Film Noir: The Encyclopedia*, 3rd ed. (New York: Overlook Duckworth, 2010).
74. Joseph Breen to Jack Warner, dated April 18, 1938, Memos and Correspondence, *The Letter*, USC Warner Bros. Archives, University of Southern California, Los Angeles.
75. Gaudio, quoted in "Lighting the New Fast Films," 70.
76. Tony Gaudio, "Precision Lighting," *American Cinematographer* 18, no. 7 (July 1937): 278, 288. For a longer version of the same article, see Tony Gaudio, "A New Viewpoint on the Lighting of Motion Pictures," *Journal of the Society of Motion Picture Engineers* 29, no. 2 (August 1937): 157–168.
77. Wong's name appears on an early list of possible casting choices, included in the Memos and Correspondence folder for the film at the USC Warner Bros. Archives.
78. W. Somerset Maugham, *The Complete Short Stories of W. Somerset Maugham*, vol. 1, *East and West* (Garden City, NY: Doubleday, 1934), 210. The theatrical adaptation is different, noting that the room should be "lit by one electric light, a globe without a shade." See W. Somerset Maugham, "The Letter," in *Great Melodramas*, ed. Robert Saffron (New York: Collier Books, 1966), 247.
79. Philippa Gates, *Criminalization/Assimilation: Chinese/Americans and Chinatowns in Classical Hollywood Film* (New Brunswick, NJ: Rutgers University Press, 2019), 53–56.
80. Research Folder, *The Letter*, USC Warner Bros. Archives.
81. Miller, quoted in Higham, *Hollywood Cameramen*, 135.
82. Howard Koch, "Final Screenplay," dated May 15, 1940, *The Letter*, USC Warner Bros. Archives.
83. See also Phebe Shih Chao's discussion of camera movement in the two scenes. In the opening, the camera cranes over the walls to enter the compound; in the ending, the camera cranes the other direction to exit it. Phebe Shih Chao, "Reading *The Letter* in a Postcolonial World," in *Visions of the East: Orientalism on Film*, ed. Matthew Bernstein and Gaylyn Studlar (New Brunswick, NJ: Rutgers University Press, 1997), 299.
84. Christina Lane, *Phantom Lady: Hollywood Producer Joan Harrison, the Forgotten Woman behind Hitchcock* (Chicago: Chicago Review Press, 2020), 144.
85. Helen Hanson, *Hollywood Heroines: Women in Film Noir and the Female Gothic Film* (London: I. B. Tauris, 2007), 18–20.
86. Alastair Phillips, "Crisscrossed? Film Noir and the Politics of Mobility and Exchange," in *Companion to Film Noir*, 105.
87. Raines, quoted in Lane, *Phantom Lady*, 151–152.
88. Janey Place, "Women in Film Noir," in *Women in Film Noir*, 60.
89. Hurrell, quoted in John Kobal, *People Will Talk* (New York: Alfred A. Knopf, 1985), 261.
90. Cornell Woolrich, *Phantom Lady* (New York: iBooks, 2001), 43. This book was originally written under the pseudonym William Irish. Woolrich also notes that her hairstyle is a bit masculine, but this hint of boyishness is undercut by the fact that she is repeatedly called *the girl*.

91. One onlooker is played by Harry Cording. I believe that the second is played by Bess Flowers, but I am not sure. Although neither character is represented as having a specific ethnicity, their relatively dark makeup contrasts notably with Raines's.
92. Raines, quoted in Lane, *Phantom Lady*, 154.
93. David Butler, "In a Lonely Tone: Music in Film Noir," in *Companion to Film Noir*, 309.
94. On the representation of Jack as an implicit fascist, see Vincent Brook, *Driven to Darkness: Jewish Émigré Directors and the Rise of Film Noir* (New Brunswick, NJ: Rutgers University Press, 2009), 119–120.

CHAPTER 4 GENRE, ADAPTATION, AND THE ART OF UNFOLDING

1. Raymond Borde and Etienne Chaumeton, "Towards a Definition of Film Noir," in *Film Noir Reader*, ed. Alain Silver and James Ursini (New York: Limelight, 1996), 17; Raymond Durgnat, "Paint It Black: The Family Tree of the Film Noir," in *Film Noir Reader*, 38; Janey Place and Lowell Peterson, "Some Visual Motifs of Film Noir," in *Film Noir Reader*, 65; James Damico, "Film Noir: A Modest Proposal," in *Film Noir Reader*, 101. The Borde and Chaumeton passage is drawn from their 1955 book, cited in the bibliography.
2. Steve Neale, *Genre and Hollywood* (New York: Routledge, 2000), 173–174.
3. Neale, 174.
4. Neale, 180.
5. See, for instance, the essays collected in Christine Gledhill, ed., *Home Is Where the Heart Is: Studies in Melodrama and the Woman's Film* (London: British Film Institute, 1987). Janet Staiger draws on the work of Gledhill and Neale to develop her argument that many noirs are melodramas about fallen men in "Film Noir as Male Melodrama: The Politics of Film Genre Labeling," in *The Shifting Definitions of Genre: Essays on Labeling Films, Television Shows, and Media*, ed. Lincoln Geraghty and Mark Jancovich (Jefferson, NC: McFarland and Company, 2008), 73.
6. *Exhibitors Herald World*, April 20, 1929, 16–17.
7. See *Movie Classic* 6, no. 5 (July 1934): 70; *Film Daily*, January 12, 1935, 3; *Film Daily*, September 3, 1936, 6; *National Box Office Digest*, March 20, 1939, 10; *The Exhibitor*, October 1, 1941, 863; *The Exhibitor*, April 26, 1944, 23; *Motion Picture Herald*, September 7, 1946, 56; *Film Bulletin*, September 29, 1947, 18; *Film Bulletin*, September 27, 1948, 10; *Photoplay* 39, no. 5 (May 1951): 27; *Film Bulletin*, May 18, 1953, 26. All sources available on Lantern.
8. *Motion Picture Herald*, October 14, 1944, 2137.
9. See, in particular, the argument that noir lighting is "anti-traditional" in Place and Peterson, "Some Visual Motifs of Film Noir," 66.
10. Andrew Spicer, *Film Noir* (Harlow, UK: Pearson Education, 2002), 45.
11. On lighting effects in the 1910s, see Barry Salt, *Film Style and Technology: History and Analysis*, 3rd ed. (London: Starword, 2009), 125–136; and David Bordwell, "Film Noir, a Hundred Years Ago," *Observations on Film Art*, April 18, 2017, http://www.davidbordwell.net/blog/2017/04/18/film-noir-a-hundred-years-ago/. For a well-illustrated argument that Hollywood cinematographers employed dark lighting for certain crime thrillers throughout the 1920s and into the 1930s, see Marc Vernet, "Film Noir on the Edge of Doom," in *Shades of Noir: A Reader*, ed. Joan Copjec (New York: Verso, 1993), 1–31.
12. Alvin Wyckoff, "Cinematography and Lighting as They Affect the Screened Story," *Moving Picture World*, August 19, 1922, 617. See also Wyckoff's comments in "'Lighting for Temperament' Is the Newest Wrinkle in Cinematography," *Moving Picture World*, February 11, 1922, 673. Wyckoff is best known for his pitch-black shadow work in *The Cheat* (1915).
13. A. Lindsley Lane, "Cinematographic Lighting: Mood Stimulus: The Philosophic Approach," *International Photographer* 2, no. 8 (September 1930): 43. This was the second of a three-part series.
14. Victor Milner, "Painting with Light," in *The Cinematographic Annual*, vol. 1, ed. Hal Hall (Los Angeles: American Society of Cinematographers, 1930), 96. Like most of the other citations in

this paragraph, I discuss this article in more detail in Patrick Keating, *Hollywood Lighting from the Silent Era to Film Noir* (New York: Columbia University Press, 2010), 140–151.

15. Charles Lang, "The Purpose and Practice of Diffusion," *American Cinematographer* 14, no. 3 (July 1933): 193. This article is primarily about lens diffusion, but it includes recommendations for lighting, as well.

16. John Arnold, "Why Is a Cameraman?," *American Cinematographer* 17, no. 11 (November 1936): 462.

17. Miller, interviewed in Robert Birchard, "Virgil Miller, ASC," *American Cinematographer* 64, no. 5 (May 1983): 51.

18. Arthur C. Miller, "Motion Picture Set Lighting," *American Cinematographer* 42, no. 4 (April 1961): 233.

19. Lane, "Cinematographic Lighting," 43.

20. Arnold, "Why Is a Cameraman?," 462.

21. All of the previously cited trade articles discuss mood. In addition, see Victor Milner, "Creating Moods with Light," *American Cinematographer* 16, no. 1 (January 1935): 7, 14–16; Walter Bluemel, "Composition in Practice—Part II," *International Photographer* 6, no. 8 (September 1934): 18–19, 28; and John F. Seitz, "Expressing Tempo in Lighting," *American Cinematographer* 16, no. 2 (February 1935): 54, 60–61.

22. Arnold, "Why Is a Cameraman?," 462.

23. Herbert Aller, "Koffman's Mystery Effect Stills," *International Photographer* 10, no. 8 (September 1938): 13–16. For further discussion of this curious article, see Steven Jacobs, *Framing Pictures: Film and the Visual Arts* (Edinburgh: Edinburgh University Press, 2011), 128.

24. Darryl F. Zanuck to Andy Lawler and Joseph L. Mankiewicz, November 7, 1945, Joseph L. Mankiewicz Papers, Academy of Motion Picture Arts and Sciences, Margaret Herrick Library, Beverly Hills, CA. See also Hal Wallis's memo to Arthur Edeson, calling for "backgrounds in shadow, and dim, sketchy lighting" in the proto-noir *Casablanca* (1942). Wallis, quoted in Sheri Chinen Biesen, *Blackout: World War II and the Origins of Film Noir* (Baltimore: Johns Hopkins University Press, 2005), 82.

25. Darryl F. Zanuck to Henry King, memo, October 12, 1950, Henry King Papers, Academy of Motion Picture Arts and Sciences, Margaret Herrick Library, Beverly Hills, CA.

26. On these terms, see Leger Grindon, "Cycles and Clusters: The Shape of Film Genre History," in *Film Genre Reader IV*, ed. Barry Keith Grant (Austin: University of Texas Press, 2012), 44.

27. John Alton, *Painting with Light* (Berkeley: University of California Press, 1995), 36.

28. A. Lindsley Lane, "Cinematographic Lighting: Mood Stimulus: The Dramatic Emphasis Approach," *International Photographer* 2, no. 9 (October 1930): 44.

29. Lane considers the other scenario (about the impoverished woman) in the final entry of his three-part series. Again, he imagines a story with a twist, as the woman finds some sort of happiness in the end. See Lane, 43–44.

30. Milner, "Painting with Light," 96–97.

31. Compare with the same author's later remark that lighting functions like a "musical undertone," in Milner, "Creating Moods with Light," 16.

32. Arnold, "Why Is a Cameraman?," 462.

33. "Photography of the Month," *American Cinematographer* 14, no. 3 (July 1933): 92. Additional articles that use the word *ominous* include "Photography of the Month," *American Cinematographer* 22, no. 8 (August 1941): 375; Herb A. Lightman, "'The Lady from Shanghai': Field Day for the Camera," *American Cinematographer* 29, no. 6 (June 1948): 200; Herb A. Lightman, "Low Key and Lively Action," *American Cinematographer* 29, no. 12 (December 1948): 411; and Frederick Foster, "'Six Bridges to Cross'—Suspense in Black-and-White," *American Cinematographer* 36, no. 2 (February 1955): 100. The films in question are *The Story of Temple Drake* (1933),

a lurid drama with scenes of sexual violence; *Underground* (1941), an anti-Nazi action film; *The Lady from Shanghai* (1947), a noir classic; *Blood on the Moon* (1948), a noir-tinged Western; and *Six Bridges to Cross* (1955), an action melodrama in the semidocumentary style.

34. Peter J. Rabinowitz, *Before Reading: Narrative Conventions and the Politics of Interpretation* (Columbus: Ohio State University Press, 1987), 111.
35. Rabinowitz, 117.
36. Rabinowitz, 200.
37. Rabinowitz, 112.
38. *Mildred Pierce* famously combines brightly lit domestic scenes with dimly lit crime scenes. See the classic analysis in Pam Cook, "Duplicity in *Mildred Pierce*," in *Women in Film Noir*, new ed., ed. E. Ann Kaplan (London: British Film Institute, 1998), 71–73.
39. Paul Kerr, "Out of What Past? Notes on the B Film Noir," in *Film Noir Reader*, 116.
40. James Naremore, *More Than Night: Film Noir in Its Contexts*, 2nd ed. (Berkeley: University of California Press, 2008), 142–155.
41. Biesen, *Blackout*, 109.
42. The industry's profits reached a record high in 1946 and started to decline in 1947. See Thomas Schatz, *Boom and Bust: American Cinema in the 1940s* (Berkeley: University of California Press, 1999), 172–173.
43. I discuss the expansion of the electricity industry in chapter 5.
44. Budget, *Stranger on the Third Floor*, undated, Production Files, RKO Collection, Special Collections, University of California, Los Angeles.
45. Budget, *The Unsuspected*, December 27, 1946, Picture File, Warner Bros. Archives, University of Southern California, Los Angeles.
46. Budget, *The Window*, undated, Production Files, RKO Collection, Special Collections, University of California, Los Angeles.
47. Budget, *Sorry, Wrong Number*, undated, Paramount Production Records, Margaret Herrick Library, Beverly Hills, CA. Of course, these four brief examples prove nothing by themselves. I offer more remarks about electricity and electricians, along with a couple more examples, in Patrick Keating, "Film Noir and the Culture of Electric Light," *Film History* 27, no. 1 (2015): 84n45.
48. Alain Silver, Elizabeth Ward, James Ursini, and Robert Porfirio, eds., *Film Noir: The Encyclopedia* (New York: Overlook Duckworth, 2010). This edition is a significantly revised version of the book formerly titled *Film Noir: An Encyclopedic Reference to the American Style*, which first appeared in 1979.
49. David Bordwell, *Perplexing Plots: Popular Storytelling and the Poetics of Murder* (New York: Columbia University Press, 2023), 22.
50. Arthur Conan Doyle, *A Study in Scarlet & The Sign of Four* (London: Arcturus, 2018), 157.
51. Mary Roberts Rinehart, *Miss Pinkerton* (New York: Penzler, 2019), 48.
52. Robert Spadoni, "Horror Film Atmosphere as Anti-narrative (and Vice Versa)," in *Merchants of Menace: The Business of Horror Cinema*, ed. Richard Nowell (New York: Bloomsbury, 2014), 112–116; a complementary piece is Robert Spadoni, "Carl Dreyer's Corpse: Horror Film Atmosphere and Narrative," in *A Companion to the Horror Film*, ed. Harry Benshoff (Medford, MA: Wiley, 2014), 151–167. As the titles of these two chapters might suggest, atmosphere can usefully be thought of as both narrative and antinarrative.
53. Other Woolrich-inspired movies from the noir period include *Street of Chance* (1942), *The Leopard Man* (1943), *Black Angel* (1946), *Fear in the Night* (1947), *Night Has a Thousand Eyes* (1948), *I Wouldn't Be in Your Shoes* (1948), *No Man of Her Own* (1950), and *Rear Window* (1954). For an overview, see Francis M. Nevins, "Translate and Transform: From Cornell Woolrich to Film Noir," in *Film Noir Reader 2*, ed. Alain Silver and James Ursini (New York: Limelight, 1999), 137–157.

54. Cornell Woolrich, *Deadline at Dawn* (Lakewood, CO: Centipede Press, 2012), 81. Woolrich originally published this novel under the pen name William Irish.
55. Woolrich, 84.
56. See, for instance, Seymour Chatman, "What Novels Can Do That Films Can't (And Vice Versa)," *Critical Inquiry* 7, no. 1 (Autumn 1980): 128. Chatman did not invent the term, but he suggests that it had already become commonplace among Hemingway's critics.
57. Ernest Hemingway, "The Killers," in *The Complete Short Stories of Ernest Hemingway* (New York: Scribner, 2003), 215.
58. Seymour Chatman, *Story and Discourse: Narrative Structure in Fiction and Film* (Ithaca, NY: Cornell University Press, 1978), 168.
59. Dashiell Hammett, *Red Harvest* (New York: Vintage Books, 1989), 66. I quote and discuss this passage in Patrick Keating, "Out of the Shadows: Noir Lighting and Hollywood Cinematography," in *A Companion to Film Noir*, ed. Andrew Spicer and Helen Hanson (Malden, MA: Wiley-Blackwell, 2013), 273.
60. On Hammett's style, see William Marling, *Dashiell Hammett* (Boston: Twayne, 1983), 43–46.
61. For more on the contrast between Hammett and Woolrich, see Frank Krutnik, *In a Lonely Street: Film Noir, Genre, Masculinity* (New York: Routledge, 1991), 39–44.
62. Hammett, *Red Harvest*, 62.
63. Dashiell Hammett, *The Maltese Falcon* (San Francisco: Arion Press, 1983), 31, 70, 135, 198. See also the discussion of eyes in Bordwell, *Perplexing Plots*, 215–216.
64. Hammett, *Maltese Falcon*, 219.
65. Naremore, *More Than Night*, 51. See also Erin A. Smith, *Hard-Boiled: Working-Class Readers and Pulp Magazines* (Philadelphia: Temple University Press, 2000), 138–139.
66. James M. Cain, *Double Indemnity* (New York: Vintage Books, 1989), 4.
67. Cain, 103.
68. Elisabeth Sanxay Holding, *The Innocent Mr. Duff and The Blank Wall: Two Novels of Suspense* (New York: Quality Paperback Book Club, 2002), 201.
69. Dorothy B. Hughes, *Ride the Pink Horse* (New York: Penzler, 2021), 56.
70. To be fair, Bredell argued that he had been true to the source. His use of top lighting suited the story perfectly because "nothing had to be beautiful." Bredell, quoted in Fred Banker, "Speed Cameraman," *American Cinematographer* 29, no. 10 (October 1948): 341.
71. John Huston, Final Screenplay, *The Maltese Falcon*, Warner Bros. Archives, University of Southern California, Los Angeles.
72. Steve Fisher, *I Wake Up Screaming* (New York: Dodd, Mead, 1941), 113.
73. Fisher, 178.
74. Fisher, 225.
75. *I Wake Up Screaming* is another member of the working-girl investigator subcycle that I analyzed in the previous section on *Phantom Lady*. See Helen Hanson, *Hollywood Heroines: Women in Film Noir and the Female Gothic Film* (London: I. B. Tauris, 2007), 18–19.
76. David Bordwell, *Reinventing Hollywood: How 1940s Filmmakers Changed Movie Storytelling* (Chicago: University of Chicago Press, 2017), 68.
77. A brief but interesting exception appears in the scene in which Jill finds Frankie standing over Vicky's body. Jill walks through a shadow, which overtly symbolizes her moment of doubt.
78. Ormonde wrote the final screenplay after Hitchcock rejected Chandler's draft. Previously, Hitchcock had worked with Whitfield Book on a treatment and with Barbara Keon on a temporary script. See Bill Krohn, *Hitchcock at Work* (London: Phaidon Press, 2000), 114–116.
79. Patricia Highsmith, *Strangers on a Train* (New York: W. W. Norton, 1993), 152.
80. Highsmith, 153.
81. Highsmith, 157.

82. Robin Wood, *Hitchcock's Films Revisited* (New York: Columbia University Press, 1989), 90.
83. Patricia Highsmith, *Plotting and Writing Suspense Fiction* (New York: St. Martin's Griffin, 1983), 38. On Hitchcock's persistent use of surprise, see Maria Belodubrovskaya, "The Master of Surprise: Alfred Hitchcock and Premise Uncertainty," *Projections: The Journal for Movies and Mind* 17, no. 1 (2023): 1–19.
84. On the temporal dynamics of surprise and suspense, see Meir Sternberg, "Narrativity: From Objectivist to Functional Paradigm," *Poetics Today* 31, no. 3 (Fall 2010): 640–641.
85. Richard Allen, *Hitchcock's Romantic Irony* (New York: Columbia University Press, 2007), 193.
86. Highsmith, *Strangers on a Train*, 281.

CHAPTER 5 LIGHTING MILIEU

1. This paragraph draws on my argument in Patrick Keating, "Film Noir and the Culture of Electric Light," *Film History* 27, no. 1 (2015): 59, 61, 70.
2. Frances Guerin, *A Culture of Light: Cinema and Technology in 1920s Germany* (Minneapolis: University of Minnesota Press, 2005), xv.
3. Guerin, 79.
4. For other important works on the visual culture of electricity, see Daisuke Miyao, "Bright Lights, Big City: Lighting, Technological Modernity, and Ozu Yasujiro's *Sono yo no tsuma* (*That Night's Wife*, 1930)," *Positions: East Asian Culture Critique* 22, no. 1 (Winter 2014): 161–201; Murray Pomerance, "Lights, Looks, and *The Lodger*," *Quarterly Review of Film and Video* 26, no. 5 (2009): 425–433; and Lucy Fischer, "The Shock of the New: Electrification, Illumination, Urbanization, and the Cinema," in *Cinema and Modernity*, ed. Murray Pomerance (New Brunswick, NJ: Rutgers University Press, 2006), 19–37.
5. Phil Tannura, "What Do We Mean When We Talk about 'Effect-Lightings'?," *American Cinematographer* 23, no. 1 (January 1942): 25. I quote and discuss this passage in Patrick Keating, *Hollywood Lighting from the Silent Era to Film Noir* (New York: Columbia University Press, 2010), 134.
6. Tannura, "What Do We Mean," 34.
7. Miller, quoted in "Motion Picture Set Lighting," *American Cinematographer* 42, no. 5 (May 1961): 300. This article was the second of a two-part series.
8. Charles Loring, "Source Lighting," *American Cinematographer* 30, no. 9 (September 1949): 324, 336–338.
9. Charles Loring, "Natural Source Set Lighting," *American Cinematographer* 38, no. 2 (February 1957): 86, 109–112. See also the same author's articles for the makers of industrial films.
10. Garmes, interviewed in Charles Higham, *Hollywood Cameramen: Sources of Light* (Bloomington: Indiana University Press, 1970), 47.
11. See, for instance, the comments of Charles Lang, quoted in Walter Blanchard, "Aces of the Camera, XXIII: Charles Lang," *American Cinematographer* 23, no. 12 (December 1942): 532; and the entire chapter on "mystery lighting" in John Alton, *Painting with Light* (Berkeley: University of California Press, 1995), 44–56.
12. Robert Surtees, "The Story of Filming 'Act of Violence,'" *American Cinematographer* 29, no. 8 (August 1948): 268, 282–284.
13. Robert L. Richards, Screenplay, *Act of Violence*, April 13, 1948, Academy of Motion Picture Arts and Sciences, Margaret Herrick Library, Beverly Hills, CA.
14. On worldhood, see V. F. Perkins, "Where Is the World? The Horizon of Events in Movie Fiction," in *Style and Meaning: Studies in the Detailed Analysis of Film*, ed. John Gibbs and Douglas Pye (Manchester: Manchester University Press, 2005), 20.
15. I discuss this art of compromise in Keating, *Hollywood Lighting*, 160–197.

16. Foster Hirsch, *The Dark Side of the Screen: Film Noir* (Cambridge, MA: Da Capo Press, 1981), 86.
17. See the discussion of milieu in Alastair Phillips, *City of Darkness, City of Light: Émigré Filmmakers in Paris, 1929–1939* (Amsterdam: Amsterdam University Press, 2004), 120.
18. Thom Anderson, "Red Hollywood," in *"Un-American" Hollywood: Politics and Film in the Blacklist Era*, ed. Frank Krutnik, Steve Neale, Brian Neve, and Peter Stanfield (New Brunswick, NJ: Rutgers University Press, 2007), 257. Anderson's original list included thirteen titles; subsequent critics have proposed additions to the list, and Anderson welcomes many of the additions in the Afterword to this essay.
19. Abraham Polonsky and Ira Wolfert, Screenplay, *Force of Evil*, May 25, 1948, Study Collection, Cinematic Arts Library, University of Southern California, Los Angeles.
20. Polonsky and Wolfert, Screenplay, *Force of Evil*.
21. Brian Neve, "The Politics of Film Noir," in *A Companion to Film Noir*, ed. Andrew Spicer and Helen Hanson (Malden, MA: Wiley-Blackwell, 2013), 183.
22. For a practitioner's endorsement of the invisible style, see Arthur C. Miller's remarks in Leonard Maltin, *The Art of the Cinematographer: A Survey and Interviews with Five Masters*, enl. ed. (New York: Dover, 1978), 64. For an overview of scholarly approaches to classical Hollywood cinema, including a discussion of invisibility and realism as guiding ideals, see Jane Gaines, "Introduction: The Family Melodrama of Classical Narrative Cinema," in *Classical Narrative Cinema: The Paradigm Wars*, ed. Jane Gaines (Durham: Duke University Press, 1992), 1–8.
23. Charles Loring, "Special Effects Lighting for Commercial Films," *American Cinematographer* 29, no. 12 (December 1948): 418.
24. Not for the first time, my thinking draws inspiration from the rhetorical-functionalist approach of Meir Sternberg. See, for instance, Meir Sternberg, "Telling in Time (II): Chronology, Teleology, Narrativity," *Poetics Today* 13, no. 3 (Autumn 1992): 482. The next chapter includes further discussion, along with additional citations.
25. Loring, "Source Lighting," 337.
26. Lisa Dombrowski, "Postwar Hollywood, 1947–1967," in *Cinematography*, ed. Patrick Keating (New Brunswick, NJ: Rutgers University Press, 2014), 63. R. Barton Palmer explains how the trend differed from Italian Neorealism in *Shot on Location: Postwar American Cinema and the Exploration of Real Place* (New Brunswick, NJ: Rutgers University Press, 2016), 114.
27. Herb A. Lightman, "'13 Rue Madeleine': Documentary Style in the Photoplay," *American Cinematographer* 28, no. 3 (March 1947): 89.
28. The words come from MGM staffer Philippe de Lacey, quoted in Palmer, *Shot on Location*, 157.
29. Herb A. Lightman, "Documentary Style," *American Cinematographer* 30, no. 5 (May 1949): 174.
30. Herb A. Lightman, "'The Naked City': Tribute in Celluloid," *American Cinematographer* 29, no. 5 (May 1948): 179.
31. Lightman, "'13 Rue Madeleine,'" 89.
32. For Brodine at his best, see the climax in *The House on 92nd Street*.
33. Elia Kazan, telegram to Darryl F. Zanuck, October 28, 1949, *Panic in the Streets*, Elia Kazan Collection, Wesleyan Cinema Archives, Middletown, CT. I discuss this movie in further detail in Patrick Keating, "Elia Kazan and the Semidocumentary: Composing Urban Space," in *Kazan Revisited*, ed. Lisa Dombrowski (Middletown, CT: Wesleyan University Press, 2011), 148–162.
34. Edward Dimendberg, *Film Noir and the Spaces of Modernity* (Cambridge, MA: Harvard University Press, 2004), 25.
35. David Nye, "Energy Narratives," in *Narratives and Spaces: Technology and the Construction of American Culture* (New York: Columbia University Press, 1997), 77–78. See also the chapter titled "Technology and the Construction of American Space" in the same volume. In the former chapter, Nye proposes five "energy narratives." In the latter chapter, Nye lists six characteristic narratives about technology (179). I discuss Nye in Keating, "Film Noir and the Culture of Electric Light," 65–66. This section of the chapter draws extensively on that article.

36. See the chart in H. H. Magdsick, "Impact of the Fluorescent Lamp on the Lighting Art," *Magazine of Light* 17, no. 1 (April 1948): 5.
37. L. V. James, "Office Lighting Trends," *Transactions of the Illuminating Engineering Society* 31, no. 6 (June 1936): 604.
38. For sales and use of electrical energy, see Gavin Wright, "Table Db228-233: Electrical Energy—Sales and Use: 1902–2000." For power, see Gavin Wright, "Table Db218-227: Electrical Utilities—Power Generation and Fossil Fuel Consumption, by Energy Source: 1920–2000." For outputs, see Susan B. Carter, "Table Dh219-223: Indexes of Output and Productivity in Electric and Gas Utilities: 1899–1942." For household consumption of electricity, see Lee A. Craig, "Table Cd78-152: Consumption Expenditures, by Type: 1900–1929," and Lee A. Craig, "Table Cd153-263: Consumption Expenditures by Type: 1929–1999." Each chart indicates an increase in electricity for the decades leading up to 1929 or 1930, followed by a decline lasting until 1932 or 1933, and then a rising trend through the 1930s and 1940s. All these statistics can be found in the *Historical Statistics of the United States*, Millennial Edition Online, ed. Susan B. Carter, Scott Sigmund Gartner, Michael R. Haines, Alan L. Olmstead, Richard Sutch, and Gavin Wright (New York: Cambridge University Press, 2006). http://hsus.cambridge.org/HSUSWeb/index.do.
39. George H. Miehls, "The Industrial Plant of the Future—1," *Journal of the American Institute of Architects*, 5, no. 6 (June 1946): 282.
40. For a history of these programs, see David Nye, "Rural Lines," in *Electrifying America: Social Meanings of a New Technology* (Cambridge, MA: MIT Press, 1992), 287–338.
41. Stuart R. Williams, "Effective Street Lighting Must Be Planned," *Illuminating Engineering* 31, no. 1 (January 1940): 83–85.
42. Mary Dodds, Mary E. Webber, and Myrtle Fassbender, "Recommended Practices of Home Lighting," *Illuminating Engineering* 40, no. 6 (June 1945): 342–343. For an earlier example of room-specific lighting recommendations, see Inez Caroline Wood, "Custom-Built Lighting Enters the Home," *Transactions of the Illuminating Engineering Society* 27, no. 7 (September 1932): 611–622.
43. Roger L. Nowland, "Lighting Horizons," *Illuminating Engineering* 40, no. 2 (February 1945): 117.
44. J. M. Gensberger, "Lighting for the U.S. Engineers," *Magazine of Light* 8, no. 4 (November 1949): 12–13.
45. See Magdsick, "Impact of the Fluorescent Lamp," 4–8, which summarizes GE's innovations in fluorescent technology.
46. Jennifer Fay and Justus Nieland, *Film Noir: Hard-Boiled Modernity and the Cultures of Globalization* (New York: Routledge, 2010), 69. I quote and discuss this passage in Patrick Keating, "Out of the Shadows: Noir Lighting and Hollywood Cinematography," in *Companion to Film Noir*, 274–275. This chapter also contains some of the examples I discuss in the remainder of this section.
47. For a discussion of obsolescence, see Joel Burges, "Obsolescence/Innovation," in *Time: A Vocabulary of the Present*, ed. Joel Burges and Amy J. Elias (New York: New York University Press, 2016), 83.
48. For an early example of the industry marketing its products toward the suburbs, see the advertisement for Mazda lamps in *Magazine of Light* 1, no. 9 (Summer 1931): 3.
49. Herb A. Lightman, "'A Double Life': The Camera Goes Backstage," *American Cinematographer* 29, no. 4 (April 1948): 132.
50. Dan Flory, "Ethnicity and Race in American Film Noir," in *Companion to Film Noir*, 391.
51. Jay Dratler, Screenplay, *Call Northside 777*, September 13, 1947, Study Collection, Cinematic Arts Library, University of Southern California, Los Angeles.
52. For an extended discussion of these associations, see Eric Lott, "The Whiteness of Film Noir," *American Literary History* 9, no. 3 (Autumn 1997): 542–566.

53. Raymond Chandler, *Farewell, My Lovely* (New York: Vintage Books, 1988), 4, 12.
54. Julian Murphet, "Film Noir and the Racial Unconscious," *Screen* 39, no. 1 (Spring 1998): 30. See also the discussion in Fay and Nieland, *Film Noir*, 161–169.
55. See also the discussion of *Murder, My Sweet* in James Naremore, *More Than Night: Film Noir in Its Contexts*, 2nd ed. (Berkeley: University of California Press, 2008), 234–235.
56. Art Cohn, Shooting Script, *The Set-Up*, n.d., Special Collections, University of California—Los Angeles.
57. For an analysis of the film in comparison to the poem, see Charles Scruggs, "The Subversive Shade of Black in Film Noir," in *Film Noir*, ed. Homer B. Pettey and R. Barton Palmer (Edinburgh: Edinburgh University Press, 2014), 175–179.
58. Notes of parody had begun to appear in the Chinatown crime film in the 1920s. See Philippa Gates, *Criminalization/Assimilation: Chinese/Americans and Chinatowns in Classical Hollywood Film* (New Brunswick, NJ: Rutgers University Press, 2019), 66.
59. See the discussion of "uniform and homogeneous" police lighting, in contrast to heterogeneous commercial lighting in Wolfgang Schivelbusch, *Disenchanted Night: The Industrialization of Light in the Nineteenth Century*, trans. Angela Davies (Berkeley: University of California Press, 1995), 143. For a discussion of this passage in relation to noir, see Murray Pomerance, "The Climb and the Chase: Film Noir and the Urban Scene—Representations of the City in Three Classic Noirs," in *Companion to Film Noir*, 407.
60. Frank Van Gilluwe, "Passengers' Pleasure Attests Fine Appointments in Los Angeles Terminal," *Magazine of Light* 8, no. 6 (September 20, 1939): 10–12.
61. Seitz, interviewed in Robert Porfirio, Alain Silver, and James Ursini, eds., *Film Noir Reader 3: Interviews with Filmmakers of the Classic Period* (New York: Limelight, 2002), 210. Seitz may have been inspired by George Folsey's recent experiments with reflected light, as in *Green Dolphin Street* (1947).
62. James Naremore cites *The Big Clock* to develop his larger argument about the stylistic heterogeneity of noir. See Naremore, *More Than Night*, 167–168.
63. The preceding paragraph is based closely on Keating, "Film Noir and the Culture of Electric Light," 58–59.
64. Paul Schrader, "Notes on Film Noir," in *Film Noir Reader*, ed. Alain Silver and James Ursini (New York: Limelight, 1996), 54.
65. "Office . . . A-C-E Lighting for Appearance, Comfort, and Efficiency," *Magazine of Light* 16, no. 1 (June 1947), 42.
66. See Doug Dibbern, "The Violent Poetry of the Times: The Politics of History in Daniel Mainwaring and Joseph Losey's *The Lawless*," in *"Un-American" Hollywood*, 97–112. Dibbern also discusses the movie's relationship to the Sleepy Lagoon murder trial of 1942–1944, as well as the movie's analogy between the lynch mob and the House Un-American Activities Committee.
67. See the photograph in Thomas F. Coghlan, "Relighted Armory Provided Offices for Wartime F.B.I.," *Magazine of Light* 12, no. 6 (October 1943): 10.
68. James Wong Howe, "The Documentary Technique in Hollywood," *American Cinematographer* 25, no. 1 (January 1944): 10, 32.
69. James Wong Howe, "Lighting," in *The Cinematographic Annual*, vol. 2, ed. Hal Hall (Los Angeles: American Society of Cinematographers, 1931), 57.
70. Howe, interviewed in Scott Eyman, *Five American Cinematographers* (Metuchen, NJ: Scarecrow Press, 1987), 78. See also Higham, *Hollywood Cameramen*, 75.
71. For a book-length overview of Howe's career, see Todd Rainsberger, *James Wong Howe, Cinematographer* (San Diego: A. S. Barnes, 1981).
72. Dombrowski, "Postwar Hollywood," 65.
73. James Naremore, *Sweet Smell of Success* (London: British Film Institute, 2010).
74. Jonathan Rosenbaum, "*Touch of Evil* Retouched," in *Discovering Orson Welles* (Berkeley: University of California Press, 2007), 250.

75. On Welles's collaborations with Metty, see Richard Deming, *Touch of Evil* (London: British Film Institute, 2020), 66–71.
76. Deming, 6.
77. Frank Krutnik, "Something More Than Night: Tales of the Noir City," in *The Cinematic City*, ed. David B. Clarke (New York: Routledge, 1997), 96.
78. On the film's mixture of "parody and tragedy," see Fay and Nieland, *Film Noir*, 173.
79. James Naremore, *The Magic World of Orson Welles*, new and rev. ed. (Dallas: Southern Methodist University Press, 1989), 159.
80. Welles specifically stated that he added the signs to each location throughout the film. Welles, interviewed in Orson Welles and Peter Bogdanovich, *This Is Orson Welles*, ed. Jonathan Rosenbaum (New York: Da Capo Press, 1998), 312–313.
81. Naremore, *Magic World of Orson Welles*, 149–150.
82. Matthew Luckiesh, "We Have Needed Efficient Artificial Daylight—Now We Have It," *Magazine of Light* 7, no. 7 (Fall 1938): 6–8.
83. Robin Wood, "Welles, Shakespeare, and Webster," in *Personal Views: Explorations in Film*, rev. ed. (Detroit: Wayne State University Press, 2006), 169. *Chimes at Midnight* (1966) offers the clearest demonstration of the pattern. Wood notes that *Touch of Evil* fits the model closely, with the exception that Mike and Hank are not close friends.
84. Perkins, "Where Is the World?," 25.

CHAPTER 6 SUBJECTIVITY, SYMBOLISM, AND DEPICTION

1. Vera Caspary, *Laura* (New York: Feminist Press, 2005), 143.
2. Caspary, 143. See also the discussion of this passage in David Bordwell, *Perplexing Plots: Popular Storytelling and the Poetics of Murder* (New York: Columbia University Press, 2023), 254–257.
3. David Bordwell, *Reinventing Hollywood: How 1940s Filmmakers Changed Movie Storytelling* (Chicago: University of Chicago Press, 2017). See, in particular, chapter 7, 273–296.
4. For more on these three examples, see the discussion of narrative strategies in Andrew Spicer, *Film Noir* (Harlow, UK: Pearson Education, 2002), 74–83. See also Christophe Gelly, "Film Noir and Subjectivity," in *A Companion to Film Noir*, ed. Andrew Spicer and Helen Hanson (Malden, MA: Wiley-Blackwell, 2013), 341–348.
5. Janey Place and Lowell Peterson, "Some Visual Motifs of Film Noir," in *Film Noir Reader*, ed. Alain Silver and James Ursini (New York: Limelight, 1996), 71.
6. George M. Wilson, *Narration in Light: Studies in Cinematic Point of View* (Baltimore: Johns Hopkins University Press, 1986), 87 (italics in the original).
7. The cinematographer of *In a Lonely Place* was Burnett Guffey. A few years earlier, he had photographed *So Dark the Night* (1946), which also features a memorable moment of inflected lighting. The protagonist is a detective with a split personality: one personality is calm and thoughtful; the other is a murderer. When the latter personality reasserts itself, the lighting completely changes, illuminating the detective from below.
8. Dana Polan, *In a Lonely Place* (London: British Film Institute, 1993), 15.
9. Woody Bredell was the film's cinematographer, but production documents indicate that this sequence was photographed by Robert Burks, the special effects cinematographer. Burks later enjoyed a long collaboration with Alfred Hitchcock. See Daily Production Reports, *The Unsuspected*, Picture File, Warner Bros. Archives, University of Southern California, Los Angeles.
10. In their analysis of this shot, Therese Grisham and Julie Grossman argue that the movie uses the imagery of pathos to express sympathy for Millie, even in her downfall. See Therese Grisham and Julie Grossman, *Ida Lupino, Director: Her Art and Resilience in Times of Transition* (New Brunswick, NJ: Rutgers University Press, 2017), 79–80.
11. Here I am presenting a radically condensed version of the rhetorical-functional model of narrative analysis that has influenced me for years. For a more sustained discussion of this

model, see Patrick Keating, "Narrative and the Moving Image," in *The Palgrave Handbook for the Philosophy of Film and Motion Pictures*, ed. Noël Carroll, Laura T. DiSumma-Knoop, and Shawn Loht (London: Palgrave Macmillan, 2019), 119–141. For the definitive accounts, see Meir Sternberg, "Narrativity: From Objectivist to Functional Paradigm," *Poetics Today* 31, no. 3 (Fall 2010): 507–659; and Meir Sternberg, "Mimesis and Motivation: The Two Faces of Fictional Coherence," *Poetics Today* 33, no. 3–4 (Fall–Winter 2012): 329–483.

12. I discuss camera movement in relation to Sternberg's theory in Patrick Keating, *The Dynamic Frame: Camera Movement in Classical Hollywood* (New York: Columbia University Press, 2019), 208–214.

13. For a discussion of the shadow's many meanings across the history of Western art, see Victor I. Stoichita, *A Short History of the Shadow* (London: Reaktion, 1997). On the theme of incarnation, see page 69.

14. Lotte Eisner, *The Haunted Screen* (Berkeley: University of California Press, 1973), 24.

15. Eisner, 179.

16. Many books and articles on noir begin with a quick list of the cycle's key traits, and the word *expressionistic* is a regular member of these lists. See, for instance, Paul Schrader, "Notes on Film Noir," in *Film Noir Reader*, 55; Sheri Chinen Biesen, *Blackout: World War II and the Origins of Film Noir* (Baltimore: Johns Hopkins University Press, 2005), 2; and Christopher Beach, *A Hidden History of Film Style: Cinematographers, Directors, and the Collaborative Process* (Berkeley: University of California Press, 2015), 95. Of course, all three of these authors go on to contextualize the term in various ways.

17. See the celebration of "jagged trapezoids" and "obtuse triangles" in Schrader, "Notes on Film Noir," 57.

18. As the set designer and director Paul Leni once said, "It is not extreme reality that the camera perceives, but the reality of the inner event, which is more profound, effective, and moving than what we see through everyday eyes." Leni, quoted in Eisner, *Haunted Screen*, 127.

19. Michael Walker, "Film Noir: Introduction," in *The Book of Film Noir*, ed. Ian Cameron (New York: Continuum, 1993), 26. In this passage, Walker explicitly extends expressionism beyond *Caligari*.

20. Preminger, interviewed in Robert Porfirio, Alain Silver, and James Ursini, eds., *Film Noir Reader 3: Interviews with Filmmakers of the Classic Noir Period* (New York: Limelight, 2002), 93.

21. Anthony Veiller, Screenplay, *The Killers*, April 3, 1946, Study Collection, Cinematic Arts Library, University of Southern California, Los Angeles.

22. Raymond Borde and Etienne Chaumeton, *A Panorama of American Film Noir, 1941–1953*, trans. Paul Hammond (San Francisco: City Lights Books, 2002), 24.

23. Foster Hirsch, *The Dark Side of the Screen: Film Noir* (Cambridge, MA: Da Capo Press, 1981), 53–58.

24. Ginette Vincendeau, "Noir Is Also a French Word: The French Antecedents of Film Noir," in *Book of Film Noir*, 50–52.

25. Robert Porfirio, "The Strange Case of Film Noir," in *Companion to Film Noir*, 23.

26. Marc Vernet, "Film Noir on the Edge of Doom," in *Shades of Noir: A Reader*, ed. Joan Copjec (New York: Verso, 1993), 8.

27. Thomas Elsaesser, *Weimar Cinema and After: Germany's Historical Imaginary* (New York: Routledge, 2000), 431.

28. See also the careers of Anatole Litvak and Robert Siodmak, discussed in Alastair Phillips, *City of Darkness, City of Light: Émigré Filmmakers in Paris, 1929–1939* (Amsterdam: University of Amsterdam Press, 2004), 43–46, 65–72; and the career of Edgar Ulmer, discussed in Noah Isenberg, *Detour* (London: British Film Institute, 2008), 84–85.

29. See Elsaesser's brilliant discussion of Siodmak's *Phantom Lady* in light of Woolrich's source novel and Siodmak's previous film *Pièges*, a serial killer story with touches of musical comedy, in Elsaesser, *Weimar Cinema and After*, 432–435.

30. Simon Callow, *Orson Welles*, vol. 2, *Hello Americans* (New York: Penguin, 2006), 356.
31. On this ambiguity, see Janet Bergstrom, "Warning Shadows: German Expressionism and American Film Noir," in *Film Noir*, ed. Homer B. Pettey and R. Barton Palmer (Edinburgh: Edinburgh University Press, 2014), 54.
32. Phillips, *City of Darkness*, 66.
33. Wilder, interviewed in Cameron Crowe, *Conversations with Wilder* (New York: Alfred A. Knopf, 1999), 53. See also the discussion of this passage in Beach, *Hidden History of Film Style*, 100–101.
34. Frances Guerin, *A Culture of Light: Cinema and Technology in 1920s Germany* (Minneapolis: University of Minnesota Press, 2005), 13.
35. Piotr Sadowski, *The Semiotics of Light and Shadows: Modern Visual Arts and Weimar Cinema* (London: Bloomsbury, 2018), 158, 170.
36. Tom Gunning, *The Films of Fritz Lang: Allegories of Vision and Modernity* (London: British Film Institute, 2000), 435.
37. R. Barton Palmer, "Borderings," in *Companion to Film Noir*, 126.
38. Biesen, *Blackout*, 30.
39. Robert Porfirio discusses the dream sequence's debt to German Expressionism in Alain Silver and James Ursini, *The Noir Style* (New York: Overlook Press, 1999), 164–165.
40. Herb A. Lightman, "Low Key and Lively Action," *American Cinematographer* 29, no. 12 (December 1948): 411.
41. Rudolf Arnheim, *Film as Art* (Berkeley: University of California Press, 1957), 12.
42. Richard Wollheim, "Seeing-as, Seeing-in, and Pictorial Representation," in *Art and Its Objects*, 2nd ed. (New York: Cambridge University Press, 1980), 212.
43. Richard Wollheim, *Painting as an Art* (Princeton, NJ: Princeton University Press, 1987), 73.
44. For a sympathetic discussion, see Robert Stecker, "Film Narration, Imaginative Seeing, and Seeing-In," *Projections* 7, no. 1 (Summer 2013): 147–154.
45. Again, I refer to the authority of Sternberg, previously cited—but I hasten to add that Sternberg might reject the affinity with the seeing-in theory that I am proposing here.
46. To be clear, Wollheim's usage of the term *configuration* differs from the usage discussed in chapter 4, where *configuration* referred to our awareness that a narrative is organized to unfold in time. For this reason, I sometimes substitute the word *composition* or *construction* when it seems suitable.
47. This brief biography draws on Todd McCarthy's excellent introduction to John Alton, *Painting with Light* (Berkeley: University of California Press, 1995), ix–xxxiv.
48. Alton, 30–34.
49. Elizabeth Cowie, "Women in Film Noir," in *Shades of Noir*, 139. Cowie goes on to show that there is no simple hierarchy in the film; at different times, Pat, Joe, and Ann are all essential to the narrative.
50. Here I am condensing some other important distinctions that I owe to Sternberg, such as the difference between perspectival and existential motivation, and the relationship between fictional and functional motivation. See Sternberg, "Mimeses and Motivation," 364, 453.
51. Sternberg, "Narrativity," 644.
52. Thomas Schatz, *Boom and Bust: American Cinema in the 1940s* (Berkeley: University of California Press, 1999), 236.
53. Helen Hanson, *Hollywood Heroines: Women in Film Noir and the Female Gothic Film* (London: I. B. Tauris, 2007), 43.
54. See the charts listing box-office leaders and Academy Award winners in Schatz, *Boom and Bust*, 467, 474–475. As far as I can tell, the most canonical noir to appear on both lists (that is, the box-office lists and the Oscars lists) is *Mildred Pierce* (1945)—perhaps not coincidentally, a noir with a female protagonist. Other noir-adjacent movies appearing on both lists include *Rebecca* (1940), *The Picture of Dorian Gray* (1945), *Leave Her to Heaven* (1945), *Spellbound* (1945), and *The Snake Pit* (1948).

55. As early as 1955, *Gaslight* was considered a significant noir. See Borde and Chaumeton, *Panorama of American Film Noir*, 48.
56. Ruttenberg, interviewed in Scott Eyman, *Five American Cinematographers* (Metuchen, NJ: Scarecrow Press, 1987), 44. See also Ruttenberg's remarks in Richard Koszarski and Diane Koszarski, "'No Problems. They Liked What They Saw on the Screen': An Interview with Joseph Ruttenberg," *Film History* 1, no. 1 (1987): 79, 82.
57. Kate Abramson, "Turning Up the Lights on Gaslighting," *Philosophical Perspectives* 28 (2014): 2. Thanks to Sarah Erickson for suggesting this source.
58. Diane Waldman, "'At Last I Can Tell It to Someone!': Feminine Point of View and Subjectivity in the Gothic Romance Film of the 1940s," *Cinema Journal* 23, no. 2 (Winter 1983): 31.
59. Waldman, 29.
60. The play that served as the movie's source material is structured rather differently, allowing the female protagonist and the detective figure to solve much of the mystery before the end of the first act. Patrick Hamilton, "Angel Street," in *Great Melodramas*, ed. Robert Saffron (New York: Collier Books, 1966), 295.
61. John van Druten and Walter Reisch, Screenplay, *Gaslight*, August 25, 1943, George Cukor Collection, Academy of Motion Picture Arts and Sciences, Margaret Herrick Library, Beverly Hills, CA.
62. Hanson, *Hollywood Heroines*, 42–43.
63. Schatz, *Boom and Bust*, 183–185, 339–341.
64. Gunning, *Films of Fritz Lang*, 341.
65. See, for instance, the discussion of fantasy in Cowie, "Film Noir and Women," 145–159; and the discussion of the absent mother in Kelly Oliver and Benigno Trigo, *Noir Anxiety* (Minneapolis: University of Minnesota Press, 2003), 73–96.
66. I quote and discuss Selznick's memos to cinematographers in Patrick Keating, "Shooting for Selznick: Craft and Collaboration in Hollywood Cinematography," in *The Classical Hollywood Reader*, ed. Steve Neale (London: Routledge, 2012), 287, 289.
67. Sternberg, "Narrativity," 641–642.
68. For an analysis of the film's radical construction, see Douglas Pye, "Film Noir and Suppressive Narrative: *Beyond a Reasonable Doubt*," in *Book of Film Noir*, 98–109.
69. Cortez's views are summarized in Steve O'Donnell, "Psychological Photography," *American Cinematographer* 24, no. 12 (December 1943): 430. Perhaps O'Donnell is putting words into Cortez's mouth, but Cortez continues to speak of music as an inspiration in Charles Higham, *Hollywood Cameramen: Sources of Light* (Bloomington: Indiana University Press, 1970), 113–114. His example is the murder scene in *The Night of the Hunter*.
70. Director Fritz Lang did something similar a few years earlier in *Ministry of Fear* (1944). During a climactic fight, the lights go out for several seconds.
71. Cowie, "Film Noir and Women," 148.

CHAPTER 7 CONCLUSION

1. I refer to the title of John Alton, *Painting with Light* (Berkeley: University of California Press, 1995).
2. Daniels, interviewed in Charles Higham, *Hollywood Cameramen: Sources of Light* (Bloomington: Indiana University Press, 1970), 72.

BIBLIOGRAPHY

This bibliography includes all the scholarly sources in the text, plus some key works of literature. It does not include audiovisual essays, how-to books, screenplays, or articles from trade journals such as *American Cinematographer*. See the notes to each chapter for that information.

Abell, Catherine. "Cinema as a Representational Art." *British Journal of Aesthetics* 50, no. 3 (July 2010): 273–286.

Abramson, Kate. "Turning Up the Lights on Gaslighting." *Philosophical Perspectives* 28 (2014): 1–30.

Allen, Richard. *Hitchcock's Romantic Irony*. New York: Columbia University Press, 2007.

Alton, John. *Painting with Light*. Berkeley: University of California Press, 1995.

Anderson, Thom. "Red Hollywood." In *"Un-American" Hollywood: Politics and Film in the Blacklist Era*, edited by Frank Krutnik, Steve Neale, Brian Neve, and Peter Stanfield, 225–275. New Brunswick, NJ: Rutgers University Press, 2007.

Aristotle. *The Poetics of Aristotle*. Translated by Stephen Halliwell. Chapel Hill: University of North Carolina Press, 1987.

Arnheim, Rudolf. *Film as Art*. Berkeley: University of California Press, 1957.

Beach, Christopher. *A Hidden History of Film Style: Cinematographers, Directors, and the Collaborative Process*. Berkeley: University of California Press, 2015.

Belodubrovskaya, Maria. "The Master of Surprise: Alfred Hitchcock and Premise Uncertainty." *Projections: The Journal for Movies and Mind* 17, no. 1 (2023): 1–19.

Bergstrom, Janet. "Warning Shadows: German Expressionism and American Film Noir." In *Film Noir*, edited by Homer B. Pettey and R. Barton Palmer, 38–57. Edinburgh: Edinburgh University Press, 2014.

Biesen, Sheri Chinen. *Blackout: World War II and the Origins of Film Noir*. Baltimore: Johns Hopkins University Press, 2005.

Borde, Raymond, and Etienne Chaumeton. *A Panorama of American Film Noir, 1941–1953*. Translated by Paul Hammond. San Francisco: City Lights Books, 2002.

Bordwell, David. "Film Noir, a Hundred Years Ago." *Observations on Film Art*, April 18, 2017, http://www.davidbordwell.net/blog/2017/04/18/film-noir-a-hundred-years-ago/.

———. *Perplexing Plots: Popular Storytelling and the Poetics of Murder*. New York: Columbia University Press, 2023.

———. *Poetics of Cinema*. New York: Routledge, 2008.

———. *Reinventing Hollywood: How 1940s Filmmakers Changed Movie Storytelling*. Chicago: University of Chicago Press, 2017.

Bordwell, David, Janet Staiger, and Kristin Thompson. *The Classical Hollywood Cinema: Film Style and Mode of Production to 1960*. New York: Columbia University Press, 1985.

Britton, Andrew. "Betrayed by Rita Hayworth: Misogyny in *The Lady from Shanghai*." In *The Book of Film Noir*, edited by Ian Cameron, 213–221. New York: Continuum, 1993.

Bronfen, Elisabeth. "Gender and Noir." In *Film Noir*, edited by Homer B. Pettey and R. Barton Palmer, 143–163. Edinburgh: Edinburgh University Press, 2014.

Brook, Vincent. *Driven to Darkness: Jewish Émigré Directors and the Rise of Film Noir*. New Brunswick, NJ: Rutgers University Press, 2009.

Buhle, Paul, and Dave Wagner. *A Very Dangerous Citizen: Abraham Lincoln Polonsky and the Hollywood Left*. Berkeley: University of California Press, 2001.

Burges, Joel. "Obsolescence/Innovation." In *Time: A Vocabulary of the Present*, edited by Joel Burges and Amy J. Elias, 82–96. New York: New York University Press, 2016.
Butler, David. "In a Lonely Tone: Music in Film Noir." In *A Companion to Film Noir*, edited by Andrew Spicer and Helen Hanson, 302–317. Malden, MA: Wiley-Blackwell, 2013.
Cagle, Chris. "Classical Hollywood, 1928–1946." In *Cinematography*, edited by Patrick Keating, 34–59. New Brunswick, NJ: Rutgers University Press, 2014.
Cain, James M. *Double Indemnity*. New York: Vintage Books, 1989.
———. *The Postman Always Rings Twice*. New York: Vintage Books, 1989.
Callow, Simon. *Orson Welles*. Vol. 2, *Hello Americans*. New York: Penguin, 2006.
Carnicke, Sharon. *Stanislavski in Focus: An Acting Master for the Twenty-First Century*. 2nd ed. New York: Routledge, 2009.
Carroll, Noël. "Toward a Theory of Film Suspense." In *Theorizing the Moving Image*, 94–117. New York: Cambridge University Press, 1996.
Carter, Susan B., Scott Sigmund Gartner, Michael R. Haines, Alan L. Olmstead, Richard Sutch, and Gavin Wright, eds. *Historical Statistics of the United States*, Millennial Edition Online. New York: Cambridge University Press, 2006. http://hsus.cambridge.org/HSUSWeb/index.do.
Caspary, Vera. *Laura*. New York: Feminist Press, 2005.
Chandler, Raymond. *Farewell, My Lovely*. New York: Vintage Books, 1988.
Chao, Phebe Shih. "Reading *The Letter* in a Postcolonial World." In *Visions of the East: Orientalism on Film*, edited by Matthew Bernstein and Gaylyn Studlar, 292–314. New Brunswick, NJ: Rutgers University Press, 1997.
Chatman, Seymour. *Coming to Terms: The Rhetoric of Narrative in Fiction and Film*. Ithaca, NY: Cornell University Press, 1990.
———. *Story and Discourse: Narrative Structure in Fiction and Film*. Ithaca, NY: Cornell University Press, 1978.
———. "What Novels Can Do That Films Can't (and Vice Versa)." *Critical Inquiry* 7, no. 1 (Autumn 1980): 121–140.
Ciletti, Elena. "'Gran Macchina è Bellezza': Looking at the Gentileschi *Judiths*." In *The Artemisia Files: Artemisia Gentileschi for Feminists and Other Thinking People*, edited by Mieke Bal, 63–105. Chicago: University of Chicago Press, 2005.
Cook, Pam. "Duplicity in *Mildred Pierce*." In *Women in Film Noir*, new ed., edited by E. Ann Kaplan, 69–80. London: British Film Institute, 1998.
Cowan, Philip. *Authorship and Aesthetics in the Cinematography of Gregg Toland*. Lanham, MD: Lexington Books, 2022.
Cowie, Elizabeth. "Film Noir and Women." In *Shades of Noir*, edited by Joan Copjec, 121–165. New York: Verso, 1993.
Cripps, Thomas. *Making Movies Black: The Hollywood Message Movie from World War II to the Civil Rights Era*. New York: Oxford University Press, 1993.
Crowe, Cameron. *Conversations with Wilder*. New York: Alfred A. Knopf, 1999.
Damico, James. "Film Noir: A Modest Proposal." In *Film Noir Reader*, edited by Alain Silver and James Ursini, 95–105. New York: Limelight, 1996.
Dance, Robert, and Scott Reisfield. *Garbo: Portraits from Her Private Collection*. New York: Rizzoli, 2005.
Dance, Robert, and Bruce Robertson. *Ruth Harriet Louise and Hollywood Glamour Photography*. Berkeley: University of California Press, 2002.
Deming, Richard. *Touch of Evil*. London: British Film Institute, 2020.
Dibbern, Doug. "The Violent Poetry of the Times: The Politics of History in Daniel Mainwaring and Joseph Losey's *The Lawless*." In *"Un-American" Hollywood: Politics and Film in the*

Blacklist Era, edited by Frank Krutnik, Steve Neale, Brian Neve, and Peter Stanfield, 97–112. New Brunswick, NJ: Rutgers University Press, 2007.

Dimendberg, Edward. *Film Noir and the Spaces of Modernity*. Cambridge, MA: Harvard University Press, 2004.

Dixon, Wheeler Winston. *Black and White Cinema: A Short History*. New Brunswick, NJ: Rutgers University Press, 2015.

Dombrowski, Lisa. "Postwar Hollywood, 1947–1967." In *Cinematography*, edited by Patrick Keating, 60–83. New Brunswick, NJ: Rutgers University Press, 2014.

Doty, Alexander. "Marlene Dietrich and Greta Garbo: The Sexy Hausfrau and the Swedish Sphinx." In *Glamour in a Golden Age: Movie Stars of the 1930s*, edited by Adrienne McLean, 108–128. New Brunswick, NJ: Rutgers University Press, 2011.

Durgnat, Raymond. "Paint It Black: The Family Tree of the Film Noir." In *Film Noir Reader*, edited by Alain Silver and James Ursini, 37–51. New York: Limelight, 1996.

Dyer, Richard. *White*. New York: Routledge, 1997.

Eisner, Lotte. *The Haunted Screen*. Berkeley: University of California Press, 1973.

Elsaesser, Thomas. *Weimar Cinema and After: Germany's Historical Imaginary*. New York: Routledge, 2000.

Eyman, Scott. *Five American Cinematographers*. Metuchen, NJ: Scarecrow Press, 1987.

Fay, Jennifer, and Justus Nieland. *Film Noir: Hard-Boiled Modernity and the Cultures of Globalization*. New York: Routledge, 2010.

Finler, Joel. *Hollywood Movie Stills: Art and Technique in the Golden Age of the Studios*. 2nd ed. London: Reynolds and Hearn, 2008.

Fischer, Lucy. "The Shock of the New: Electrification, Illumination, Urbanization, and the Cinema." In *Cinema and Modernity*, edited by Murray Pomerance, 19–37. New Brunswick, NJ: Rutgers University Press, 2006.

Fisher, Steve. *I Wake Up Screaming*. New York: Dodd, Mead, 1941.

Flory, Dan. "Ethnicity and Race in American Film Noir." In *A Companion to Film Noir*, edited by Andrew Spicer and Helen Hanson, 387–404. Malden, MA: Wiley-Blackwell, 2013.

Gaines, Jane. "Introduction: The Family Melodrama of Classical Narrative Cinema." In *Classical Narrative Cinema: The Paradigm Wars*, edited by Jane Gaines, 1–8. Durham, NC: Duke University Press, 1992.

Gates, Philippa. *Criminalization/Assimilation: Chinese/Americans and Chinatowns in Classical Hollywood Film*. New Brunswick, NJ: Rutgers University Press, 2019.

———. "Independence Unpunished: The Female Detective in Classic Film Noir." In *Kiss the Blood Off My Hands: On Classic Film Noir*, edited by Robert Miklitsch, 17–36. Urbana: University of Illinois Press, 2014.

Gelly, Christophe. "Film Noir and Subjectivity." In *A Companion to Film Noir*, edited by Andrew Spicer and Helen Hanson, 337–352. Malden: Wiley-Blackwell, 2013.

Gledhill, Christine, ed. *Home Is Where the Heart Is: Studies in Melodrama and the Woman's Film*. London: British Film Institute, 1987.

Grindon, Leger. "Cycles and Clusters: The Shape of Film Genre History." In *Film Genre Reader IV*, edited by Barry Keith Grant, 42–59. Austin: University of Texas Press, 2012.

Grisham, Therese, and Julie Grossman. *Ida Lupino, Director: Her Art and Resilience in Times of Transition*. New Brunswick, NJ: Rutgers University Press, 2017.

Grossman, Julie. *Rethinking the Femme Fatale in Film Noir: Ready for Her Close-Up*. New York: Palgrave Macmillan, 2009.

Guerin, Frances. *A Culture of Light: Cinema and Technology in 1920s Germany*. Minneapolis: University of Minnesota Press, 2005.

Gundle, Stephen. *Glamour: A History*. New York: Oxford University Press, 2008.

Gunning, Tom. *The Films of Fritz Lang: Allegories of Vision and Modernity*. London: British Film Institute, 2000.
Hammett, Dashiell. *The Maltese Falcon*. San Francisco: Arion Press, 1983.
———. *Red Harvest*. New York: Vintage Books, 1989.
Hanson, Helen. "Feminist Film Criticism and the Femme Fatale." In *The Femme Fatale: Images, Histories, Contexts*, edited by Helen Hanson and Catherine O'Rawe, 214-227. New York: Palgrave Macmillan, 2010.
———. *Hollywood Heroines: Women in Film Noir and the Female Gothic Film*. London: I. B. Tauris, 2007.
Hemingway, Ernest. "The Killers." In *The Complete Short Stories of Ernest Hemingway*, 215–222. New York: Scribner, 2003.
Higham, Charles. *Hollywood Cameramen: Sources of Light*. Bloomington: Indiana University Press, 1970.
Highsmith, Patricia. *Plotting and Writing Suspense Fiction*. New York: St. Martin's Griffin, 1983.
———. *Strangers on a Train*. New York: W. W. Norton, 1993.
Hirsch, Foster. *The Dark Side of the Screen: Film Noir*. Cambridge, MA: Da Capo Press, 1981.
Holding, Elisabeth Sanxay. *The Innocent Mr. Duff and The Blank Wall: Two Novels of Suspense*. New York: Quality Paperback Book Club, 2002.
Hughes, Dorothy B. *Ride the Pink Horse*. New York: Penzler, 2021.
Isenberg, Noah. *Detour*. London: British Film Institute, 2008.
Jacobs, Steven. *Framing Pictures: Film and the Visual Arts*. Edinburgh: Edinburgh University Press, 2011.
Jacobs, Steven, and Lisa Colpaert. *The Dark Galleries: A Museum Guide to Painted Portraits in Film Noir, Gothic Melodramas, and Ghost Stories of the 1940s and 1950s*. Ghent: Aramer, 2013.
Kaplan, E. Ann. "'The Dark Continent of Film Noir': Race, Displacement, and Metaphor in Tourneur's *Cat People* (1942) and Welles's *The Lady from Shanghai* (1948)." In *Women in Film Noir*, new ed., edited by E. Ann Kaplan, 183–201. London: British Film Institute, 1998.
Keating, Patrick. "Artifice and Atmosphere: The Visual Culture of Hollywood Glamour Photography, 1930–1935." *Film History* 29, no. 3 (2017): 105–135.
———. "The Art of Cinematography." In *The Palgrave Handbook for the Philosophy of Film and Motion Pictures*, edited by Noël Carroll, Laura T. DiSumma-Knoop, and Shawn Loht, 71–93. London: Palgrave Macmillan, 2019.
———. *The Dynamic Frame: Camera Movement in Classical Hollywood*. New York: Columbia University Press, 2019.
———. "Elia Kazan and the Semidocumentary: Composing Urban Space." In *Kazan Revisited*, edited by Lisa Dombrowski, 148–162. Middletown, CT: Wesleyan University Press, 2011.
———. "Emotional Curves and Linear Narratives." *Velvet Light Trap* 58 (Fall 2006): 4–15.
———. "Film Noir and the Culture of Electric Light." *Film History* 27, no. 1 (2015): 58–84.
———. *Hollywood Lighting from the Silent Era to Film Noir*. New York: Columbia University Press, 2010.
———. "Light and Time in the Narrative Fiction Film." *Journal of Cinema and Media Studies* 61, no. 3 (Spring 2022): 59–81.
———. "Narrative and the Moving Image." In *The Palgrave Handbook for the Philosophy of Film and Motion Pictures*, edited by Noël Carroll, Laura T. DiSumma-Knoop, and Shawn Loht, 119–141. London: Palgrave Macmillan, 2019.
———. "Out of the Shadows: Noir Lighting and Hollywood Cinematography." In *A Companion to Film Noir*, edited by Andrew Spicer and Helen Hanson, 267–283. Malden, MA: Wiley-Blackwell, 2013.
———. "Shooting for Selznick: Craft and Collaboration in Hollywood Cinematography." In *The Classical Hollywood Reader*, edited by Steve Neale, 280–295. London: Routledge, 2012.

Kerr, Paul. "Out of What Past? Notes on the B Film Noir." In *Film Noir Reader*, edited by Alain Silver and James Ursini, 107–127. New York: Limelight, 1996.
Kobal, John. *The Art of the Great Hollywood Portrait Photographers, 1925–1940*. New York: Alfred A. Knopf, 1980.
———. *People Will Talk*. New York: Alfred A. Knopf, 1985.
Koszarski, Richard, and Diane Koszarski. "'No Problems. They Liked What They Saw on the Screen': An Interview with Joseph Ruttenberg." *Film History* 1, no. 1 (1987): 65–96.
Kozloff, Sarah. *The Life of the Author*. Montreal: Caboose, 2014.
Krohn, Bill. *Hitchcock at Work*. London: Phaidon Press, 2000.
Krutnik, Frank. *In a Lonely Street: Film Noir, Genre, Masculinity*. New York: Routledge, 1991.
———. "Something More Than Night: Tales of the Noir City." In *The Cinematic City*, edited by David B. Clarke, 83–109. New York: Routledge, 1997.
Lane, Christina. *Phantom Lady: Hollywood Producer Joan Harrison, the Forgotten Woman behind Hitchcock*. Chicago: Chicago Review Press, 2020.
Langdon-Teclaw, Jennifer. "The Progressive Producer in the Studio System: Adrian Scott at RKO, 1943–1947." In *"Un-American" Hollywood: Politics and Film in the Blacklist Era*, edited by Frank Krutnik, Steve Neale, Brian Neve, and Peter Stanfield, 152–168. New Brunswick, NJ: Rutgers University Press, 2007.
Lawrence, Amy. *Echo and Narcissus: Women's Voices in Classical Hollywood Cinema*. Berkeley: University of California Press, 1991.
Leff, Leonard J., and Jerrold L. Simmons. *The Dame in the Kimono: Hollywood, Censorship, and the Production Code*. Rev. ed. Lexington: University Press of Kentucky, 2001.
Lott, Eric. "The Whiteness of Film Noir." *American Literary History* 9, no. 3 (Autumn 1997): 542–566.
Macnab, Geoffrey. *Searching for Stars: Stardom and Screen Acting in British Cinema*. London: Continuum, 2000.
Maltin, Leonard. *The Art of the Cinematographer: A Survey and Interviews with Five Masters*, enlarged ed. New York: Dover, 1978.
Marling, William. *Dashiell Hammett*. Boston: Twayne, 1983.
Martin, Adrian. *Mise-en-Scène and Film Style: From Classical Hollywood to New Media Art*. New York: Palgrave Macmillan, 2014.
Martin, Angela. "'Gilda Didn't Do Any of Those Things You've Been Losing Sleep Over!': The Central Women of 40s Film Noirs." In *Women in Film Noir*, new ed., edited by E. Ann Kaplan, 202–228. London: British Film Institute, 1998.
McLean, Adrienne L. "'I'm a Cansino': Transformation, Ethnicity, and Authenticity in the Construction of Rita Hayworth, American Love Goddess." *Journal of Film and Video* 44, no. 3–4 (Fall–Winter 1992–1993): 8–26.
Miklitsch, Robert. "Periodizing Classic Noir: From *Stranger on the Third Floor* to the 'Thrillers of Tomorrow.'" In *Kiss the Blood Off My Hands: On Classic Film Noir*, edited by Robert Miklitsch, 193–218. Urbana: University of Illinois Press, 2014.
———. *The Red and the Black: American Film Noir in the 1950s*. Urbana: University of Illinois Press, 2017.
Miyao, Daisuke. "Bright Lights, Big City: Lighting, Technological Modernity, and Ozu Yasujiro's *Sono yo no tsuma (That Night's Wife*, 1930)." *Positions: East Asian Culture Critique* 22, no. 1 (Winter 2014): 161–201.
Morson, Gary Saul. "Narrativeness." *New Literary History* 34, no. 1 (Winter 2003): 59–73.
Murphet, Julian. "Film Noir and the Racial Unconscious." *Screen* 39, no. 1 (Spring 1998): 22–35.
Naremore, James. *The Magic World of Orson Welles*. New and rev. ed. Dallas: Southern Methodist University Press, 1989.

———. *More Than Night: Film Noir in Its Contexts*. 2nd ed. Berkeley: University of California Press, 2008.

———. *Sweet Smell of Success*. London: British Film Institute, 2010.

Neale, Steve. *Genre and Hollywood*. New York: Routledge, 2000.

———. "'I Can't Tell Anymore Whether You're Lying': *Double Indemnity, Human Desire*, and the Narratology of *Femme Fatales*." In *The Femme Fatale: Images, Histories, Contexts*, edited by Helen Hanson and Catherine O'Rawe, 187–198. New York: Palgrave Macmillan, 2010.

Neve, Brian. "The Politics of Film Noir." In *A Companion to Film Noir*, edited by Andrew Spicer and Helen Hanson, 177–192. Malden, MA: Wiley-Blackwell, 2013.

Nevins, Francis M. "Translate and Transform: From Cornell Woolrich to Film Noir." In *Film Noir Reader 2*, edited by Alain Silver and James Ursini, 137–157. New York: Limelight, 1999.

Nye, David. *Electrifying America: Social Meanings of a New Technology*. Cambridge, MA: MIT Press, 1992.

———. *Narratives and Spaces: Technology and the Construction of American Culture*. New York: Columbia University Press, 1997.

Oliver, Kelly, and Benigno Trigo. *Noir Anxiety*. Minneapolis: University of Minnesota Press, 2003.

Palmer, R. Barton. "Borderings." In *A Companion to Film Noir*, edited by Andrew Spicer and Helen Hanson, 125–141. Malden, MA: Wiley-Blackwell, 2013.

———. *Shot on Location: Postwar American Cinema and the Exploration of Real Place*. New Brunswick, NJ: Rutgers University Press, 2016.

Perkins, V. F. *Film as Film: Understanding and Judging Movies*. New York: Penguin, 1972.

———. "Where Is the World? The Horizon of Events in Movie Fiction." In *Style and Meaning: Studies in the Detailed Analysis of Film*, edited by John Gibbs and Douglas Pye, 16–41. Manchester: Manchester University Press, 2005.

Phillips, Alastair. *City of Darkness, City of Light: Émigré Filmmakers in Paris, 1929–1939*. Amsterdam: Amsterdam University Press, 2004.

———. "Crisscrossed? Film Noir and the Politics of Mobility and Exchange." In *A Companion to Film Noir*, edited by Andrew Spicer and Helen Hanson, 94–110. Malden, MA: Wiley-Blackwell, 2013.

Pippin, Robert. *Fatalism in American Film Noir: Some Cinematic Philosophy*. Charlottesville: University of Virginia Press, 2012.

Place, Janey. "Women in Film Noir." In *Women in Film Noir*, new ed., edited by E. Ann Kaplan, 47–68. London: British Film Institute, 1998.

Place, Janey, and Lowell Peterson. "Some Visual Motifs of Film Noir." In *Film Noir Reader*, edited by Alain Silver and James Ursini, 65–75. New York: Limelight, 1996.

Polan, Dana. *In a Lonely Place*. London: British Film Institute, 1993.

———. *Power and Paranoia: History, Narrative, and the American Cinema, 1940–1950*. New York: Columbia University Press, 1985.

Pomerance, Murray. "The Climb and the Chase: Film Noir and the Urban Scene—Representations of the City in Three Classic Noirs." In *A Companion to Film Noir*, edited by Andrew Spicer and Helen Hanson, 405–419. Malden, MA: Wiley-Blackwell, 2013.

———. "Lights, Looks, and *The Lodger*." *Quarterly Review of Film and Video* 26, no. 5 (2009): 425–433.

Porfirio, Robert. "No Way Out: Existential Motifs in Film Noir." In *Film Noir Reader*, edited by Alain Silver and James Ursini, 77–93. New York: Limelight, 1996.

———. "The Strange Case of Film Noir." In *A Companion to Film Noir*, edited by Andrew Spicer and Helen Hanson, 17–32. Malden, MA: Wiley-Blackwell, 2013.

Porfirio, Robert, Alain Silver, and James Ursini, eds.. *Film Noir Reader 3: Interviews with Filmmakers of the Classic Noir Period*. New York: Limelight, 2002.
Pye, Douglas. "Film Noir and Suppressive Narrative: *Beyond a Reasonable Doubt*." In *The Book of Film Noir*, edited by Ian Cameron, 98–109. New York: Continuum, 1993.
Quinn, Eithne. *A Piece of the Action: Race and Labor in Post–Civil Rights Hollywood*. New York: Columbia University Press, 2020.
Rabinovitz, Lauren. "The Hitch-Hiker." In *Queen of the 'B's: Ida Lupino behind the Camera*, edited by Annette Kuhn, 90–102. Westport, CT: Greenwood Press, 1995.
Rabinowitz, Peter J. *Before Reading: Narrative Conventions and the Politics of Interpretation*. Columbus: Ohio State University Press, 1987.
Rainsberger, Todd. *James Wong Howe, Cinematographer*. San Diego: A. S. Barnes, 1981.
Ramachandran, Vilayanur S. "Perceiving Shape from Shading." *Scientific American* 259, no. 2 (August 1988): 76–83.
Ricoeur, Paul. *Time and Narrative*. Vol. 1. Translated by Kathleen McLaughlin and David Pellauer. Chicago: University of Chicago Press, 1984.
Rinehart, Mary Roberts. *Miss Pinkerton*. New York: Penzler, 2019.
Rosenbaum, Jonathan. *Discovering Orson Welles*. Berkeley: University of California Press, 2007.
Ross, Steven J. *Hollywood Left and Right: How Movie Stars Shaped American Politics*. New York: Oxford University Press, 2014.
Ryan, Marie-Laure. *Possible Worlds, Artificial Intelligence, and Narrative Theory*. Bloomington: Indiana University Press, 1991.
Sadowski, Piotr. *The Semiotics of Light and Shadows: Modern Visual Arts and Weimar Cinema*. London: Bloomsbury, 2018.
Salt, Barry. *Film Style and Technology: History and Analysis*. 3rd ed. London: Starword, 2009.
Sarris, Andrew. *Interviews with Film Directors*. New York: Avon, 1967.
Schatz, Thomas. *Boom and Bust: American Cinema in the 1940s*. Berkeley: University of California Press, 1999.
Schivelbusch, Wolfgang. *Disenchanted Night: The Industrialization of Light in the Nineteenth Century*. Translated by Angela Davies. Berkeley: University of California Press, 1995.
Schlotterbeck, Jesse. "Radio Noir in the USA." In *A Companion to Film Noir*, edited by Andrew Spicer and Helen Hanson, 423–439. Malden, MA: Wiley-Blackwell, 2013.
Schrader, Paul. "Notes on Film Noir." In *Film Noir Reader*, edited by Alain Silver and James Ursini, 53–63. New York: Limelight, 1996.
Scott, Jennifer, and Helen Hillyard. *Rembrandt's Light*. London: Dulwich Picture Gallery, 2019.
Scruggs, Charles. "The Subversive Shade of Black in Film Noir." In *Film Noir*, ed. Homer B. Pettey and R. Barton Palmer, 164–181. Edinburgh: Edinburgh University Press, 2014.
Silver, Alain, and James Ursini. *The Noir Style*. New York: Overlook Press, 1999.
Silver, Alain, Elizabeth Ward, James Ursini, and Robert Porfirio, eds. *Film Noir: The Encyclopedia*. 3rd ed. New York: Overlook Duckworth, 2010.
Smith, Erin A. *Hard-Boiled: Working-Class Readers and Pulp Magazines*. Philadelphia: Temple University Press, 2000.
Sobchack, Vivian. "Lounge Time: Postwar Crises and the Chronotope of Film Noir." In *Refiguring American Film Genres*, edited by Nick Browne, 129–170. Berkeley: University of California Press, 1998.
Spadoni, Robert. "Carl Dreyer's Corpse: Horror Film Atmosphere and Narrative." In *A Companion to the Horror Film*, edited by Harry Benshoff, 151–167. Medford, MA: Wiley, 2014.
———. "Horror Film Atmosphere as Anti-narrative (and Vice Versa)." In *Merchants of Menace: The Business of Horror Cinema*, edited by Richard Nowell, 109–128. New York: Bloomsbury, 2014.

Spicer, Andrew. *Film Noir*. Harlow, UK: Pearson Education, 2002.
Staiger, Janet. "Film Noir as Male Melodrama: The Politics of Film Genre Labeling." In *The Shifting Definitions of Genre: Essays on Labeling Films, Television Shows, and Media*, edited by Lincoln Geraghty and Mark Jancovich, 71–91. Jefferson, NC: McFarland, 2008.
Stanislavski, Constantin. *An Actor Prepares*. Translated by Elizabeth Reynolds Hapgood. New York: Routledge, 1989.
Stecker, Robert. "Film Narration, Imaginative Seeing, and Seeing-In." *Projections* 7, no. 1 (Summer 2013): 147–154.
Sternberg, Meir. "Mimeses and Motivation: The Two Faces of Fictional Coherence." *Poetics Today* 33, no. 3–4 (Fall–Winter 2012): 329–483.
———. "Narrativity: From Objectivist to Functional Paradigm." *Poetics Today* 31, no. 3 (Fall 2010): 507–659.
———. "Telling in Time (II): Chronology, Teleology, Narrativity." *Poetics Today* 13, no. 3 (Autumn 1992): 463–541.
Stoichita, Victor I. *A Short History of the Shadow*. London: Reaktion, 1997.
Studlar, Gaylyn. "'The Corpse on Reprieve': Film Noir's Cautionary Tales of 'Tough Guy' Masculinity." In *A Companion to Film Noir*, edited by Andrew Spicer and Helen Hanson, 369–386. Malden, MA: Wiley-Blackwell, 2013.
Tasker, Yvonne. "Women in Film Noir." In *A Companion to Film Noir*, edited by Andrew Spider and Helen Hanson, 353–368. Malden, MA: Wiley-Blackwell, 2013.
Telotte, J. P. *Voices in the Dark: The Narrative Patterns of Film Noir*. Urbana: University of Illinois Press, 1989.
Thomas, Deborah. "Psychoanalysis and Film Noir." In *The Book of Film Noir*, edited by Ian Cameron, 71–87. New York: Continuum, 1993.
Thompson, Kristin. *Storytelling in the New Hollywood: Understanding Classical Narrative Technique*. Cambridge, MA: Harvard University Press, 1999.
Thompson, Lara. *Film Light: Meaning and Emotion*. Manchester: Manchester University Press, 2015.
Vernet, Marc. "Film Noir on the Edge of Doom." In *Shades of Noir: A Reader*, edited by Joan Copjec, 1–31. New York: Verso, 1993.
Vieira, Mark. *George Hurrell's Hollywood: Glamour Portraits, 1925–1992*. Philadelphia: Running Press, 2013.
Vincendeau, Ginette. "Noir Is Also a French Word: The French Antecedents of Film Noir." In *The Book of Film Noir*, edited by Ian Cameron, 49–58. New York: Continuum, 1993.
von Sternberg, Josef. *Fun in a Chinese Laundry*. London: Columbus Books, 1987.
Waldman, Diane. "'At Last I Can Tell It to Someone!': Feminine Point of View and Subjectivity in the Gothic Romance Film of the 1940s." *Cinema Journal* 23, no. 2 (Winter 1983): 29–40.
Walker, Michael. "Film Noir: Introduction." In *The Book of Film Noir*, edited by Ian Cameron, 8–38. New York: Continuum, 1993.
Watter, Seth Barry. "On the Concept of Setting: A Study of V. F. Perkins." *Journal of Cinema and Media Studies* 58, no. 3 (Spring 2019): 72–92.
Welles, Orson, and Peter Bogdanovich. *This Is Orson Welles*. Edited by Jonathan Rosenbaum. New York: Da Capo Press, 1998.
Williams, Linda. "Melodrama Revised." In *Refiguring American Film Genres: History and Theory*, edited by Nick Browne, 42–88. Berkeley: University of California Press, 1998.
Willis-Tropea, Liz. "Glamour Photography and the Institutionalization of Celebrity." *Photography and Culture* 4, no. 3 (November 2011): 261–275.
Wilson, George M. *Narration in Light: Studies in Cinematic Point of View*. Baltimore: Johns Hopkins University Press, 1986.

Wollheim, Richard. *Painting as an Art*. Princeton, NJ: Princeton University Press, 1987.

———. "Seeing-as, Seeing-in, and Pictorial Representation." In *Art and Its Objects*, 2nd ed., 205–226. New York: Cambridge University Press, 1980.

Wood, Robin. *Hitchcock's Films Revisited*. New York: Columbia University Press, 1989.

———. "Welles, Shakespeare, and Webster." In *Personal Views: Explorations in Film*, rev. ed., 167–188. Detroit: Wayne State University Press, 2006.

Woolrich, Cornell. [William Irish]. *Deadline at Dawn*. Lakewood, CO: Centipede Press, 2012.

———. *Phantom Lady*. New York: iBooks, 2001.

INDEX

Page numbers in *italics* represent photographs.

Abramson, Kate, 190
action movies, 98
Act of Violence, 132, 133–134, *134*
Albert, Katherine, 73
Alibi, 96, 98
alienation, creation of, 5, 11, 111–112, 115, 131, 151, 166
Allen, Dede, 56
Allen, Richard, 126
Alton, John, 34–34, 66, 71–72, 78–79, 90, 101, 120, 186–189, 205
Ameche, Don, 44
American Cinematographer: gender guidelines, 69; general illumination, 65–66; glamour lighting, 72; lighting as conventions of configuration, 102; lighting for time of day, 36–37; Lightman on lighting and society, 148; Lightman on theory of mood lighting, 43; Loring on source lighting, 132–133; Mellor on shadows, 66; Physioc's Venus de Milo photographs, 69; Rosson's lighting techniques in *The Asphalt Jungle*, 13, 15; Tannura on effect and conventional lighting, 132; use of modeling, 58
American in Paris, An, 187
Anderson, Thom, 139
Anna and the King of Siam, 87
Arnheim, Rudolf, 185–186
Arnold, John, 98, 99–100, 102
Asian characters. *See* race; racism
Asian-themed thrillers, 69–70, 86, 96, 98, 150
Asphalt Jungle: box-office disappointment, 100; critical acclaim, 100; distinctions between characters, 72; as example of film noir, 11–19, *14–17*, 50, 52, 62, 87; fatalism in, 25; poorly lit spaces, 148
Astaire, Fred, 115
Astor, Mary, 2, 4, 113, 133–134, 209n6
atmospheric prose, 107–108, 112–114, 123–125
attention, subfunction of storytelling, 28–29
Atwater, Edith, 157
authorship, 8, 180
Ayars, Ann, 149

Bacall, Lauren, 151
Bachrach, Ernest, 74
backlight: character lighting, 58; elimination for realism, 142; in *Gaslight*, 191, 193; in *Human Desire*, 40, *40*; in *I Wake Up Screaming*, 118; kickers and, 66; in *The Letter*, 84, *84*, 86; modeling and modulation, 78; in *Odds Against Tomorrow*, 55; in *Panic in the Streets*, 144, *144*; in *Phantom Lady*, 91
Bad Day at Black Rock, 54
Ball, Lucille, 149
Ballard, Lucien, 67
Bankhead, Tallulah, 73
Barnes, George, 139
baroque style, 161
bar pattern. *See* grid/bar pattern
beam-of-light effect, 140–141
beats, 39–42, 127, *128*, 129–130, 212n55
beauty. *See* glamour
Begley, Ed, 51
Belafonte, Harry, 50–52, 57
Bennett, Joan, 60, 67, 195
Bergman, Ingrid, 189
Bernhardt, Curtis, 180
Beyond a Reasonable Doubt, 201
Biesen, Sheri Chinen, 105, 183
Big Clock, The, 44, 45, 151–152
Big Combo, The, 95, 138, 161
Big Sleep, The, 96, 103
Black characters. *See* race; racism
blackface. *See* racism: blackface makeup
blacklist, 39, 139, 154, 173
Blank Wall, The (novel; Holding), 111
blinking signs/neons: in *Cornered*, 38; in *I Wake Up Screaming*, 117, 161–162; in *The Maltese Falcon*, 113; noir iconography, 131, 161; in *Scarlet Street*, 202; in *Touch of Evil*, 203; in *The Unsuspected*, 171–172, *172*, 176–178, 180, 202. *See also* noir symbolism
Blondell, Joan, 98
Blue Angel, The, 74
Blue Gardenia, The, 138, 139, 161

241

Body and Soul, 155
Bogart, Humphrey, 44, 113, 170
Boomerang!, 143, *143*
Borde, Raymond, 6, 180
Bordwell, David, 21, 22, 107
Born to Kill, 24
bounce lighting, 73, 152, 226n61
Boyer, Charles, 189
Brahm, John, 180
Brasher Doubloon, The, 162
Bredell, Woody, 63, 65, 89, 90, 92, 94, 113, 222n70, 227n9
Breen, Joseph, 83
Britton, Andrew, 25–26, 82–83
Brodine, Norbert, 142, *143*
Bronfen, Elizabeth, 26
brownface. *See* racism: brownface makeup
Brun, Joseph, 52, 55, 56, 80, 214n82
Brute Force, 26
budgets, 105–106
Bull, Clarence Sinclair, 76
Bulldog Drummond movies, 100
Burks, Robert, 124, 130, 227n9
Burning Secret, The, 89
Butler, David, 93–94
butterfly lighting: Dietrich lighting, 74, 120, 163; in female/glamour lighting, 59–60, *60, 62, 63,* 74, 85, *197*; flat, 59, 84–85, *84*, 92; in *I Wake Up Screaming*, 118; in *The Lady from Shanghai*, 82, *82*; in *The Letter*, 84–85, *84*, 91; in *Mildred Pierce*, 67; north light, 70–71, 74–75; in *Phantom Lady*, 91, 92; relationship to camera, 68; in *Secret beyond the Door*, *197*, *197*; use of term, 214n3

Cabinet of Dr. Caligari, 178–181, *179*
Cain, James M., 27, 78, 109, 110–111
Calhern, Louis, 11
Call Northside 777, 8–10, *9*, 30–31, 141, 149–150, 162, 203
camera-eye narration, 108
capitalism, 51, 173. *See also* social class
Caravaggio, Michelangelo Merisi da, 29
Casablanca, 220n24
Caspary, Vera, 167, 177
Cassavetes, John, 79–80
cast shadow. *See* shadow
catch light. *See* eyelight
Cat People, 80, 112

causal chain, 21, 33, 190, 210n3. *See also* classical Hollywood cinema; dramatic arc
Cause for Alarm, 96
Chandler, Raymond, 26, 27, 103, 122, 150, 222n78
Chao, Phebe Shih, 218n83
characterization, subfunction of storytelling, 28–36
characters, lighting: age of character, 84; backlight, 66 (*see also* backlight); character subjectivity, 26; depictions, 81–83, *82, 84*; exposing the face, 62–64, *63*; eye glimmer, 67; face modeling, 58–62, *60, 61, 63* (*see also* key light); fill light, 64–66, *64*; in *Gaslight*, 191–195, *194*; gender, 68–72; general illumination, 65–66; glamour (*See* glamour: character lighting); interaction with milieu, 139; in *I Wake Up Screaming*, 115, 119, *120*; kicker, 66 (*see also* kicker); in *The Letter*, 83–88, *84, 86*; in *The Locket*, 175; modeling and modulation, 77–81, *79, 80, 81*, 104; in *Phantom Lady*, 88–94, *90, 91, 93*; race, 68–72, *86, 93*; recurring narrative situations and lighting, 77–81; shadows, 67–68, 71–72; suspense/danger, 80–81; in tragic fall, 79–80; use of snoot, 210n24
Chase, The, 107, 150–151
Chatman, Seymour, 32, 109
Chaumeton, Etienne, 6, 180
"cheating" effects, 17, 85, 133, 141, 158, 209n3
chiaroscuro, 40, 101–102, 112, 113, 114, 148: expressionistic, 121, 178, 182; Italian, 71
Christmas Holiday, 63, *63*, 65, 89, 91
Ciletti, Elena, 29
cinematography: diffusion on lens, 84–85; guiding principles, 6–10; high-angled camera, 161; lens aperture, 62; lens filter, 62; location shooting, 141–145; low-angled camera, 52, 161; music comparison, 203; point-of-view shot, 26, 167, 169; source lighting as masking, 140; wide-angle lens, 52, 78–79, 80, 161, 214n82. *See also specific lighting techniques*
Citizen Kane, 45, 140
class. *See* social class
classical Hollywood cinema, 1, 5–6, 8, 11, 21–22, 27, 97, 181, 201. *See also* goal-driven plot
classic noir, 24, 95–96, 105, 113, 121, 144, 161, 185. *See also* melodramas
Cobb, Lee J., 173

coherence. *See* configuration vs. coherence
Cohn, Art, 150
Colbert, Claudette, 43
colonialization, depicted in film, 83, 85, 88
comedy, 95, 96–97, 98, 99–100, 120: screwball mysteries, 98, 103–104, *104*
Compson, Betty, 74
configuration vs. coherence, 103, 122. *See also* storytelling
Conrad, William, 113
consonant lighting, 168, 171–172, *183*, *184*, 191, *194*
Cook, Elisha, Jr., 91, 121
cookie. *See* cucoloris
Cording, Harry, 219n91
Cornered, 37–39, *37*, 80, 203
Cortez, Stanley, 133, 196–197, 198, 203
Cotten, Joseph, 194
counterpoint, 18–19
Cowie, Elizabeth, 24
Crawford, Joan, 67, 73, 76
Cregar, Laird, 115, 122
crime, as defining noir cycle, 83, 96, 100, *119*, 181
Cronjager, Edward, 115, 116, 117
Crossfire, 54
cucoloris, 67
Cukor, George, 192
culture of light, 131, 182
Cummings, Robert, 150
Curtis, Tony, 156
Curtiz, Michael, 171

Daniels, William, 100, 142, 205
Dark Corner, The, 80, 149–150
Dark Mirror, The, 177
Dark Passage, 25
Dassin, Jules, 173
Davis, Bette, 83, 84, 86
Day, Laraine, 174
Day, Richard, 139
Deadline at Dawn (film), 112–113
Deadline at Dawn (novel; Woolrich), 107–108, *112*
Dead Reckoning, 44–45
del Río, Dolores, 76
depictions: depicting-as, 9–10, 58, 72, 81, 145, 151, 164, 205; glamour lighting, 72–77; in *Human Desire*, 41–42; in *The Letter*, 84–85, 86; lighting's contribution to, 7–8, 81–83; nuances of, 185; in *Odds Against Tomorrow*,

57; in *Phantom Lady*, 92; seeing-in theory, 33, 186, 229n45; in *Strangers on a Train*, 129; working through—, 32–33, 141
description, 32
Detour, 25, 27
diagonal lines, 86–87, 118–120, 144, 156, 177, *179*, *180*, 185–189
Diana Productions, 195
Dietrich, Marlene, 59, 73–76, *75*, 81, 91, 163–164
Dietrich lighting. *See* butterfly lighting
Dimendberg, Edward, 4–5, 145
Dishonored, 74
dissonance, 168, 172–173
Divorcee, The, 73
Dmytryk, Edward, 39, 212n52
Docks of New York, The, 74
Dombrowski, Lisa, 141
Donnell, Jeff, 158
doom-laden scenario. *See* fatalism
Doty, Alexander, 76
Double Indemnity (film), 24, 27–28, 46, 52, 96, 182
Double Indemnity (novel; Cain), 110–111
Double Life, A, 148
Douglas, Kirk, 151
Down Argentine Way, 115
downbeat films, 22, 44, 95, 100–101, 104, 181
dramas, 96, 98, 99–100, 103, 181. *See also* melodramas
dramatic arc: beats, 39–42, 127, *128*, 129–130, 212n55; in *Call Northside 777*, 8–10, *9*, 30–31; in *Cornered*, 37–39, *37*; described, 20, *21*; dynamic range, 10; in *The Hitch-Hiker*, 35–36, *36*; in *The Letter*, 88; lighting and time, 28–36, *31*, *32*, *36*; milieu and, 152–155; mood lighting, 43–45; in *Odds Against Tomorrow*, 50–57, *52*, *53*, *56*; in *Pickup on South Street*, 30–33, *31*, *32*; representation of time, 36–39, *37*; shaping of, 7–8; in *Sorry, Wrong Number*, 45–50, *48*; space in scene, 39–42, *40*, 48–49; storytelling convention, 21–28. *See also* time: unfolding
Dr. Fu Manchu, 98
Dr. Jekyll and Mr. Hyde, 98
Durbin, Deanna, 63, 66, 67
Dyer, Richard, 71

Earnest, Allison, 215n7
Edeson, Arthur, 3, 8, 220n24
Edge of the City, 52, 79–80, *80*

Edison, the Man, 147
effect lighting, 98–99, 131–139, 171–172. *See also* beam-of-light effect; blinking signs/neons; "cheating" effects; venetian blinds
Eisner, Lotte, 178
electricity: costs, 105–106; culture of electric light, 131, 153; decorating mistakes, 147–148; demand, 146, 225n38; office lighting, 152, 153, 154–155, *154*, 157–158, *158*, 178; room lighting suggestions, 146, 165–166; social inequities/meanings, 145–147, *148*; in *Touch of Evil*, 165
Elsaesser, Thomas, 181
emotions, impact of lighting, 34–35, 43, 50, 101–102
English, Don, 74
ethnicity. *See* racism: racial/ethnic boundaries
exceptionalism. *See* noir exceptionalism
exoticism. *See* glamour: exoticism
expectation, play of, 7–8, 10, 29, 33, 34, 102–105, 118
eyelight: described, 67; in *The Letter*, 86; in *In a Lonely Place*, 170, *170*; in *The Maltese Falcon*, 113–114, *114*; in *The Postman Always Rings Twice*, 78; in *Reign of Terror*, 79; in *Secret beyond the Door*, 197; in *Strangers on a Train*, 129; in *Sweet Smell of Success*, 159

family films, 72, 96, 100–101
Farewell, My Lovely, 150
fascism, 39
fatalism, 25–27, 45, 83, 88, 105, 144, 150, 153, 165
Father of the Bride, 100–101
Fay, Jennifer, 147
femme fatale, 24–25, 77–78, 82–83, 174–175. *See also* gender
figure lighting, 7–8, 58. *See also* characters, lighting; modeling
fill light: in *Gaslight*, 191, 192, 194; in *The Letter*, 84, *84*; in *Odds against Tomorrow*, 55; in *Phantom Lady*, 90, 91, *91*; in *Sweet Smell of Success*, 159; technique, 58, 64, 65–66, 69
film gris, 139, 154, 173
film noir: budgets, 105–106; as category, 6, 95–97, 98; configuration of story, 104–105, 117–118; defined, 4–5, 95; emotional effect, 96; genre confusion, 116, 118–119, *119*; in relation to classical Hollywood cinema, 22–23; in relation to German Expressionism, 181–182; source literature, 106–114;

subgenres, 96. *See also* melodramas; noir exceptionalism
Film Noir (encyclopedia), 83
Fisher, Steve, 115
flashbacks: in *Dead Reckoning*, 44; in *Double Indemnity*, 27–28, 46, 52, 95; in *I Wake Up Screaming*, 116; in *The Killers*, 95; in *Laura*, 177; in *The Locket*, 175, 185; in *Secret beyond the Door*, 198, 201; in *Sorry, Wrong Number*, 45–46, 49, 52; storytelling tactic, 26, 27; in *Sunset Blvd.*, 167
flat lighting, 1, 14, 59, 156, 182, 214n1
Fletcher, Lucille, 45, 48, 49
Flory, Dan, 149
Flowers, Bess, 219n91
fluorescent lighting, 14–15, *15*, 151, 154, *154*, 156–157, *157*, *158*, 164–166, 173–174, *174*, 178
Folsey, George, 80–81, 226n61
Force of Evil, 19, 138–140, 160, 202
Foreign Correspondent, 21, 201
Foster, Norman, 162
Freund, Karl, 70, 71, 180, 181
frontal lighting, 15, 47, 68, 127. *See also* flat lighting
Fuller, Sam, 30, 33

gangster films, 98
Garbo, Greta, 73, 76, 100
Garfield, John, 78, 134, 138
Garmes, Lee, 59, 70–72, 74–75, 80, 133, 153, 217n58
Gaslight, 189–195, *192*, *193*, *194*, 202
gaslighting, 190, 193
Gates, Philippa, 24, 86
Gaudio, Tony, 83–84, 85, 86
Gaynor, Janet, 73
gender: character lighting, 68–72, 83–94, 121, 197, *197*; character's agency, 46–47, 94; "cultural crisis in masculinity," 35–36; in film noir, 24–25; glamour and, 76; lighting conventions, 69, 84, 197–198 (*see also* butterfly lighting; loop lighting; Rembrandt lighting; split lighting); "nurturing woman," 90; "spider woman," 90–91; visible femininity in *The Maltese Falcon*, 4; women's roles, 24–25, 89, 222n75
General Died at Dawn, The, 96, 98
General Electric, 147
general illumination, 65–66, 142
Gentileschi, Artemisia, 29

German Expressionism, 178–182, 185, 186
Gidding, Nelson, 51
Gilda, 25–26, 83, 138
Gish, Lillian, 34
glamour: character lighting, 28, 59–60, 72–77, 75, 214n3; commercialism and, 91–92; cultural assumptions, 72; deglamorizing angle, 47; Dietrich's close-up, 75, 75; exoticism, 75–77; gender and, 76, 92; image of heightened, 77–78, 190; in *I Wake Up Screaming*, 119, 120; in *The Lady from Shanghai*, 82, 82; in *The Letter*, 86, 87; in *Phantom Lady*, 90–91, 90; recurring narrative situation, 77–78; sexuality and, 91–92; as a style, 73; in *Sweet Smell of Success*, 156–157; in *Touch of Evil*, 163–164; use of term, 72–73; Venus de Milo as default for beauty, 69, 71, 78; white standards, 71, 72, 75–77, 85, 86, 92, 93. *See also* butterfly lighting
Glass Key, The, 61, 62, 64–65
Gledhill, Christine, 219n5
goal-driven plot, 21–28, 45, 124, 210n6
Godfather, The, 62
godfather lighting. *See* top-light effect
Gomez, Thomas, 92
gothic melodrama, 6, 11, 100, 189–190, 195
Grable, Betty, 114–115, 120
Grahame, Gloria, 39
Grand Hotel, 100
Granger, Farley, 61, 66, 67, 122
Green Dolphin Street, 80–81, 81, 217n69, 226n61
Greer, Jane, 77
grid/bar pattern, 2, 153, 153, 166, 177, 180, 184, 194, 198, 209n6. *See also* noir symbolism
Grisham, Therese, 227n10
Grossman, Julie, 24–25, 227n10
Guerin, Frances, 131, 182
Guffey, Burnett, 40, 196, 227n7
Guilty Hands, 98
Gun Crazy, 23, 76
Gundle, Stephen, 72
Gunning, Tom, 182

Hagen, Jean, 11
Hammett, Dashiell, 109–110, 111, 113
Hangover Square, 100
Hanson, Helen, 89, 189, 195
HarBel (film production company), 50
Hard, Fast, and Beautiful, 161, 175, 180

Harlow, Jean, 13, 76
Harrison, Joan, 88–89, 90
Hatfield, Hurd, 64, 67
Hathaway, Henry, 8
Hawks, Howard, 103
Hayden, Sterling, 11
Hayworth, Rita, 77, 82, 138
Heflin, Van, 133
Hemingway, Ernest, 23, 108–109, 112, 113
"hepcat," 93–94
He Ran all the Way, 69, 134, 135
Heston, Charlton, 160
He Walked by Night, 140
He Was Her Man, 96
high front lighting, 214n3. *See also* butterfly lighting
high-key lighting, 5, 43, 85, 106, 181: defined, 64–65; and genre, 98; in *Phantom Lady*, 90, 94
Highsmith, Patricia, 114, 122–125, 130
High Wall, 24
Hirsch, Foster, 6, 138, 181
historical poetics methodology, 8
Hitchcock, Alfred, 21, 59, 60, 122, 124–127, 222n78, 227n9
Hitch-Hiker, The, 35–36, 36, 80, 96
Holding, Elisabeth Sanxay, 111
Hollywood lighting. *See* glamour; lighting, functions of; three-point lighting
Hollywood Lighting from the Silent Era to Film Noir (Keating), 68
horror films, 98, 184
horror lighting, 78–79, 79, 182. *See also* lighting from below
hot spot, 13–14
House on 92nd Street, The, 141, 155
House Un-American Activities Committee, 226n66
Howe, James Wong, 43, 134, 155–160
Hughes, Dorothy B., 111
Human Comedy, The, 26, 148–149
Human Desire, 39–42, 196
Humberstone, H. Bruce, 115
Hunt, Marsha, 187
Hurrell, George, 73, 74, 75, 76, 86–87, 91–92
Huston, John, 2, 3, 8, 11, 18, 113

if-only plot, 27
imagined lighting effect, 168–170, 169, 183, 184, 190, 192

In a Lonely Place, 95, 170–171, *170*, *180*
inflected lighting effect, 168, 170–171, *183*, *184*, *191*, *192*, *194*–*195*, 227n7
Ingster, Boris, 182
International Photographer, 69, 73, 100
International Pictures, 195
Irish, William. *See* Woolrich, Cornell
Island of Lost Souls, The, 98
I Wake Up Screaming, 114–122, *114*, *117*, *119*, 138, 161, 222n75
I Want to Live!, 138

Jaffe, Sam, 11
Janus face, 126–127, *128*
jazz stereotypes, 90–94, 151
Johnny Belinda, 132
Jones, Ray, 74
Journey into Fear, 162
Juarez, 83
Judith and Her Maidservant with the Head of Holofernes (Gentileschi), 29
June, Ray, 103–104

kammerspiel films, 178, 181
Karloff, Boris, 99
Kazan, Elia, 144
Keating, Patrick, 68
Kellaway, Cecil, 78
Keon, Barbara, 222n78
Kerr, Paul, 105
key light: compared to key lighting, 132; defined, 58–62, *60*, *61*, *62*; in relation to exposure, 62–64, *63*. *See also* butterfly lighting; lighting from below; loop lighting; Rembrandt lighting; split lighting; top-light effect
kicker: character lighting, 66; gender use, 66, 78; in *The Hitch-Hiker*, 35–36, *36*; in horror/grotesque, 79–80; in *Human Desire*, 40, *41*; in *Odds Against Tomorrow*, 55; in *Phantom Lady*, 90, *90*, *91*, *91*; in *Strangers on a Train*, *128*; in *Sweet Smell of Success*, 157, *158*; use in Physioc's preferred method of illuminating Venus de Milo, 71; use of term, 66; variation of backlight, 66
Kiley, Richard, 31
Killens, John O., 50–51
Killers, The (film): creation of suspense, 112–113; key lighting, 62, *62*, *65*; modeling and modulation, 77; moody silhouette, *180*;

protagonist's passivity, 23, 46; Siodmak and Bredell's collaboration, 89; subjective storytelling, 167
"Killers, The" (short story; Hemingway), 108–109, 112
Kings Row, 43
Kiss Me Deadly, 26, 50
Kitty Foyle, 26
Koch, Howard, 83, 97–88
Kodak, 66, 84
Komai, Tetsu, 80, *85*
Kozloff, Sarah, 8
Krasner, Milton, 196

La bête humaine (Zola), 39
Ladd, Alan, 61, 64
Lady from Shanghai, The, 19, 24, 45, 78, 82–83, *82*, 159–160, 181
Lady in the Lake, 26, 167, 169
lamp, 59, 142, 131, 151
Lancaster, Burt, 23, 45, 156, 158–159
Lanchester, Elsa, 131
Landis, Carole, 115
Lane, A. Lindsley, 98–102
Lane, Christina, 89
Lang, Charles, 38, 98
Lang, Fritz, 12, 39, 96, 138, 180–183, 195–196, 198, 201, 230n70
Langdon-Teclaw, Jennifer, 212n52
LaShelle, Joseph, 135
Laura, 100, 167, 177–178, *180*
Lawless, The, 154–155, *154*
Lawrence, Amy, 49
Lawrence, Marc, 13
Lawton, Charles, Jr., 82
Leave Her to Heaven, 229n54
Leeds, Lila, 80–81
Lehman, Ernest, 156
Leigh, Janet, 160
Leni, Paul, 228n18
Letter, The, 83–88, *84*, *86*, 218n83
Letter to Three Wives, A, 26
Life magazine, 155
lighting. *See* backlight; bounce lighting; butterfly lighting; effect lighting; eyelight; fill light; high-key lighting; key light; lighting from below; loop lighting; low-key lighting; mood lighting; north light; Rembrandt lighting; source lighting; split lighting; three-point lighting; top-light effect

lighting from below, 16–18, 17, 31–32, 32, 62, 70, 78–79, 79, 87, 117, 119
lighting, functions of, 6–10, 28–29
Lightman, Herb, 43, 148
lights-out scene, 204, 230n70
Little Foxes, The, 85
Litvak, Anatole, 46, 182
Lloyd, Norman, 78
localized lighting, 168, 173–175, 183, 183, 191, 192
location shooting, 141–145, 143
Locket, The, 174–175, 185
Lodger, The, 67
Look magazine, 155
loop lighting: broad, 60–61, 61; character lighting, 59, 60–61, 62, 68; closed, 215n7 (*see also* Rembrandt lighting); default lighting for women, 197; in *Gaslight*, 191; in *I Wake Up Screaming*, 119, 121; modeling and modulation, 78; open, 215n7; in *Phantom Lady*, 90, 90; short, 60–61, 60
Loring, Charles, 132–133, 140
Lorre, Peter, 183
Losey, Joseph, 154
Lott, Eric, 54
Louise, Ruth Harriet, 75–76
Lovejoy, Frank, 35
low-key lighting: as defining feature of the noir style, 1, 5–6; effect of film stocks, 66; effect on mood, 43, 102; and genre, 98–101, 106, 120; in relation to race and ethnicity, 70, 149–150; as source lighting, 144; technique of, 64–65; variable functions, 181–182
Loy, Myrna, 70
Lugosi, Bela, 70
Lupino, Ida, 35, 80, 175
Lured, 44, 89

M, 183
MacDonald, Joe, 8, 30, 31, 144
Mackendrick, Alexander, 160
MacMurray, Fred, 28
Maddow, Ben, 18
Mad Miss Manton, The, 98, 103–104, 104, 112
Magazine of Light, 146–147, 151, 153, 155
Magnificent Ambersons, The, 162, 196
Maltese Falcon, The (film), 2–5, 3, 11, 24, 113–114, 114
Maltese Falcon, The (novel; Hammett), 110, 113
Maltin, Leonard, 72
Mankiewicz, Joseph L., 100

Mann, Anthony, 187
Marion, Frances, 23
Marked Woman, 147
Martin, Angela, 24
Mask of Fu Manchu, The, 70
Mata Hari, 100
Maté, Rudolph, 82, 138
Mature, Victor, 114, 115
Mayer, Louis B., 72
McCord, Ted, 132
McDaniel, Hattie, 71
McGill, Barney, 98
McGivern, William P., 50
McGraw, Charles, 113
meller, 96. *See also* melodramas
Mellor, William C., 66
melodramas, 96–97, 98, 114–119, 114, 117, 119, 219n5: murder mysteries, 96, 98, 107, 116, 117; suspenseful, 96, 97, 98–100
memories, in subjective storytelling, 167
Metty, Russell, 160, 162, 165
Mildred Pierce, 19, 45, 67, 68, 221n38, 229n54
milieu: in *The Asphalt Jungle*, 13–18, 14, 15, 16, 17; counternarrative of the dark, 147–151, 165; counternarrative of the light, 151–152, 165–166; dramatic arcs, 152–155; effects and sources, 131–133; place, 135–139; social critique, 139–141; as social environment, 7, 177–178, 202; social meanings of electricity, 145–147; source lighting, 133–135, 141–145; in *Sweet Smell of Success*, 155–160, 157, 158, 159; time, 135–139; in *Touch of Evil*, 160–166, 163, 164. *See also* place
Milland, Ray, 152
Miller, Arthur C., 68, 87, 99, 132
Miller, Virgil, 98
Milner, Victor, 98, 102
Ministry of Fear, 25, 230n70
Miranda, Aurora, 93
mirror, 2, 78, 92, 160. *See also* noir symbolism
misdirection/trickery, 67, 89, 103, 104, 116–117, 124, 126, 201, 203. *See also* surprise
Miss Pinkerton (film), 98, 99
Miss Pinkerton (novel; Rinehart), 107
Mitchum, Robert, 175
modeling, 7, 58–72, 60, 61, 62, 63, 64, 77–81, 79, 80, 81, 132
modulation, 42, 43–45, 58, 77–83, 89
Mole-Richardson Company, 84
Monroe, Marilyn, 12, 15

Montgomery, Robert, 103, 169
mood lighting, 28–36, 43–45, 47, 101–105, 189–195
Moontide, 140
Moorhead, Agnes, 45
Morley, Karen, 70
Morocco, 74
motif. *See* noir symbolism
Mummy, The, 99
Murder, My Sweet, 23, 25, 44, 95, 150, 161
murder mysteries. *See* melodramas
Murphet, Julian, 150
Musuraca, Nick, 35, 37, 90, 103, 112, 138, 175, 184–185
My Darling Clementine, 8, 72
Mysterious Mr. Wong, The, 150
Mystery of Mr. Wong, The, 96
Mystery Street, 131, 148, 202

Naked City, The, 43, 141, 142
Naremore, James, 6, 105, 110, 156, 165
narration/narrative: artificial light as subject, 131 (*see also* electricity); atmospheric prose, 107–108, 112–114, 123–125; camera-eye narration, 108; darkness as counternarrative, 147–151; description vs., 32; focalization, 201; functionalist model, 33–34; lighting and narrative dynamics, 125–126, 200–201; lightness as counternarrative, 151–152; misdirection/trickery, 89, 116, 203 (*see also* surprise); narrative situations and tools for figure lighting, 77–81, 97; objectivist model, 33; of progress, 145–147; as representation of action, 33; rhetorical level vs. storyworld level, 176–178; as unfolding arc, 34; voice-over, 26, 95, 184, 187, 198–201. *See also* storytelling
Neale, Steve, 95, 96, 219n5
Negulesco, Jean, 132
net, 67
Niagara, 95
Nichols, Barbara, 158
Nieland, Justus, 147
Night and the City, 78
Nightmare Alley, 153–154, 153, 177, 202
Night Must Fall, 103–104
Night of the Hunter, The, 34, 196
noir-adjacent films, 6, 185
noir cycle, 83
noir exceptionalism, 1, 5–6, 97, 178–185

noir symbolism: darkness, 39, 44–45, 54, 83, 99, 120–121, 122–129, 147–151, 155, 203–204; described, 1–5; in *Gaslight*, 191–194, *192*, *193*; lighting and narrative dynamics, 200–201; lightness, 44–45, 151–152, 155; painting with light, 185–195; reflective lighting, 201–204; in *Secret beyond the Door*, 195–204; subjectivity, 175–178; subjectivity and ambiguity, 174–175, 190–194, 201; subjectivity and expressionism, 178–185; symbolic lighting, 196–200; symbolic motifs, 2, 10, 175–178 (*see also* blinking sign/neon; grid/bar pattern; Janus face; mirror; prison-like bars; venetian blinds). *See also* storytelling
Nora Prentiss, 24
north light, 70–71, 74–75, 217n58. *See also* butterfly lighting
Notorious, 168–170, *169*, 171, 180
Novarro, Ramon, 76
Now, Voyager, 96
Nye, David, 146

Oberon, Merle, 67
Obie, 67. *See also* eyelight
O'Brien, Edmond, 35
obsolesce, meanings of, 147–151, 153, 162–163, *163*, 164
Odds Against Tomorrow, 50–57, *52*, *53*, *56*, 72, 80, 129–130, 165
Odets, Clifford, 156
O'Donnell, Cathy, 60–61, 66, 67
office lighting. *See* electricity: office lighting
O'Keefe, Dennis, 187
Old Maid, The, 83
Oliver, Kelly, 52
On Dangerous Ground, 25
One Million B.C., 115
Ophuls, Max, 111, 180
Ormonde, Czenzi, 122, 222n78
Out of the Past, 25, 77, 138

painterly, described, 185, 186
painting: analogy between film noir, 185–195; lighting in subfunctions of storytelling, 28; representational and configurational aspects, 186–188, 229n46; temporal effects, 29; two-dimensional image, 185–195; use of *description*, 32; with light, 136, 177, 205
Painting with Light (Alton), 34–35, 71, 101, 187

Panic in the Streets, 100, 144, *144*
Paradine Case, 59–60, *60*, 63
Paramount lighting, 59, 214n3. *See also* butterfly lighting
Paxson, John, 212n52
People on Sunday, 89
Perkins, V. F., 42, 166
Perplexing Plots (Bordwell), 22
Peterson, Lowell, 2, 5, 170
Phantom Lady: action and romance plots, 25; beam-of-light effect, 140; blinking light, 161; character lighting, 88–94, *90*, *91*, *93*; dim lighting and suspense, 203; expressionistic, 180; fully integrated set piece, 138; obsolesce in, 148; Siodmak and Bredell's collaboration, 113; source material, 107
Phantom of the Opera, 98
Phillips, Alastair, 89, 182
photoflood bulb, 133, *134*, 142, 210n22
Photoplay (fan magazine), 73
Physioc, Lewis, 69, 70, 71
Pickford, Mary, 73
Pickup on South Street, 30–33, *31*, *32*, *34*, 138, 139, 148
Picture of Dorian Gray, The, 64–65, *64*, 138, 229n54
Picture Play, 69
Pièges, 89
Pippin, Robert, 25
place, 28–36, 135–139, 141–145. *See also* milieu; storytelling
Place, Janey, 2, 5, 90, 170
Planer, Franz, 180
plot, 21–28, 45, 124, 210n6. *See also specific films*
Plus-X film stock, 66
Poetic Realism, 139, 181
Poitier, Sidney, 51, 79–80
Polan, Dana, 171
Polito, Sol, 47–48, *49*
Polonsky, Abraham, 50, 52, 138
Porfirio, Robert, 22–23, 181
Possessed (film), 23–24, 195–196
Possessed (screenplay; Richards), 195
Postman Always Rings Twice, The, 24, 77, 78
Powell, Dick, 38
Powolny, Frank, 73–74
Preminger, Otto, 177, 180, 182
Prison Train, 98
Production Code Administration, 12, 25, 71, 83
proto-noir films, 74, 98

Prowler, The, 161
psychological drama, 43, 96, 181, 195–196

Rabinovitz, Lauren, 35
Rabinowitz, Peter, 102, 103, 122
race: Asian characters, 69–70, 71, 80, 81, 83, 85–88, 150; association between criminality and blackness, 150–151; biracial character, 80–81, *81*; Black characters, 80, 150; character lighting, 68–72, *86*, *93*, 197, 217n69; erasure of Black characters, 150; use of shadows, 92
racism: blackface makeup, 148; brownface makeup, 149, 154, 160, 163, 164; in *Call Northside 777*, 149–150; casting practices, 71; in *I Wake Up Screaming*, 115; in *Lawless*, 154; in *The Letter*, 83–88; liberalism-of-conscience framework, 51; in *Odds Against Tomorrow*, 50–57; in *Phantom Lady*, 90–94; racial/ethnic boundaries, 86, 148–150, 163–164; in *Touch of Evil*, 164; violence, 226n66; yellowface makeup, 69–70, 71, 80, 85
Raines, Ella, 89, *90*
Rains Came, The, 87
Random Harvest, 21, 201
Raw Deal, 161, 187–188, *188*
Ray, Nicholas, 170
realism, lighting for, 13–14, 28, 142, 155, 156
Rebecca, 229n54
Reckless Moment, The, 111
Redgrave, Michael, 195, 197
Red Harvest (novel; Hammett), 109–110
reflected lighting. *See* bounce lighting
reflexive lighting, 201–204
Reign of Terror, 78, 79, 80
Reinventing Hollywood (Bordwell), 22
Rembrandt lighting: default lighting for men, 68, 197; described, 59, 61–62, 215n7; in *Gaslight*, 192; in *Green Dolphin Street*, 81; in *I Wake Up Screaming*, 118, 121; in *The Letter*, 84–85, *84*; Old Masters painting as ideal, 70; in *Secret beyond the Door*, 197, *197*
Rembrandt van Rijn, 61, 74
Renoir, Jean, 39
Republic Pictures, 195
Richards, Silvia, 195
Richee, Eugene Robert, 74
Ricoeur, Paul, 29
Ride the Pink Horse (novel; Hughes), 111–112

rim light. *See* backlight
Rinehart, Mary Roberts, 107–108
Ritter, Thelma, 30, 138, 148
Road House, 96
Rogers, Ginger, 26, 115
romance films, 97, 98, 103, 104, 119, *119*, 181: romantic comedy, 25–26, 115, 116, 118; romantic dramas, 100
Rooney, Mickey, 148
Rosenbaum, Jonathan, 160
Rose Tattoo, The, 156
Rosson, Hal, 13, 72
Rural Electrification program, 146
Russell, Gail, 154
Russell, Rosalind, 103
Ruttenberg, Joseph, 61, 189, 194–195
Ryan, Marie-Laure, 27
Ryan, Robert, 51, 54, 150

Sadowski, Piotr, 182
Scarface, 98
Scarlet Street, 12, 95, 161, 196
scene and lighting, 39–42, *40*, 127–130, *128*, 135–139: set piece, fully integrated, 138–139, 200
Schatz, Thomas, 189
Schoenfeld, Bernard, 89
Schrader, Paul, 2, 152
Schüfftan, Eugen, 180
Scott, Adrian, 39
scrim, 67
Secret beyond the Door, 195–204, *197*, *199*
Seitz, John F., 74, 151–152, 226n61
Selznick, David O., 196
set piece. *See* scene and lighting: set piece
Set-Up, The, 54, 95, 150, 154
shadow: in *The Asphalt Jungle*, 13–18, *14*, *15*, *16*, *17*; attached, 127, *128*, 129; cast shadow, 47, 62, 67–68, *68*, 99, 117–119, *119*, 125, 127–129, 144, 151, 153, 184, 203; crisscrossing, 121; to emphasize racial difference, 86; filling in, 64–65, *64*; film stocks, 66, 84; function of, 2–4; in *Gaslight*, 191–194, *192*, *193*, *194*; impact on costume and set design, 4; invocation of marginality and otherness, 150; in *I Wake Up Screaming*, 116, 117–122, *117*; in *The Lady from Shanghai*, 82, *82*; in *The Locket*, 175; in *The Maltese Falcon*, 2–5, *3*; money-saving technique, 105; in *Notorious*, 168–169, *169*; in *Odds Against Tomorrow*, 51–54, *52*, *53*; in *Panic in the Streets*, 144, *144*; in *Phantom Lady*, 91–92; recurring motif, 53, 98, 100–101, 104; scene geography and, 2–3; in *Secret beyond the Door*, 197–200, *199*; sense of roundness in space, 42; in *Sorry, Wrong Number*, 47, 48, 50, 52; in *Strangers on a Train*, 124–126, *125*, *128*, *128*; in *Sweet Smell of Success*, 158, 159; as symbol of duality, 4; as symbol of duplicity, 2–3; in *Touch of Evil*, 163; within a shadow, 65; *See also* chiaroscuro; silhouette
Shadow of Chinatown, 70
Shamroy, Leon, 196
Shanghai Express, 74, 75, 76, 80, 81
Shanghai Gesture, The, 71
Shearer, Norma, 73, 76
Sheridan, Ann, 24
Side Street, 60–61, *61*, 66, 140
silhouette: in *Cornered*, 203; in *The Dark Mirror*, 177; in *Dead Reckoning*, 44; in *Human Desire*, 40, *41*, 42; in *The Killers*, 180; in *The Maltese Falcon*, 4; in *Secret beyond the Door*, 197–199, *197*; in *Strangers on a Train*, 124–125, *127*; in *Sweet Smell of Success*, 159; in *The Uninvited*, 38. *See also* shadow
silk, 67
Silver, Alain, 2
Since You Went Away, 8, 133, 196
single-source lighting, 74–75, 217n58
Siodmak, Robert, 88–89, 112–113, 180, 181, 182
Sirk, Douglas, 89, 160
Sleep, My Love, 43, 44, 45
Sleepy Lagoon murder trial, 226n66
Snake Pit, The, 196, 229n54
Sobchack, Vivian, 4
social class: in *Laura*, 177–178; milieu, 131, 139–141, 145, 151, 153–154, *153*; in *Odds Against Tomorrow*, 52–53; in *Phantom Lady*, 94; in *Strangers on a Train*, 129; use of shadows, 92, 113. *See also* capitalism; race
So Dark the Night, 227n7
Somewhere in the Night, 100
Sondergaard, Gale, 85
Sorry, Wrong Number, 45–50, *48*, 61, 106, 148
source lighting: imitated, 134, *135*; implied, 134–135, *136*; immediate, 133–134, *134*. *See also* effect lighting; single-source lighting
space: character represented through, 156; in *Odds Against Tomorrow*, 53–54; in *Phantom*

Lady, 93–94; in *Secret beyond the Door*, 201–204; as seen in scene, 39–42, *40*, 48–49; in suspense scene, 80; in *Touch of Evil*, 164–165. *See also* who stands where
Spadoni, Robert, 107
Spellbound, 196, 229n54
Spicer, Andrew, 5, 97
spill, effect of, 13–14
Spiral Staircase, The, 44
split lighting: broad, 61; default lighting for men, 197; described, 59, 61–62, *62*, *63*; glamour lighting, 74; in *Phantom Lady*, 90, 91, *91*; Physioc's preferred method of illuminating Venus de Milo, 71; radical binary, 198; relationship to camera, 68; in *Secret beyond the Door*, 198; in *Strangers on a Train*, 127–128, *128*; in *Sweet Smell of Success*, 158
spotlights, use of, 65–66, 84, *85*
Staiger, Janet, 21, 219n5
Stanislavski, Constantin, 212n55
Stanwyck, Barbara, 45, 103
Stephenson, James, 84
Sternberg, Josef von, 59–60, 71, 74, 76, 120, 229n45
Sternberg, Meir, 22, 200
Stevens, Mark, 149
Stewart, James, 9
storytelling: configurations, 97, 101–105, *104*, 117–118, 122; depictions, 32–33; emotional impact, 30–33, 43; ending known in advance, 26–27; fatalism, 25–27; frame-and-flashback structure, 45–47; in *Gaslight*, 189–195; gender roles, 23–25; goal-driven plot, 21–28, 45, 124, 210n6; light as action, 33–34; lighting effects, 168–175; lighting and time, 28–36; narration as representation of action, 33; narration vs. description, 32; pictorial, 185–195 (*see also* painting); rhetorical effects, 176–178; in *Secret beyond the Door*, 195–204; seeing-in theory, 33, 186, 229n45; story-level tactics, 23–26; subfunctions, 28–36; subjective storytelling, 175–185; telling-level tactics, 26–28; threefold present, 29; timeline (*see* time). *See also* dramatic arc; narration/narrative; noir symbolism
Strange Affair of Uncle Harry, The, 89
Strange Love of Martha Ivers, The, 26
Stranger, The, 160, 172–173, *173*, 180

Stranger on the Third Floor, 95, 106, 182–185, *183*, 189, 195
Strangers on a Train (film), 122–130, *125*, *128*, 165, 203, 222n78
Strangers on a Train (novel; Highsmith), 114, 122, 123
Studlar, Gaylyn, 25
subjectivity: categories of subjective lighting, 168–175; and German Expressionism, 178–185; in relation to noir symbolism, 175–178. *See also* consonant lighting; imagined lighting effect; inflected lighting effect; storytelling
sunlight, 18–19, 35–36, *36*, 142–143, 159–160, *159*. *See also* noir symbolism: lightness
Sunset Blvd., 26, 27, 167
Super-XX film stock, 66
surprise, 22, 26, 33, 102, 125–126, 151, 200–201. *See also* misdirection/trickery
Surtees, Robert, 132, 133–134
Susan Lenox—Her Rise and Fall, 100
suspense: abnormal, 28; in *Gaslight*, 194–195; in *I Wake Up Screaming*, 115, 120–122; narrative situations and lighting, 80–81, 97, 100–101, *104*, 112, 200, 203; in *Secret beyond the Door*, 200; in *Sorry, Wrong Number*, 45, 49; source literature, 107; in *Strangers on a Train*, 122–130, *125*, *128*. *See also* melodramas: suspenseful; shadow; silhouette
Suspense (radio program), 45
Suspicion, 96
Sweet Smell of Success, 19, 23, 155–160, *157*, *158*, *159*, 166, 177–178, 202
symbolism. *See* noir symbolism
symmetry, 47, 59–60, 65, 74, 82, 118, 185, 187–188, *188*

Tannura, Phil, 132
Tasker, Yvonne, 77
Taylor, Dwight, 115
Taylor, Robert, 76
Telotte, J. P., 26
Tennessee Valley Authority, 146
Thalberg, Irving, 73
Thief, The, 161
Thieves Highway, 173–174, *174*, 180
13 Rue Madeleine, 142
Thomas, Deborah, 26
Thompson, Lara, 77

three-point lighting, 17–18, 47, 55, 66, 73, 74, 119, 191
thrillers. *See* melodramas; suspense
Tierney, Gene, 71
time: chain of events, 7, 21, 26, 27; concept of configuration, 103–104; daytime exterior, 37, 38; daytime interior, 37, 37, 38, 142; historical period of story, 38–39; lighting, 20, 28–39, 36, 37, 188–189; of movie progression, 36, 204; nighttime exterior, 37, 143–144; nighttime interior, 37, 37; passage of, 52, 56, 129–130, 165; representation of, 36–39, 36, 37; of scene, 36, 135–139; of shot, 36; source lighting, 135–139, 141–145; story timeline, 22; subfunction of storytelling, 28–36; unfolding, 7, 30, 34, 41, 101–105, 174, 205
Tin Pan Alley, 115
T-Men, 23, 50, 187
Toland, Gregg, 85
tonality, 37, 40, 64–65, 71, 94, 104, 125. *See also* high-key lighting; low-key lighting
Tone, Franchot, 94
Top Hat, 115
top-light effect, 13, 14, 47, 48, 54, 62, 62, 135, 136, 222n70
Torrid Zone, 87
Touch of Evil, 160–166, 163, 164, 203
tragedy: configuration of story, 101–103; *Gaslight*, 191; *I Wake Up Screaming*, 116; mood of, 5, 33, 43, 104
Trevor, Claire, 175, 187
Trigo, Benigno, 52
Tumultes, 89
Turner, Lana, 24, 78
Tuttle, Lurene, 156

Ulmer, Edgar, 180, 181
Undercurrent, 23
Underworld, 74
Unfaithfully Yours, 26
unfolding. *See* time
Uninvited, The, 38
Union Station, 151
Union Station (Los Angeles, California), 151
Unsuspected, The, 96, 106, 171, 172, 176–177, 178, 180, 202
uplighting. *See* lighting from below
urban space conceptions, 4–5
Ursini, James, 2

Valentine, Joseph, 45
Valli, Alida, 59, 62, 66
Veiller, Anthony, 180
Velez, Lupe, 76
venetian blinds: in *I Wake Up Screaming*, 117, 117, 131; in *Laura*, 177–178, 180; in *The Letter*, 85, 87; noir iconography, 2, 131; in *Odds against Tomorrow*, 55; in *Strangers on the Third floor*, 183, 183, 184. *See also* noir symbolism
Venus de Milo, 69, 71, 78
Vernet, Marc, 181
Vieira, Mark, 73
Vincendeau, Ginette, 181
voice-over. *See* narration/narrative: voice-over

Wagner, Sidney, 78
Waldman, Diane, 190
Walker, Robert, 122, 129
Wallis, Hal, 220n24
Wanger, Walter, 195
Warner Bros. Research Department, 86
wartime/postwar time culture, 25, 148
Weimar cinema, 131, 178, 180, 182
Welles, Orson, 82, 160, 162, 163, 172, 181
Wexley, John, 39, 212n52
Where the Sidewalk Ends, 100, 134–135, 136, 162
White Cockatoo, The, 96
whiteness. *See* race
who stands where: in *The Lady from Shanghai*, 82; in *The Maltese Falcon*, 2–5; in *Odds Against Tomorrow*, 57; in *Pickup on South Street*, 31–32, 31, 32, 138; in *Strangers on a Train*, 129. *See also* space
Widmark, Richard, 148
Wild, Harry, 37, 38
Wilder, Billy, 27, 28, 46, 180, 182
Willinger, László, 76–77
Willis, Gordon, 62
Wilson, George M., 171
Window, The, 106, 107
Wise, Robert, 51, 54, 56
Wizard of Oz, The, 13, 92
Wollheim, Richard, 186
Woman in the Window, The, 60, 60, 61, 96
Woman on the Run, 24
women in film noir. *See* gender
women of color. *See* glamour: white standards
women's films, 24, 96
Wong, Anna May, 75–76, 85

Wood, Robin, 124, 166
Woolrich, Cornell, 88–89, 92, 107–108, 110, 150
Written on the Wind, 96
Wyckoff, Alvin, 98

yellowface. *See* racism: yellowface makeup
Yellow Ticket, The 99
Young, Loretta, 73–74

Young Man with a Horn, 151
You Only Live Once, 196
Yung, Victor Sen, 86, 87

Zanuck, Darryl F., 100–101, 142, 144
Zinnemann, Fred, 132
Zola, Émile, 39
Zoot Suit Riots, 154

ABOUT THE AUTHOR

PATRICK KEATING is a professor in the Department of Communication at Trinity University in San Antonio, Texas. He is the author of *The Dynamic Frame: Camera Movement in Classical Hollywood* and the editor of *Cinematography*.